BARN

Preservation & Adaptation

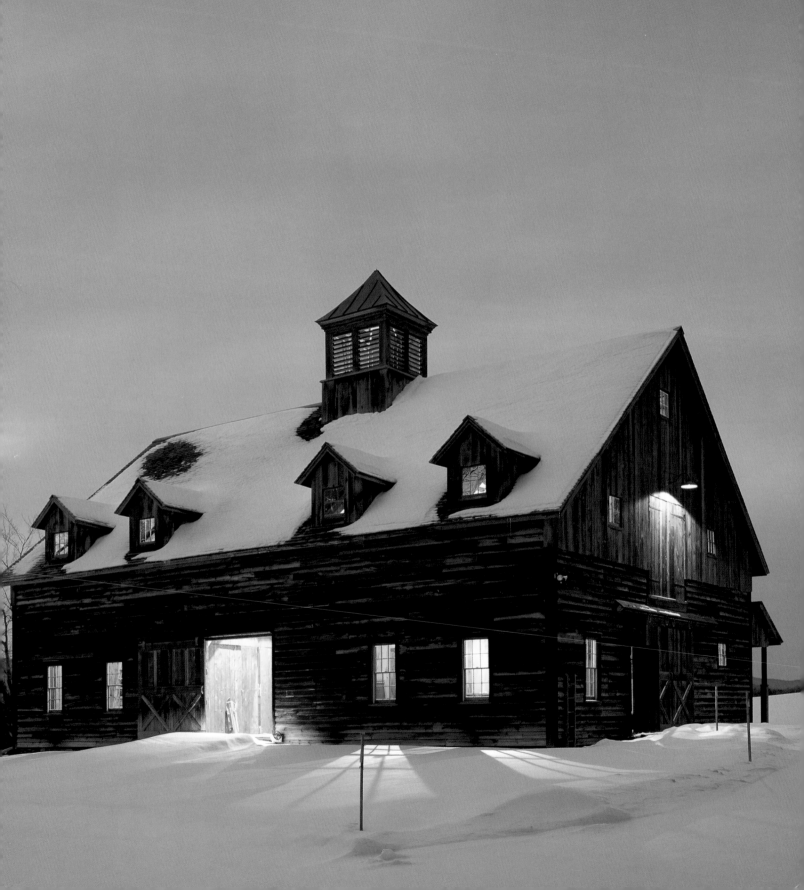

BARN
Preservation & Adaptation

THE EVOLUTION OF A VERNACULAR ICON

BY ELRIC ENDERSBY, ALEXANDER GREENWOOD,
AND DAVID LARKIN

Principal photography by Paul Rocheleau

A David Larkin Book
Universe Publishing

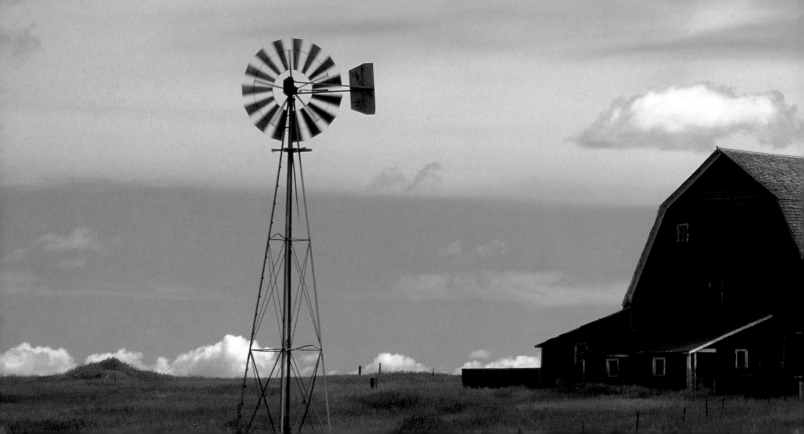

First published in the United States of America in 2003
by UNIVERSE PUBLISHING
A Division of Rizzoli International Publications, Inc.
300 Park Avenue South, New York, NY 10010
www.rizzoliusa.com
Text copyright © 2003 by Elric Endersby, Alexander Greenwood,
and David Larkin
Compilation copyright © 2003 by David Larkin
Special Contributor: Ken Epworth

Lines from *Barn Fever*,
poems by Peter Davison, are reproduced by permission
of Alfred A. Knopf

2006 2007 2008 2009 2010 10 9 8 7 6 5 4

Printed in China

Paperback ISBN-13: 978-0-7893-0794-1
Hardcover ISBN-10: 0-7893-0791-X
Paperback ISBN-10: 0-7893-0794-4
Hardcover ISBN-13: 978-0-7893-0791-0

Library of Congress Catalog Control Number: 2002115751

CONTENTS

Preface

ON A BLEAK MARCH MORNING, by chance we happened upon an abandoned farm still populated by an ancient stone house, smokehouse, summer kitchen, corn crib, wagonhouse, and, at a fair remove from these buildings and the road, a substantial barn. A cursory investigation of the roadside structures established that although variously built over the course of a century, beginning before 1800, each was a remarkable example of its kind. This circumstance might have served as preamble to the barn, but for its unassuming exterior appearance. Approached by a long rutted lane, only the gable was visible, disheveled in knotted vines and obscured by asbestos tiles. As we entered the cellar, the size of the structure came as a surprise. The ceiling in the former stall area was unusually high and dominated by massive double summerbeams dispersing the weight of dozens of bark-laden floor joists. A steep gap-treaded stair led up to the half-rotted barn floor, where it was at last possible to scrutinize the vast interior. Awe should have been our first reaction. Instead, as confused intruders, we were confronted by a visual overload of too many simultaneous and wholly unexpected impressions – enormous timbers, ladders, tongues, turning post, red timbers. Red?

First impressions of a barn are generally tested against known framing conventions and time-specific forms and materials. Together these gleanings establish a basic classification beyond which singular features establish each structure's individual character. This barn exceeded previous experience, defied immediate description. It is arranged in six bays of which the central pair creates a double threshing floor. At either side, the bents separating this space from the flanking mows are framed according to typical German-Swiss tradition with breastboards and ladders. Due to the barn's great width, the bents that define the mow include center posts connected to one another by horizontal girts. But remarkably, each girt is fashioned with a through tenon forming a semicircular tongue. Typically associated with the Dutch, this feature, in a stacked configuration, appears in no other known barn. More astonishing still is the central bent bisecting the threshing bays. Supported by mighty posts, the lower tie spans the full forty-foot width of the barn and is crowned at twenty inches. Further, it assumes the character of a Dutch anchorbeam, positioned high off the floor and

stiffened with foot-thick braces. What renders the bent unique is a central turning post, the upper portion of which takes the form of a true Tuscan column with capital and entasis. Amazingly, this carved timber and the chamfered tie beam were long ago painted oxblood red! More discreetly embellished on one of the breastboards is the name Tittman, surname of nineteenth-century builders in the area. If this is the identity of the framer, this superlative structure is surely his masterpiece.

Ten years ago in *BARN: The Art of a Working Building,* the companion to this study, we described dominant European barn traditions, which eventually came to the New World, where they were gradually adapted into wholly American forms. These new patterns were in part generated by growing familiarity with alternate forms fostered by community barn raisings, which relied on the willingness of neighbors from all backgrounds to share labor and expertise. The resulting structures, several of which we included, are marvelously diverse. At the time we had never seen anything like the Tittman Barn. In fact, we had never seen anything like it until the fortunate day we discovered it.

Disturbingly, had we not stumbled upon it, the Tittman Barn would almost certainly have been destroyed without any record of its existence. With its removal a remarkable link between cultures and an extraordinary masterwork by a formidable framer would have been lost before it was rediscovered.

Today, though recognized and recorded, the Tittman Barn still may not survive unless some financially viable, adaptive reuse is established. Although the land has been secured as part of a state-sponsored Green Acres program, the barn is no longer practical for modern farming. The local historical society, wishing to restore the house, has scant resources for its restoration, let alone for the overdue repair to the associated farm structures. Because the Tittman Barn is located in a remote, rural corner of a state otherwise awash in sprawl, commercial conversion of the structure is problematic, particularly given the strictures on public land. And removal for restoration elsewhere precludes its permanent inclusion in the context of the farmstead. In the end, examination of these issues in an attempt to save structures like the Tittman Barn is the impetus for this new offering.

Somehow the barn is all that they have left us.

What else is lingering on the land to press

its bristling, fading harvests in our arms? . . .

Without the barn there would be little cause

to call this piece of land more than a piece of land . . .

PETER DAVISON

Introduction

IN THE VERNACULAR VOCABULARY OF AMERICA the barn stands proud, a hulking icon in the agricultural landscape. Unlike a house, the barn is chaste. For this is a place for work – a space rubbed by livestock, worn by labor, redolent with the pungent odors of hay, oil, harness, flesh, sweat, and dung. The broadside of the barn acts as a bulkhead against wind and driven snow; the roof is broad and at times resounds with the cacophony of rain deflected from the sheltered harvest. At the cusp of a new century, it is hard to fathom how vulnerable the barn has become to the changing circumstances that have eclipsed the agrarian world for which it is emblematic.

The family farm, stubborn testament to cooperative, individual labors, is disappearing across much of North America. Chief among the factors precipitating its decline is the value of the land itself, not for farming, but as acreage to be eviscerated by commercial and domestic development. With indifference, land speculators allow barns to decline before developers summarily destroy them. In times past, proximity to the city made milk and produce profitable for farmers. Today, that same

accessibility, heightened by the pervasive highway system, has replaced farms and their individual, local features with indistinguishable suburban subdivisions.

Even where the smaller farm persists, the practice of modern agriculture has made too many barns impractical. Dairying, which once defined the daily rhythm of farm labor, is today consigned to giant operations whose output is disseminated by refrigerated trucks across hundreds of miles. Thousands of "milking parlors"– where welcoming lights once beckoned at dusk and dawn – are now dark, stanchions rusting, whitewash flaking to the concrete floor.

Competitively marketable crops have changed as well. With herds culled and husbandry in decline, hay is no longer the signature harvest of the family farm. Soybeans and other more profitable crops are hauled directly from fields to elevators. Specialty crops and perishables like berries find little use in barns, except as protection for tools, trucks, and equipment. Too often now, the haymow, festooned in cobwebs, is vacant; the threshing floor, central work site of agricultural industry, lies dormant.

Where cultivation of hay remains profitable, other factors hinder the traditional function of the barn. Farm labor is no longer cheap. In place of farmhands, the thrifty farmer has harnessed the dumb, dogged capabilities of the forklift and front-end loader to stack huge bales in tarp-covered outside bunkers or clear-spanned pole buildings. The very intricacy of timber frames, which lend the old barns their intrinsic character, are now impediments to efficiency.

And so the splendid spaces of these often monumental structures lie mostly empty. Inevitably, the broad-shouldered roofs, which once sheltered the farm's agricultural treasure, surrender to insistent weather damage, and reroofing is more expensive than tight budgets can justify. Then, too soon, a broken gable window is left alone, a breached foundation allowed to give way. The myriad tasks of daily maintenance go untended, perhaps out of guilty acquiescence to the fact that the barn, once-hallowed symbol of farm bounty, has been humbled by disuse.

Few will argue that the great age of barns is behind us, at least as the center of hard-muscled agricultural activity. But for those given to innovation, the opportunities to reinvigorate the tough old structures are manifold. These mighty monuments to our agrarian past may no longer be well-suited for their original purpose, but through thoughtful adaptation, they can again be vital.

¶

Long before the crisis that now threatens their survival, barns were invested with vigor by assigning them new roles. Often this occurred while the fields — whose harvests they were built to protect — were still being farmed. Beginning in the mid-nineteenth century, enterprising promoters realized the potential of appropriating the broad, blank walls of roadside barns for advertising. Posters promoting everything from carnivals to revival meetings were slapped on, layer upon layer. Before long the custom was extended by commercial enterprises that would contract with a farmer to paint his barn, free, in exchange for embellishing gables or broadsides with their slogans.

I heard the barn . . . heave a sigh

 anticipating usufruct: or else decline,

decay, a sagging and senility;

 or, worse, more merciless, a careless match

to send it up in flames

 Nobody knows how much to make of barns

that do not shelter anything we value.

PETER DAVISON

Farmers themselves often employed their barns for retail sale of milk and seasonal produce. In time this custom gave rise to the farm markets that sustain many farms even after surrounding agricultural acreage has succumbed to subdivision. Garden markets have followed the formula. Growing out of the tradition of country auctions, antiques emporia have co-opted many a moribund barn on the basis of sheer capacity, adequate even for the largest of objects. Bookstores and hardware stores; ski, bike and tackle shops; and taxidermists have similarly adapted these great spaces.

Artists were perhaps the first to recognize the potential in barns for a more personal retreat. Sculptors and writers, bookbinders, cabinetmakers, and even musicians have come to exercise their creative energies in the comfortable and compatible spaces once reserved for hay and livestock. Following in the tradition of the occasional ping pong match or half-court basketball game, many barns have also become spaces for personal recreation and fitness. Some even house swimming pools. And, naturally, ever since the first thunderstorm interrupted a summer picnic, barns have been called upon to absorb and enliven parties.

The open spaces and honest framing that characterize barns likewise lend themselves to easy transformation for larger enterprises. It is hardly surprising that the traditional venue for the barn dance or corn-shucking bee would naturally lead to the role of reception hall or restaurant. Galleries, libraries, and concert halls have broadened the theme. Judy Garland and Mickey Rooney were not the first or last to see the dramatic possibilities of the barn as playhouse. And just as many early congregations made use of barns as temporary chapels and schools before permanent sanctuaries were secured. Today several large barns have been enlisted to fulfill the spiritual needs of new flocks, as churches, temples, and meetinghouses.

Still, by far the most widespread and accommodating conversion of former barns is for domestic application. Early in the twentieth century, as farming foundered in remote areas, many hardscrabble properties were purchased to become vacation retreats. Not only were the houses rehabilitated; so too were many of the barns, whose modest dimensions and open plan lend themselves to the relaxed conventions of the home away from home. No matter that these seasonal hideaways were uninsulated; a centrally positioned potbellied stove was enough to take the chill off the frosty mornings before it was time to pack up and close the place down until the following summer.

Following the Second World War, as the pattern of domestic life relaxed, the contemporary openness and easy circulation of the barnhouse found favor for transformation into year-round residences, as well. Throughout Europe and North America, as barns were left behind due to the decline of agriculture, many were purchased and converted in situ. Many more, however, were destroyed before the notion was put forth that threatened structures might be documented, disassembled, and removed for eventual reerection elsewhere. This possibility was coincidental with a reawakening of appreciation for timber-frame construction. A growing number of professional framers not only recognized the superlative features inherent in early barns; they possessed the skills to save them when original sites were jeopardized. In the years since, hundreds have been renovated and reerected in more hospitable surroundings. For many structures this has been the last, best hope for preservation. But it must not be the only solution.

¶

In just the last decade thousands of barns have been lost. We, and the legacy we have been entrusted to maintain, are much the poorer for the rapid recession of the rural landscape they once dominated. As no two early barns are exactly the same, with the disappearance of each model our potential understanding of these structures, and the way of life they represent, is diminished. But we who regret their disappearance are not alone. Individuals, rallying around the preservation of specific structures, have begun to join forces. In place of customary house tours, historical organizations have opted for tours of local barns, some at working farms, some converted, and some abandoned to the double threats of development and deterioration. Surveys have been funded to document notable and endangered structures. States like New York, Vermont, Michigan, and Wisconsin have set up coalitions to save the barns that survive. Some states even offer tax incentives for their maintenance and preservation.

The most effective measures, however, lie in seeking and sharing successful instances of barn preservation through conversion. Diverse examples are shared here, in the hope of demonstrating not just that these are extraordinary structures, but that they are wholly adaptable to any number of compatible new purposes. In sum, these are the stories of individual barns and their survival through very separate circumstances. May this litany serve as preamble to the future success of the growing effort to secure and preserve these grand monuments to innovation and industry. Save the Barn!

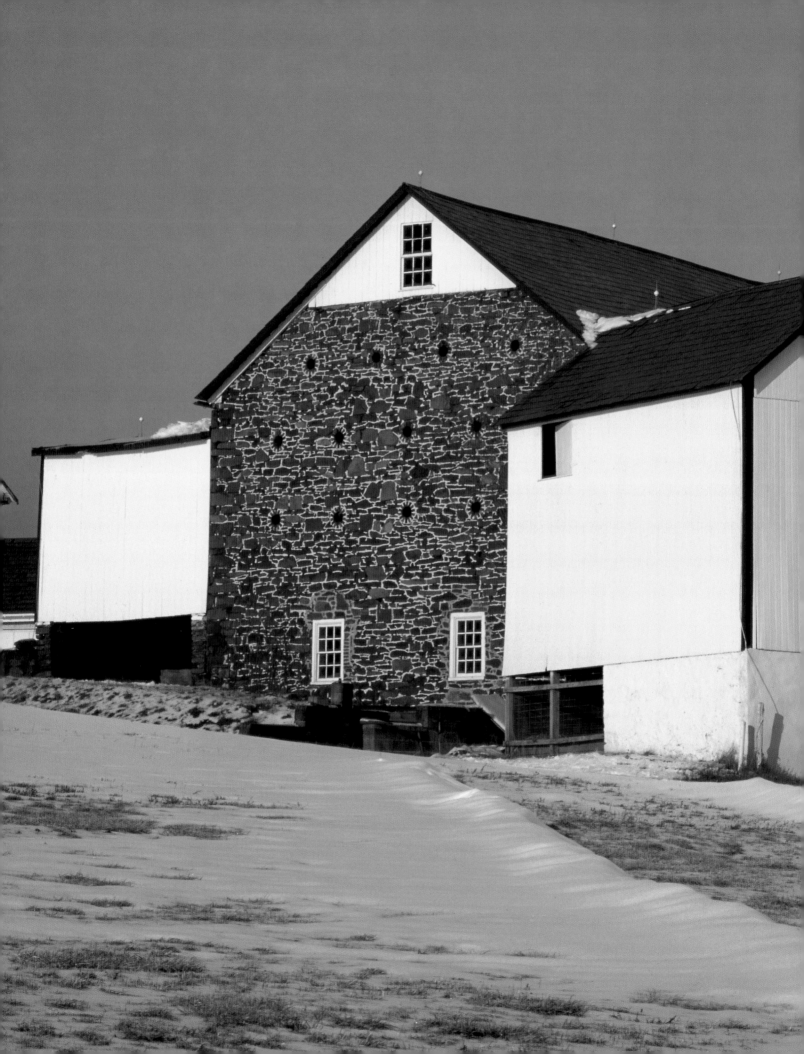

Continuing Life

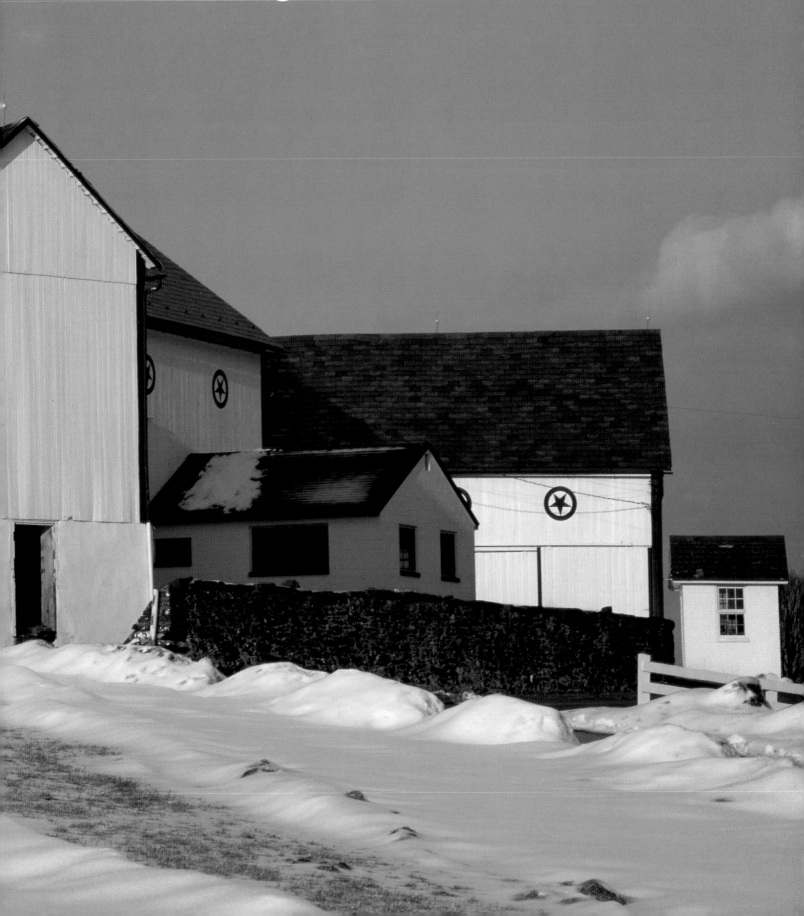

Previous pages: Connected barns in Ferndale, Pennsylvania.

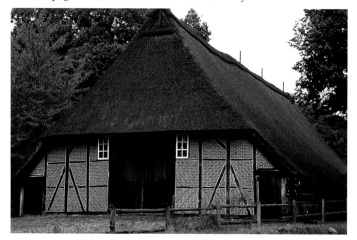

The barn end of a barnhouse in Schleswig-Holstein, Germany.

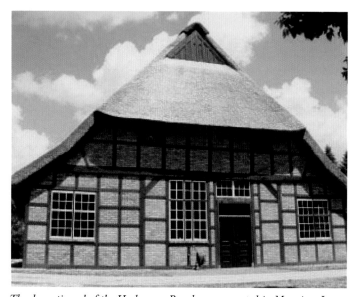

The domestic end of the Hachmann Barnhouse, reerected in Manning, Iowa.

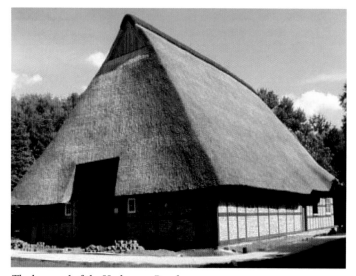

The barn end of the Hachmann Barnhouse.

Constructed as great storehouses for the bounty of the land, barns were built to last long after those who fashioned them. Those that survive have of necessity adapted to changing circumstances. In northern Germany the medieval basilica plan, distinguished by a central nave flanked by side aisles, was employed in laying out barns like those pictured left. Its particular framing details are clearly visible on the exterior due to the use of pargeted masonry infill. This construction is called *fachwerk*.

Typical, too, was the practice of housing the farm family and their livestock under the same roof in what was called the *bauernhaus*. One end of the structure was reserved for domestic requirements; the other was set aside for animals whose stalls flanked a broad, earthen threshing floor. The haymow above also acted as insulation. There was no fireplace or chimney; rather, a central pit cradled an open fire for heat and cooking. Hams and sausages, suspended above, were not alone in displaying the effects of unchanneled smoke. The evidence is clearly visible on blackened interior timbers. Given the proximity of fire and hay, it is remarkable that so many barnhouses survive into our own times; remarkable, too, given the political history of the surrounding area.

Raised circa 1660 near the village of Klein Offenseth Sparriesshoop in the Schleswig-Holstein region of Germany, the Hachmann Barn (left and bottom left) stood on the same spot under the political rule of Prussia, Germany, Austria, Denmark, and again Germany, before suffering damage in a severe windstorm in 1990. Owner Claus Hachmann believed the barn to be beyond restoration before learning of the interest of a German-American community in Manning, Iowa, in acquiring just such a structure for inclusion in a living history museum. With the help of Dr. Carl Johannsen and his students from the Open Air and Field Museum, the barn was documented and prepared for removal. Measuring forty-six by sixty-eight feet, the Hachmann *bauernhaus* was reassembled by skilled German framers and Iowan volunteers during the summer of 1999. At the traditional *Richfest*, or builders' party, carpenters Stephan Prongs and Heinz Voss festooned the gable with a *richkranz*, or builder's wreath. At the opening of the restored structure a year later, Claus Hachmann offered this blessing: "This 340-year-old [*bauernhaus*] now will be a bridge between our homelands. I am very confident that this house will exist longer than our days will be on earth."

The Bourne, Lincolnshire, barn.

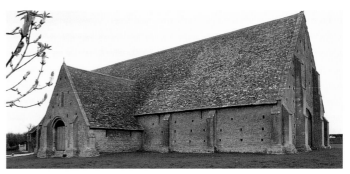

The Great Coxwell, Oxfordshire, barn.

Throughout history barns have seemingly grown out of the natural terrain, drawing on wood, stone, clay, straw, and other close-at-hand components. Building materials are frequently reused as well. Loopholes, or narrow, vertical slits, integral to the design of England's tithe barns (like Great Coxwell), were incorporated into barns for generations. Their purpose was to facilitate ventilation of the mow, thereby drying the crop and precluding spontaneous combustion of green hay. The highly embellished cruciform loopholes at a Bourne, Lincolnshire, barn predate that structure by centuries. They were requisitioned from the ruins of nearby Bourne Castle, where they earlier served as defensive apertures for firing arrows.

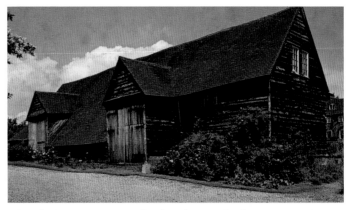

The Old Jordans Barn in Buckinghamshire, England.

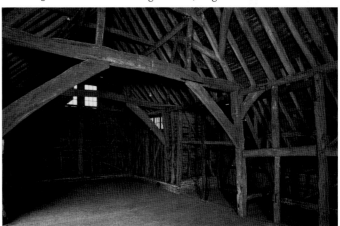

The interior of the Old Jordans Barn.

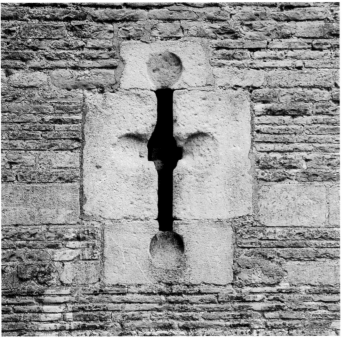

An arrow slit in the Bourne Barn.

By the end of the sixteenth century, long straight beams became increasingly scarce for framing. In Holland, where farmland was reclaimed from the sea, trees were floated in from Scandinavia. It is asserted that in England, following the assault of the Spanish Armada, any timbers longer than sixteen feet belonged by fiat to the King's navy for use as masts and spars. Ironically, more than a few retired ships were salvaged to produce framing members for barns. One stands in Old Jordans, Buckinghamshire. Dating to about 1624, it includes not only timbers, but intricately carved doors and one beam bearing the letters "R HAR I," possibly part of the words "MAYFLOWER HARWICH."

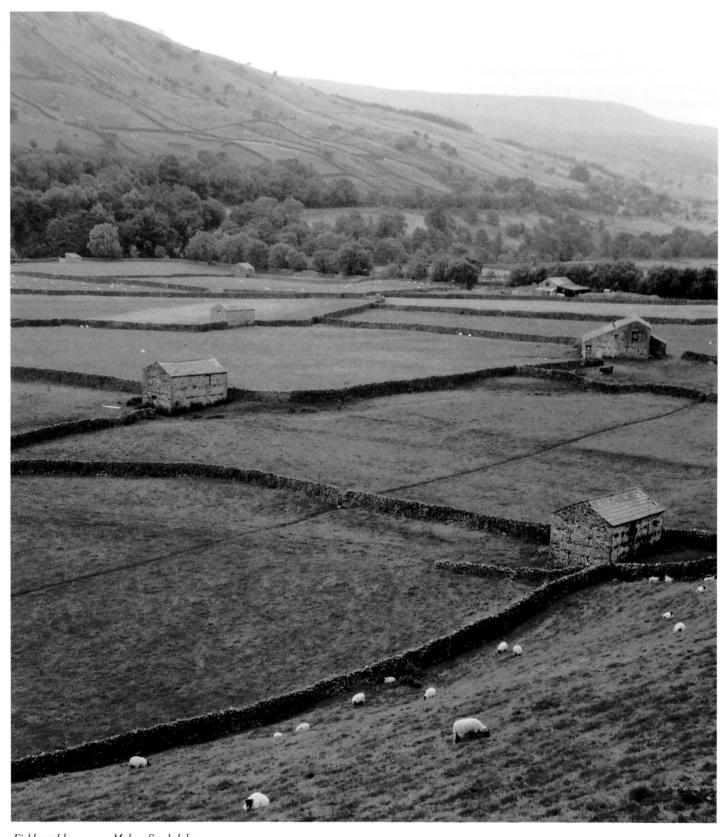

Fields and barns near Muker, Swaledale.

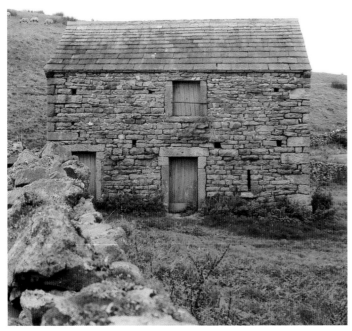

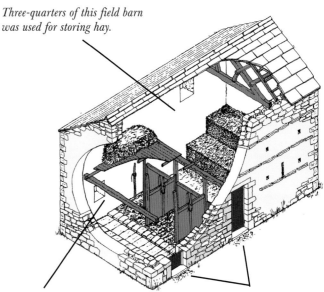

A stone field barn, similiar to the drawing on the right, on the high road above Askrigg, and another (below) with projecting through-stones visible, near Reeth, in Swaledale.

A timber partition divided the haymow from the cattle stalls.

A typical field barn had two doors. One led to the stalls and one to the haymow.

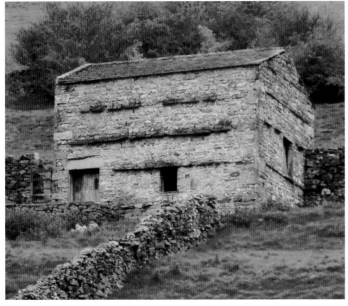

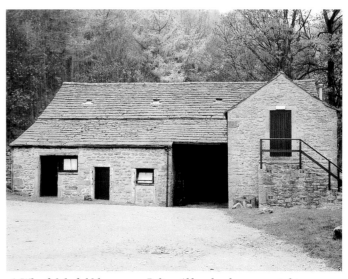

A Wharfedale field barn, near Bolton Abbey, has been converted to accommodate overnight hikers.

Yorkshire's patchwork landscape of pastures fettered by fieldstone walls is punctuated by a disproportionate number of individual stone barns. Known as field barns or field houses, these smallish structures of the Pennines and Lake District took advantage of the generally inclined topography to accommodate livestock in the lower level and harvested hay in the story above. Borne of practicality, these structures were truly outbuildings, far removed from the farmstead. Their function was to protect the hay gathered from just one field, which fed a limited complement of sheep and cows, whose manure, in turn, fed the field.

Centralized agricultural practice has rendered many of these rugged structures redundant. But rather than molder back into the stony earth from which they were drawn, many of these redoubtable shelters have been transformed into camping barns or stone tents for those seeking to experience the same landscape that might otherwise be diminished by their demolition. Hill climbers, walkers, and cyclists who avail themselves of the opportunity are encouraged to participate in weekend work parties engaged in maintenance and repair. One example of such an overnight accommodation (bottom-right) is situated near Bolton Abbey in Yorkshire.

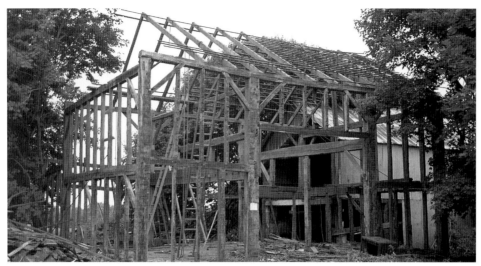

The frame of the Thatcher Barn on its original site.

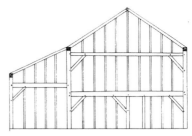

An end elevation showing Bent A.

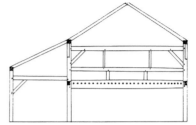

Bent B.

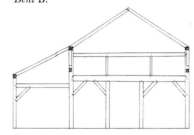

Bent C.

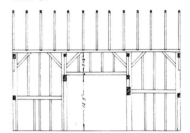

A side elevation.

It was in 1980 that a barn enthusiast, intent on chasing a hot-air balloon across the central New Jersey countryside, found not only the field where the air ship made its final descent, but a forlorn barn beside it, disused and deteriorating. Built in the English form, the Thatcher Barn is a three-bay structure with an early, full-length lean-to. Its modest size – twenty-six by thirty-six feet – would have been sufficient to meet the needs of a typical central Jersey farm in the eighteenth and early-nineteenth centuries. Typical, too, are the generous dimensions of the white oak timbers fashioned from the mighty trees felled to create the farmland.

Sadly, by the closing years of the twentieth century, new factors in the local environment forced many fine barns into redundancy and decline in a reconfig-ured landscape burgeoning with the chaos of commercial and residential devel-opment. Abandoned by its absentee owner, the Thatcher Barn might have suc-cumbed to insidious neglect, but for its disassembly and subsequent relocation to a field in Fireplace on the north shore of Long Island's South Fork. The purchaser made only one provision: that her then-teenaged sons be allowed to participate as part of the crew in its reerection. During August of 1985 that happy circumstance was realized.

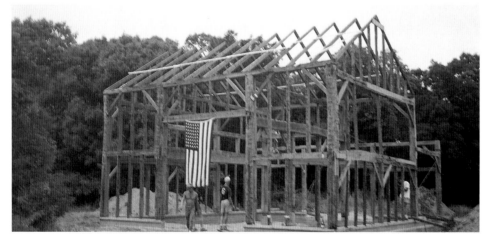

The barn starts to go up at the end of Fireplace Road, and (right) young members of the crew pose in the great doorway.

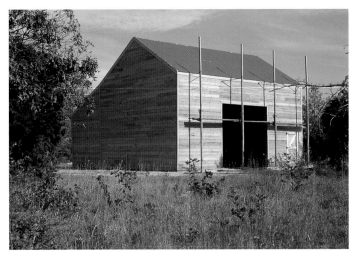
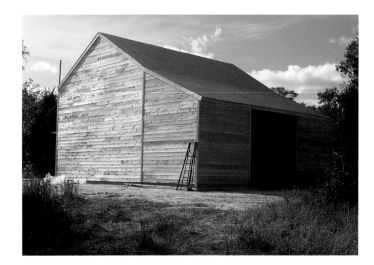

The new clapboarding is applied.

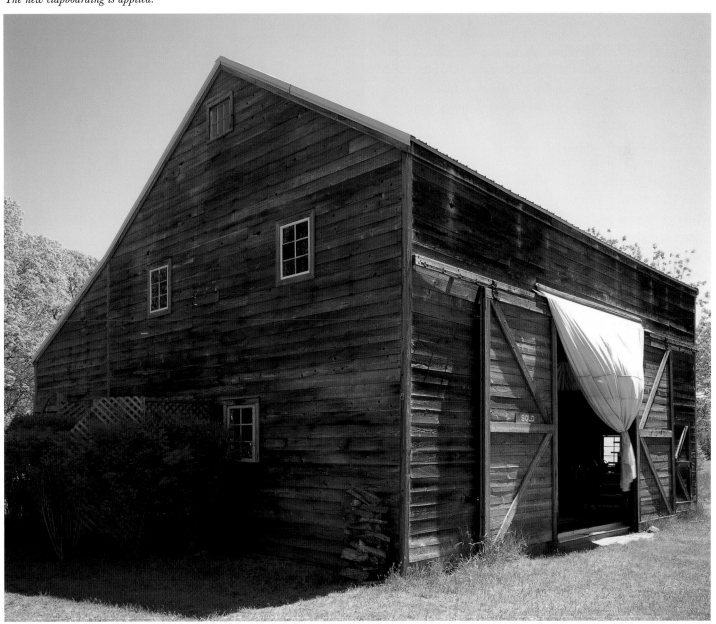

The Ryan Barn, with weathered boarding, fifteen years later.

19

For its second life the Thatcher Barn was sited across a broad stretch of pasture from a seaside cottage, itself a former barn, long ago converted into a seasonal retreat. The distance between the two structures was deliberate, reflecting the customary separation on early farms, but allowed for the eventuality that the property might one day be subdivided. In the short term it was reckoned that the structure might be used to shelter sheep, with the possibility that it might be converted to domestic use.

Following the departure of the professional barn raisers, the owner's sons and their friends laid down lath and a metal roof. Before returning to school, they also nailed up clapboard siding. This investment of time and youthful energies gave its participants a personal stake in the structure they had helped to recreate. The envisioned sheep hadn't a chance of occupying this cherished building. By summer's end the Thatcher Barn had become a clubhouse of sorts, a perennial retreat accumulating haphazard furnishings and colorful stories in equal measure.

As built nearly two centuries ago, the Thatcher Barn's interior was subdivided to serve several distinct functions. The central bay, accessed by broad wagon doors at both ends, was reserved for threshing and winnowing, whereby channeled breezes separated wheat from chaff. Farm animals were cloistered in one aisle beside the threshing floor, while the space above was set aside for the fragrant haymow. For its new role the barn's spaces have come to be similarly segregated, albeit less by design than from day-to-day exigency.

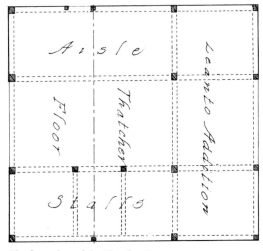

The floor plan of the Thatcher Barn.

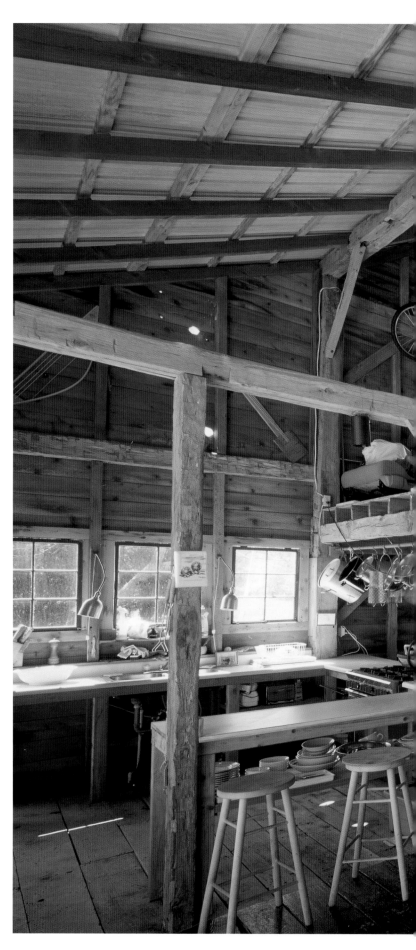

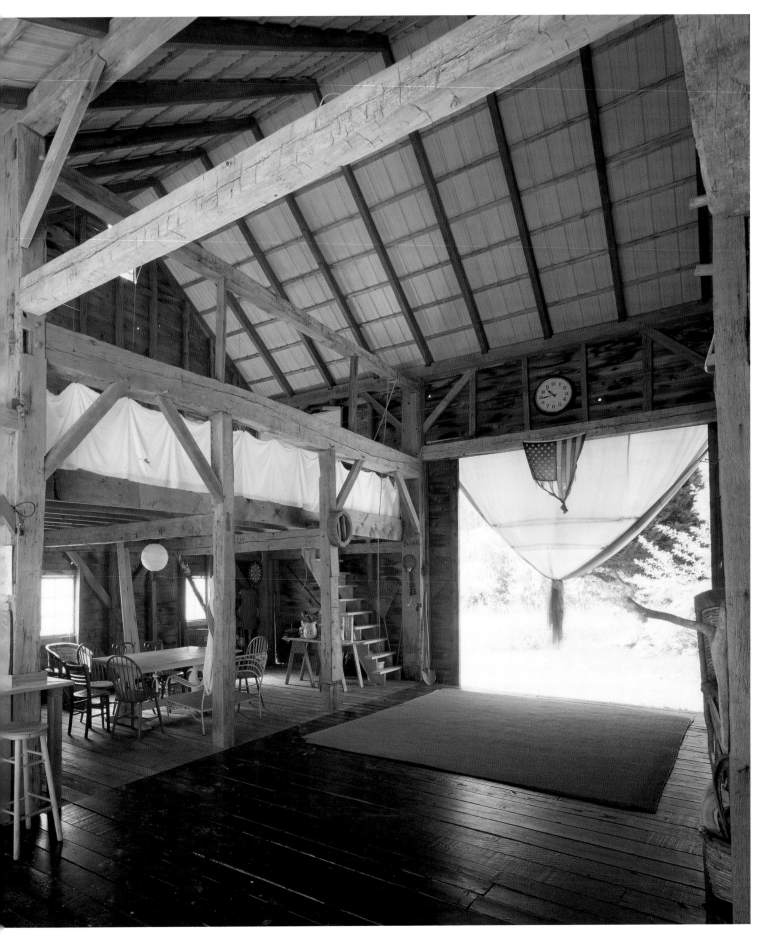

One corner of the lean-to has become the sunny, seasonal kitchen. Where stalls once sequestered livestock, stairs now lead to a comfortable sleeping loft, a measure of unpretentious privacy provided by draped canvas. The central bay still benefits from channeled breezes, not for farm labor but for refreshment during the lazy days of summer.

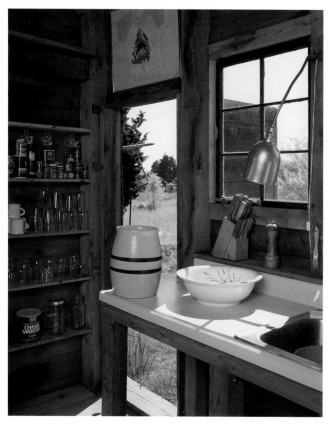

Part of the barn's appeal is the play of great uninterrupted space experienced in the central bay against the comfortable constraint offered by the areas under the lofts of the flanking aisles. As welcoming as a breath of a funneled breeze might be on the threshing floor in summer, in the pre-dawn chill of a winter morning the close proximity of fellow creatures in their stalls brings its own solace. The shared intimacies of friends gathered around a table in the same converted space are no less convivial. Girts from which tack once hung now offer a convenient armature for hanging pots and pans. And just as a farmer might make do with what is close at hand, irrespective of convention, the six light sashes are turned on end for kitchen windows for no better reason than that they *fit* that way.

22

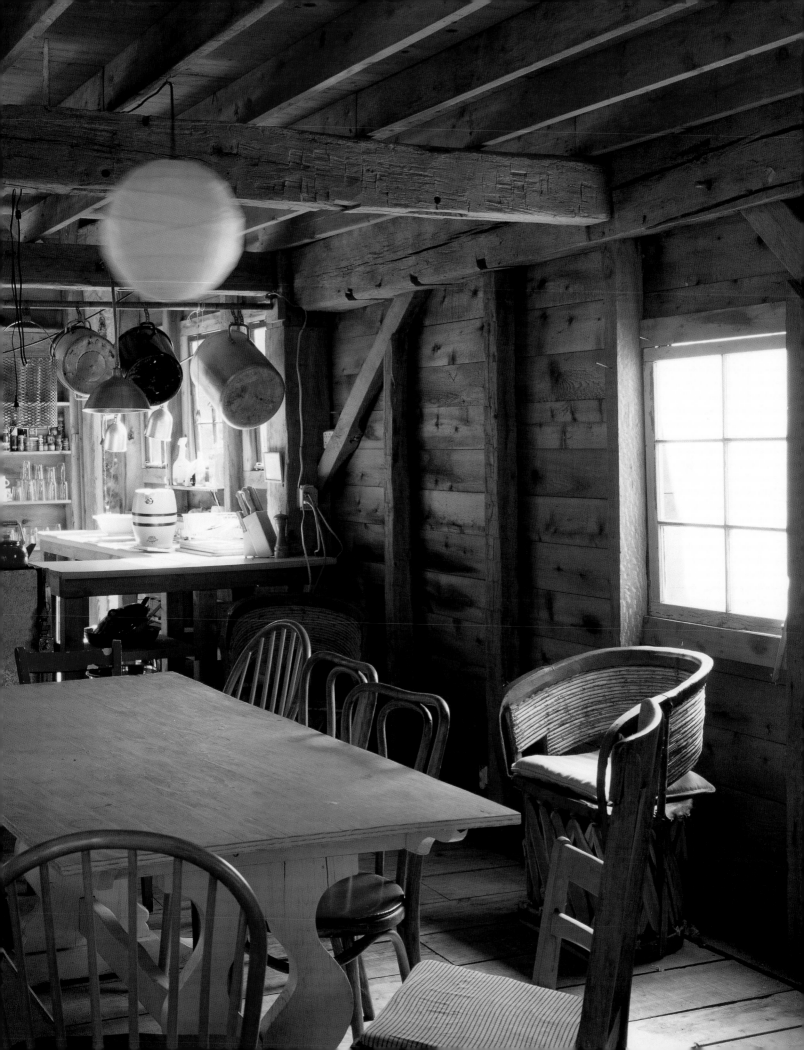

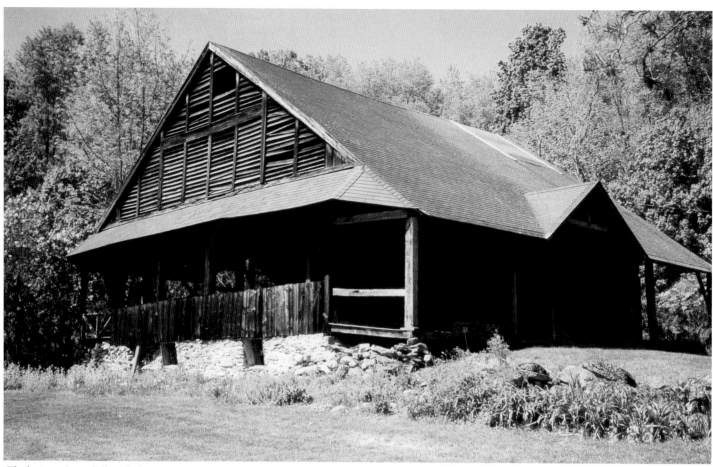

The barn at Springhill with the sagging porch on the north side.

The history of the recently resurrected barn at Springhill near Berlin, New York, is testament to the resilience of old buildings as they adapt to changing conditions. The property on which it stands was first settled in 1753 by Peter Simmons, farm master of the Rensselaerwick Patroonship. (Among his duties was the collection of farmers' rents, which amounted to fifteen bushels of grain annually.) The proportions of the Springhill Barn are impressive, with tie beams stretching a full thirty-six feet. It has been speculated that this oversized barn might have been used to store the bounty excised by the patroonship, in the same vein as the great medieval tithe barns. The general appearance of the frame would seem to preclude an eighteenth-century ascription, but because many of its earlier features have been amended or replaced, it is possible that at least part of the barn dates from that time.

Among its more interesting features are the selection of beech and maple for the major timbers and the wedged, half-dovetailed joints by which they are secured. In the early nineteenth century, under the ownership of the Dennison family, extensive changes were effected.

Replacement of the foundation and sill plates at that time may have necessitated full disassembly. The inclusion of sawn braces and other timbers with dissimilar dimensions and tool marks would seem to indicate that the frame was reworked during the process. In any event, the original rafters were not only replaced with hemlock, but the spacing between them was reduced from forty-eight to thirty-four inches on center. Still later, under the stewardship of the Streeter family, the building was modified once again for use as a sheep barn, sheltering the first flock of Suffolk sheep in America.

The evolution of farming practice in the eighteenth and nineteenth centuries was reflected in attendant alterations to the Springhill Barn. In time the romantic yearnings of urbanites with increasing leisure time became an unlikely factor in gaining the structure renewed vitality even as agriculture declined in the region. The most extensive renovations to the barn at Springhill were made in the early years of the twentieth century, when it was converted for use as a lodge.

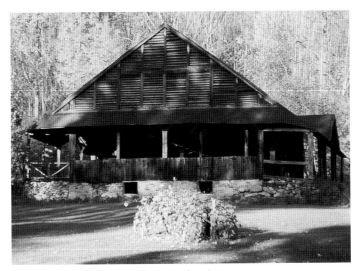

The east side and the crumbling stone foundation.

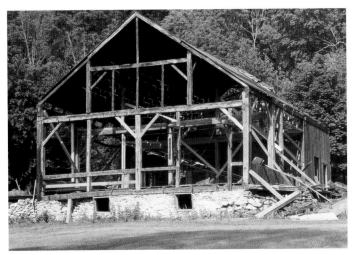

The frame is exposed.

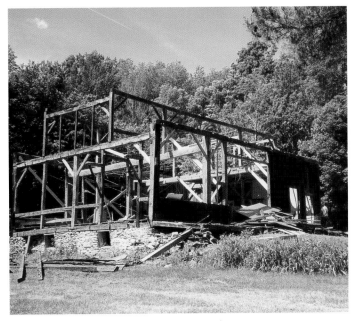

The roof removed, the nearest bent is found to be rotten and will collapse during dismantling.

Porches were added to the north and south sides of the barn and two apartments with baths were carved out of the western third of the interior. Unfortunately, this was facilitated through the removal of a number of structural timbers. Other beams were cut away simply to "open up the look" of the building. In the 1920s a western red fir floor was installed in the open end of the barn in order to accommodate dancing, but thereafter the farm was largely left dormant, and conditions declined through inattention to maintenance and repair.

The younger members of family who assumed its stewardship in 1957 made abundant use of the "Pavilion," as the old barn had come to be called, hosting family Fourth of July pageants, dances, tag sales, yoga classes, and innumerable basketball games. Some repairs were made including the replacement of the roof, but failing foundations and sill plates, and the earlier removal of integral structural members, so weakened the frame that by the turn of the new century the venerable building was in disrepair. In 2001 the barn was dismantled once

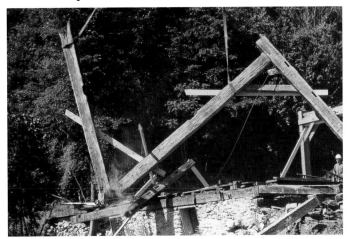

again. One bent was so rotted that it collapsed during disassembly. In all, two of the principal bents and the rafter plate to the south were too far gone to save except as templates for their replacements, which were fashioned of eastern white pine and hard maple. Other timbers, removed and discarded during earlier renovations, were similarly replicated. The failing foundation was relaid, using the same stones, to support new sill plates and floor joists. Once repairs were complete the framing sections were repegged and re-erected. Of the four original bents two remain, including massive ten-by-twelve-inch, thirty-six-foot-long tie beams, hewed long ago from timbers felled from surrounding virgin forest.

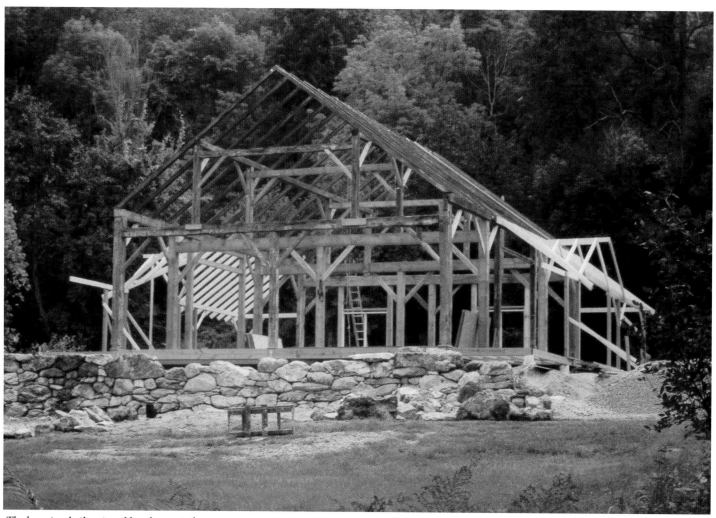

The barn is rebuilt using old and new timbers.

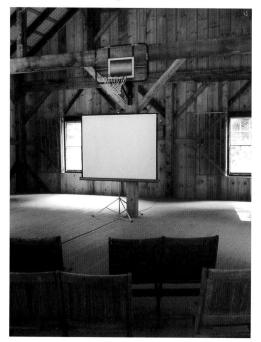

The open floor of the repaired barn is ready for a local historical society lecture.

The original windows from the western end are reinstalled.

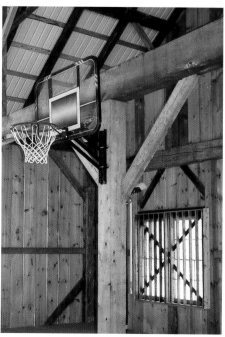

The insides of the windows are protected from basketballs by a grille made of boards from the old dance floor.

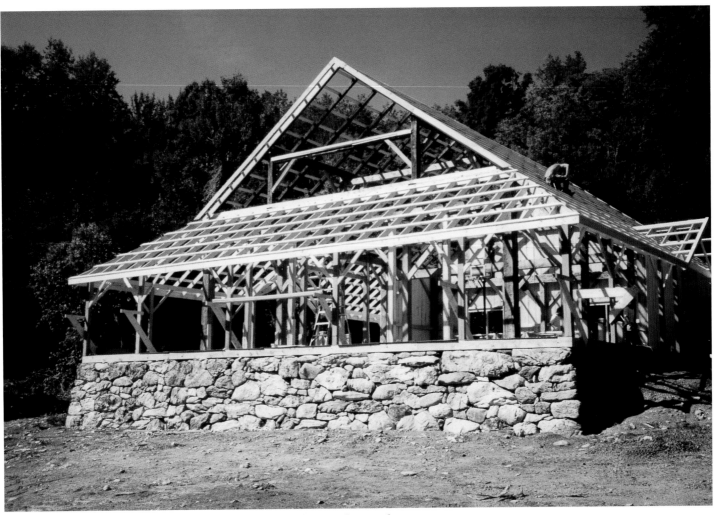

The recreated porches go up, and the foundation is repaired with the original material.

Sometimes when a timber-framed structure has so far deteriorated that it requires replacement of major features like the foundation, roof, or siding and the replication of significant timbers, the option of complete disassembly, though daunting, may better serve the interests of enlightened preservation more than piece-meal remedies. Each structure must be individually evaluated before a course of action is undertaken. Restoration of a structure that has served a plethora of purposes and has borne the consequent alterations, begins with determining which of the many previous guises to emulate. In the case of the Springhill Barn it was decided that it would follow the precedent of the best-known and most recent chapter in its long history — as the multi-use Pavilion. Accordingly, the north and south porches were recreated. Early glass salvaged from the lodge windows was reused, as was the western red fir flooring, as material for a low partition wall. Canny recycling of existing materials for new purposes follows the time-honored dictum, "Think like a farmer."

A view of the porch area with more old dance floor boards used in the partition wall.

27

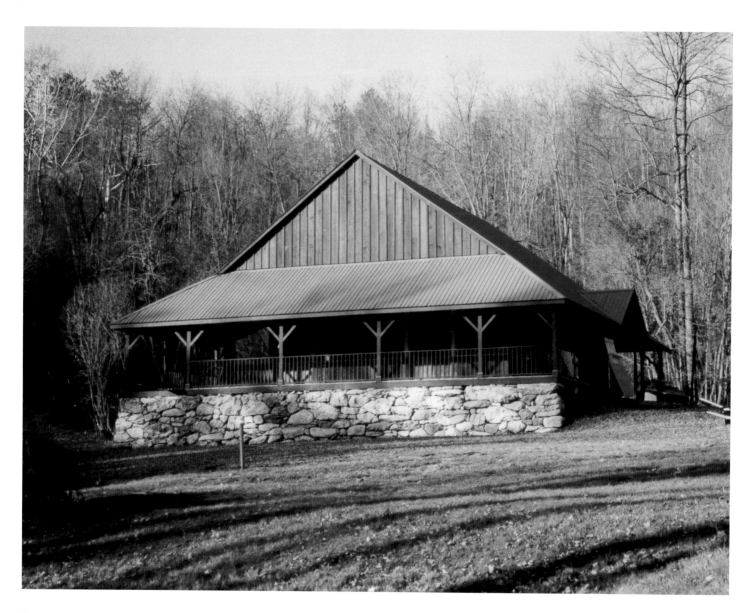

Realizing that by its rehabilitation the old barn was already at the threshold of another evolution, a significant new feature was added in the form of a new porch along the east side, taking advantage of the view across a wide lawn. Structurally sound again, the Springhill Barn awaits further amendments, which the future will surely impose.

Right: The barn at Tusculum, in Princeton, New Jersey.

28

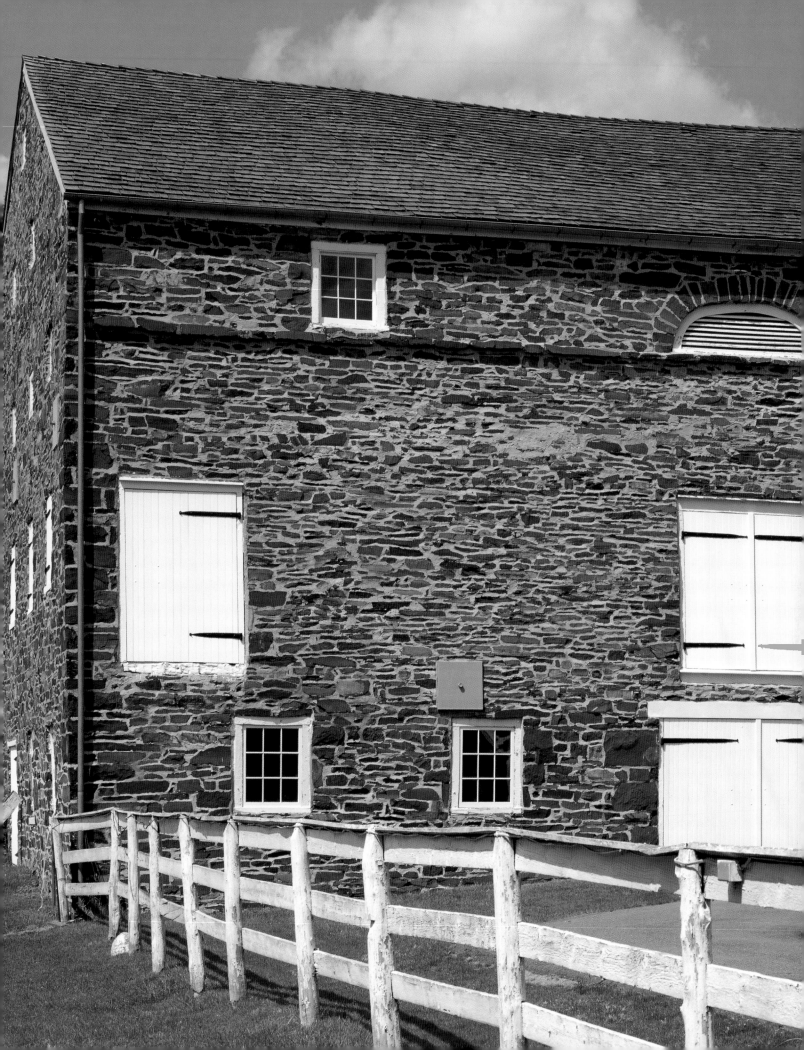

In 1773, John Witherspoon, Scottish-born president of the College of New Jersey, built a "neat and elegantly finished" country retreat close to the Princeton campus. Named "Tusculum" after Cicero's villa, the house was laid up with a quarried stone facade and outfitted with the best elements of the high Georgian style. Nonetheless, for several years Witherspoon chose to rent the house though not the land, stipulating that ". . . the Proprietor being fond of agriculture and engag'd in a scheme of improvement, will not let any of the land for tillage. . . ." Like many of his peers, Witherspoon, the peripatetic preacher, scholar, and signer of the Declaration of Independence, took an active interest in "scientific gardening," by which he meant the cultivation of crops and vegetables, not flowers. In answer to a query at the time, he is quoted as saying, "No Madam, no flowers in my garden, nor in my discourses either." The success of his endeavors may be judged by a notice, posted soon after his death in 1794:

> *For Sale. Beautiful farm called Tusculum, situated one mile from the city of Princeton, containing 283 acres of land, of which 30 are in woods, a kitchen garden enclosed by a dry laid wall, orchards, meadows, workable land and pastures . . . Dairy, barn, stables, house for grain, – five horses for working and carriage,; 2 beef cattle, 4 milk cows, 3 calves, 3 heifers, 26 sheep or ewes, 14 pigs, etc. . . . The harvest yields substantial income from 14 or 15 acres of rye, 16 or 17 acres of oats, 20 acres of corn, 10 or 11 acres of buckwheat, one acre of flax, 1acre of potatoes, 30 to 40 tons of hay. . .*

None of the structures described in the bill of sale survive. In keeping with other farms of the day, the "house for grain" probably took the form of a timber structure with corncribs flanking a central wagon bay and individual grain bins in a granary located in the garret above. Despite the mention of a separate dairy and stables, it is more than likely that the plowing team and other livestock were sheltered within the barn in stalls to one or both sides of a central threshing floor, under the haymow.

As the farm continued to prosper, the original barn and outbuildings may have proved inadequate. Rather than expand them, it appears that several original structures, including the barn, were entirely replaced. It is almost certain that the new barn is the one described in an 1837 advertisement:

> *It contains about two hundred and fourteen acres of land, fifty of which are Woodland, and the residue Arable land, in a high state of cultivation. There are on the place . . . a large and Commodious Barn, Wagon-house, Corn cribs, and Milk-house, with other outbuildings.*

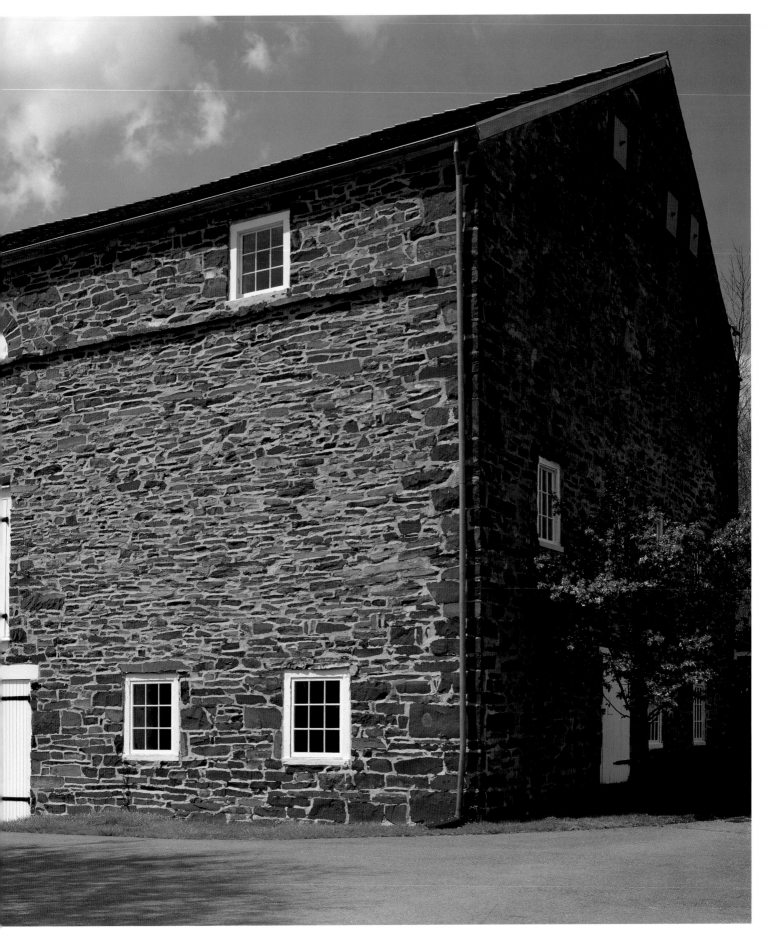

The barn at Tusculum is nothing short of extraordinary. Measuring forty-five by fifty-seven feet it was exceptionally large for its day. But it is in the originality of its design that the barn achieves greatness. Following in Witherspoon's tradition of "scientific gardening," the most enlightened innovations in barn design are synthesized into a striking and sophisticated scheme. This plan draws on the most appealing aspects of English, Dutch, and German models. Its monumental walls are laid up in stone, a construction material common enough in Delaware Valley barns, but relatively rare in Princeton. It assumes the bank barn pattern by which functions are segregated, with threshing and hay storage occupying the main and upper levels, while livestock were consigned to the cellar on the downhill side. Variations of this arrangement were introduced by both the English and the Swiss-Germans, whose structures dominate the nearby Pennsylvania landscape.

Above: The south side of the barn. Below: The north side.

Banked barns are generally distinguished by a projecting *forebay* or *overshoot.* While absent today, a single-story, timber-frame forebay once stretched across the entire south facade of the Tusculum Barn, supported by projecting floor joists at the threshing-floor level. On the north side, the doors to the threshing floor are reached by means of a gentle ramp, but in this case that feature spreads across the entire upland wall, accessing not just the wagon doors, but smaller doors at each corner. Windows, which today perforate all four faces of the barn, almost certainly replace louvers, which allowed for ventilation. Still, while the exterior may be singular, it is but a preamble to what lies beyond the huge *Dutch doors.*

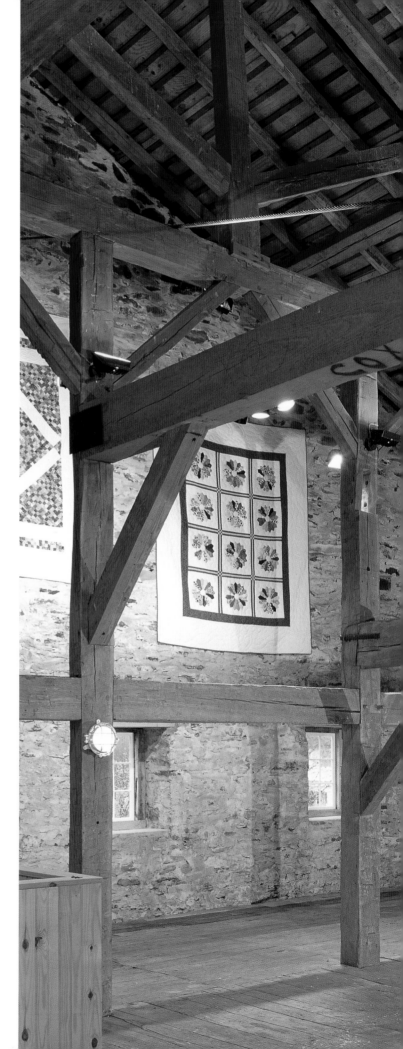

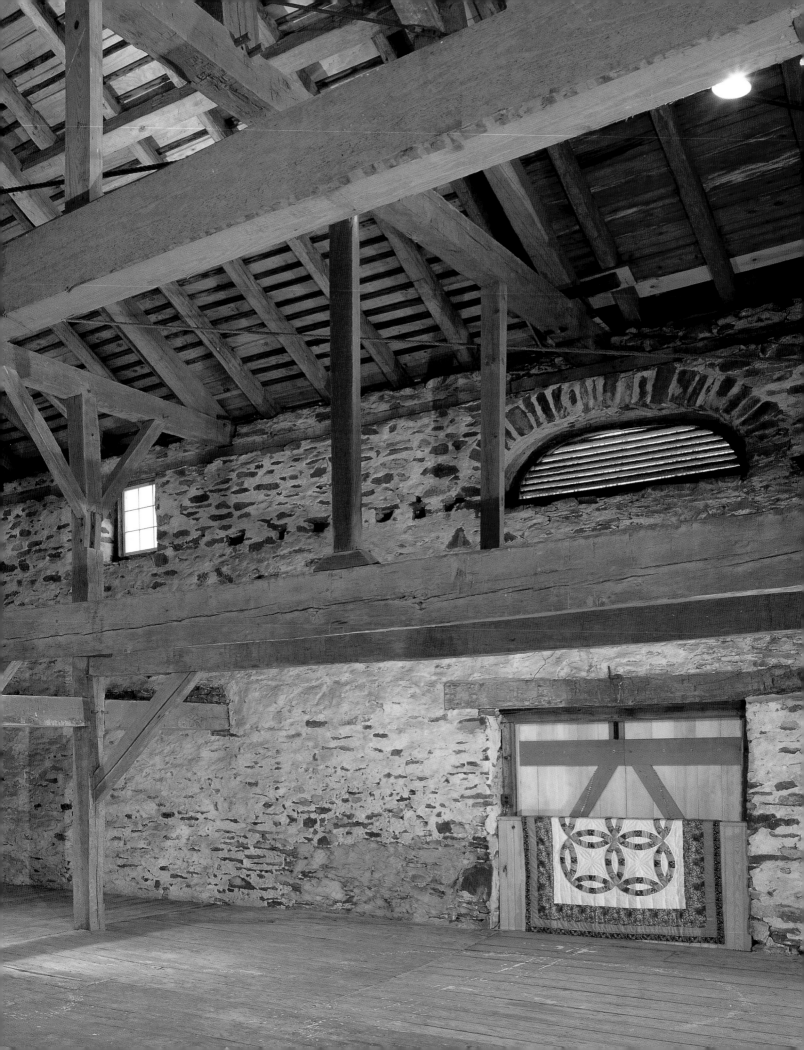

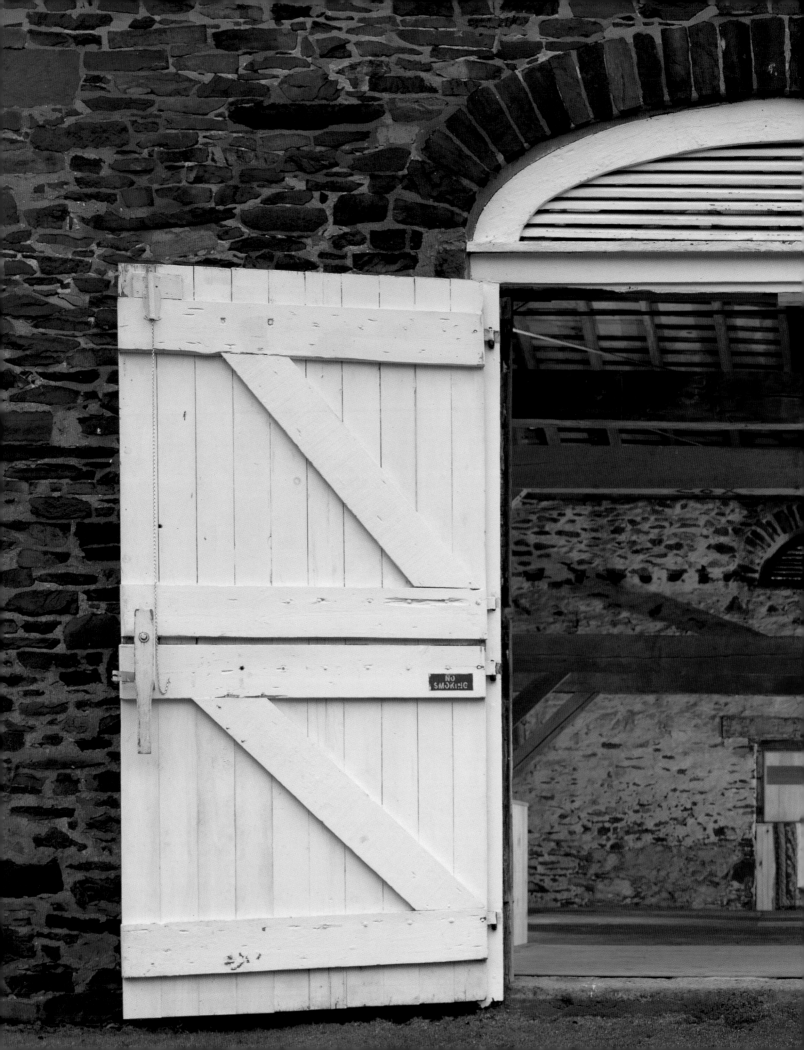

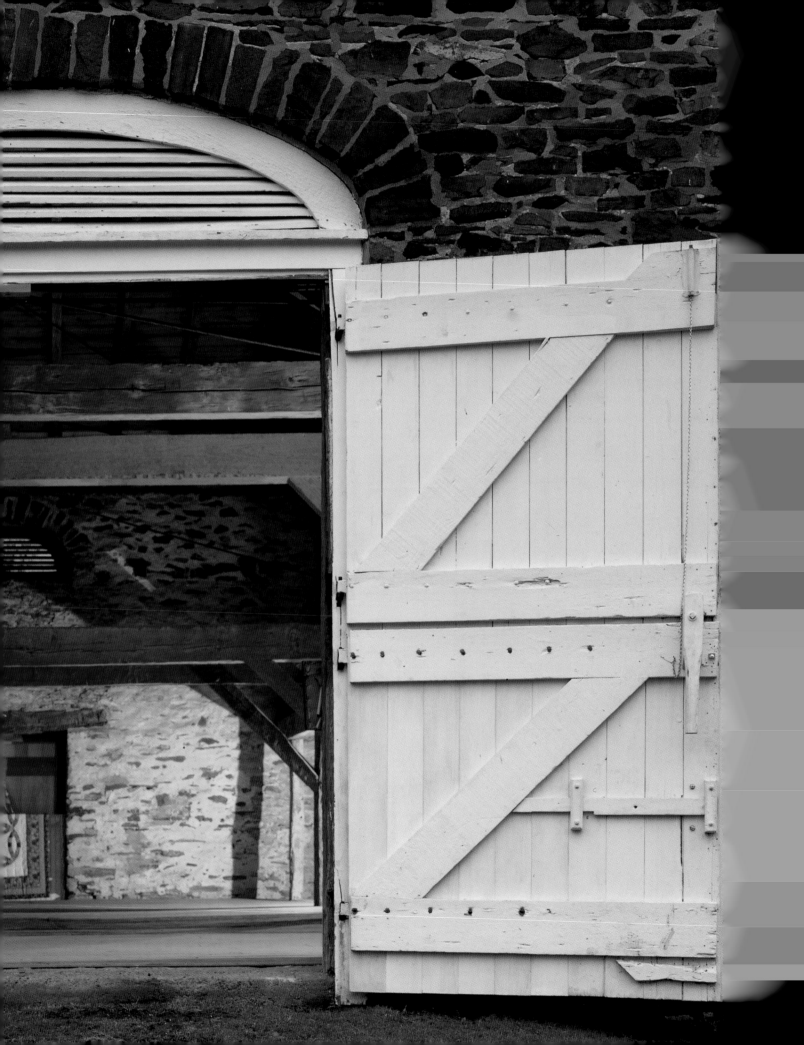

Given the Swiss-German character of the exterior, it might be expected that the barn at Tusculum would follow the precepts of that style within. The builder, obviously versed in alternative forms offered by various cultural framing systems, instead chose to construct the barn in the Dutch-English hybrid form developed in New Jersey at the end of the eighteenth century. While the roof follows English custom, the frame consists of a series of four H-shaped *anchorbents*, the hallmark of the New World Dutch barn. All four were originally positioned at about twelve feet off the floor, but subsequently the two *anchorbeams* furthest from the wagon doors were "dropped" about four feet, perhaps in order to increase the capacity of the mow. The configuration of the bents is particularly noteworthy because they are positioned less than eight feet apart, and the threshing bay is off-center, creating asymmetrical side aisles. More surprising still is the apparent use of the wider aisle for stalls. In bank barns it is almost unknown to have animals situated on two levels.

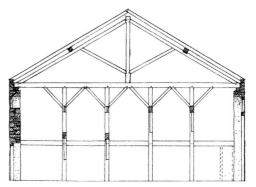

A section of the barn showing the purlins and a king post truss.

As expected in a structure so large, the barn is provided with a *purlin* system, which provides interim support for the lengthy rafters. What is remarkable is that the purlins themselves are supported not by conventional struts but by three *king post trusses*. One is free-standing over the threshing floor and addresses the structural deficiency inherent in supporting the roof over the broad twenty-six-foot-wide central bay. Struts that rise from the anchorbeams to the bottom truss cord were not included in the original construction, but their introduction has prevented the catastrophic collapse of the roof. The other two trusses, situated over the *arcades*, also transfer the roof weight to the lower frame. Trusses of this type are extremely rare in barns, but they are common in church frames as a device for facilitating unbroken space. Their use in this application suggests the work of a builder-architect acquainted with contemporary carpenter's handbooks and possibly responsible for a broader compass of work beyond barn building. Further evidence of such sophistication is the use of semi-elliptical louvers at opposite ends of the threshing floor — rare grace notes in a grand and unparalleled barn. Curiously, the central roof truss occurs directly above the semi-elliptical stone arch, making this design simultaneously sophisticated and (structurally) naive.

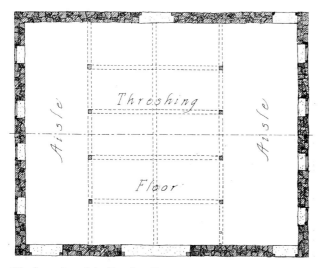

The floor plan of the Tusculum Barn.

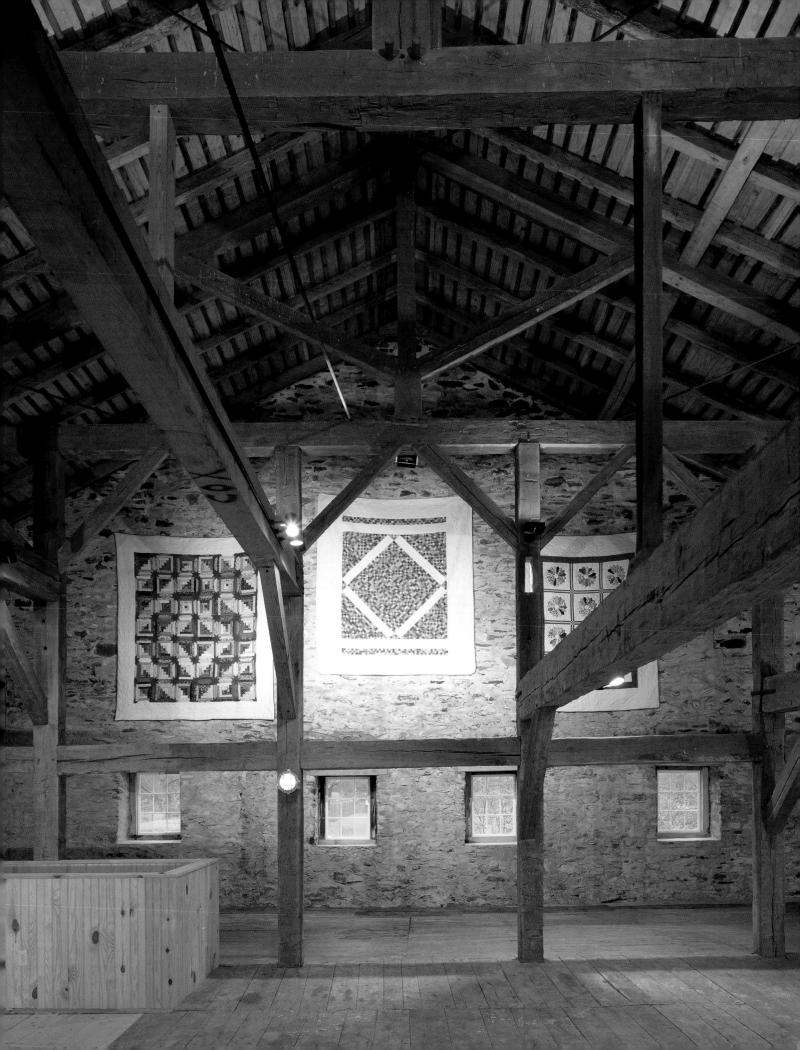

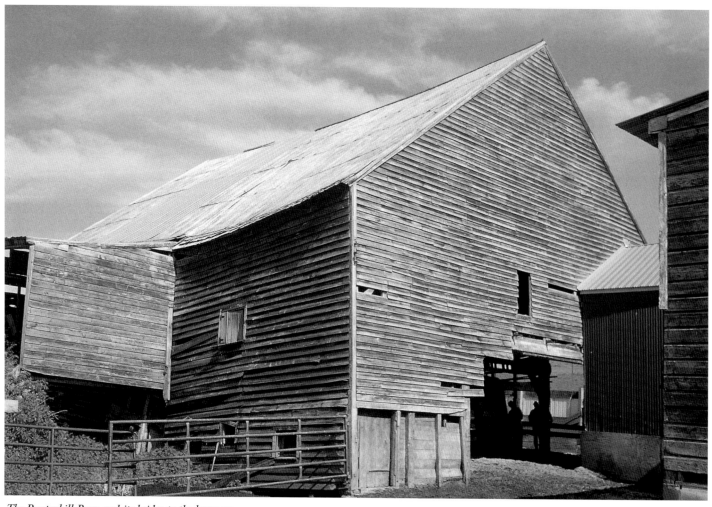

The Poestenkill Barn and its bridge to the haymow.

Two other Dutch barns in Rensselaer County with ramps to their haymows.

Not long after dawn on a hazy June day a barn enthusiast set out to get lost in the countryside near Troy, New York, in search of interesting barns. Near Poestenkill, a swaybacked specimen loomed into view with a lofty profile and exceptional proportions. "May I take some pictures of your barn?" he asked the puzzled farmer. Came the reply, "Why don't you just take the *barn!*" Like so many other early structures, the great Dutch barn on the Wagner Farm was built to serve very different needs from those dictated by modern agriculture. Its inadequacy in meeting those new ends relegated the structure to the role of an expensive relic – a fond but feeble legacy of the farmyard. Boldly incised into one of its giant anchorbeams was "1774," the year of construction. The farm must have been bounteous, indeed, given the extraordinary scale of the barn. At fifty-by-sixty feet its footprint is somewhat larger than typical Dutch barns in the area, but because it stands a full story taller, it once boasted an immense haymow. Over the years, however, acreage was reduced and cropland became pastureland for a large herd of cattle. Allowed free range within the barn, the livestock in time created mountains of manure. The bottoms of several arcade posts had rotted and in turn their tenons had dropped out of the purlins above. Although the roof was intact, the internal structure supporting it was significantly compromised. A heavy snow load might have been sufficient to precipitate partial collapse of a truly monumental structure in the American vernacular.

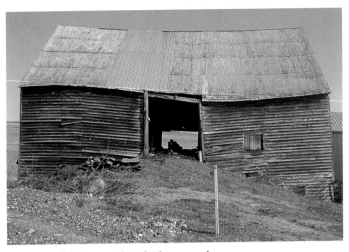

The Poestenkill Barn with its bridge removed.

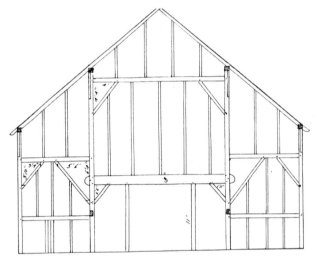

An end elevation of the Poestenkill Barn.

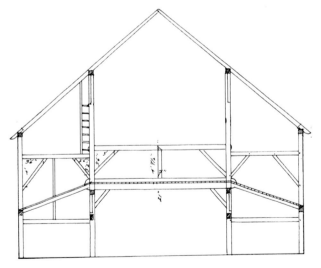

A midsection of the Poestenkill Barn showing the inner ramps up to the haymow.

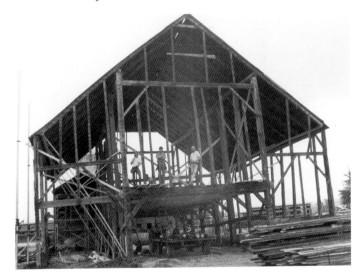

The Poestenkill Barn during dismantling. In the foreground are the exterior boards.

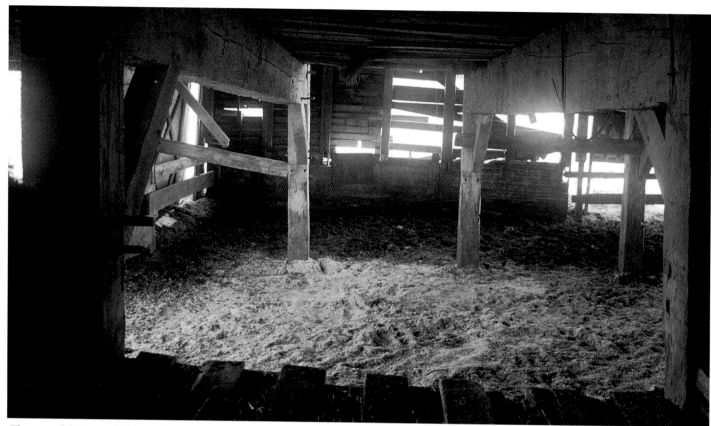

The posts of the Poestenkill Barn slowly collapse into the accumulating mire.

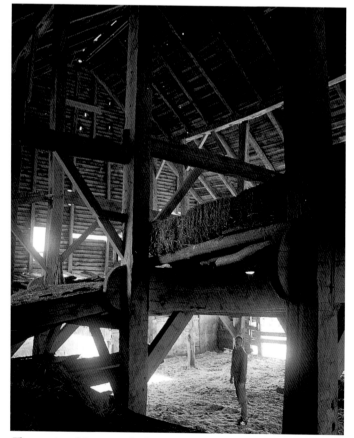

The remains of the wagon bridge can be seen on the left.

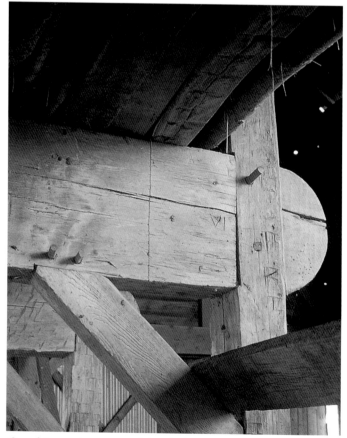

One of the massive tongue-ended anchorbeams. The largest measured tweny-two by nine inches in thickness.

The Poestenkill Barn is framed with outside posts fully twenty feet high, purlins set at thirty feet, and the peak at forty. There are eight anchorbents fashioned of oak and pine, neatly dressed with half-round tongues. Of the four hundred or so surviving New World Dutch barns, the vast majority are composed of four or five bents; no other recorded example has as many as this exceptional specimen. Still, what really distinguishes the barn at Poestenkill from its peers is a bridge that spans the threshing floor at the anchorbeam level in the center bay. This remarkable device was originally approached by means of earthen ramps rising to the center of each side wall, but detached from the frame by the use of bridge-houses with pitched floors. This arrangement provided twelve-foot-high side wagon doors to be positioned above the stalls and immediately below the rafter plates. Inside, framed ramps rose within the side aisles to the level of the anchorbeams, thus creating a bridge across the threshing floor. Unlike the rest of the bays, which are approximately eight feet wide, this central bay is ten, and the two anchorbeams that support it are notched to shoulder sturdy oak floorboards. The ingenuity and extra endeavor required to provide this soaring pass-through were considerable, but the eventual benefits justified the effort. A deficiency inherent in the Dutch barn plan is the burdensome toil of pitching hay from a wagon on the threshing floor up into the mow rising from the anchorbeams all the way to the peak. In the lofty Poestenkill Barn, where the peak occurs almost thirty feet above the anchors, this would have been an especially odious task. By providing a bridge for hay-wagons to be driven above the anchorbents, this work was greatly reduced. At least four other examples of this innovation have been chronicled in smaller barns in Rensselaer and nearby Schoharie counties. There may well have been many more. What is truly surprising is that this device was not more widely disseminated.

A side elevation showing the opening for wagons.

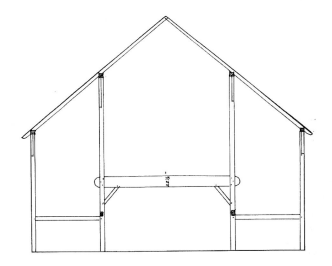

One of the eight bents showing one of the huge anchorbeams.

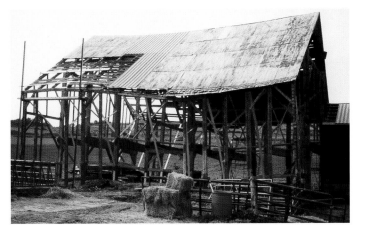

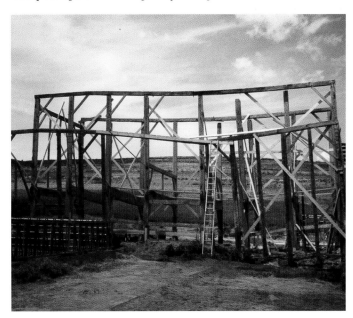

Left and above: The exposed Poestenkill Barn reveals its sorry state prior to its final removal to a new home in Vermont sixty miles away.

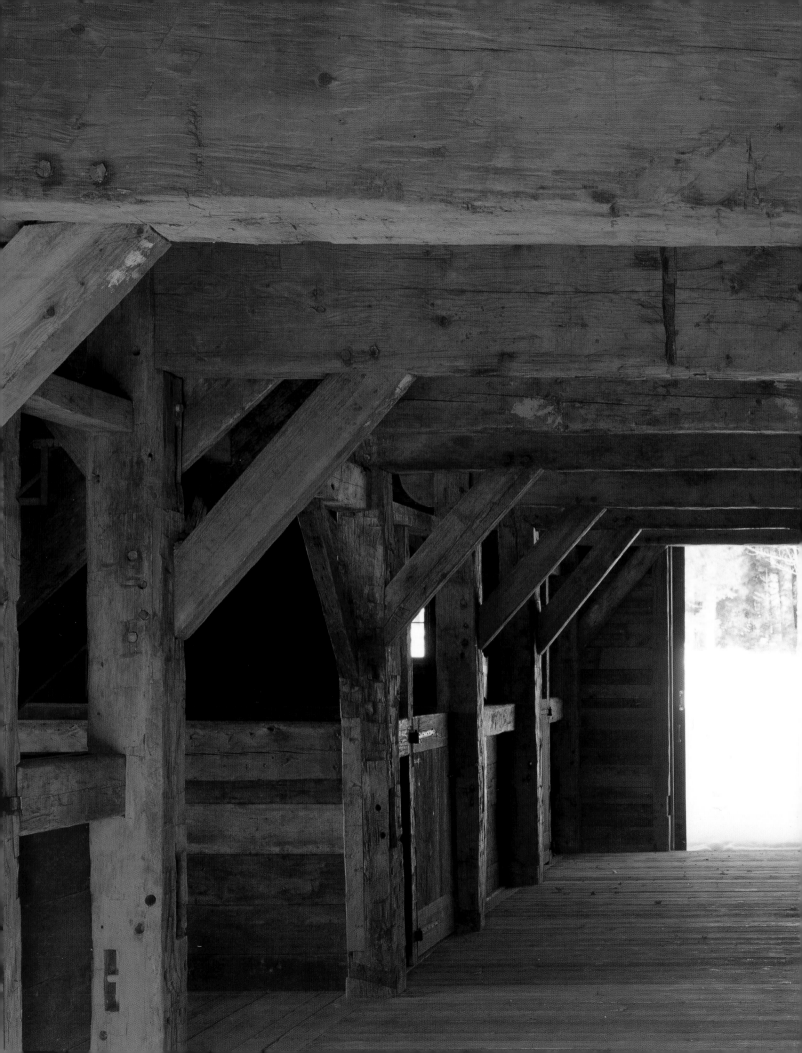

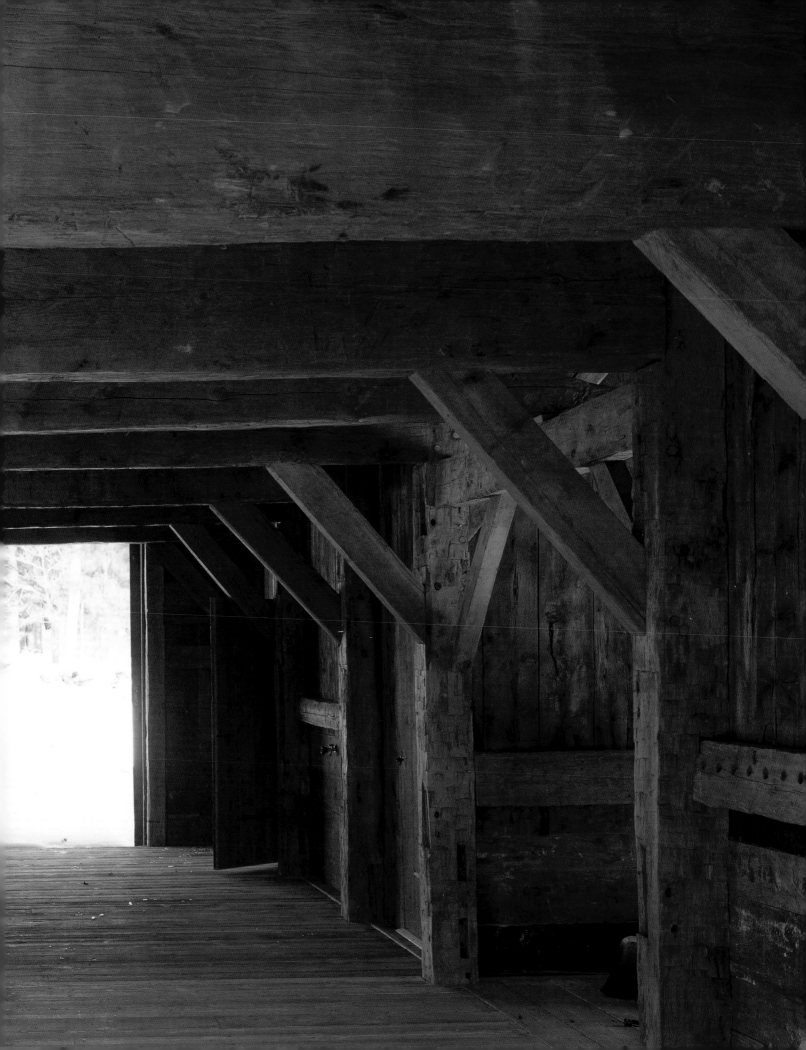

Previous two pages: The center aisle of the Poestenkill Barn now removed to Weston, Vermont.

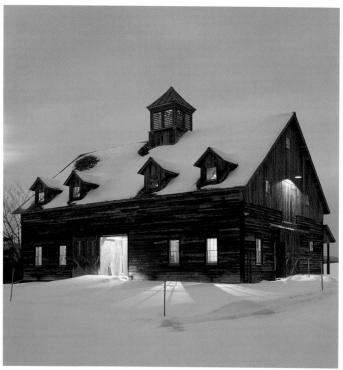

The barn in winter, with its newly aquired dormers and cupola.

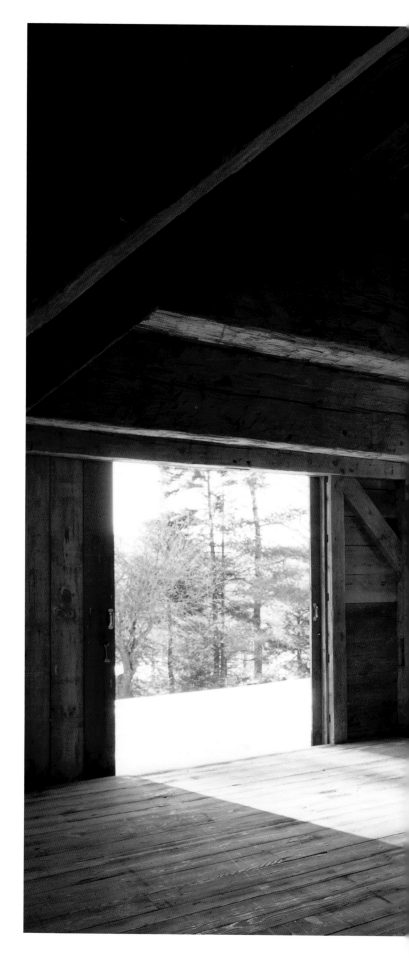

Initial enthusiasm for dismantling the giant barn at Poestenkill was dampened somewhat by logistical considerations, such as the difficulty in transporting the sixty-foot-long plates and purlins. More daunting still was the limited prospect of locating a buyer with the vision, need, and financial resources needed for such an enormous barn. Nonetheless, minor stabilization was undertaken, and the astonishing frame was documented with photographs and measured drawings. Word spread about the building, eventually reaching the ear of a barn enthusiast in Vermont. After visiting the structure, he resolved to move it to his property near Weston, to replace another, fallen barn. Problems arose about zoning measures which precluded the original notion of equestrian use, but the champion of the project resolved to see the Poestenkill barn rise again anyway. Sadly, before his dream was realized, he died of cancer. Some of the openness of the barn has been lost to the interjection of a full loft floor over the anchorbeams, but the upper space today serves the renowned Weston Playhouse both for storage of scenery and as a rehearsal space. In the future it is possible that a more authentic restoration may be attempted, but in any form, by the very act of renovating and reerecting this important structure the real battle for the barn has been won.

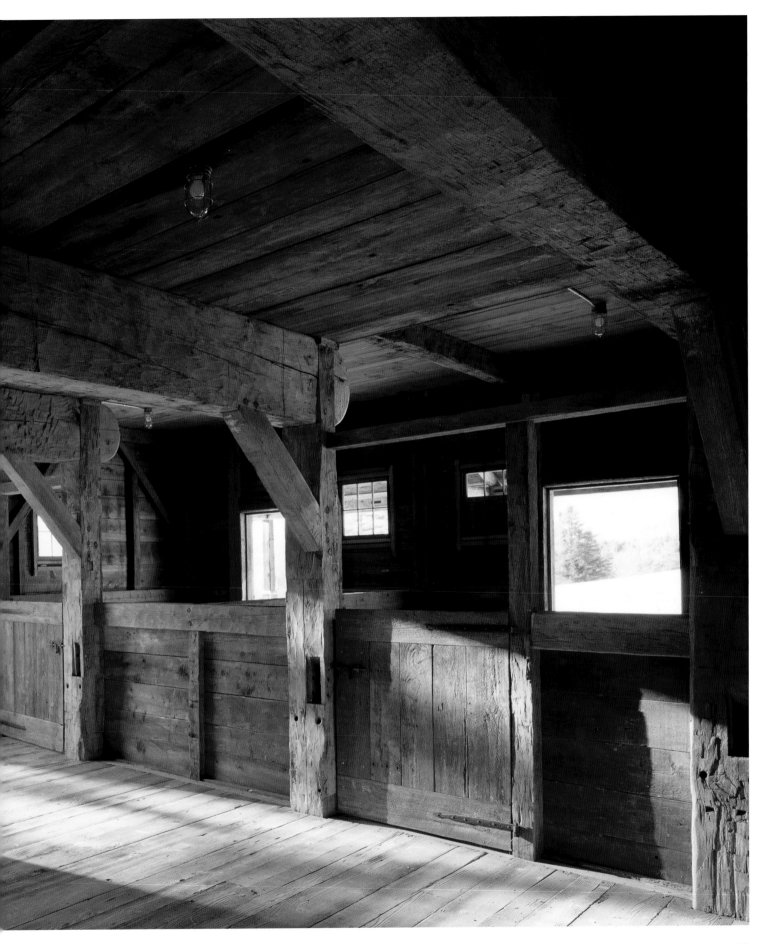

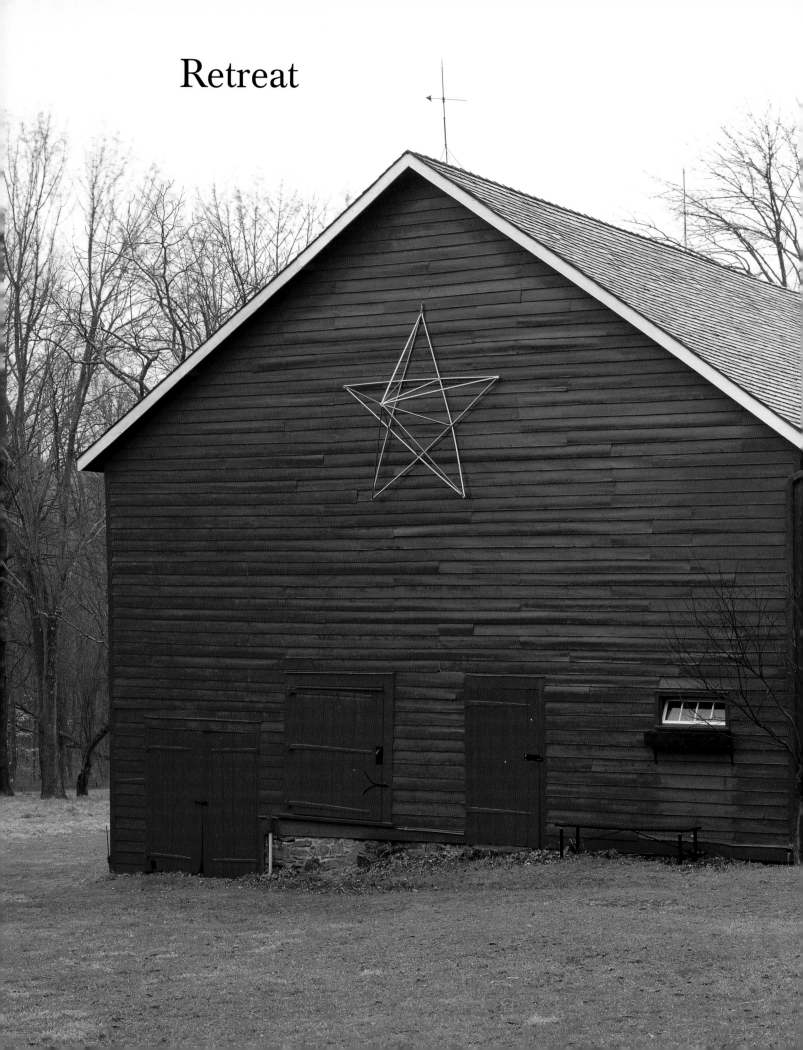

Retreat

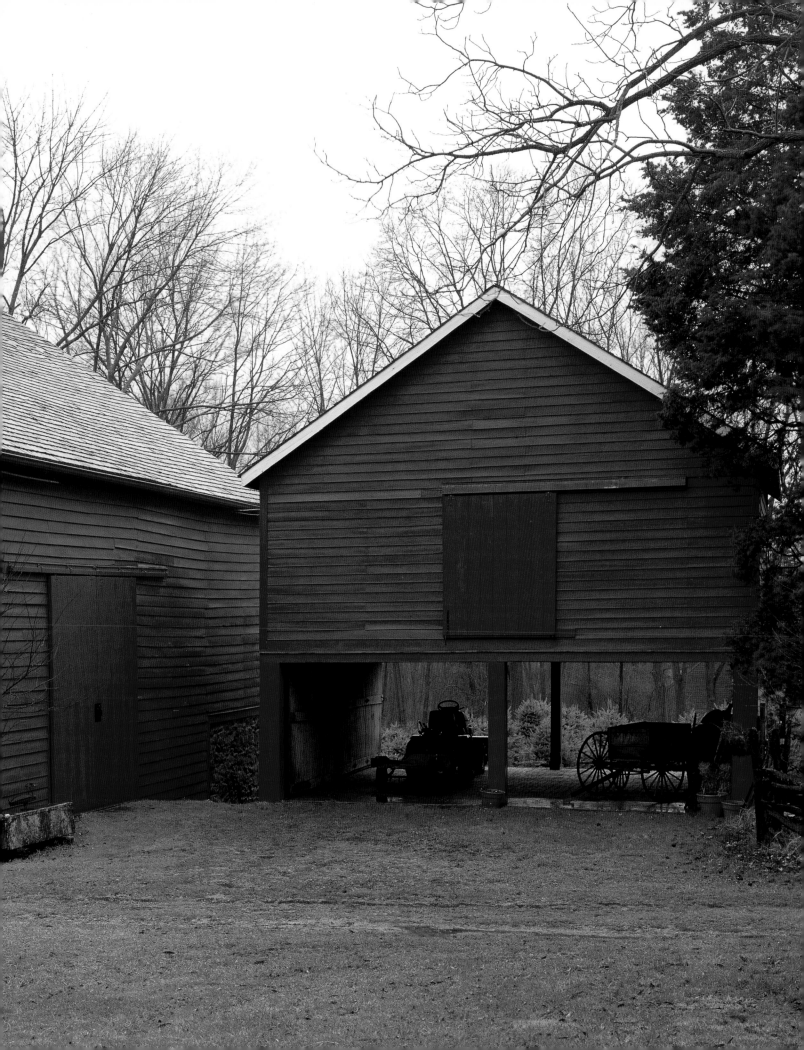

Previous pages: The Howsel-Wagoner Barn with its wagon shed.

The architectural heritage of Hunterdon County in west central New Jersey is enriched by the diversity of its first settlers, who variously contributed separate and distinct building traditions from the Netherlands, England, and Germany. Among the founders of Stanton, New Jersey, in the early years of the eighteenth century were the Howzels, a German family whose house and barn (dated 1741), both built of local stone, still command the main road in the village. By the end of that century, under the hand of William Howzel, the farm had prospered and a larger barn was required to house greater harvests. By then, previously exclusive ethnic cultures had rubbed shoulders in robust community enterprises like barn raisings, and the most favorable aspects of several traditions were melded to create wholly original New World models. The Howsel-Wagoner Barn is a great testament to this fresh American culture, drawing as it does on English, Dutch, and German precedent in an ingeniously original form.

A bent of the Howsel-Wagoner Barn.

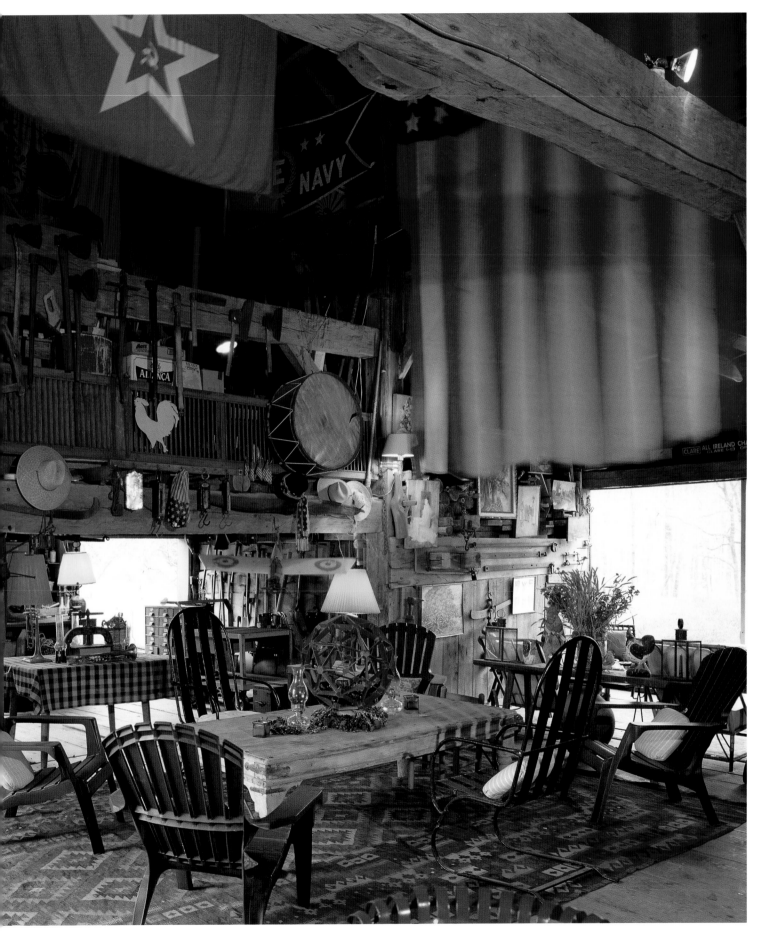

The word "barn" is descended from the Old English *bern*, meaning "a structure for storing hay." Particularly in America the definition of this key agricultural structure also came to encompass its role as the site for the threshing of grain and the shelter of livestock. But it is in its capacity for storage that the barn best continues to serve contemporary needs. Expanding harvests necessitated the construction of the Howzel-Waggoner Barn: More than a century later, however, small-scale farming foundered and fields went fallow. Grand repository of agrarian abundance, lacking renewed purpose the barn might have become an annoying anomaly, demanding endless and expensive upkeep. Fortunately, its present owners are obsessive collectors. In their early years of stewardship, the barn served a practical role as a repository for trucks, tractors, mowers, garden implements, firewood, and the like. Then gradually, auction and roadside yard sale finds, often oversized, found their way into the ample spaces offered by side aisles and lofts. Gas station signs and second-rate paintings, scale models, propellers, and flags followed one by one until, unbidden, the serendipitous storehouse became a space of compelling character. A destination. In time, an old refrigerator in one corner became the core of a seasonal outdoor kitchen. And today on a torrid summer afternoon amidst a clutter of collectibles, easy chairs cluster on the threshing floor under fluttering flags offering the promise of solace from the same channeled breezes that once separated wheat from chaff.

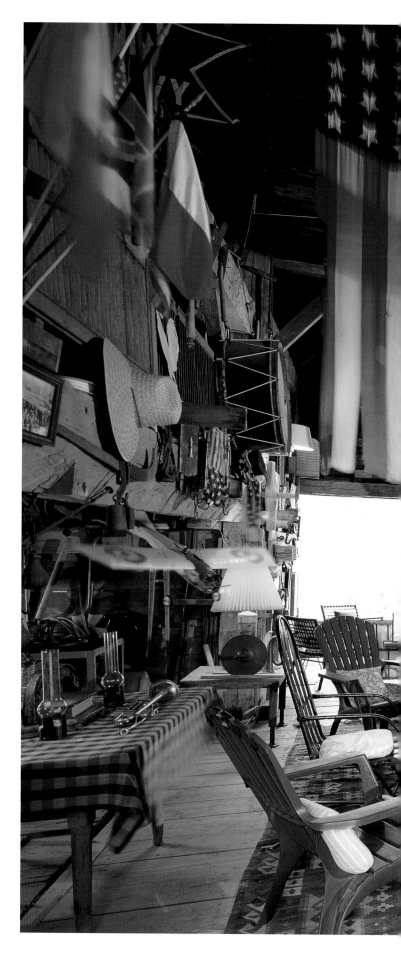

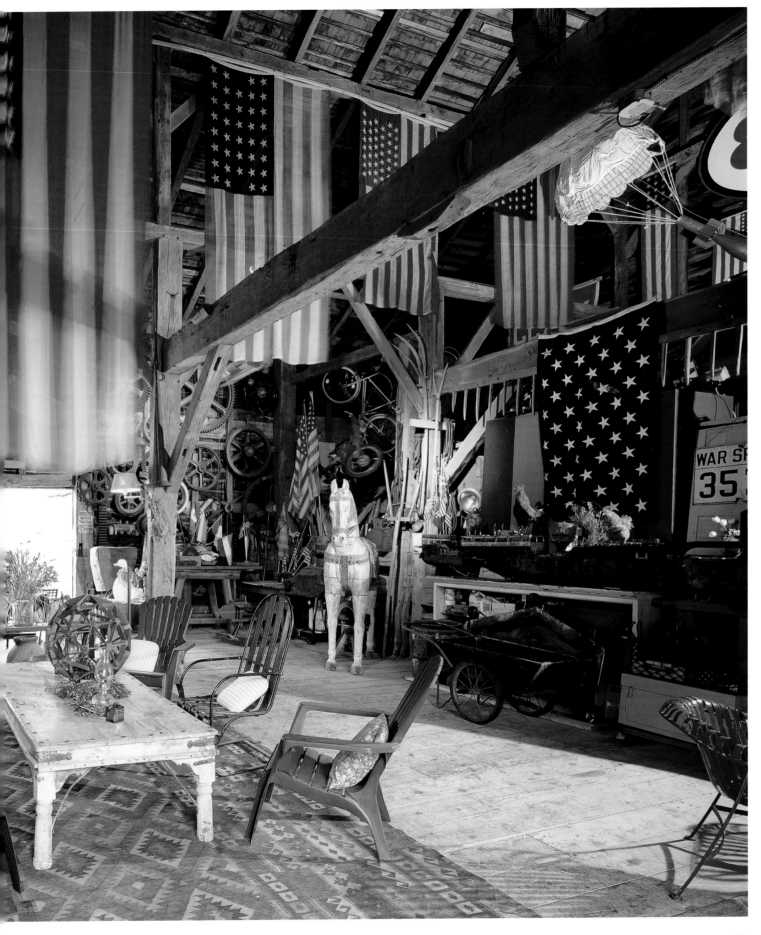

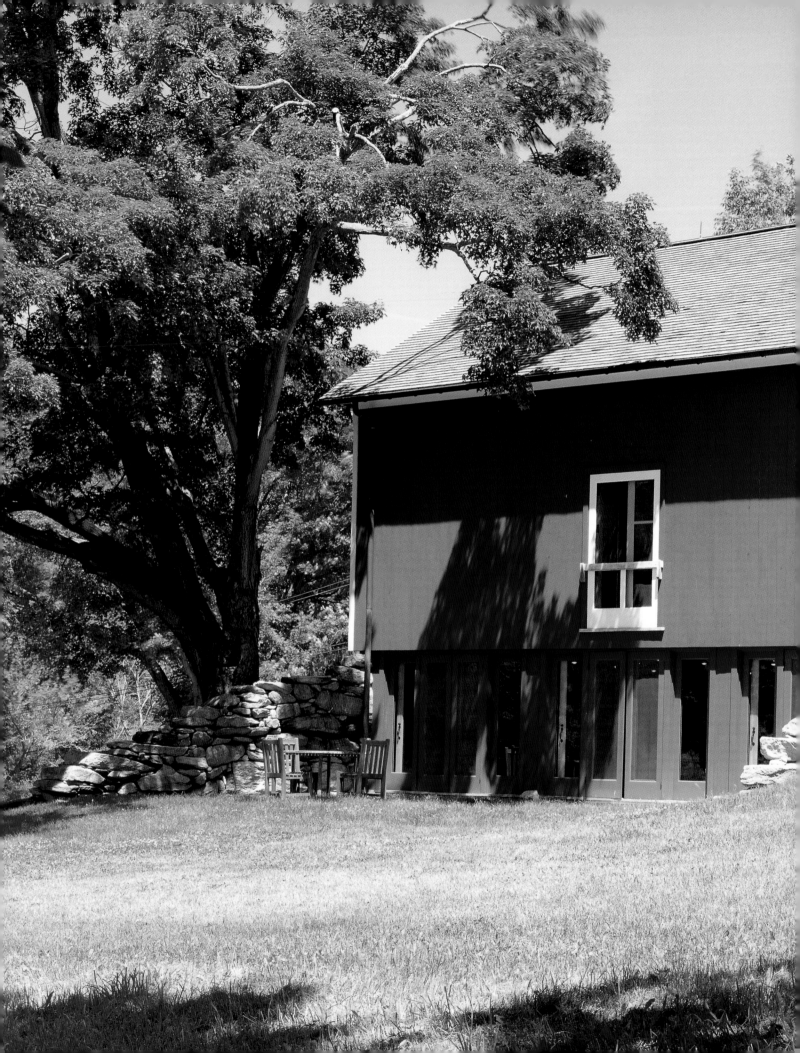

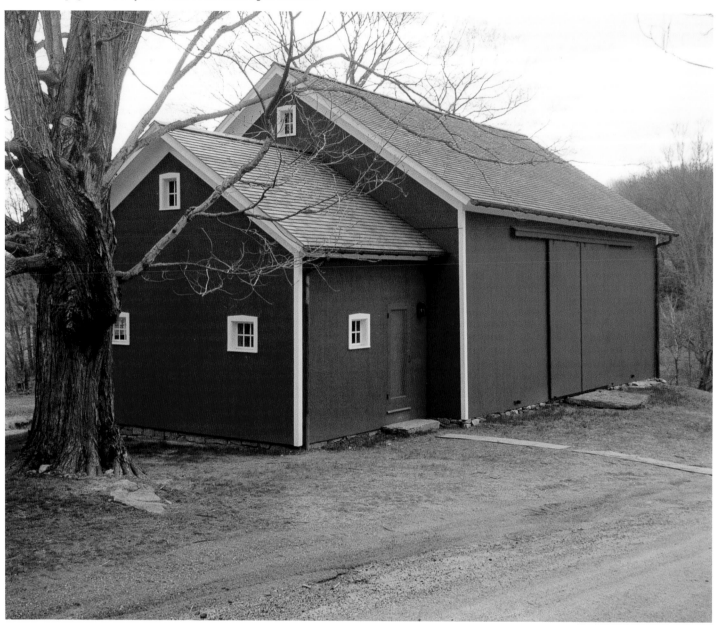

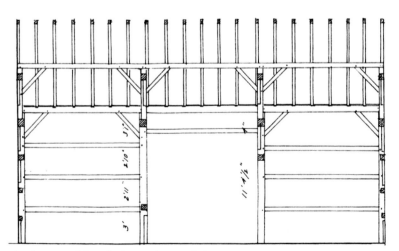

An elevation of the side shown above with the sliding wagon doors closed.

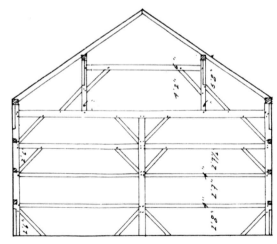

An end bent of the barn.

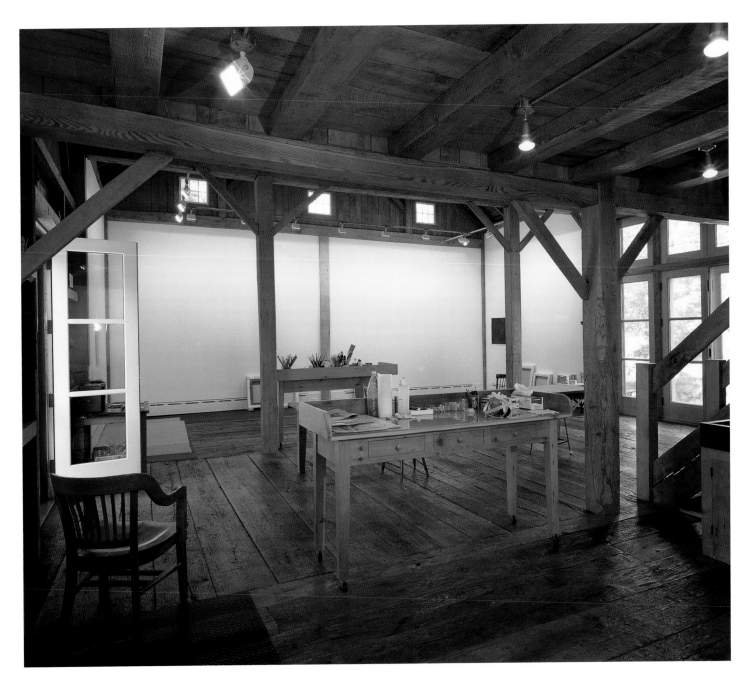

It is the rare barn that doesn't display spatterings of paint on the weathered floorboards of the threshing bay. Whether rejuvenating a farm wagon, sled, or sailboat, there are few settings more hospitable or forgiving, rain or shine, for daubing paint. As barns came to outlast the fields they once served, the notion of commandeering these serene and commodious spaces for seasonal or year-round studio space became irresistible. Thousands of artists, amateur and professional alike, have appropriated barns as the vessel of their muse. An apt example is the old Benedict Barn in South Kent, Connecticut, which has recently been converted to serve as the weekend retreat for a professional painter from Manhattan. The barn's varied spaces offer varied opportunities for an artist adept at several mediums. The main floor provides large sections of wall space for oversized paintings, while an office in the loft offers a vantage point from which to view current works in progress. Work lights illuminate the various painting stations and display panels, while indirect lamps highlight the sculptural *queen post* framing of this mid-nineteenth-century bank barn.

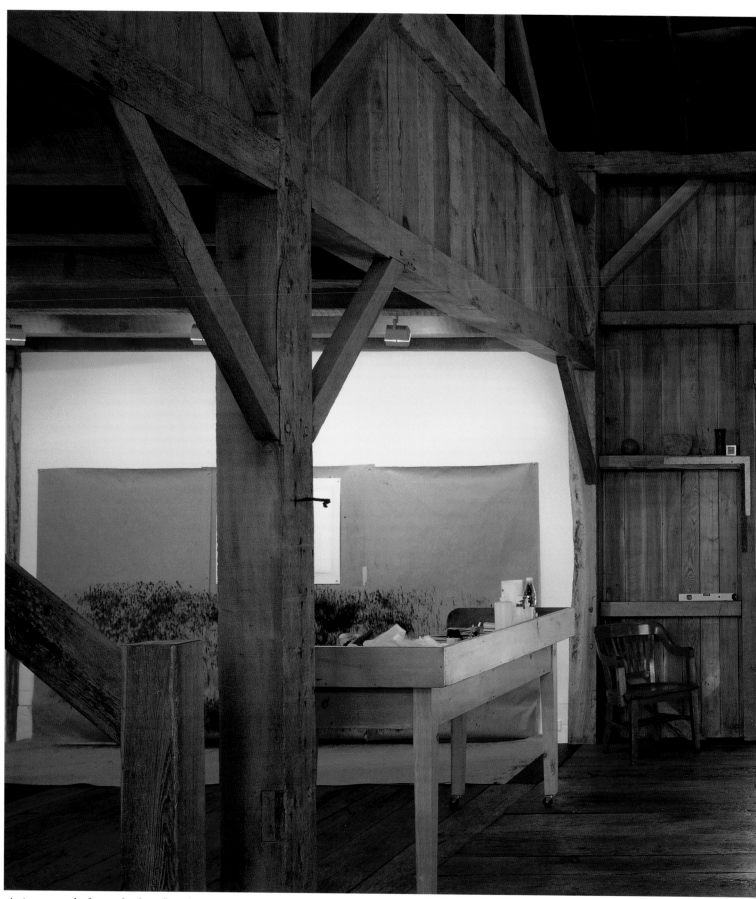

A view across the former threshing floor shows the divisions of work spaces between the bays.

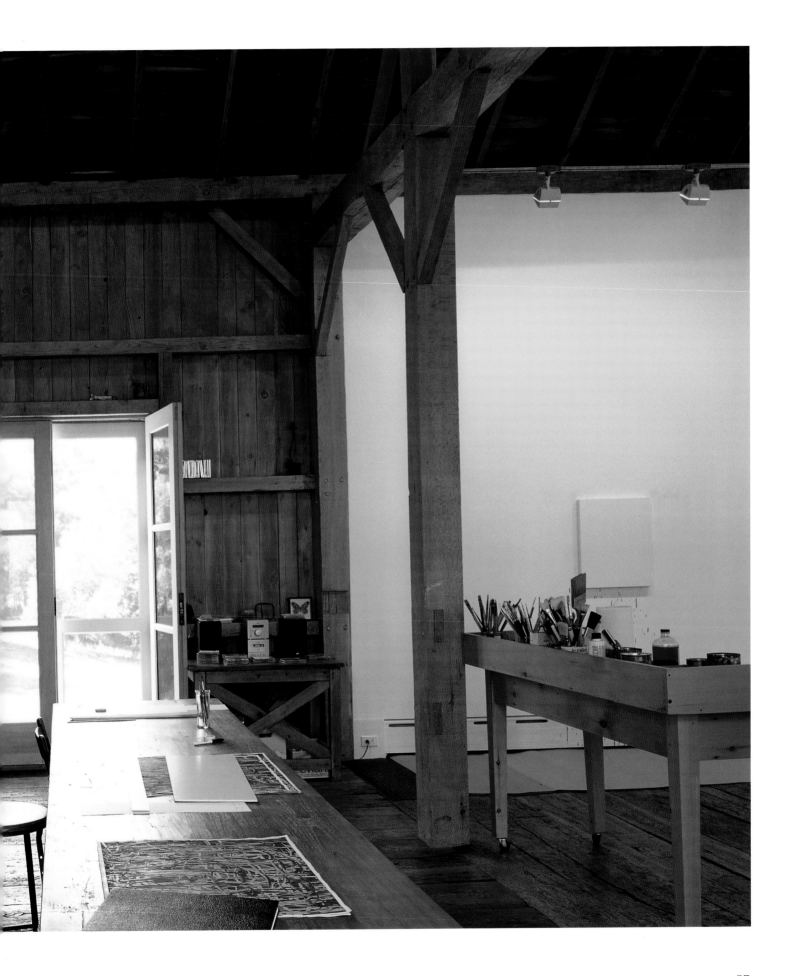

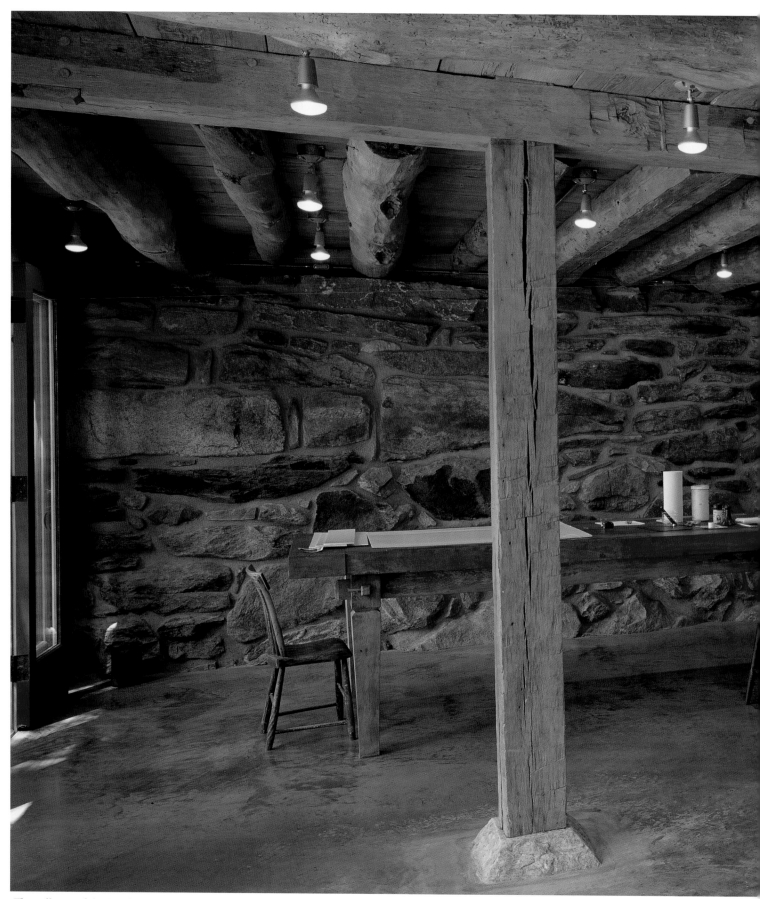

The stall area of the Benedict Barn.

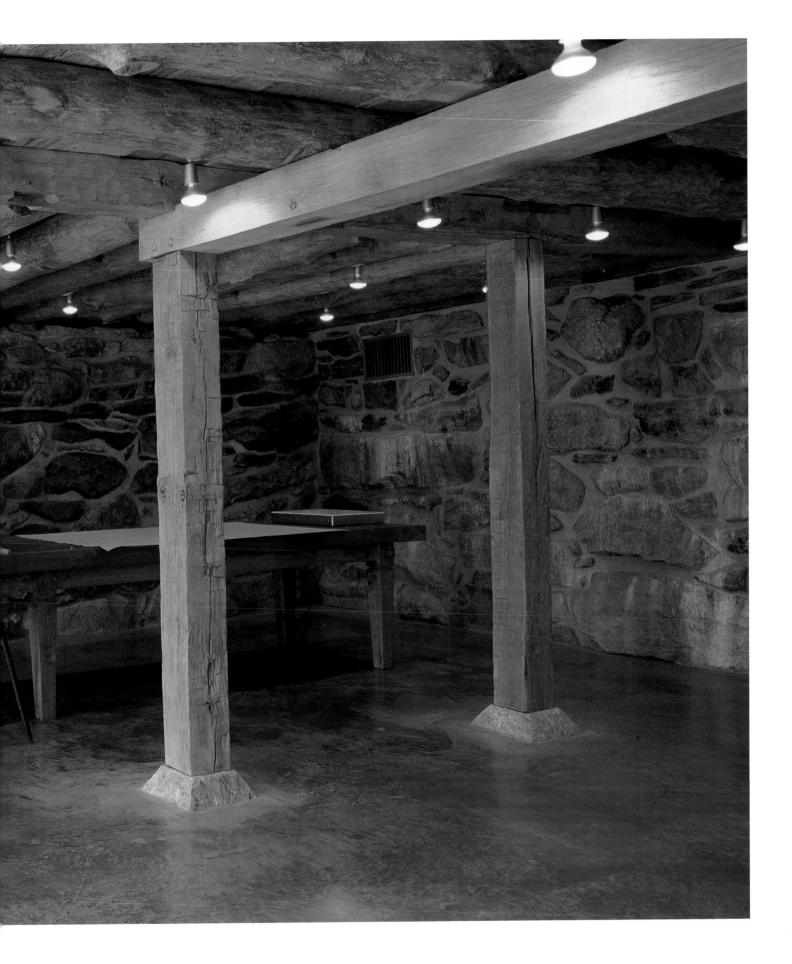

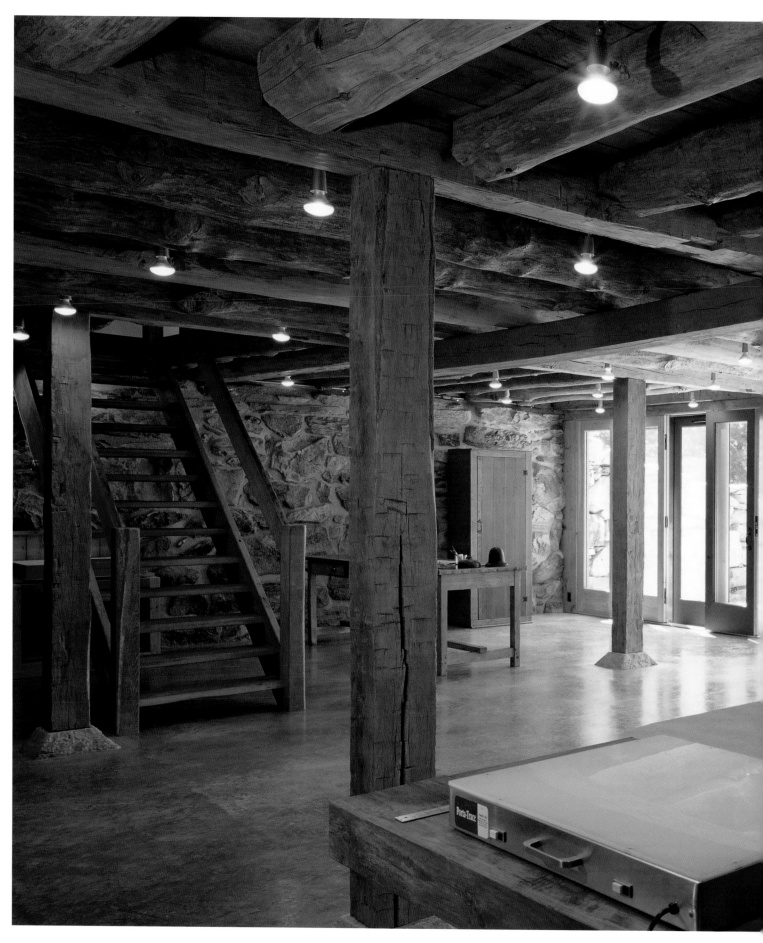

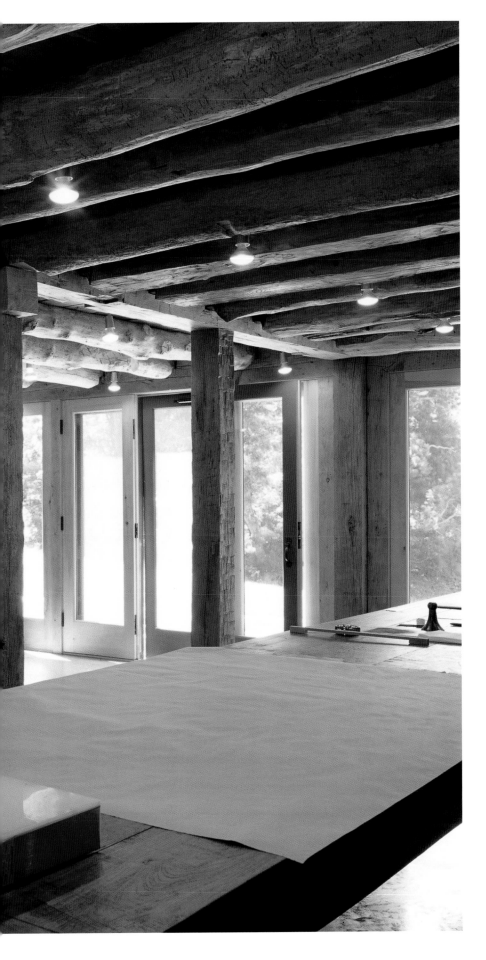

In contrast to the expansive studio space on the main floor of the Benedict Farm, the former stall area in the cellar is both intimate and intense. With craggy granite walls on three sides, a polished concrete floor and massive joists above, it becomes a workmanlike space (reminiscent of old Connecticut factories) for printmaking. A wall of French doors under the *overshoot* offers natural light, ventilation, and a framed view of the bucolic valley beyond.

Back before the turn of the last century five or six boys of about ten years of age took over a moribund structure behind Morven, the Stockton ancestral home in Princeton, New Jersey. By then hundreds of acres of farmland had been reduced to only two, locked in a grid of new residential streets, but several old outbuildings survived. Above the entry to one of these they nailed a sign, "Neverswept Club. Keep Out!" What amusements transpired beyond that door no one now can say, but the concept of a sequestered sanctuary where one can create a separate world of one's own remains compelling. Barns and outbuildings still offer space to indulge in the discipline of writing, the pleasures of books, collections or clutter with the general dictum, "Do Not Disturb," at a comfortable remove from the maelstrom of domestic activity. A small barn behind a Federal house in Sandisfield, Massachusetts, is representative.

With ample work space, comfortable chairs, lots of
books, a bar, and beyond the several windows, a personal
view to lose ones thoughts in, the "neverswept" notion finds
contemporary response in the Sandisfield retreat.

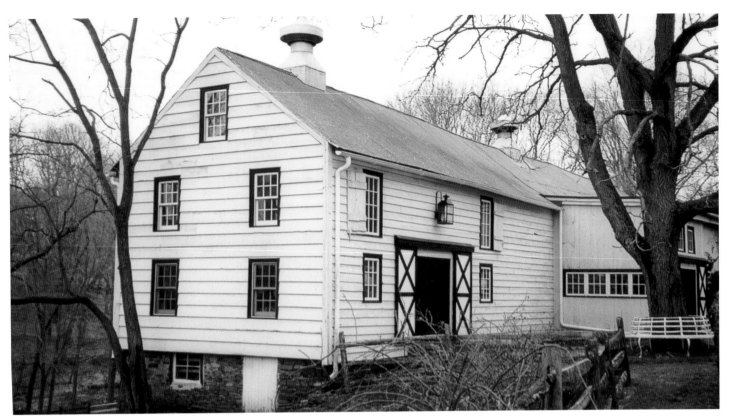

An old stone farmhouse in Bucks County, Pennsylvania, offered the owner the pervasive pleasures of seasoned woodwork and warm hearths, sufficient for daily living and intimate entertaining. But for an expansive collection of books on horticulture and the greater requisites of larger gatherings, more space was called for. Finding it was no more difficult than casting a glance out the window. The small barn that complemented the farmhouse in its agrarian past is today engaged as a library and study.

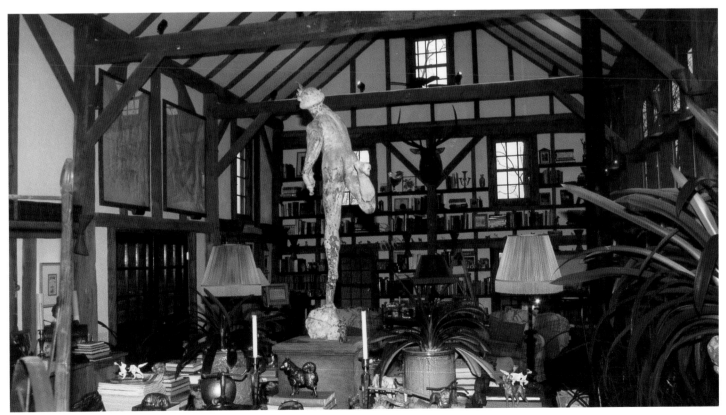

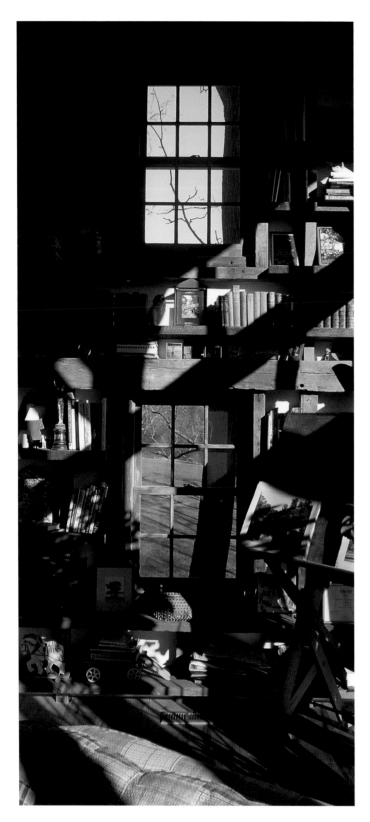
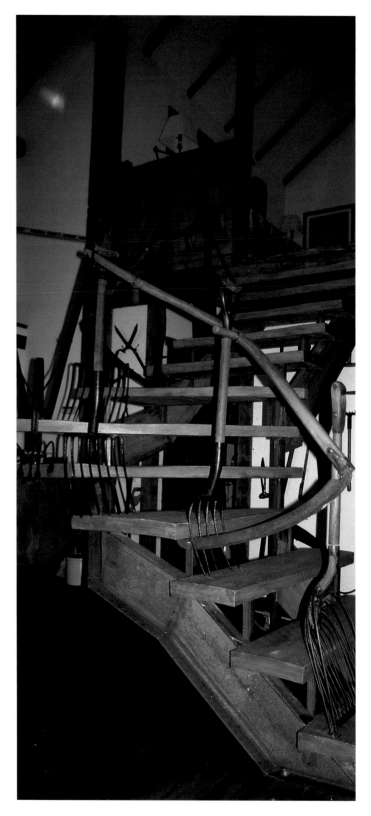

The chaste exterior remains unchanged, but the interior is transformed. Cleverness characterizes the conversion. One gable end is entirely given over to a sun-raked wall of books, while another is fully glazed. Smoke from the woodstove is ventilated by a traditional, ridge-mounted ventilator. The railing to the spiral staircase and loft is an amusing sculptural composition of welded farm implements. The result is a playful lesson to all of those who may take barn conversions too seriously.

A workplace with accommodation above, on Long Island, New York.

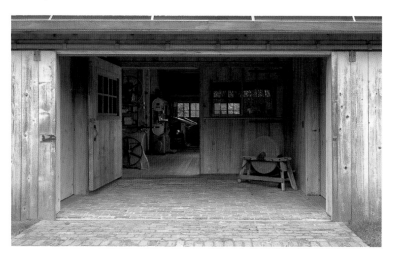

Seeking a location for both a wood shop and a living space, a restoration cabinetmaker native to the South Fork of Long Island, New York, found a fine old barn in the area and painstakingly converted it to serve both functions. The materials applied to the exterior (including vertical shiplap siding, cedar shingles, and gooseneck lights), are all appropriate to the building. Discrete fenestration further respects the structure's original role – a strategy betrayed only by the unobfuscated chimney. In this case, the point of de-emphasizing this feature is to situate the masonry mass behind the roof ridge, away from the approach to the refitted barn. An alternative approach would employ triple-insulated pipe in place of stone or brick above the firebox, allowing smoke to escape through a traditional metal ventilator above the roof line. Retaining sliding track doors in their original locations, as parenthetical shutters for windows or recessed porches, is another device that preserves the time-honored characteristics of the barn, while serving new and unaccustomed needs.

The ground floor of the barn on Long Island has been outfitted as a cabinetry repair shop, reminiscent of the traditional work spaces employed by boatwrights and other artisans. The timber frame remains intact, resheathed and insulated against the exterior in order to reveal the full depth of the timbers. Classic industrial work lights provide even overhead illumination for the several work stations. A drafting table is positioned beside double doors, which in season can be slid open to take advantage of the view, natural light, and the channeled breezes.

The armature of the barn frame provides natural purchase for clamps and other woodworking tools. Also displayed within the well-organized workshop is a bass wood scale model of a barn, a handy device for anyone planning a successful conversion.

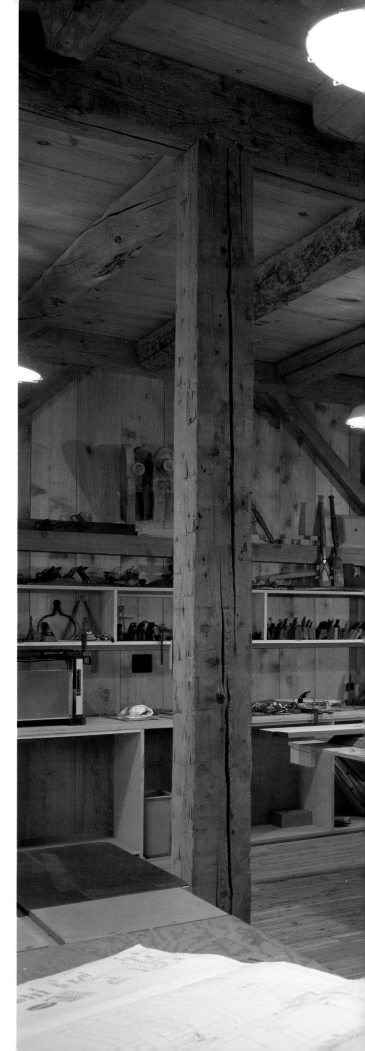

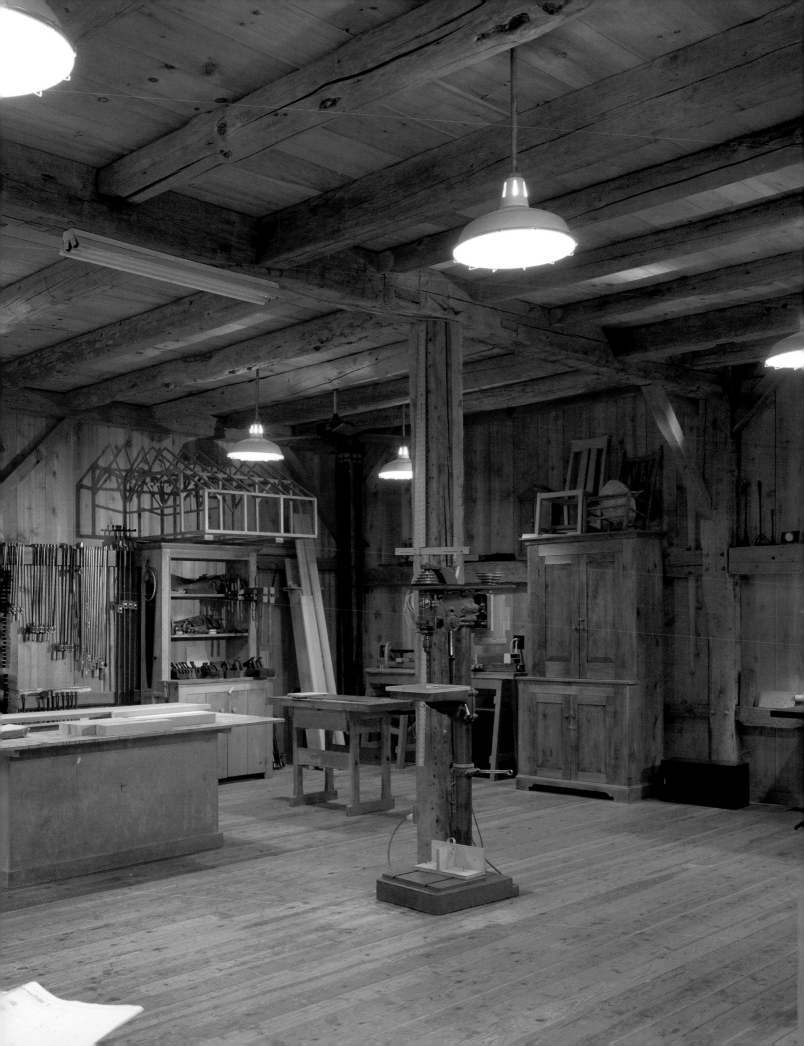

Over the shop a tidy loft affords cozy intimacy as a domestic retreat from daily labors downstairs. Old floorboards and roof sheathing complement the warmth of the hewn frame. Fireplaces are not integral to barn design, but several strategies may be considered to allow for their discrete introduction. One is to create a form that is plainly differentiated from the frame. Another is to look for precedent in related historic structures like blacksmith shops, mills, and summer kitchens, all of which display straightforward interior chimneys. A simple application of the latter approach is evident in the cabinetmaker's loft, particularly as the frame is allowed to stand proud of the brick.

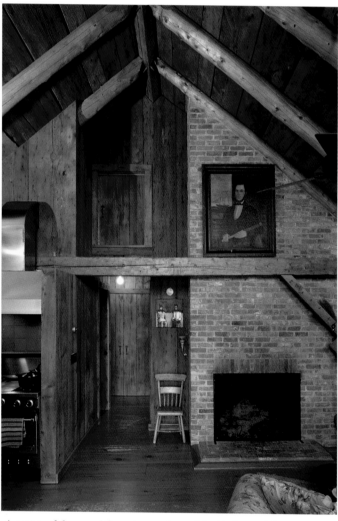

A section of the second floor shows a part of the kitchen and living area.

The bedroom on the second floor.

In a rural area outside Lambertville, New Jersey, a traditional bookbinder has set up shop in the upper loft of a nineteenth-century bank barn. On the exterior the building is maintained as a barn in every detail – with the exception of one glazed western gable. A large tree nearby provides a sunscreen in summer while also shielding the glassy aerie from the roadside view of all but the most observant passersby. The meticulous nature of this intervention is reflected in the attention to order within the shop space.

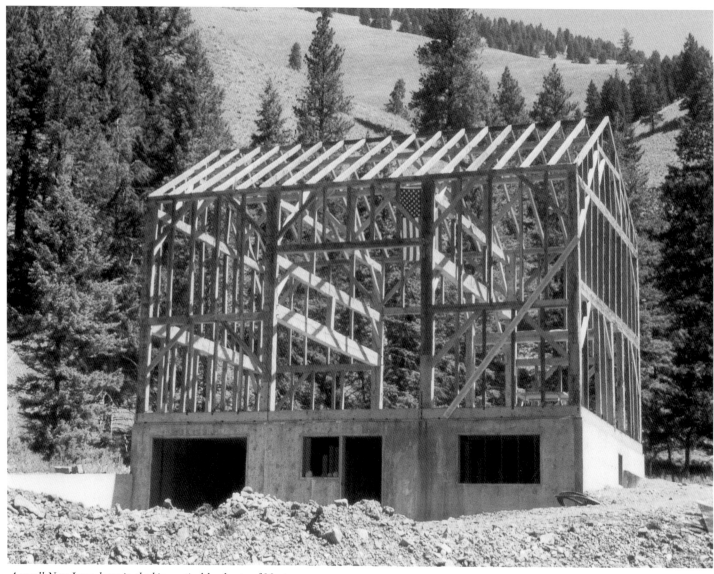

A small New Jersey barn in the big, vertical landscape of Montana.

Rock Creek, a stone's throw from Missoula, Montana, is renowned for its trout fishing. One West Coast angler was so enamored with the area that he bought a stream-side site, where a nineteenth-century bordello once stood, and set about designing a simple lodge to serve as a seasonal retreat for himself and his family. His fancy centered on finding and relocating a barn frame to stand on the rugged terrain. A moderately scaled, twenty-six-by thirty-six-foot barn from Sergeantsville, New Jersey, was eventually chosen. Rescued from demolition in the path of subdivision, the barn displays a stout, hewn-oak frame distinguished by a chamfered swingbeam and a queen post purlin system sufficient to carry heavy snow loads. Assuming an open plan, with spartan quarters and a woodstove, the barn's old timbers today resound to fish stories.

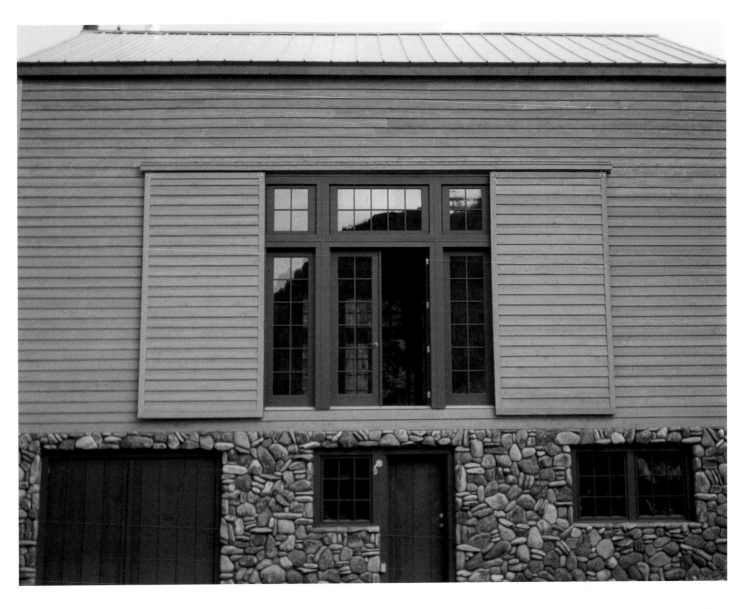

The stones that form the hearth and the foundation of the banked barn were gathered from the creek which inspired the project in the first place.

The spray-painted swingbeam, emblazoned by local teenagers for whom the old barn had become a hideaway to read "Sex Pistols." Elsewhere beams were spray-painted with "AC/DC" and "Reefer Madness." Festooned in honeysuckle and stripped of most of its siding, the old Axford Barn had fallen on hard times. In 1987, with accelerating deterioration and development threatening the site near Oxford, New Jersey, the forlorn structure was carefully documented and disassembled. The barn was stacked away in a former cowbarn for a dozen years before a new owner was identified. In preparation for reassembly on its new site, the structure was hauled out, repaired, and powerwashed. Immediately before being loaded on a trailer, flood waters spawned by an Atlantic

hurricane swept through the storage facility, and the massive beams, some weighing upwards of a ton, summarily floated away until most were snagged by a roadside fence. Some of the smaller members escaped between the rails and were rescued a half-mile across the fields after the waters receded. The irony lies in the fact that the flood caused by Hurricane Floyd occurred many miles from the coast, whereas the site where the Axford Barn now stands, beside a golf course, is within sight of the ocean at Point Judith, Rhode Island. On the occasion of the barnraising, a priest blessed the structure, in part perhaps to forestall further tempests. Today, clad in cedar shingles and capped by a modest cupola, the barn once again serves as a sort of clubhouse hideaway.

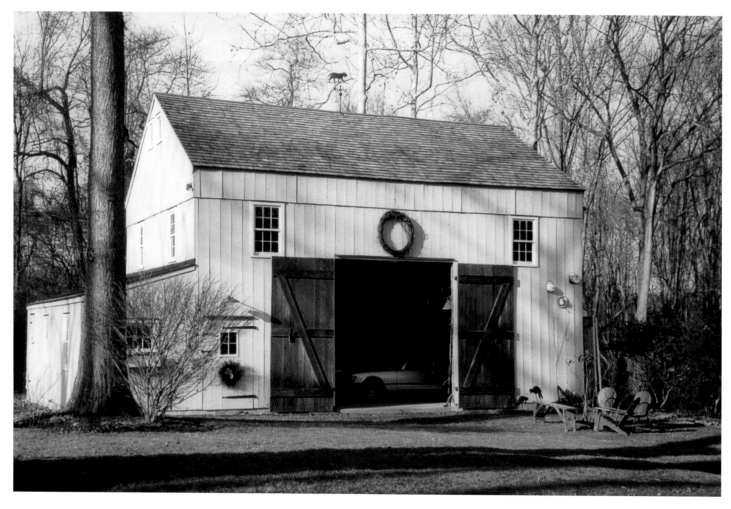

Although the barn has served as the center of industry on working farms for more than a thousand years, its reinterpretation as a location for leisure activities is not without precedent. The genre paintings of William

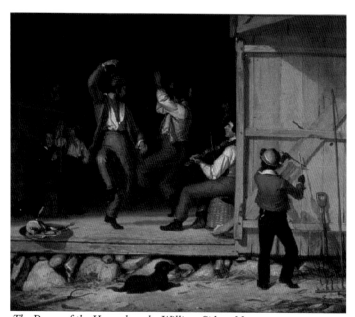

The Dance of the Haymakers, by William Sidney Mount.

Sidney Mount, for instance, are rife with the revelries of nineteenth-century Long Island barn dances. Likewise, barn-sheltered corn-shucking bees were long a staple of autumnal entertainment in simpler times. And rare is the child, raised in the country, who does not fondly remember burrowing in a haymow or swinging on a rope from bent to bent among the stolen pleasures of a favorite, not-so-secret barn retreat. In barns retired from active agricultural enterprise, many a rainy afternoon has been idled away on the former threshing floor around a ping-pong table or in the serious challenge of a half-court basketball game. After one barn was moved from Skillman, New Jersey, to Lew Beach, New York, its first organized function was a roller-skating party for the owners' grandchildren. More than a few parties, including several weddings, have been held in the J. V. B. Wicoff Barn since it was moved from Plainsboro to Princeton, New Jersey, in 1991. When not engaged for special events, children's tricycles and wagons dominate one end of the mid-nineteenth-century English-style structure, while the other end is reserved as an exercise space.

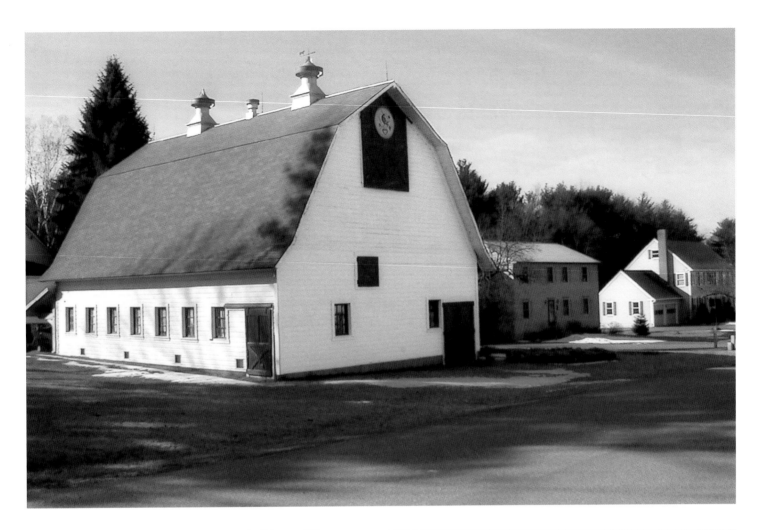

A gambrel-roofed barn built in 1929 in Keene, New Hampshire, represents thousands of generic structures raised after the end of the age of timber framing. Constructed of rough-sawn, dimensional lumber, it was designed with assistance from Louden Machinery of Fairfield, Iowa. In 1907, Louden established a barn plan service to provide guidance "in building the best barn for the money invested – making it most sanitary and convenient [and] well-ventilated. . ." Services were rendered free or at a modest price. The farmer did, however, pay for all fittings used, from stalls to stanchions, hoists to hayfork tracks. The thirty-by-fifty foot-barn is today surrounded by suburban houses and has long since outlived its agrarian function. The ground-level bays function as a garage and repair shop for the restoration of English sports cars. Above, the former hayloft, twenty-four feet to the ridge, features a trussed roof that allows for a vast open area, unencumbered by internal posts or tie beams. With a balcony at one end and a climbing wall on the other, there is space enough in between for everything from half-court basketball to badminton.

Spectators may find comfortable seating in vintage barber chairs.

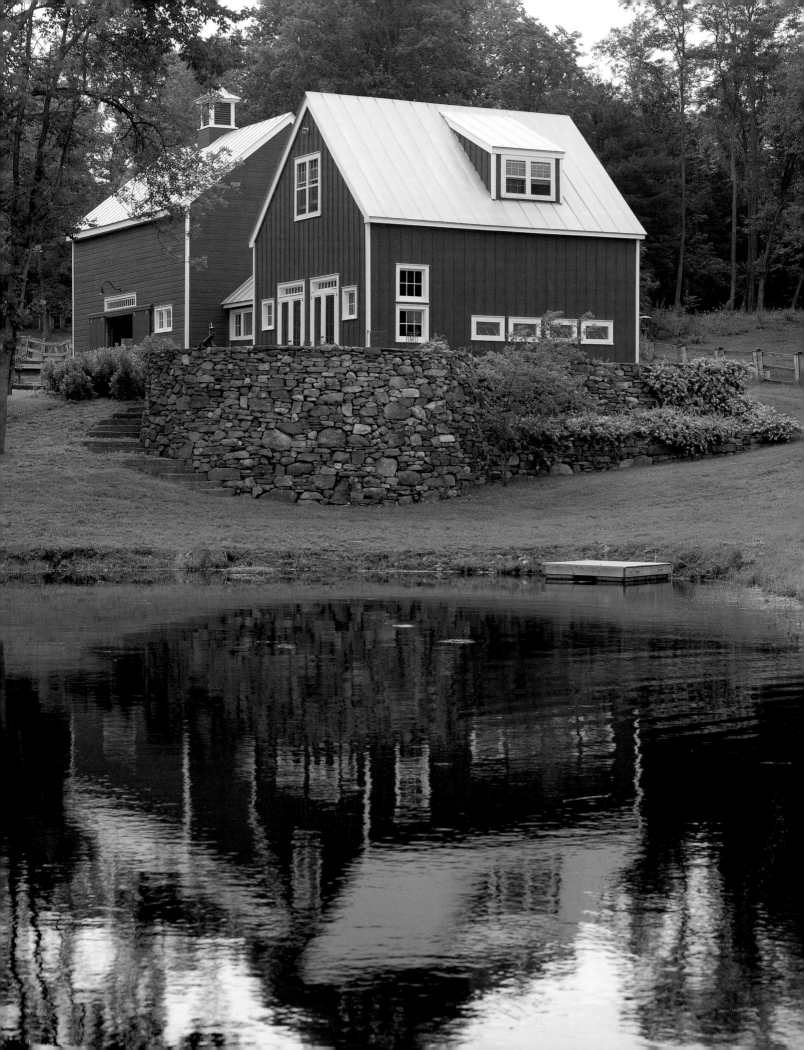

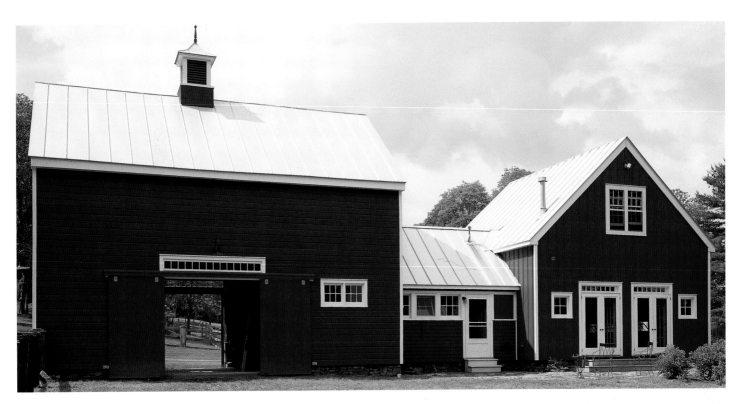

In Livingston, New York, another barn complex, created from recycled structures, serves both traditional and adaptive recreational purposes. The haybarn shelters horses, rigs, and tack, much as it might have years earlier in its long history, though equestrian activities today are devoted to pleasure rather than agrarian industry. A connecting hyphen houses a changing room and shower. A smaller barn has been set aside for a propelled-water swimming pool. Situated among fences and hard by a hedgerow, the buildings are comfortable in their adopted surroundings. Traditional materials, including vertical sheathing, clapboard. and a standing seam roof help to preserve the identity of the structures. Still, it is surprising to find the cupola centered to respect the interior threshing floor, rather than in its accustomed place in the middle of the exterior roof profile. Such seemingly inconsequential details may affect the verity of a successful conversion.

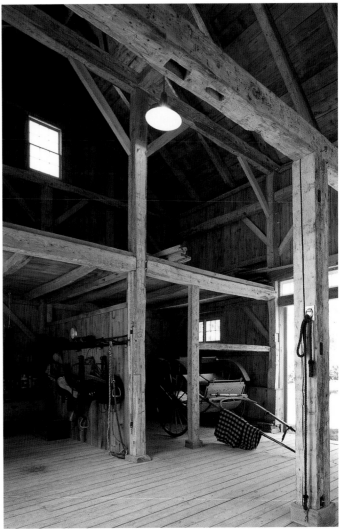

Conscious effort has been made on the interior of the Livingstone complex to employ customary and compatible materials in order to respect the integrity of the buildings while accommodating the new purposes to which they have been adapted. Both barns have been elevated by extending the posts, thereby providing greater requisite headroom. In the haybarn plinths have been lapped onto the bases of the vertical members.

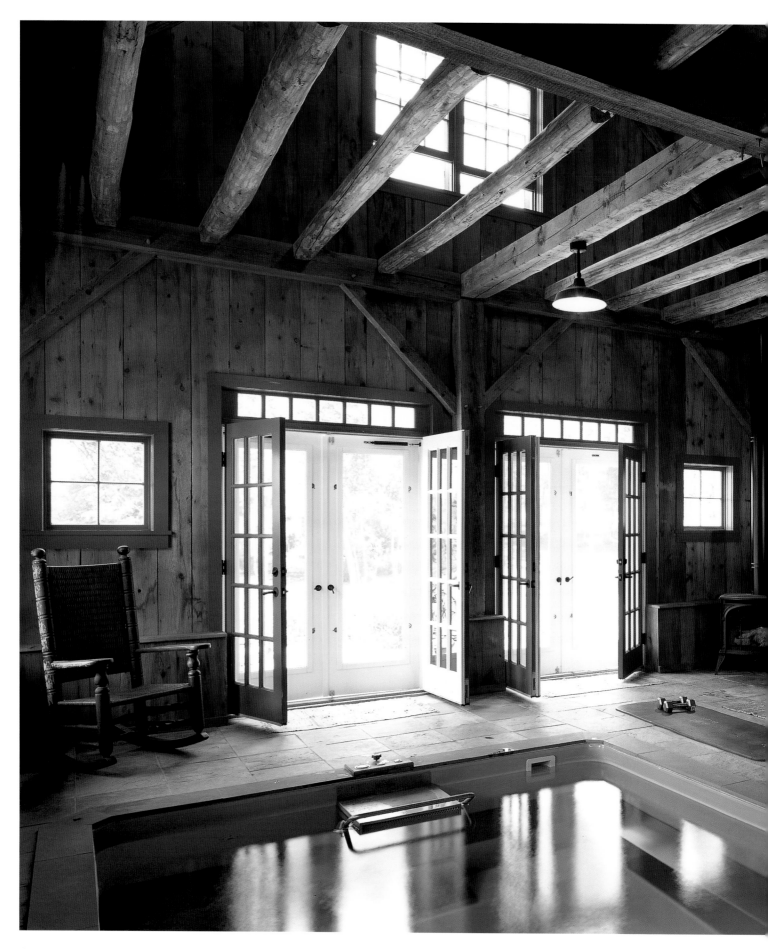

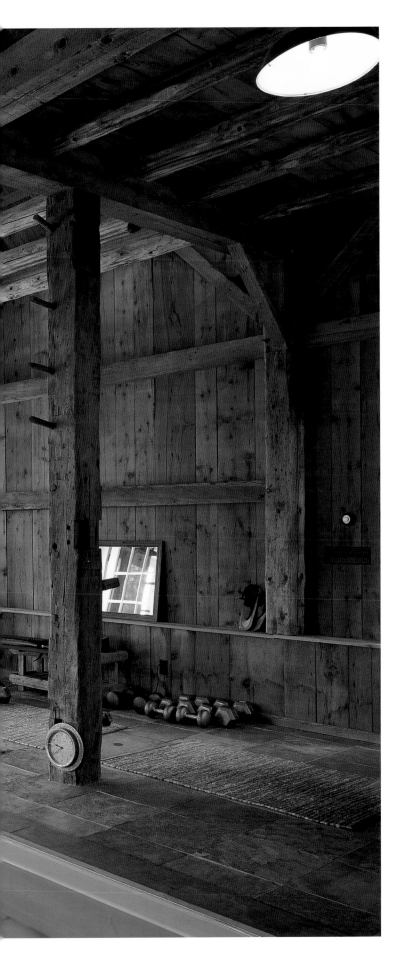

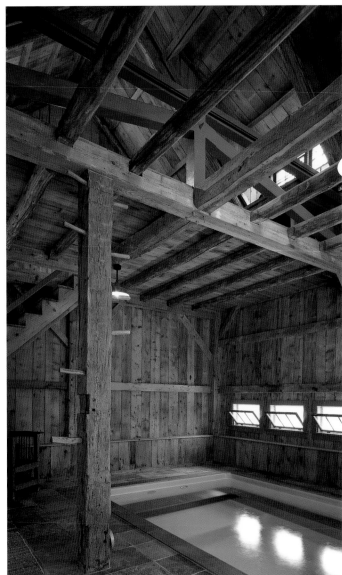

In the pool house, new post bottoms are concealed behind a broad chase, which also acts as a bench around the periphery. In both structures old roof-sheathing and siding preserve the overall character of these traditional farm buildings. In the haybarn, old flooring is also employed, although floorboards in a genuine barn would run across the threshing bay, not from door to door. In the pool house, flagstones and semi-industrial lighting fixtures are admirably harmonious additions. Insulation is discreetly positioned outside the frame, between old barn siding inside and new sheathing to the weather. The alternating rung ladder post is a fine old barn device likely relocated from elsewhere in the structure.

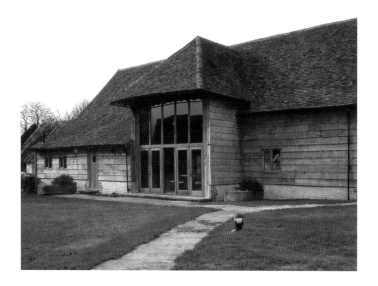

The conversion of a small barn in New York State to accommodate the modest requirements of a turbine-propelled lap tank is surpassed by the audacity of appropriating a major West Sussex yeoman's barn to enclose a full-scale swimming pool. Because tie beams traverse the entire width of the structure, there are no interior posts. The experience of paddling about while gazing up at limb-like *crucked braces*, and the vast roof structure of purlins, and *principal* and *secondary rafters* must be a remarkable experience. Exercising restraint, the designers have left intact the exterior of the Cottesmore Barn by retaining the original wagon door openings and loopholes and filling them with undivided lights. Lighting too is discreet. Most important, the original bones of the building are inviolate.

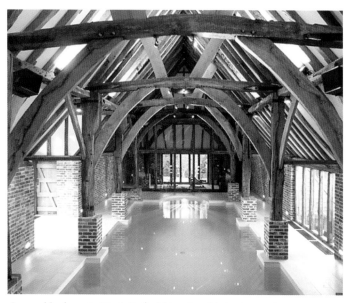

In an older barn in North Oxfordshire, the aisle posts remain in place at the pool's edge.

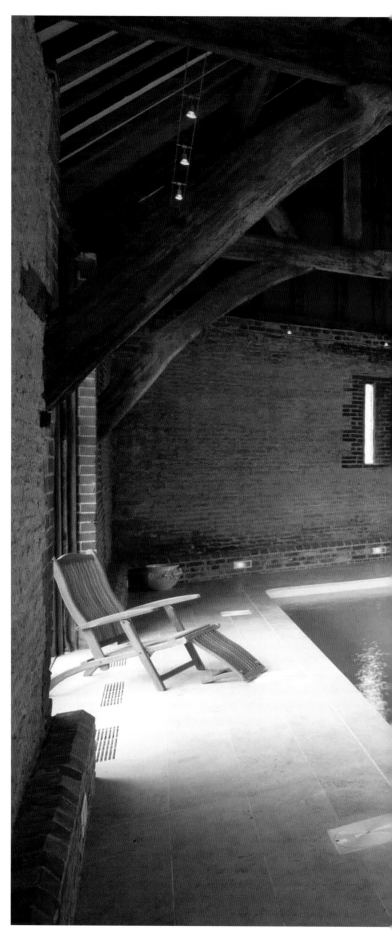

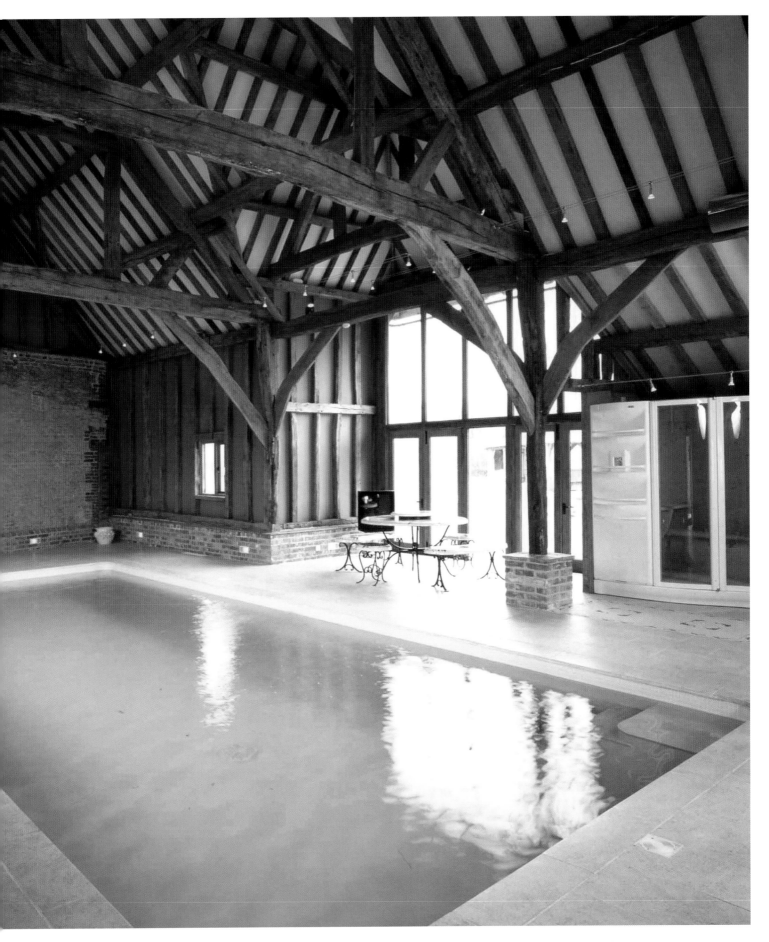

A New Working Life

Under a higher degree of civilisation,
conversion takes the place of destruction
and things merely change their owners
or their uses . . .
JOHN CLAUDIUS LOUDON
ENCYCLOPEDIA OF COTTAGE, FARM
AND VILLA ARCHITECTURE, 1833

Farm auctions were a staple of American life in the early twentieth century. It was at such events that the first great collectors of American furniture and folk art spotted items of attic surplus that in time became priceless icons of "Americana." In good weather, country sales were conducted off the front porch, but when the appointed day was threatened with inclemency, the threshing floor of the barn became the venue of choice. It is possible that such commodious surroundings inspired more than a few antique dealers of the day to seek out roadside barns as emporia for their stock in trade. Certainly, of all the applications to which barns have been adapted none is so widespread as the antiques shop. For instance, Furstover Antiques in Stanton Station, New Jersey, is housed in an excellent converted Dutch-English hybrid barn open to antiquarian and barn enthusiasts alike.

Where barns were sited hard by the side of the road, a degree of public access to farm buildings has always existed. Ever since the first "Eggs for Sale" sign was tacked to a barn door, the commercial potential of such fortuitously positioned structures has been evident. Even before the vast spaces inside barns served anything but agriculture, the great expanse of wall surface outside was recognized as advantageous for advertising. Early photographs depict barns haphazardly posted with signs hawking patent medicines and horses for sale. Farm boys were given free tickets in exchange for pasting circus posters on roadside barns. It might be argued that the term "broadside" evolved from such early applications. Certainly by the late nineteenth century the custom was well established by which a farmer could get his barn painted for free in exchange for allowing it to be embellished with advertising. Most famous of the national exponents of this medium was Mail Pouch Tobacco, whose signs once enlivened tens of thousands of barns. Smaller local firms followed the same practice, but most of their promulgations have since disappeared with the businesses they were intended to bolster. Recently, near Stockertown, Pennsylvania, a layer of modern siding was removed from an otherwise nondescript barn to reveal a promotion for the long-forgotten Bull & Bush department store.

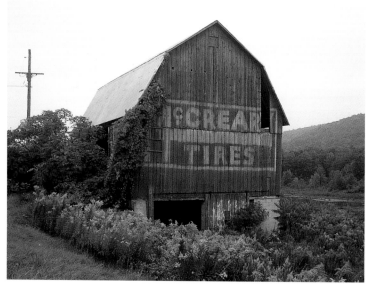

Near Horseheads, New York.

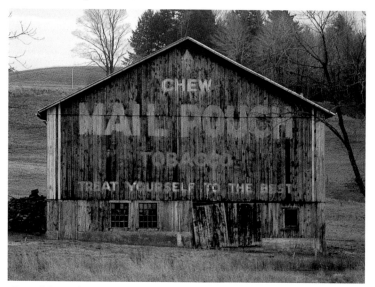

Central Pennsylvania.

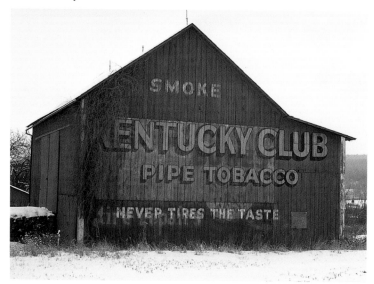

Brodheadsville, Pennsylvania.

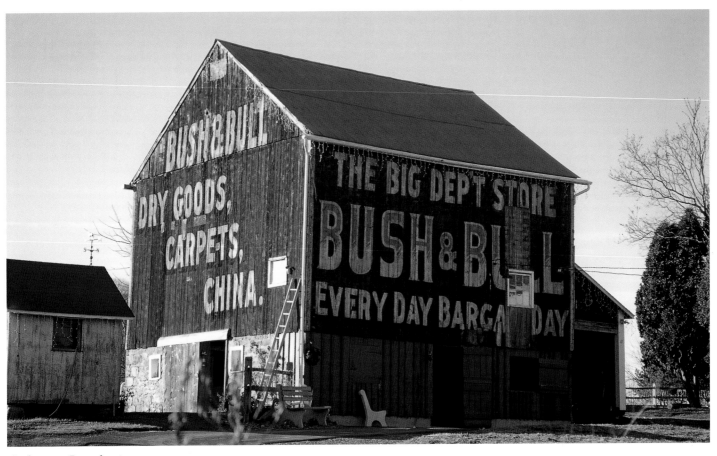

Stockertown, Pennsylvania.

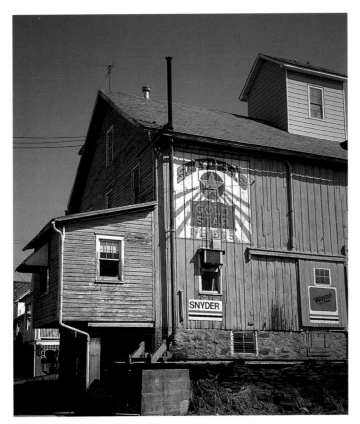

Nazareth, Pennsylvania.

Southeastern Pennsylvania.

The first and most expedient use of the barn as commercial space was to sell the produce of the farm. With a cigar box for change, such ventures began with the simple sale of farm-fresh milk and eggs year round, fruit and vegetables in season. Customers were neighbors and passersby. Particularly for farms with favorable locations, in time such homegrown enterprises often grew to engage the use of existing farm structures including, in many cases, the barn. This circumstance was often coincident with the relocation of dwindling livestock and hay storage to more efficient facilities on the farm. Among the many successful examples of such endeavors are the

Jewett Farm in upstate New York, and the Village Farm Market in Hinkeltown, Pennsylvania. In today's age of specialization, as former fields and pastures came to be devoted to new aspects of agriculture, their existing barns have been similarly appropriated. Vineyards in Unionville, New Jersey, and Buckingham, Pennsylvania, have reassigned barns both for production and retail sales, as has the Buffalo Springs Herb Farm near Raphine, Virginia. The gambrel-roofed barn near Lexington, Virginia, still shelters animals in its current incarnation as the "All God's Creatures Country Retreat for Pets."

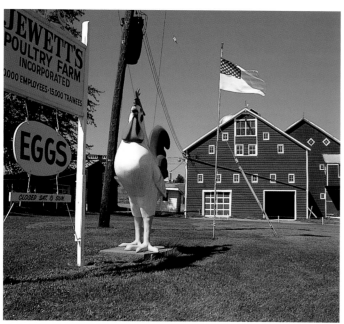

Jewett's Poultry Farm in upstate New York.

Barns at a vineyard in Unionville, New Jersey.

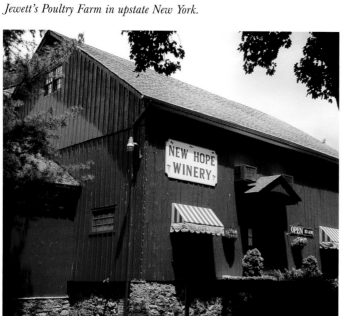

The New Hope Winery, Buckingham, Pennsylvania.

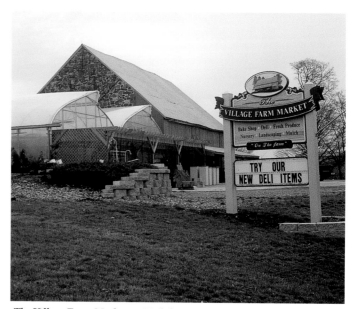

The Village Farm Market in Hinkeltown, Pennsylvania.

90

The All God's Creatures Country Retreat for Pets, near Lexington, Virginia.

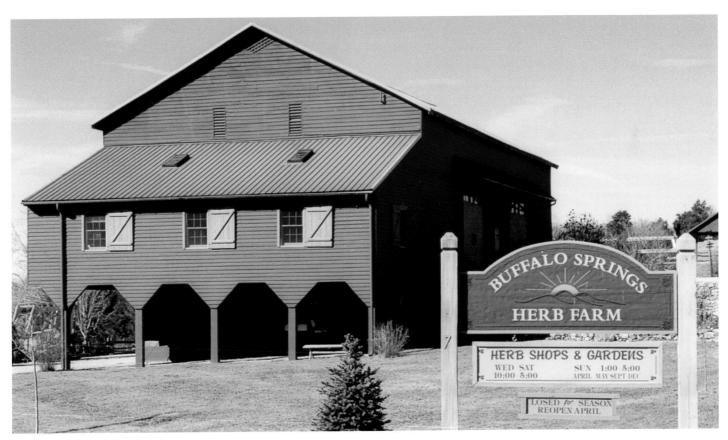

The Buffalo Springs Herb Farm near Raphine, Virginia.

Stony Brook Gardens, Pennington, New Jersey.

As the great Midwestern "agribusinesses" began to dominate production of major crops, smaller family farms of the Eastern states turned increasingly to specialty crops. These might include herbs or berries, organic or oriental vegetables. Some farms have been transformed into nurseries serving the surrounding suburbs that might otherwise have consumed them. In New Jersey, Stony Brook Gardens, Pennington, and Fair Acres Farm Sussex make efficient use of early-twentieth century, truss-roofed barns as garden centers. In a sense the barn acts as an iconic link to the agrarian past ex-urbanites seek in their formerly rural surroundings. In the case of the giant garden emporium in Bridgehampton, New York, a large timber-frame structure was actually imported from Pennsylvania to serve this function.

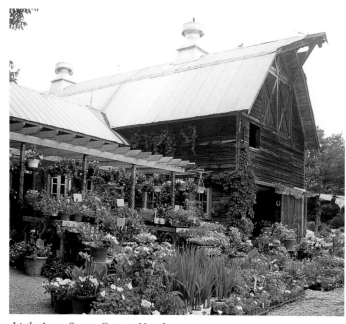

Little Acres, Sussex County, New Jersey.

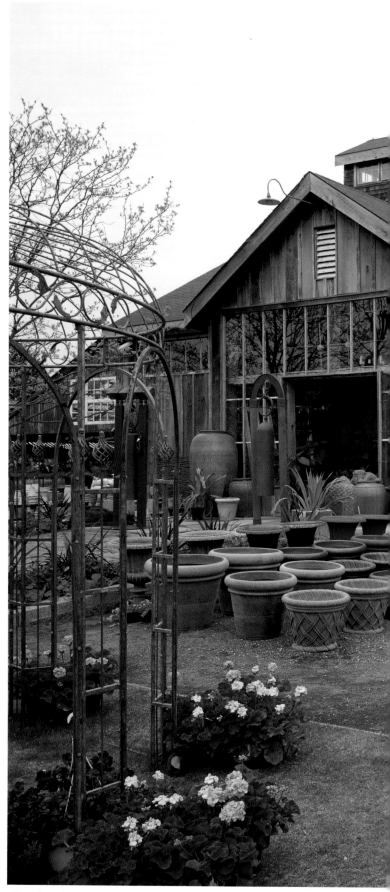

Maarder's Garden Center, Bridgehampton, New York.

92

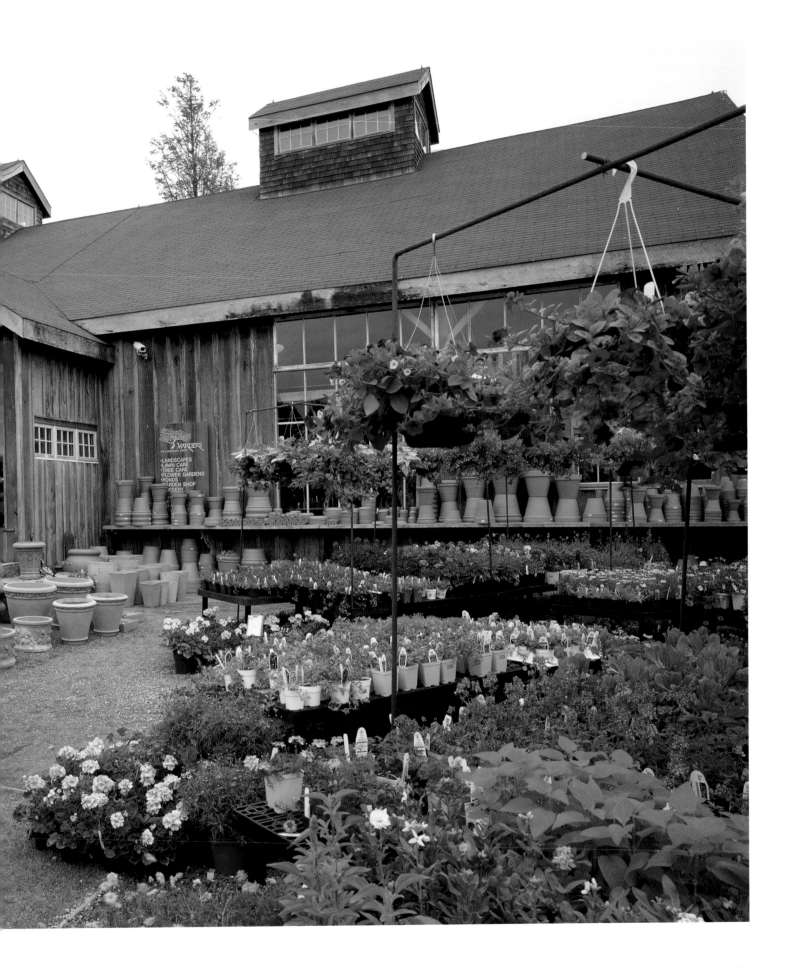

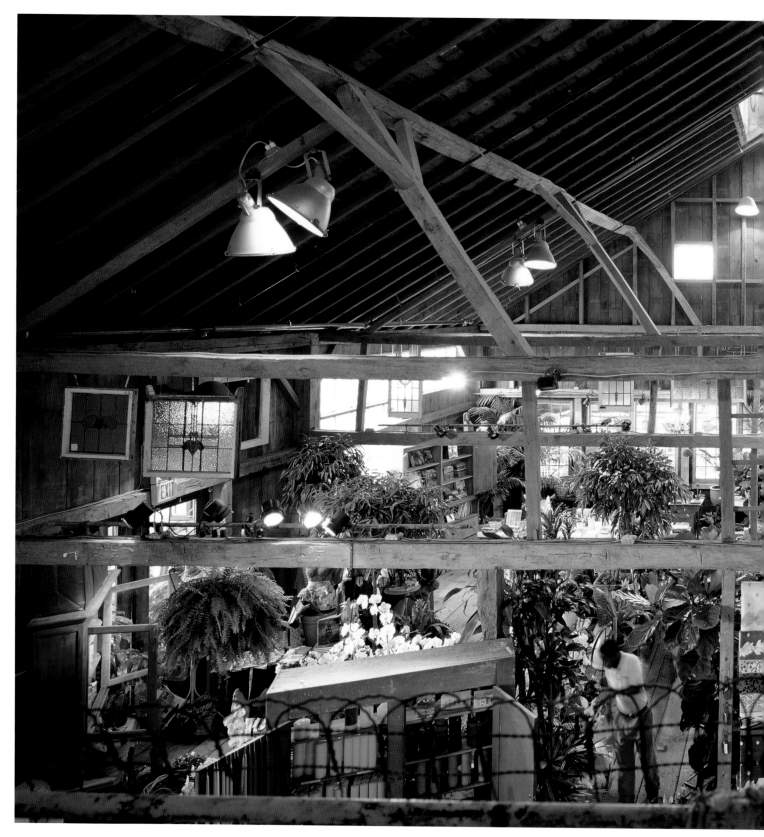

The spare, straightforward economy of great timber-framed structures, originally created as utilitarian storehouses, exemplifies a remarkably contemporary character. Relieved of the burden of the haymow, these frames become armatures on which personal or commercial collections may be displayed to extraordinary effect.

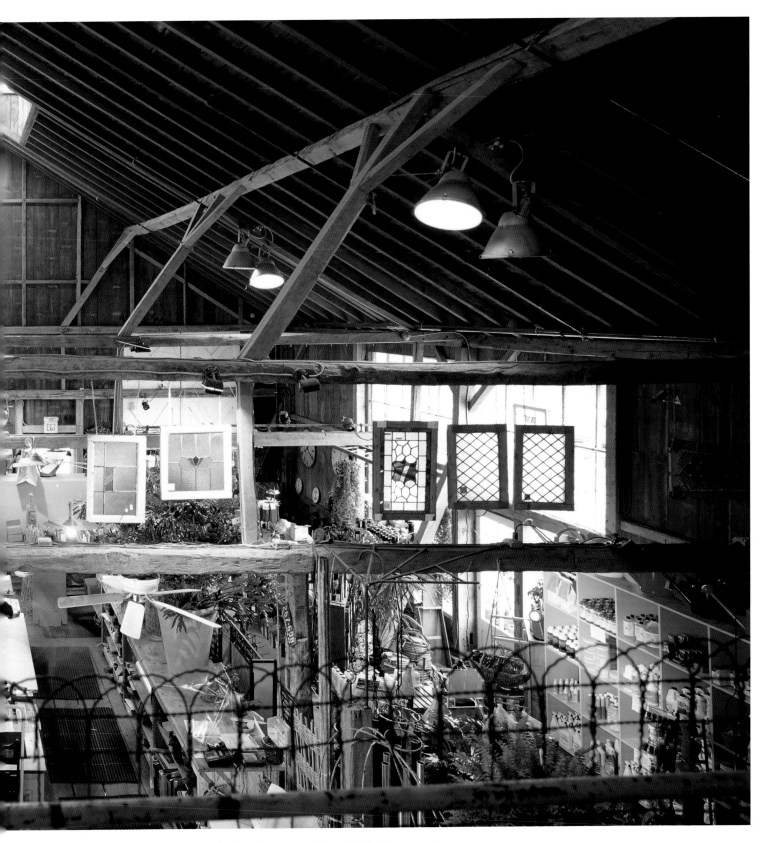

Maarder's Garden Center in Bridgehampton, New York, is a case in point. The central ladders and inclined purlin struts reveal its origins in Swiss-German Pennsylvania, but as a great exhibition hall it has more in common with the function of Sir Joseph Paxton's Crystal Palace.

Adaptation of ancient timber frames is by no means limited to the New World. Nor is the notion of transforming a barn into an attractive garden center. Old buildings give new enterprises the luster of authenticity. This eighty-foot barn and its adjoining cattle hovel were moved twenty miles to a new site in Sussex, England. Patrons can celebrate their gardening selections over a cup of tea in this splendid example. Public structures offer the passerby a welcome opportunity to venture inside barns representative of local building traditions.

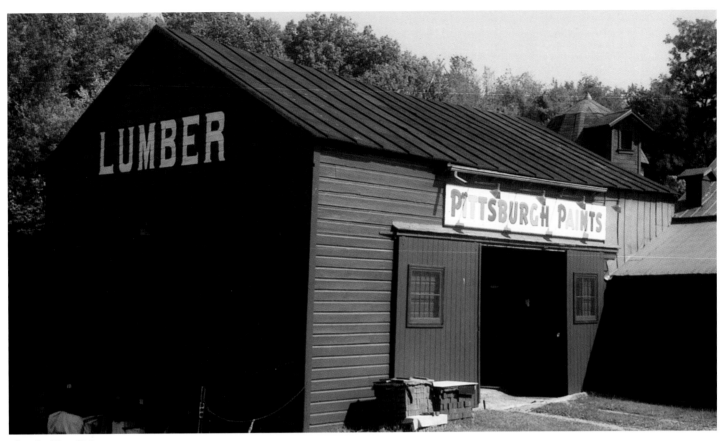

Copake, New York.

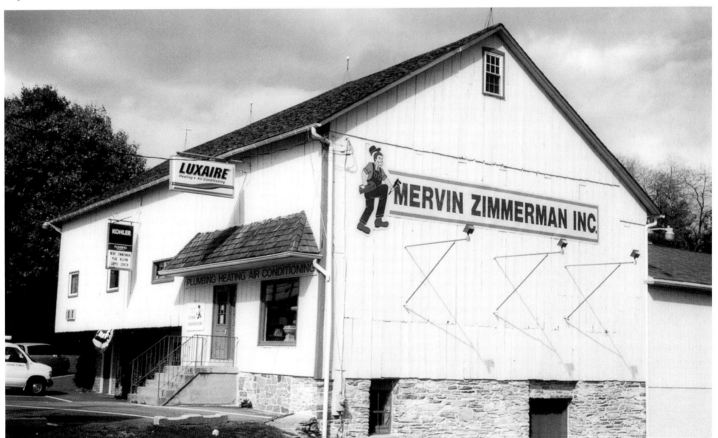

Lititz, Pennsylvania.

Of the several rational reasons, practical and aesthetic, for rescuing barns from destruction, perhaps none is so compelling as their sheer capaciousness. Dotted along the old roads of eastern America is a diverse roster of retail businesses housed in barns. Lumberyards and hardware stores long ago adopted these large, open structures to serve their stocking requirements. One mid-nineteenth-century hewn, three-bay barn in Copake Falls, New York, was adopted in 1950 by Copake Lumber and Supply to house a hardware and lumber

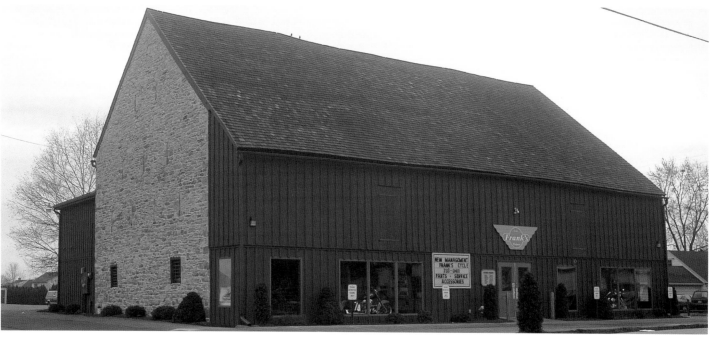

Above: Frank's Cycles near Ephrata, Pennsylvania. Below: A bicycle store in West Woodstock, Vermont.

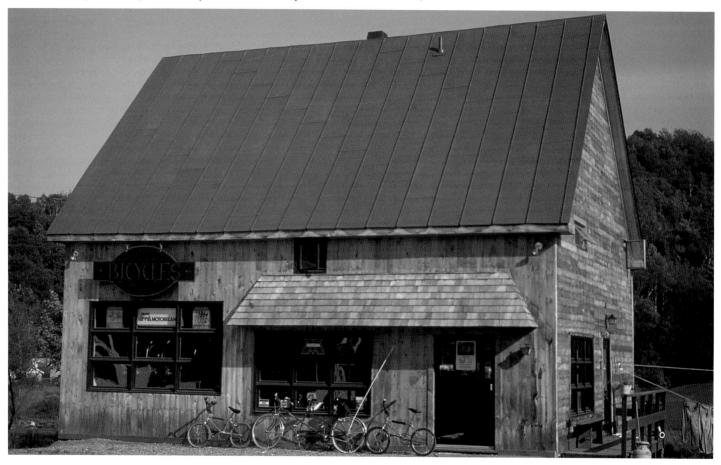

business. For many years the silo served as the office. Another example is Mervin Zimmerman's Supply in Lititz, Pennsylvania. A motorcycle shop now inhabits a streetside, stone-gabled barn near Ephrata, Pennsylvania, and a bicycle store occupies a Woodstock, Vermont barn, while the Family Arts and Crafts Center appropriates a great double-cupola barn near Ludlow, Vermont. And near Hecktown, Pennsylvania, a round-up of recreational vehicles has replaced the dairy herd in the farmyard of a venerable Swiss-German bank barn.

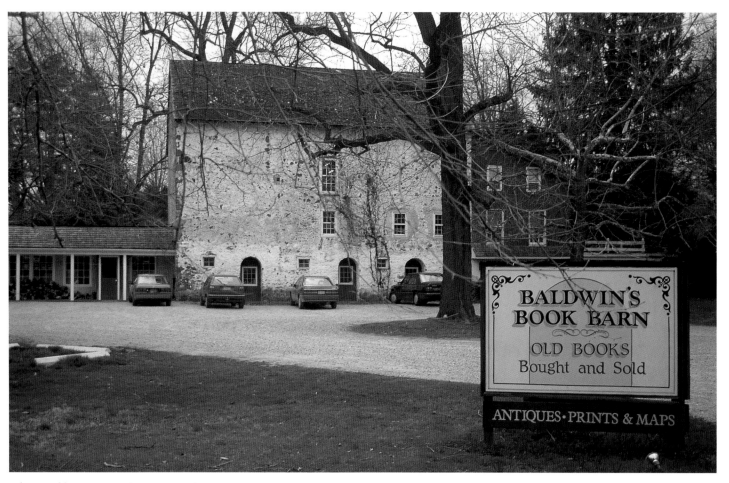

Above: Baldwins in Brandywine, Pennsylvania. Below: The Book Barn in Dryden, New York.

Ephrata Cloister, Pennsylvania.

Books and barns have a longstanding compatibility. Shelves of books have supplanted sheaths of grain in a number of venerable structures. In New York, the Bookbarn in Etna and the Book Barn of the Finger Lakes in Dryden are but two of many examples. In Pennsylvania, Baldwin's, though founded in a mill, has made a great stone barn in Brandywine its home for nearly sixty years. Another Pennsylvania barn serves as a museum store for books and handicrafts at the Ephrata Cloister in Lancaster County. On the other hand, until recently The Computer Barn in Harlingen, New Jersey, offered a more contemporary source of information. At an earlier time it acted as a toy store; today it houses a contracting firm.

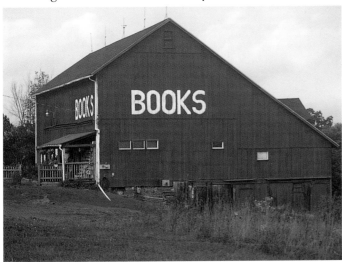

Etna, New York.

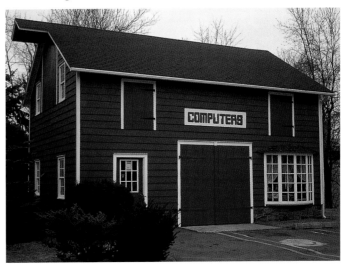

Harlingen, New Jersey.

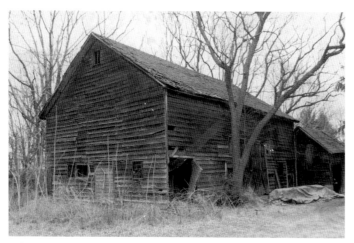

The barn at Woodcliff Lake, New Jersey.

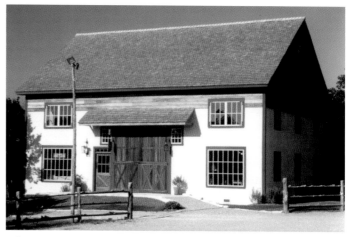

The same barn in Waco, Texas, and its interior below.

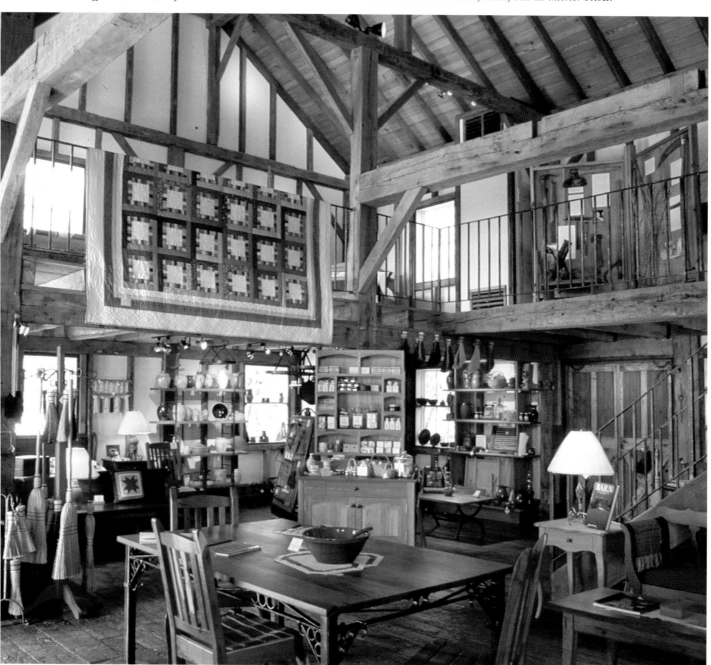

102

For years the passing traveler on the Garden State Parkway might have cast a furtive glance at the gradual undoing of a once-proud barn just beyond the roadway's grassy verge near Woodcliff Lake, New Jersey. On closer inspection the interior revealed a rather delicate Dutch-English hybrid frame fashioned of white oak and chestnut timbers. The deteriorating structure seemed destined for destruction. Its unlikely salvation came through the intervention of a transplanted Jersey native, who had become a member of a remarkable enterprise near Waco, Texas.

Reminiscent of the Shaker settlements of the nineteenth century, Brazos de Dios in Elm Mott is a Christian settlement that strives "to restore traditional patterns of family and community living – patterns for home-steading, self-sufficient farming, gardening and home-schooling, together with homestead crafts and practical skills." Central to its daily ethic is the chance for youths to learn traditional farming with animal traction, as well as other skills and crafts such as blacksmithing, basketry, beekeeping, broom making, baking, pottery, soap making, spinning, dying, weaving, turning, joinery, and carpentry. The sale of the organic produce and traditional products resulting from these diverse endeavors funds the community. By the mid-1990s a showcase for this commerce was needed, and it was to this end that the barn near Woodcliff Lake became attractive.

Over the summer of 1997 several youths ranging in age from fourteen to twenty-two helped the community's master carpenters with the painstaking disassembly, repair of the structure, and eventual reerection at Brazos de Dios. Today, the Durfee Barn stands rejuvenated not just as a showcase for smaller crafts but for the art of timber framing, as well.

Having become versed in the exacting skills of traditional timber framing, including the vagaries of disassembly, rehabilitation, and reassembly, the young artisans from Brazos de Dios resolved to return to the Northeast, where other fine frames, having passed their days of usefulness, were available for removal. In much of the Catskill region in upstate New York, the population at the turn of the twenty-first century is smaller than it was when many of the local barns were built nearly two hundred years ago. Among the several structures since relocated are the Briggs Dutch Barn, erected about 1790. It stands today near Austin, Texas, reclad in dramatic, if historically incorrect, materials – glass and stucco over the framed walls and thatch on the roof. As a catering facility it hosts more than a hundred weddings yearly. The Cooke Barn from Florida, New York, is a huge forty-by-ninety-foot structure with two threshing floors. The forty-foot width is spannned by three steel-rod king posts, a nice feat of engineering. Also raised to serve as a site for large events, the Cooke Barn has been more faithfully restored near Dallas.

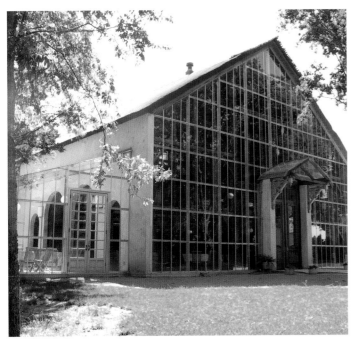

The Briggs Dutch Barn.

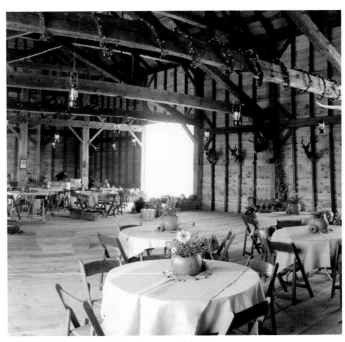

The Cooke Barn, ready for a harvest celebration.

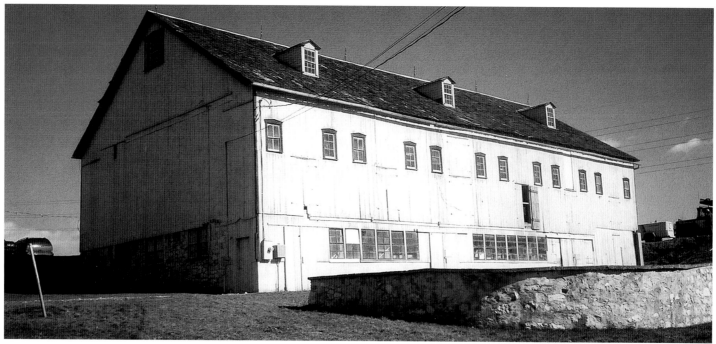

The Johns Barn before conversion.

In 1993, a Pennsylvania firm that specializes in site and utility work purchased an old Lancaster County farm that they had previously leased for their dispatch and field operations. A few years later plans were put in place to rent the old stone farmhouse and remove the substantial bank barn in order to replace it with a new office and shop facility. Ironically, much of the requisite demolition equipment was already stored on the site. A prescribed historical report on the property, however, initiated a new perspective on the project. The farm of 118 acres was settled in 1796 by two Mennonite brothers, Peter and Christian Johns. Their surname was an anglicized version of the name Tschantz, said to originate in the canton of Bern in Switzerland. Rarely is it possible to establish such a direct connection with a crucible of European cultural heritage. After Christian died in 1797, Peter built a barn which burned down only four years later. A translation from the original German of the datestone tells the tale,

> *This barn was built by Peter and Christian Tschantz in the year 1797. It was burned by lightening first of September 1801 and was with the help of friends and neighbors rebuilt by Peter Tschantz in the same year.*

The site work contractor and his family, appreciators of antiques, were very much affected by such raw testament to family tragedy and community response, especially because they were still manifest in the monumental Switzer Barn that had served the Johns farm for nearly two centuries. With new respect for the structure, they determined to forgo demolition in favor of conversion into the company's headquarters. To that end the family sought and found architects, designers, and skilled artisans who together worked as a team to document the original structure, strip it of subsequent alterations, and reconfigure it to renewed vitality. Their common attitude was expressed by the architect, who stated, "I . . . prefer doing work with old buildings because of the sprawl issue; we have to make use of the buildings we have. [Conversion of these structures] maintains our heritage. [They] identify who we are. Unless we start saving some . . . they will be lost forever."

According to the datestone, although the Johns Barn was raised within four months of the fire that consumed its predecessor, the structure which was fashioned in that short time is vast, measuring fifty by ninety-eight feet. In typical Switzer fashion, its functions were segregated: stalls in the cellar, threshing and hay storage above. Materials were straightforward and immediately available. Segregation of tasks and basic materials became tenets for its most recent transformation. New construction materials, though true to earlier notions of simplicity, are easily distinguished from the original fabric. As the architect pointed out, "A barn is about as honest as you can get. The old has its own vocabulary, and the new has its own vocabulary."

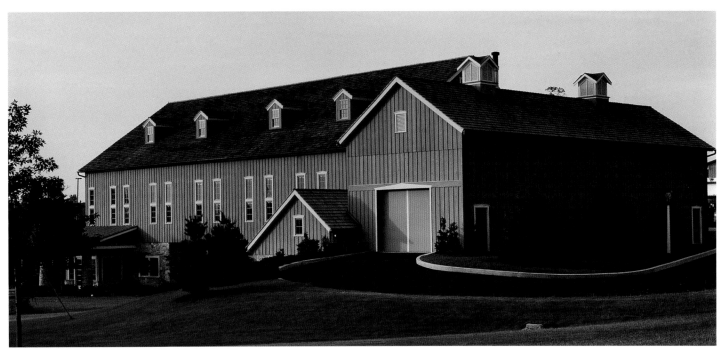

The Johns Barn after conversion.

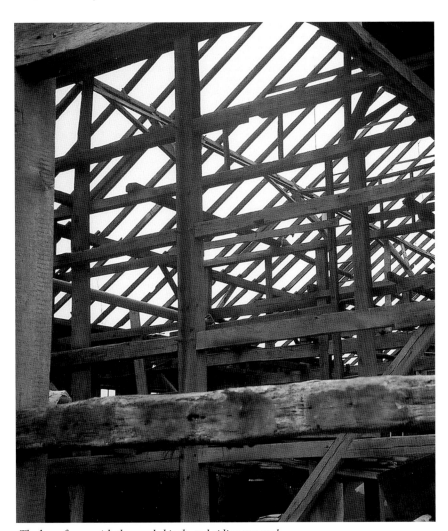

The barn frame with the wood shingle and siding removed.

Some of the resulting adaptations are particularly successful, others less than satisfying. In its original form the Johns Barn displayed a wonderful rhythm of fenestration, alternating windows with winnowing doors, further punctuated by dormers along the hundred-foot length of the roof. While the forebay elevation has been modified somewhat with additional windows and dormers, the rhythm has been retained. The recessed overshoot, stripped of subsequent concrete walls, once again allows light to penetrate the lowest level past wonderful stone piers. On the other hand, contradicting the dictates of distinguishing old from new, the use of these same piers for a superfluous entrance porch diminishes both the new add-on and the original forebay it emulates. The use of *board and batten* siding in place of the original, customary flush boards appears to be a further lapse in the stated tenets of the plan for the barn's transformation. It is the interpretation of such seemingly inconsequential details that distinguish renovation from restoration.

In terms of arrangement of internal functions the cellar is entirely new but nonetheless true to its original configuration. Starkly imitating the stalls they replace, new estimators' offices are divided by partitions complete with iron bars. In keeping with the use of discrete materials, the floor is laid in local flagstone while stairs to the main level are detailed with black steel railings. Heating, lighting, electrical tubing, and sprinkler piping are similarly exposed but painted black to contrast with the original timber frame. Upstairs, however, the original dominance of the threshing floor has been diminished. Once open, with flanking ladders climbing to the rafters, the barn's most dramatic space has been truncated by the awkward insertion of a ceiling above the tie beams to create a sort of attic. By diminishing the impact of the spaces above and below, this misguided interruption forsakes the integrity of the original structure. Still, such details of interpretation should not supersede the praiseworthy determination to rescue the barn from demolition or the cooperative effort in that transformation, which mirrors the community enterprise that raised the structure from the ashes of the first barn erected by Peter and Christian Tschantz long ago.

View of the main stairway.

Interior offices receive natural light through new horse-stall partition walls.

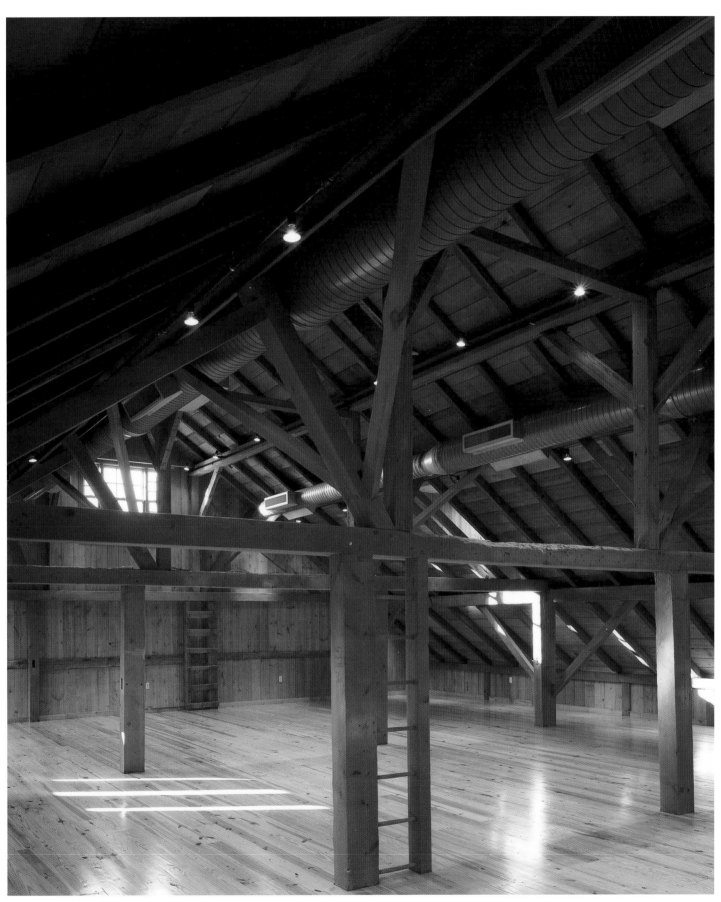

The new third floor is used as the employees' meeting room.

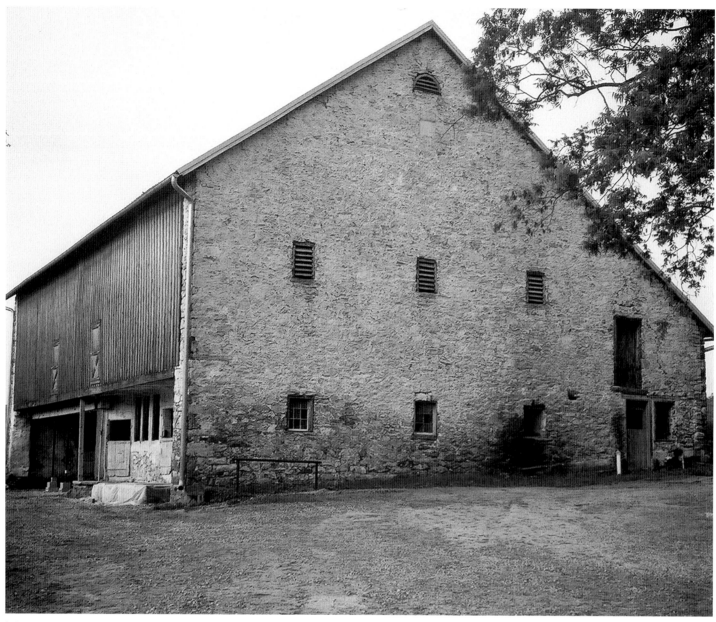

The Slaymaker Barn before conversion.

Another Lancaster County agrarian storehouse that has been converted into a business facility is the grand, stone-gabled William Slaymaker Barn. Built in 1816 according to the datestone situated just under the semi-elliptical gable louver, the main section of this bank barn measures forty-five by seventy-four feet with granary lean-tos on the upland side. As is typical among masonry examples of the Swiss-German plan, the fourth wall of the building, above the cantilevered overshoot, was framed with doors opening off the double threshing floors to channel the breeze during winnowing. Windows at the cellar level provided light for milking, while louvers at the haymow level allowed for ventilation to dry or cure the hay. The conversion strategy strove to retain most of these features.

Alterations to the recessed wall under the forebay were removed and, in a concerted effort to match the existing material, stone was appropriated from an old railroad bridge that stood just to the south of the barn. The gable walls were cleaned and repointed, but unfortunately the smearcoat of stucco, a prevalent feature in the early nineteenth century and likely original to the barn, was not reapplied. Likewise, the louvers were restored with insulated glass added to the inside, but sadly, the winnowing doors were eliminated in favor of an odd, blank wall. The overall effect, however, is admirably true to the original character of the barn William Slaymaker raised to shelter the bounty of his farm.

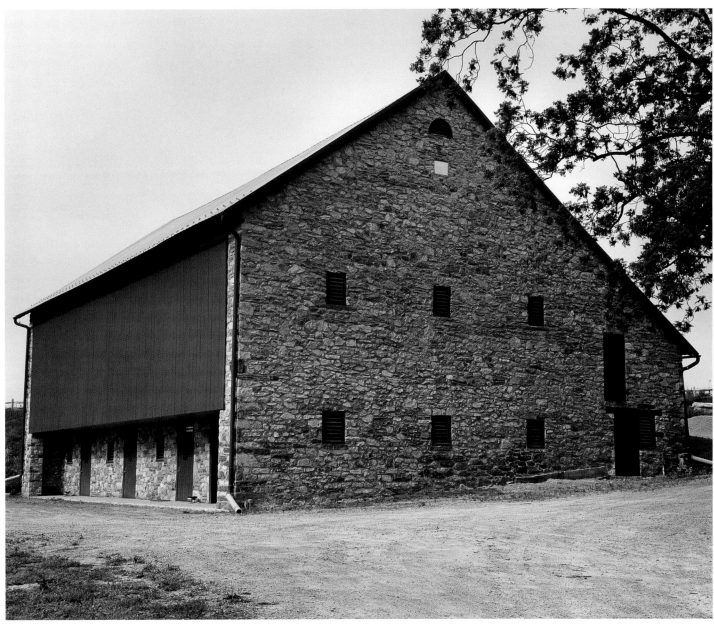

The Slaymaker Barn after conversion.

Conversion of the Slaymaker Barn was undertaken by a
large Lancaster County construction firm that operates a
nearby quarry supplying gravel for road building.
Among the several uses for which the barn has been
employed is testing of road-paving materials. To this end
the cellar has been outfitted with laboratory stations.
The upper space is reserved for storage of heavy equip-
ment necessitating a steel-reinforced concrete floor, above
which the original timber-frame structure has been left
intact. The adaptive reuse of the formally moribund
barn has been accomplished with only minor alterations
to the original structure.

Interior of the barn before reconstruction. The floor joists have been removed and the main beams temporarily shored.

Steel columns and bar joists, metal decking, and concrete floor slab have been installed.

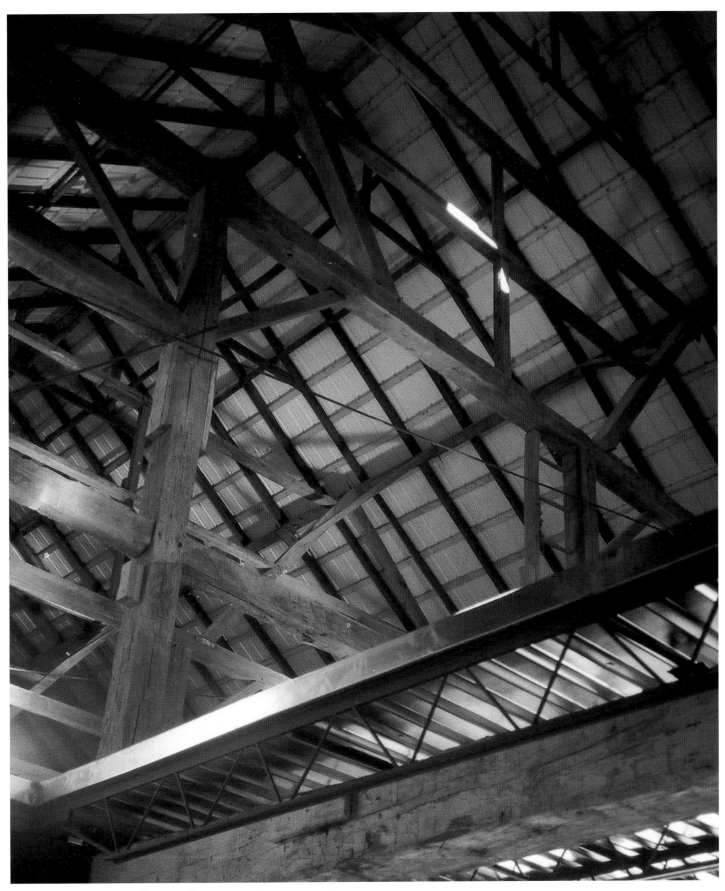

View up through the stairwell opening during construction.

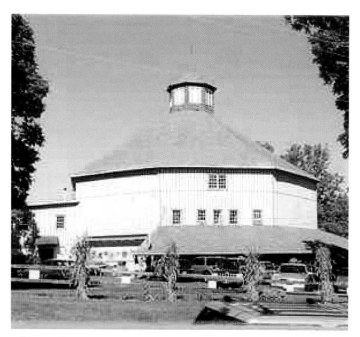

The Linvilla Barn before the fire.

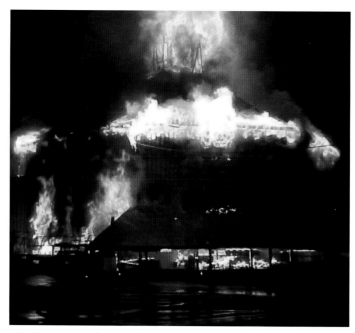

The blaze exposes the main frame and cupola.

Of all the polygonal barns that came to decorate the American landscape, few were as ambitious as the giant octagonal cow barn built near Middletown, Pennsylvania, in 1889. With side walls more than forty feet long, it was said to reach a height of nearly eighty feet from the cellar floor to the peak of the cupola. A published history of the farm recalls its original operation: "Attempting to utilize the labor-saving devices of the industrial revolution, the octagon barn served as a factory for a large dairy herd." As in the case of other polygonal barns, the forty cows were arranged around the perimeter, their heads facing into the central space which contained a well and a chute from the haymow. The extraordinary mow filled the core of the upper structure all the way to the rafters. It was girdled by a circular floor where several hay wagons could be simultaneously unloaded at harvest time.

Sensing the changing nature of agriculture, an enterprising young man, Arthur Linvill, purchased the farm in 1914 and commenced replanting the three hundred acres of pastureland with peach and apple trees. In Autumn when they bore fruit, seeking local patronage, he drove a wagon around the vicinity selling door to door. In time the popularity of his produce reversed the process and

customers came to him at the farm with the distinctive eight-sided barn. Sales were conducted from the front porch until volume demanded that the enterprise move to the barn itself. As the surroundings became increasingly suburban, the remarkable structure at Linvilla Farm became more than a destination, more than a venue; it was the core to a richly rewarding experience shared by legions of customers with at least four generations of the farm family. The annual Johnny Appleseed Arts and Crafts Festival and Pumpkinland were but two of the seasonal events held in and around the great barn.

On the morning of Friday, 15 August 2002, disaster struck. Fire! Despite the efforts of thirty-four fire companies the day-long conflagration consumed all but the foundation and skeletal framing remnants of the once-majestic barn. Well-wishers lay flowers beside the Linvilla Farm sign as a testament to their appreciation of the family and fond memories of the barn. Then, as a community, they got to work with the family to assure that the business, though bereft of its sheltering landmark, would continue to prosper. Someday, once the enterprise has fully recovered, perhaps the barn may rise again.

Public Spaces

This cutaway drawing shows a mule at work on the treading floor and a slave raking the grain below.

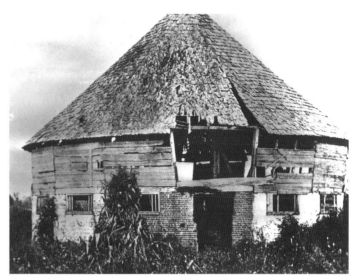

An early photogaph of the disused barn.

In addition to his seat at Mount Vernon, George Washington, who considered himself a "scientific farmer" before all other callings, acquired several adjacent properties, which he maintained as five separate farms. Though his military and political careers forced him to endure long absences from his farming affairs, he nonetheless planned and directed from a distance constant improvements to his house and holdings. One of the most notable of these works "put under way" during the early years of his presidency was the construction of a remarkable "circular," or more accurately sixteen-sided, barn at Dogue Run Farm. Largely of his own invention, it was two stories high and sixty feet in diameter. One aspect of its ingenious design was that it "was so arranged that when rain drove the farm help out of the fields they could here under shelter, in the second story, thresh out the grain on a ten-foot floor of open slats which entirely surrounded the central mows." This level was reached by a ramp, a device previously unknown among his neighbors, which allowed the access by horses and oxen alike to the circular "treading floor." Their stalls were situated below in the cellar story. Like most of Washington's properties, by the 1870s the barn had fallen into disrepair, as evidenced by a period photograph that provided essential information a century and a quarter later for restoration of this bold experiment in agriculture.

Below and opposite: Stages in the construction of the Dogue Run Barn.

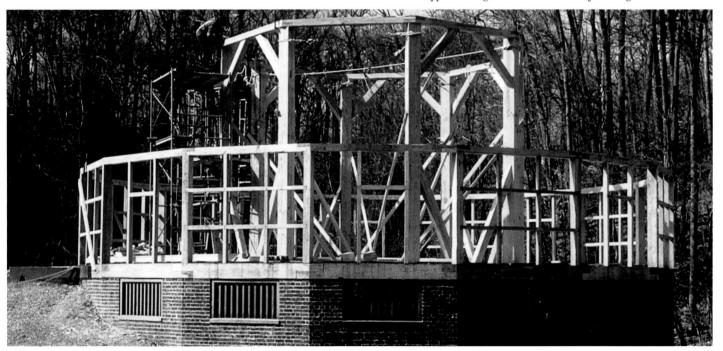

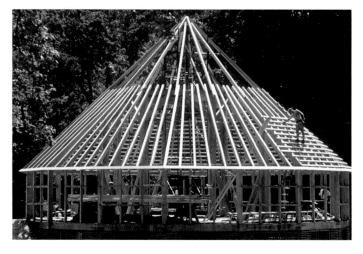

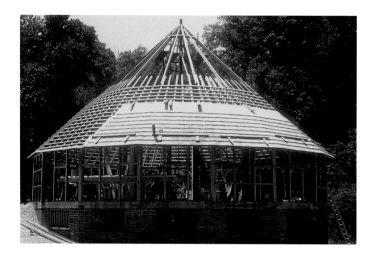

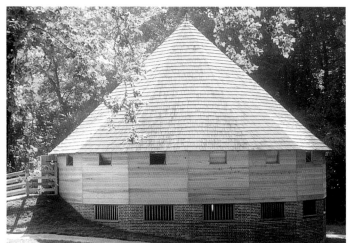

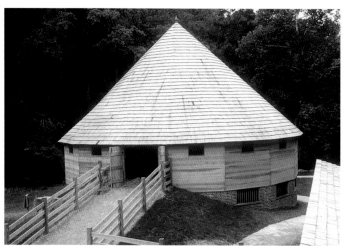

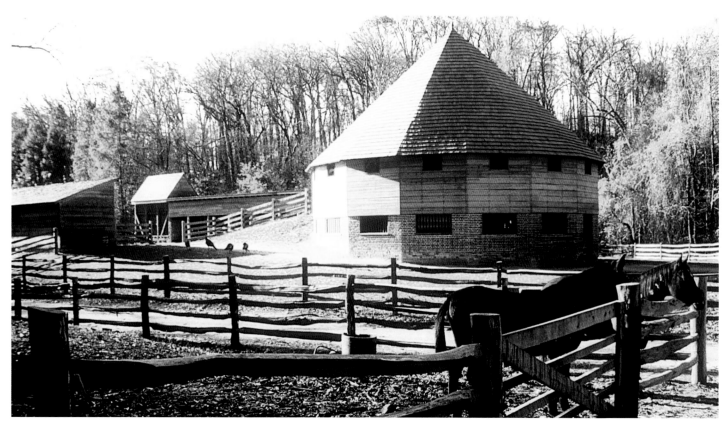

Near Montrose, Pennsylvania.

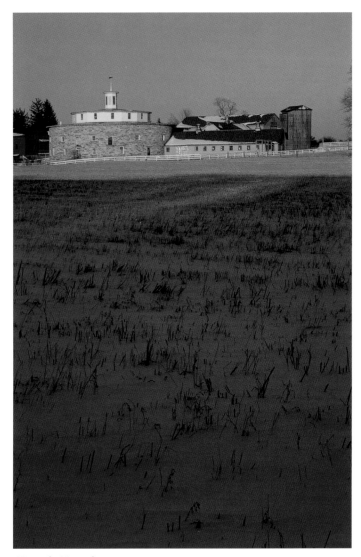

Hancock, Massachusetts.

Although the earliest use of polygonal barns in America dates back to the eighteenth century, widespread adoption of this form may be attributed to the publication in 1853 of Orson Fowler's popular treatise, *The Octagon House*, in which he poses the rhetorical query:

> *But can [the octagon] be applied to barns with equal advantage? It can, perhaps, comparatively, with even greater. In them we need some common center in and around which to work. This form openings to all the bays and bins toward this center, so that one can pass from bay to stall, and from every part to every other, with half the steps required in a square one . . . If of*

> *average size, this form will enable you to . . . drive wagon or cart around in a circle . . . so as to pass out where you entered . . . besides furnishing just the shaped floor required for threshing with horses. . . In any and every aspect, the octagonal form of barn facilitates all the ends of a barn far better than the square.*

Round and polygonal barns thereafter flourished in the years from the end of the Civil War until the Depression from New England to Indiana to Iowa. The hexagonal, tin-roofed barn commands a wide view near Afton, Minnesota. The round, ramped structure still serves farming needs near Vermont's Connecticut River Valley.

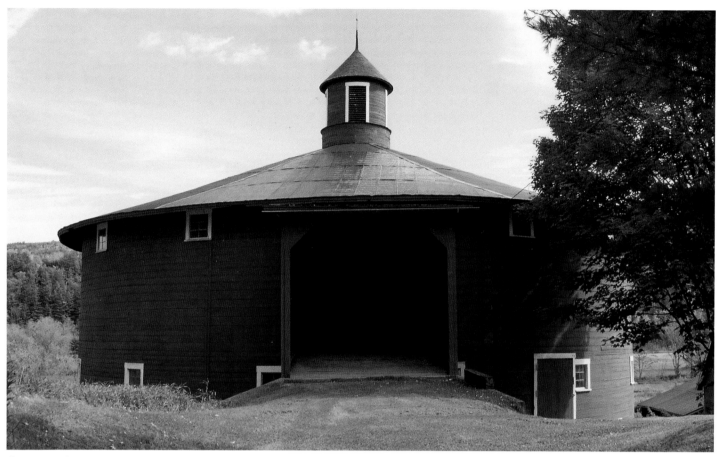

Passumpsic, Vermont.

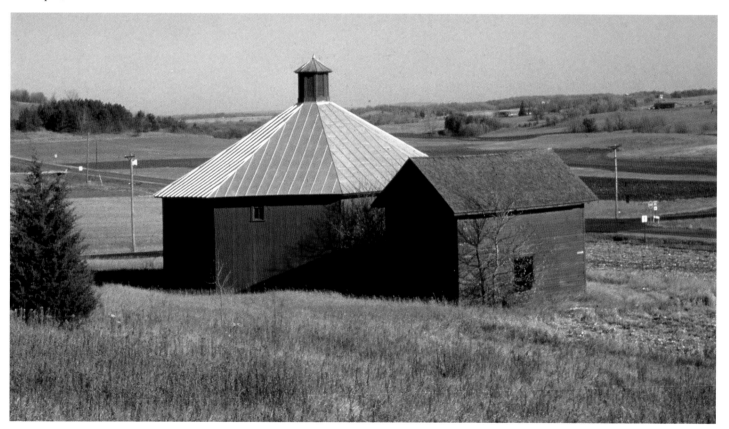

Afton, Minnesota.

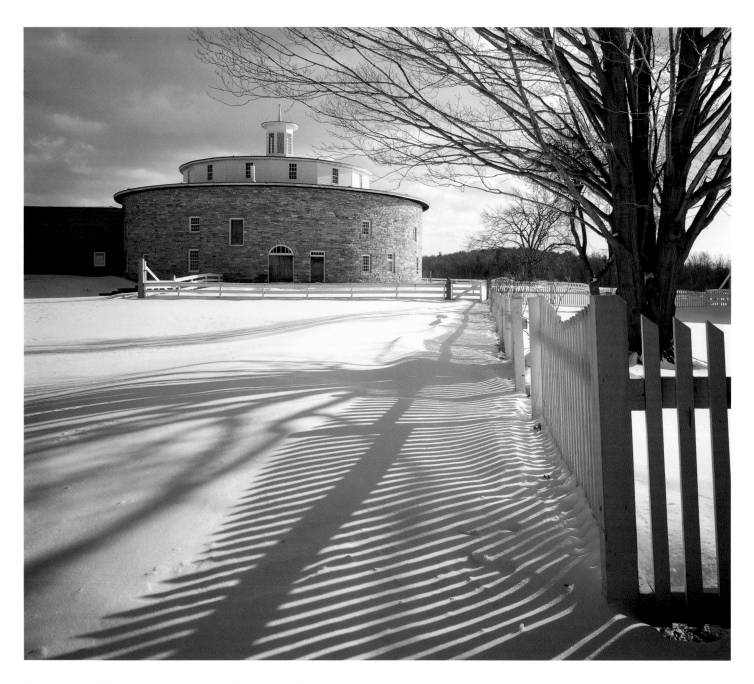

Because the Shakers were renowned not only for straightforward principles of design but for their ability to synthesize and simplify the innovations of others, it is not surprising that they adopted and adapted the centered polygonal barn. In 1826, at the Shaker community at Hancock, Massachusetts, Elder Daniel Goodrich set out to design and raise one of the largest round barns in America. Girdled in stone and rising to a height of three stories, the immense structure was approached by ramps on two levels. Fifty dairy cows were installed on the second story, their heads facing the central haymow across a circular walkway. Trapdoors behind them accessed the cellar, which was reserved for collecting their manure. Most ingenious was the top floor where hay wagons were driven into a circular perambulatory from which hay could be pitched down into the huge central mow. The original timber frame, which featured a vast conical roof, was destroyed by fire in 1864. Its replacement was largely constructed of dimensional lumber with a flattened roof topped by a multi-windowed clerestory and cupola, both measures directed at fire prevention. A century later the stone walls were entirely relayed, so in fact, little actually remains of the 1826 structure.

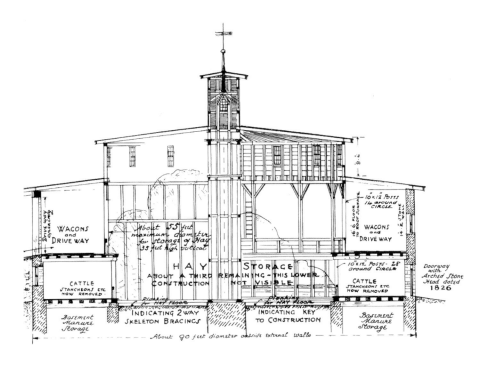

Above and below: The Round Barn at Hancock Shaker Village showing its divisions of activity at the end of the nineteenth century. About sixty tethered cows faced inward towards the haymow.

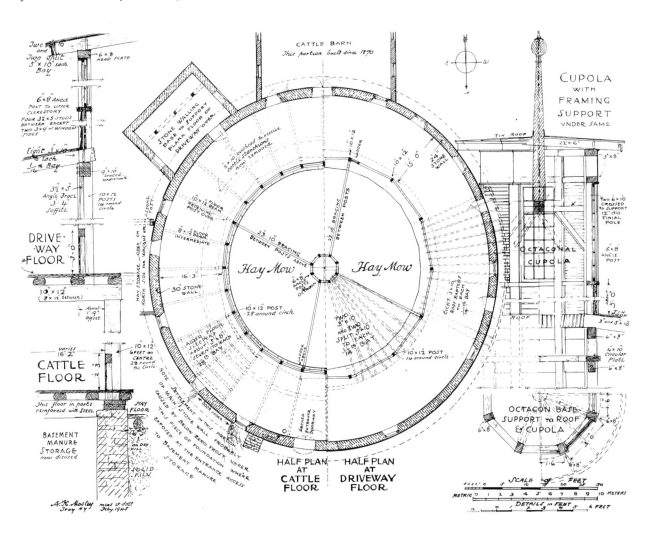

A detail from a recent antiques fair.

The round barn at Hancock proved to be highly efficient, requiring less labor by fewer brethren, but it was not emulated by other Shaker communities. This seeming incongruity is apparently explained by the strict dictates of the Lebanon Community, which required that buildings be built with "right angles and straight walls." The influence of the circular structure outside the sect was widespread. Today it has achieved iconic status in the American architectural vernacular. Thousands of visitors tour the building as a principal attraction at Hancock Shaker Village. It also serves as the site for numerous events including an annual antiques show.

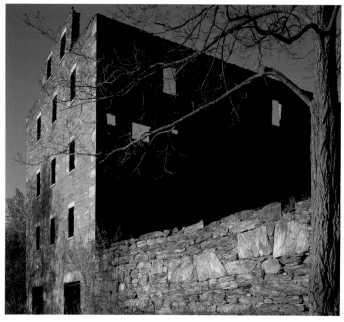

The "right angles and straight, thick walls" of the 40,000-square-foot neighboring Mount Lebanon Shaker Village Barn await rebuilding as the new home of the Shaker Museum. Like the Hancock Round Barn it was the victim of a fire. The conflagration occurred in the early 1970s.

120

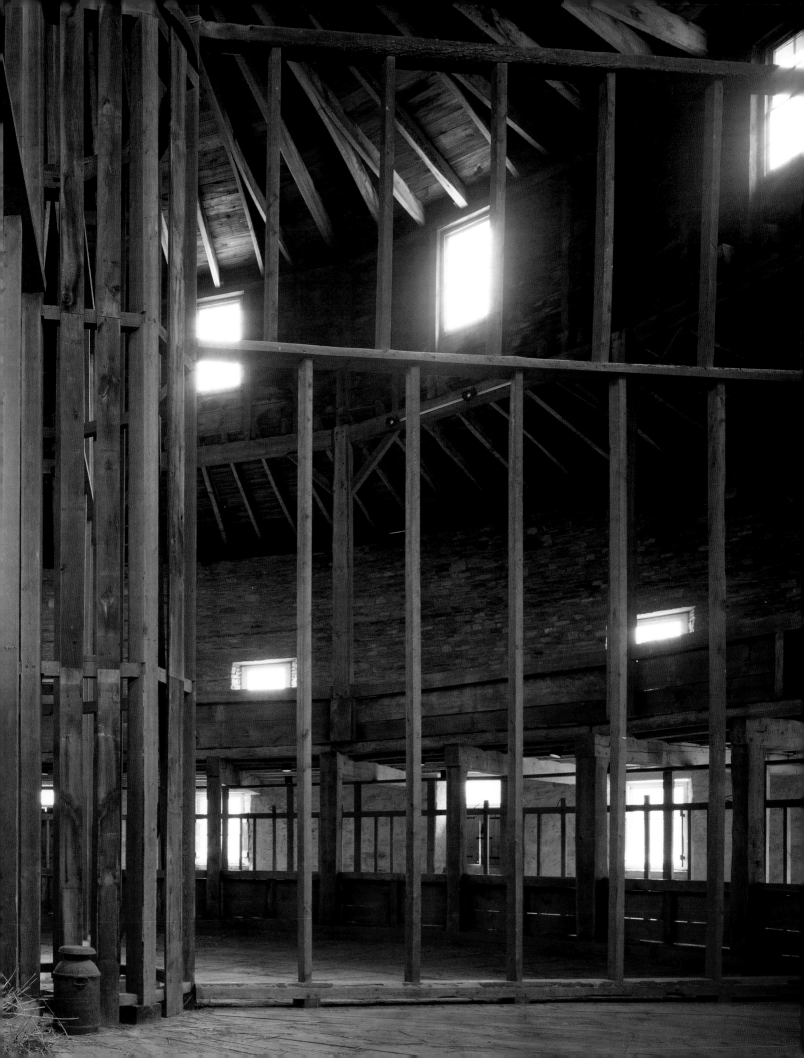

Following the Centennial Exposition in Philadelphia, in 1876, architects from the United States, though schooled in the European Beaux Arts, rekindled enthusiasm for the stylistic conventions of buildings from the Early American period. With a wealth of examples from which to draw, regionalisms were recognized and adapted locally to the style which became known as the Colonial Revival. For Philadelphia and its environs, the stone houses, barns, and outbuildings that distinguished the farms of both English and Swiss-German settlers became the vocabulary for suburban houses and country estates. Measured drawings from books and monographs documenting eighteenth-century buildings enriched the resulting structures with discerning detail. No other architect

No other architect was more practiced or proficient in the Pennsylvania Colonial milieu than R. Brognard Okie (1875–1945), whose stone mansions dotted the Main Line. In 1934 he was commissioned by Robert J. Boltz to create an estate on ninety-seven acres near Solebury in Bucks County. Dominant among the several buildings he designed is the 1935 horse barn. Okie's predilection for precedent endowed the structure with a number of Pennsylvania conventions. Laid up in local stone, the exterior is dominated by broad doors to the double "threshing floors," flanked by projecting "granaries." Inside, loopholes perforate the gable walls while a timber frame fashioned from reused, hewn-oak timbers integrates features such as ladders and inclined purlin struts.

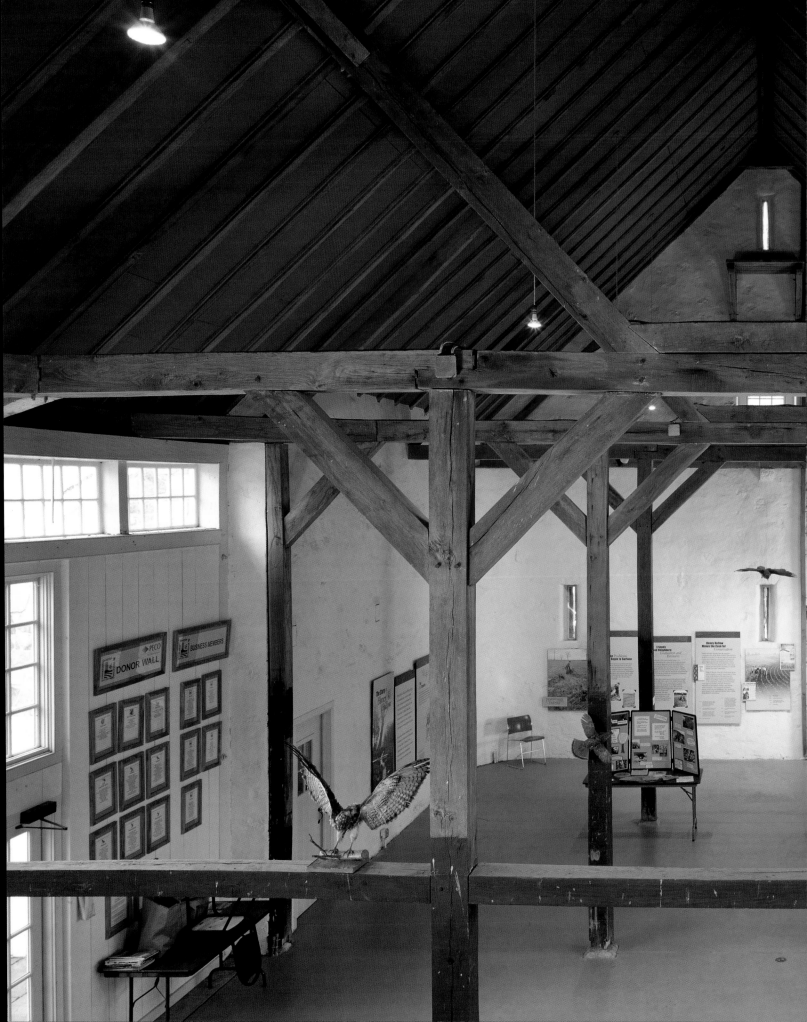

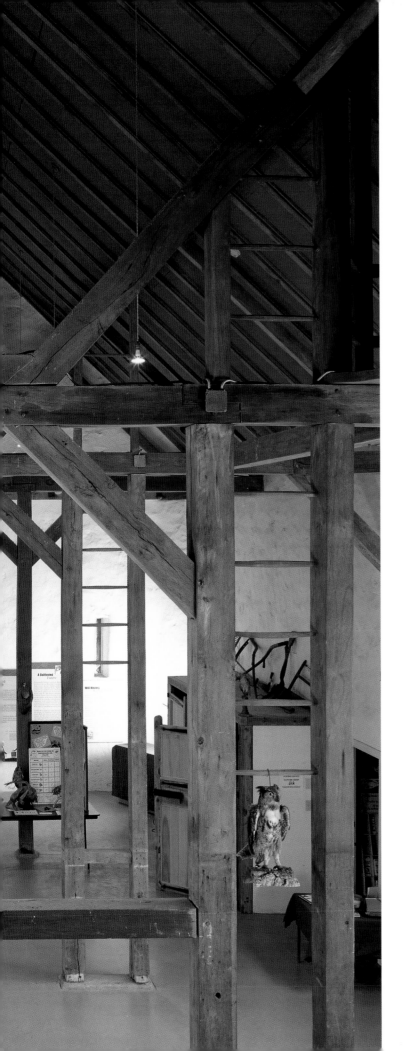

In the 1930s, landowners in the Solebury area, recognizing the importance of enlightened soil and water conservation, created the Honey Hollow Watershed. A model for similar programs across the nation, Honey Hollow was designated a National Historic Landmark in 1969. In the early 1980s, 110 acres within the protected valley, including the Boltz estate, were donated or acquired to establish a base for the Bucks County Audubon Center. Through sustained fundraising, plans were actualized to convert the former horse barn into a visitors' center. Today the great interior spaces it defines are variously appropriated for exhibitions, classrooms, a nature bookstore, offices, and catering facilities for public and private functions. One annual event is a well-attended lecture and reception preceding a tour of outstanding local barns.

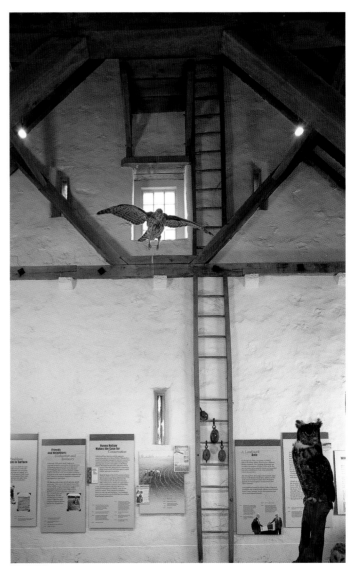

As a background to the many indoor and outdoor activities, the barn has a permanent display of exhibits and educational aids.

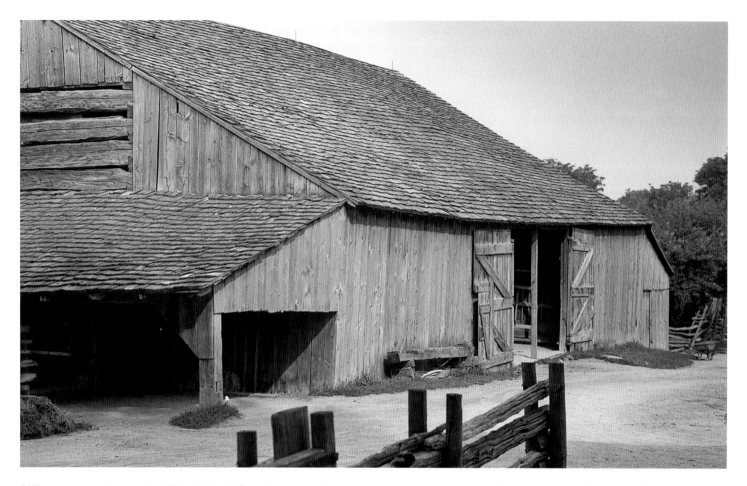

Wherever settlers to the New World found acreage for farming, the first impediment to be faced was likely to be the great forest, which soon rang with the rhythms of axes clearing the land of virgin timber. Next came the thankless labor of extracting stumps and rocks to expose soil for the first crucial crops. With providence, such arduous effort eventually rewarded the hardy home-steader with loamy soil and abundant timber and stone for building. Even the stumps were used as fencing. A superfluity of timber often resulted in log structures, particularly in areas of Swiss-German settlement where that tradition was most familiar. These boasted several advantages over timber frames in that only two sides of each member required hewing, notched corner joints were more simply fashioned than mortise and tenon, and, at least initially, no siding and consequently very few nails were needed. In the case of barns, the form generally consisted of two squarish log pens for mows separated by a broad open breezeway with a tamped earth floor for threshing and winnowing. A continuous roof covered and connected the three sections of these double-pen or dogtrot barns. In the interest of expedition, many examples stood atop *podstones* or low founda-tion walls, but banked log barns were not uncommon

where steeper grades demanded their use. In Pennsylvania, where these structures were first wide-spread, most log barns were in time disassembled and their timbers refashioned to create larger, more accessible buildings. But elsewhere, in less prosperous regions of secondary settlement along the Appalachian chain from Canada to the Carolinas, double-pen barns prevailed long into the nineteenth century.

Born in Pennsylvania in 1791, Daniel Stong emigrated to Canada as a child and, after serving in the War of 1812, settled on the banks of Black Creek near Toronto, Ontario. As the great barn he raised in 1825 manifests, he had by then cleared a considerable acreage of substan-tial timber and, in turn, transformed the land into the source of bounteous harvests. The core of the structure assumes the typical double-pen form with the long roofline extended by full-length timber-framed lean-tos, one of which forms an overshoot. Dovetail notching and mud chinking are meticulous, although infill was deliberately omitted on the gable ends to provide ventilation. The Stong Barn stands today as part of Toronto's Black Creek Pioneer Village.

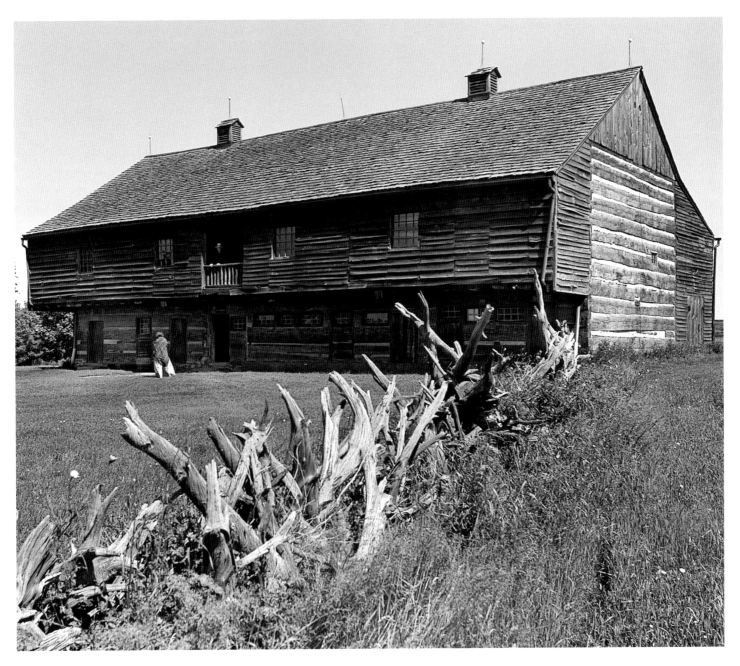

So does the similar Dalziel Barn. Built in 1809 by John Schmidt, another native Pennsylvanian, it was included in a two-hundred-acre tract purchased in 1828 by John Dalziel, a Scot whose family retained the farm for nearly 150 years. The immense bank barn measures thirty by eighty-two feet with an eight-foot, fully cantilevered overshoot running along the entire south side. Dovetailed timbers, which constitute the main structure, measure up to twenty inches in girth. The two cribs, one measuring thirty feet in width, the other twenty, are separated by a thirty-two-foot threshing bay, twice the accustomed width. It stands as testament to the confidence and industry of the sturdy stock who chose to cultivate what was previously wilderness. Both the Stong and Dalziel

barns have been given new roles by reverting to their original forms. They are preserved today not to serve awkwardly the altered needs of contemporary agriculture, but to reflect their original characteristics, educating present and future generations about the nearly forgotten agrarian practices of the past.

The Loucks Farm at Upper Canada Village in the winter, and below, the Loucks barns open for interpretation in the summer.

As in the case of the other American colonies to the south, which gained independence and consequent separation, Canadian provinces displayed individual distinctions of material culture according to the identities of their first settlers. French and English architectural conventions dominated different areas, but each influenced the other to produce novel, enlivening, cross-cultural characteristics, which in time separated New World forms from Old World precedent. Other patterns, introduced by settlers from elsewhere in Europe, as well as loyalists who settled the area after the American Revolution, were established and eventually absorbed into a singularly Canadian tradition. Upper Canada Village, a living history museum, includes structures representing many of these building types. The Loucks Farm is dominated by a substantial stone house built originally on the banks of the St. Lawrence in Dundas County by descendants of German loyalists. Several barns and outbuildings have been relocated to complete the farmstead, including the Summers Barn, a New World Dutch barn. This building type might have been chosen by the Loucks as it was native not just to the Netherlands but throughout the lowland regions of northwestern Germany, as well.

Mrs. Cook's Barn at Upper Canada Village.

The Ross Barn at Upper Canada Village.

Elsewhere at Upper Canada Village stands the one-room log house built by a Scot loyalist, Thomas Ross, who settled near the border between Quebec, dominated by the French, and Palatine German Ontario. Representing neither of these cultures, his barn stubbornly adheres to the structural tenets borne of his British roots. In the center of the village, a Mrs. Cook ran a tavern and a livery barn, and from it rented out horses, carriages, wagons, stabling, and storage space to locals and travelers passing through.

An historic barn in eastern Tennessee.

The German-Swiss log barn migrated from its New World genesis in southeastern Pennsylvania along the foothills of the Appalachians both to the north and to the south. Its popularity was in no small part based on its adaptability. In the North, as demonstrated by the preceding Canadian examples, climatic conditions dictated that the structures include ample room for livestock, most often segregated to the cellar story, recessed behind a sheltering overshoot. In the South, however, animals required no more than a protected tie-up area. The resulting barns, particularly in eastern Tennessee, retain two separated log cribs for hay storage, but these in turn act as base structures to lengthy timbers, cantilevered in all four directions which support a broad, timber-framed upper mow.

Animals could find their own shelter under the wide overhang, without individual stalls. For this reason these variant buildings are sometimes called *drover's barns*. One example stands on a 157-acre farm once owned by the author Alex Haley in Clinton, Tennessee. The Children's Defense Fund, which operates the site as a retreat, commissioned minimalist architect Maya Lin to transform the structure into a library named for the poet Langston Hughes. Barns have served as objects of admiration for many architects, but the desire to achieve conspicuously clever interpretation has produced relatively few successful adaptations. As transformed, the spaces in the Haley Barn remain clearly defined, the pens alternately serving as a bookstore and stairwell, while the stacks and reading room are segregated to the upper mow. Most of the materials are straightforward: random-width vertical siding, slate underfoot in the breezeway, store, and stair hall. New features within are clean, discrete, and clearly delineated from the original structure. But the aggressive skylights strike a note of disharmony. And the introduction of tinted, frosted glass inside the unchinked log walls, the library's most dramatic and remarkable feature, may in the end seem unsettlingly self-conscious.

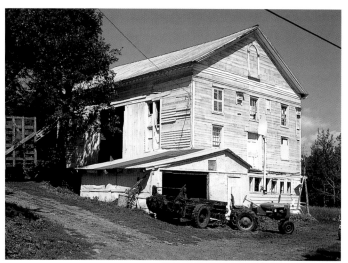

A church converted to a barn in West Durham, New York.

Intrinsically, barns and churches have shared qualities of volume and drama for a thousand years. The first great Cistercian tithe barns, built to shelter communal crops, bear more than a coincidental similarity to the monastic sanctuaries they supported. Buttressed stone walls, arched portals, lance-headed fenestration, worn stone floors, and heavily trussed king post roof assemblies are among their shared features. Visitors to either structure are likely to be left with an inescapable sense of awe. The Northern European Dutch barn was based on the early Christian Basilican plan with a central nave and flanking side aisles. In the New World, ample interior spaces afforded by barns were on occasion adopted by incipient congregations for their services before permanent churches could be raised. In rare instances, the equation was reversed and retired and abandoned churches were amended to fulfill agricultural capacities. In Greene County, New York, in place of parishioners, a herd of dairy cows today find sheltering solace within the former West Durham Church.

Old Liberty Church was established in 1810 soon after the first settlers arrived in Delaware County, Ohio. By 1990, when its old edifice had been outgrown, the notion was advanced, and wholeheartedly adopted, that a new church be raised based on traditional barn design. Precedent existed in proximate Amish communities, several of which still worship in barns. In the Olentangy River Valley, the first major buildings were barns with stone gable ends, a form brought to the area by settlers from Pennsylvania. Assuming this model, designs were drawn to erect a massive barn-like sanctuary capable of seating 1,100 parishioners. To this end, the legendary Amish barn builder, Josie Miller, was enlisted to fashion the gigantic frame. Mortising the timbers, assembling bents, and raising the frame took Miller and his crew of five Amish brethren seven months to complete. Juxtapositions between old ways and new enlivened the process. Much of the time-honored labor was performed in the parking lot. Most of the joinery was executed with traditional hand tools including corner, one- and two-inch chisels, slicks and adzes, but, since the property was not Amish-owned, power tools were also employed. Safety inspectors were partially successful in forcing Amish artisans to wear hardhats, but Miller balked at using safety belts and lines when the men walked the beams, claiming, "The 'boys' have been walking on eight-inch timbers fifty feet up in the air for years. They are careful and don't take risks. You put a rope on them and their balance point is thrown off." When the frame was finally topped off, secondary construction proceeded – much of it performed by parishioners – including sheathing the entire structure with ten- to twenty-foot-long rigid insulation panels. From groundbreaking to dedication, construction took twenty months.

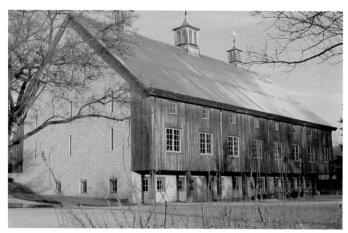

Old Liberty Church.

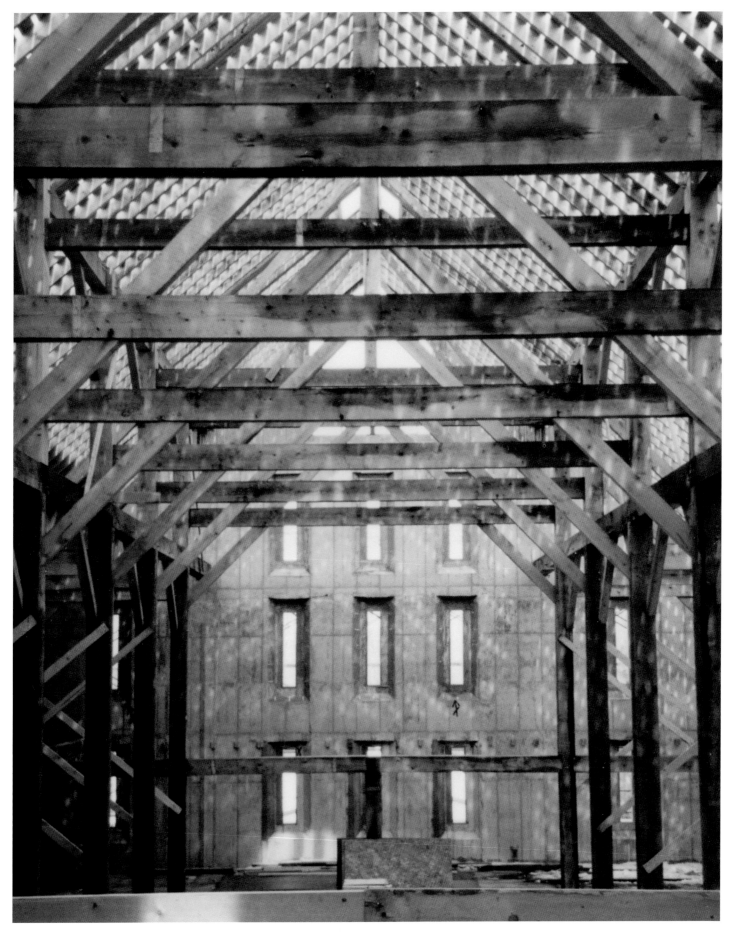

Measuring seventy-six by 120 feet, and achieving a height of seventy-five feet at the ridgepole, Liberty Presbyterian Church found inspiration for its form in similarly proportioned Pennsylvania bank barns. Those structures, however, are split into three or more bays divided by complex framing sections. Ecclesiastical use and the consequent accommodation of a sizable congregation called for reorientation of that axis and an open plan with little or no interruptive framing within the vast interior space. Several non-traditional devices were engaged to achieve the ambitious scheme. Within the masonry gable walls there are seven timber-framed bents. The exterior side walls are also framed. On either side of the central nave two longitudinal framing sections, or arcades, support purlins, which work to transfer the weight of the roof to reduce the rafter spans. Two levels of collar ties connect *queen posts*. Abandoning

traditional practice, timbers are assembled without reference to a common *layout face*, except for the outside walls. The resulting structure employs nearly 500 individual timbers, plus 450 joists and 250 rafters. Most of the requisite framing members were fashioned from a nearby stand of red and white oak. Symbolic of their participation in the raising, individual congregants signed the oak pegs with which the frame is secured. Flooring, lighting, fenestration, pews, and other interior appointments are straightforward but non-traditional, contrasting yet compatible with the frame. The pulpit was carved by a local artist out of the base of a three-hundred-year-old oak that had been felled nearby by lightning. It is perhaps symbolic of the project, which realizes harmony between old and new.

Opposite: The altar showing the carved oak trunk pulpit.

Accommodation

It might be advanced that the notion of using a barn for accommodations stretches all the way back to the Nativity. Ironically, our knowledge of how barns were outfitted in northern Europe in medieval times is considerably broadened by their depiction in minutely detailed paintings of that story. The circumstance of sharing the space within a *bauernhaus* was prevalent in the Old World, and not unknown in the New. So it is not surprising that more than a few barns, retired from agriculture, have been reinvigorated as hostelries and houses.

One popular reconfiguration is the Round Barn Inn in Waitsfield, Vermont. Adjacent to the lodgings of a bed-and-breakfast, it is currently used as a multifunctional cultural center, hosting, among other events, weddings, art shows, and church services. The lowest level contains a lap pool and fitness facility.

The Inn at Waitsfield through the seasons. Above, the barn is seen before conversion.

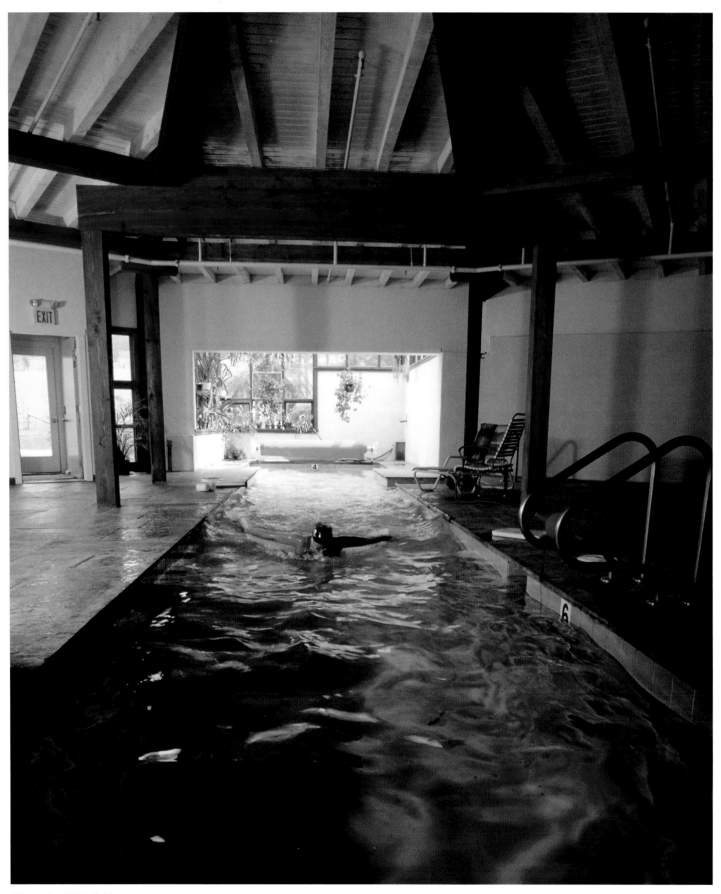

The pool at Waitsfield.

The barn at Race Brook Lodge.

Another rustic retreat has been created from a complex of farm structures in Sheffield, Massachusetts. Within hiking distance of the Appalachian Trail, Race Brook Lodge is based in a large, hewn barn said to date from the 1790s. The main floor of the structure provides abundant space for gatherings and meals, with guest rooms in the lofts as well as a number of secondary outbuildings. Well-worn timbers and flooring give sections of a second barn, reserved for receptions, a warm and welcoming atmosphere, although infilling the exterior walls with plaster and expanses of glass detracts from its authenticity. Barns inherently possess a timeless quality, borne of straightforward design and traditional materials, which is best sustained by restraining architectural exuberance. Clever devices may become dated long before the barn they disserve.

Another larger barn at Race Brook Lodge is used for receptions.

141

In New Marlborough, Massachusetts, the Old Inn on the Green has served as a hospitable hostelry since its days as a stagecoach stop. Rather than expand the original structure to accommodate large contemporary events, a nearby barn complex was acquired and converted. Built at the turn of the twentieth century, the vast Gedney Barn today offers spaces for catered gatherings and galas. A smaller, gambrel-roofed structure in the same complex has been divided into a series of two-story guest suites. Surrounded by meadows, the buildings retain their original exterior features.

On its exterior, the huge hay barn at Gedney Farm displays a lively rhythm of fenestration and a cupola that coordinates it with adjacent secondary structures. The interior, however, testifies to the truth that by the time it was constructed, the great age of American timber-framing had passed. Tradition and craftsmanship had acceded to efficiency and productivity. Sawn, softwood timbers of modest dimension are arranged in an uninspired manner. Yet, while the frame is prosaic, the vast space defined by the structure is quite wonderful. The drama of the barn is emphasized by the glow of indirect lighting. For the reception hall, straightforward design, devoid of intrusive architectural vanities, achieves a space that is chaste, a backdrop that allows each event to endow the barn with its own character.

Opposite:
The barns at Gedney Farm. On the left is the barn for guest accommodation; the large barn on the right is used for receptions and meetings. A comfortable restaurant occupies the ground floor.

142

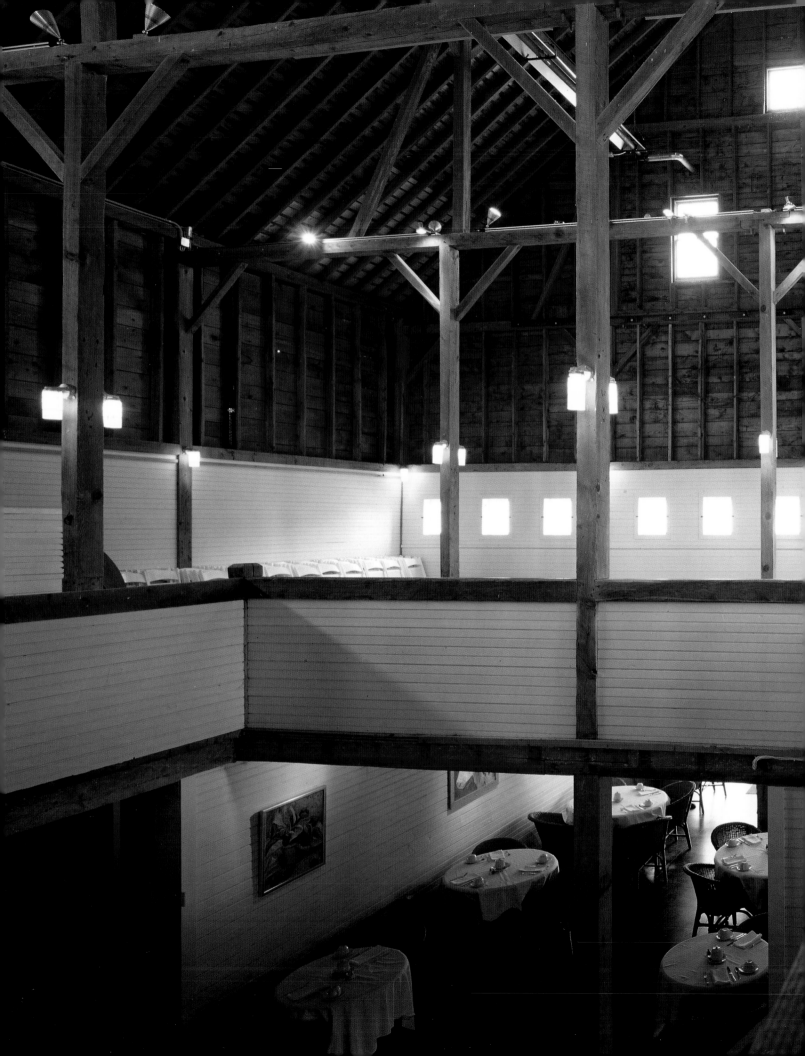

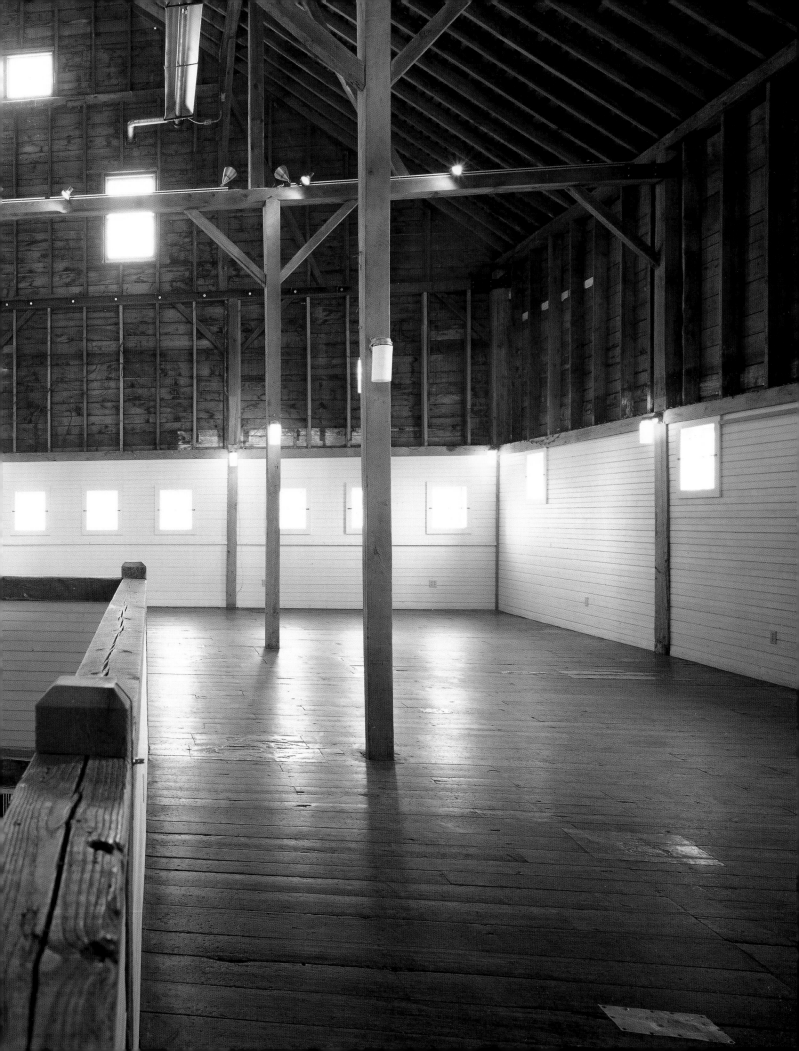

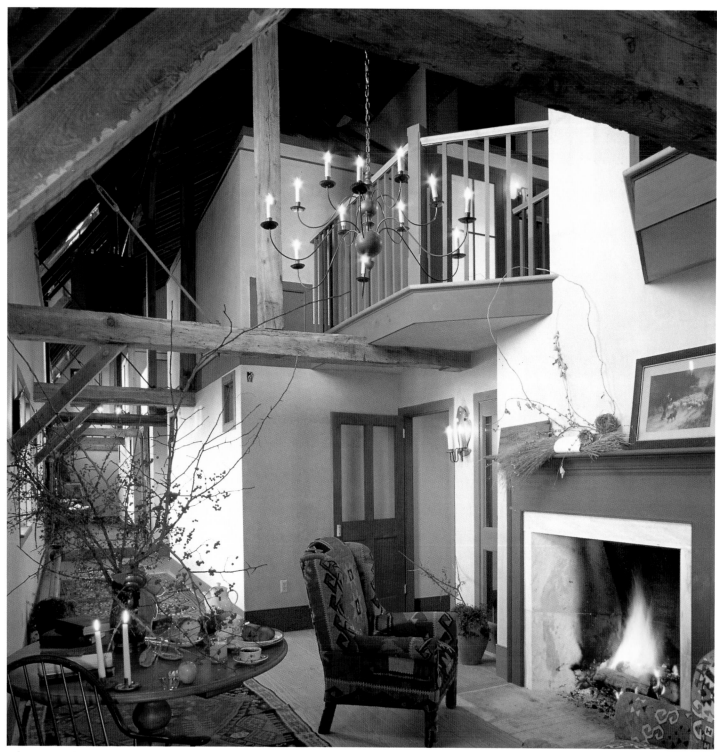

The reception hall in the dairy barn.

The dairy barn at Gedney Farm was built in the early twentieth century with a fashionable gambrel roof, which was then considered as both modern and efficient. With stalls below and hay storage above, it was never intended that the structure should be open from floor to rafters. Nor, of course, was it intended that the interior be subdivided into a series of guest suites with fireplaces and bathrooms. In contrast to the open, unencumbered space of the adjacent hay barn, the conversion of the stables restores only the exterior, relegating the structure within to an essentially decorative disposition.

Guest quarters in the dairy barn.

147

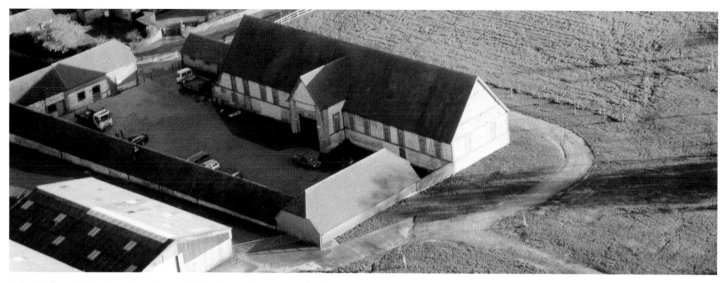

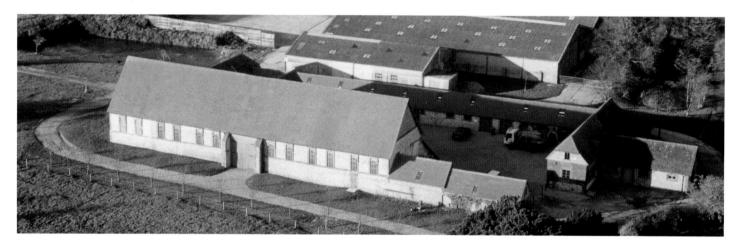

The Ditcham Tithe Barn from the north (above), and the south (below).

Adaptive reuse of barns as venues for events is not limited to America. A good example in the English countryside is the conversion of the Tithe Barn at Old Ditcham Farm near Petersfield in Hampshire. While its history is long, the actual date of construction is unknown. Architecturally the structure is distinguished by six great Gothic arches of local stone, interspersed with false hammer beam trusses. It was originally of cruciate form, although one of the central porches had disappeared by the time the present owners purchased the property in 1975. Over untold generations the building had been put to many uses and endured numerous alterations. To accommodate farm machinery four additional openings had been cut into the bays of the side walls, and a corrugated wing with an extended chimney added to contain an engine-driven threshing machine. A fire caused by the spontaneous combustion of hay had already damaged the roof, but it was only after the epoch windstorms of 1987 and 1991 that it was determined that the entire roof required replacement. It was further recognized that to reestablish requisite support, the crude perforations in the broadsides should be refilled. With the encouragement of English Heritage, a major restoration was undertaken. A local quarry was reopened to provide compatible stone, forms were fashioned to mold specially produced bricks, and hand-finished tiles were secured. Expenses grew. Only as the structural work was nearing completion did the owners begin to contemplate alternative use. Without the openings, maneuvering modern farm machines became problematic, and "the building was becoming too spectacular to return to calf pens." Working with local planners permission was gained for a use variance to serve as a place of assembly. Finally in 2000, after the installation of a heated flagstone floor, a cooking bay, and bathrooms in an adjacent structure, the Tithe Barn opened as a facility for weddings and other festivities.

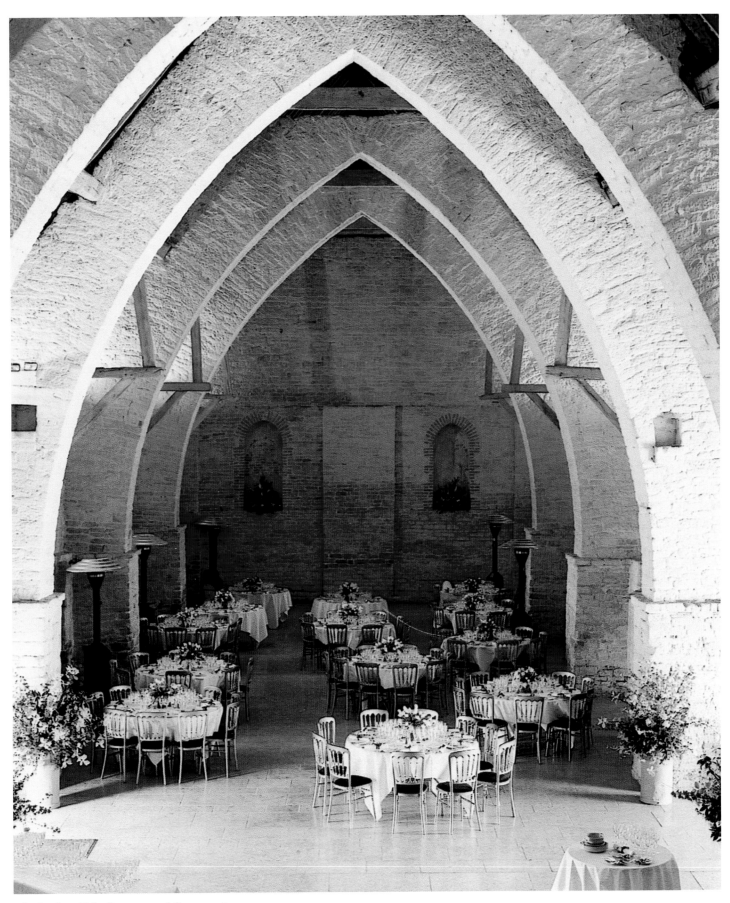

The Ditcham Tithe Barn prepared for a reception.

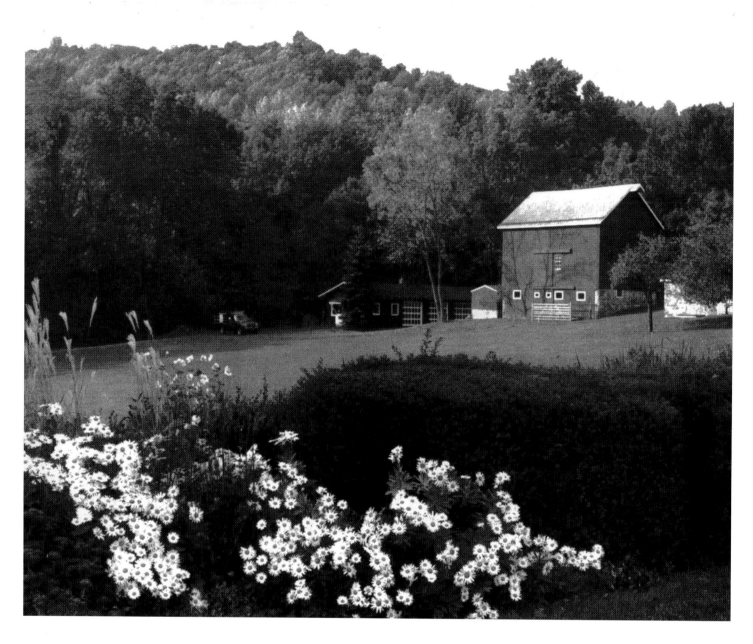

During a brief sojourn in England, a New Jersey couple, both music lovers, discovered the pleasures of concerts performed in the smaller spaces afforded by country manor houses. Back in the States they set about organizing a regular series of similar summer concerts with the assistance of musician friends. The first venue was outdoors, riverside, in Clinton. Chamber music drew an enthusiastic following, but the intervention of seasonal thunderstorms caused too many last-minute cancellations. Mindful that they had once considered the barn at their nearby farm as an emergency shelter for a family wedding, they offered it as a temporary alternative. The new site at Soclair Brooks Farm offered a perfect counterpoint to the music. The sheltering barn is relatively

small, but equipped with a spotlit dais and rows of hand-numbered chairs; the intimacy of the space is compelling, particularly as accompanied by the warmth of sound resonating off seasoned wood surfaces. Because the barn is surrounded by rolling acres of lawn, enriched by sculptures and distant views of the countryside, many attendees choose to listen from picnic blankets and lawn chairs. Performers include local musicians as well as more established talent such as the Colorado, Emerson, and Shanghai Quartets. In the cellar, where in years past a farmer might have enlivened daily milking with tunes from a tinny radio, some the world's great musicians loosen up in Solair's "green room."

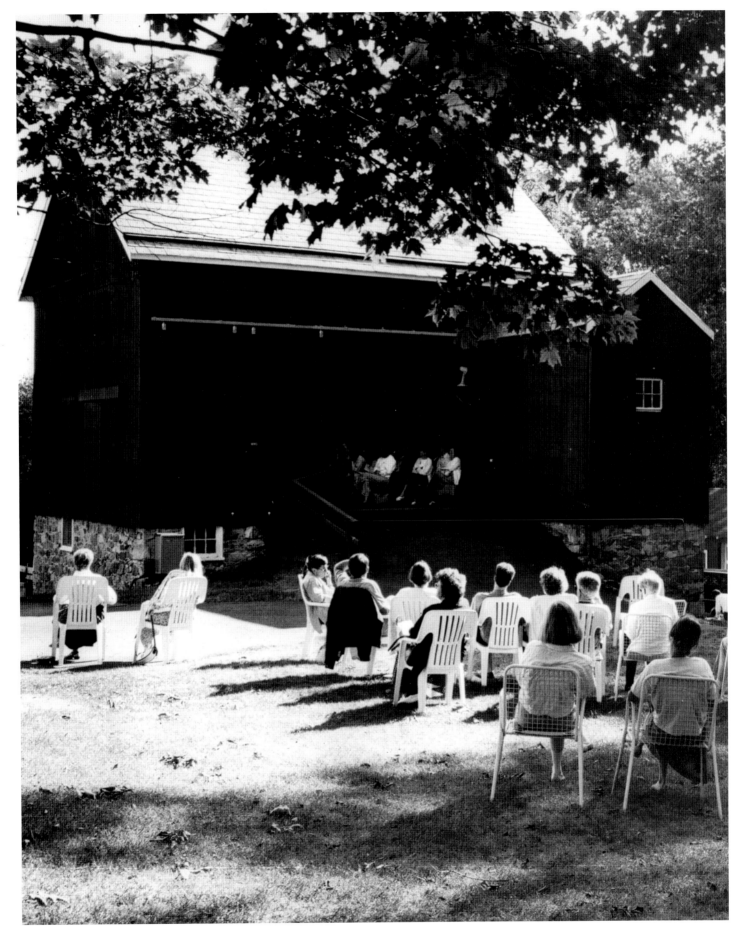

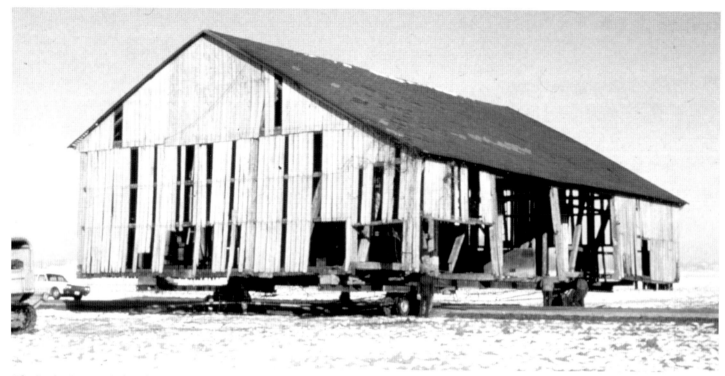

The Sauder Barn ready for relocating.

Soon after the Civil War a crew of Amish framers assembled and raised a large Swiss-German bank barn for Mose Stutzman in Fulton County, Ohio. It served his family for four generations until by the early 1970s it was no longer in active use and reaching a point of rapid physical decline. With anguish the family contemplated its demise. They well recalled that as children during Sunday afternoon family gatherings, they and their cousins would congregate and, "although we weren't supposed to be doing all the things we did, the first chance we had to slip out of the house anywhere from four to a dozen of us would head for the barn where we'd wrestle, play hide-and-seek and – best of all – swing on the ropes that carried us from one massive beam to another." On such occasions it was not uncommon to find a "walker," the family euphemism for a tramp, asleep in the haymow, curled up around his few possessions. Before consigning the barn "to go out in a blaze of glory" in a day-long bonfire, someone thought to seek out Erie Sauder, a local entrepreneur who was in the process of rescuing and restoring a collection of old buildings in nearby Archbold. Sauder recognized and appreciated the quality of the hewn frame and contracted to have it detached from the foundation, mounted on steel beams and dollies, and rolled two miles across frozen fields to its new site at Sauder Village. Where boys once celebrated and tramps found hospitable accommodation, today the barn bustles with activity as a popular full-service family restaurant. Ironically, the wagon-wheel chandeliers, hanging in a genuine barn, transcend their status as an American cliche.

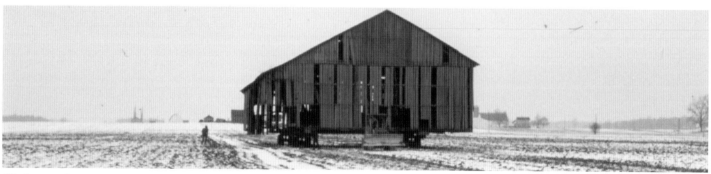

The barn on the move.

152

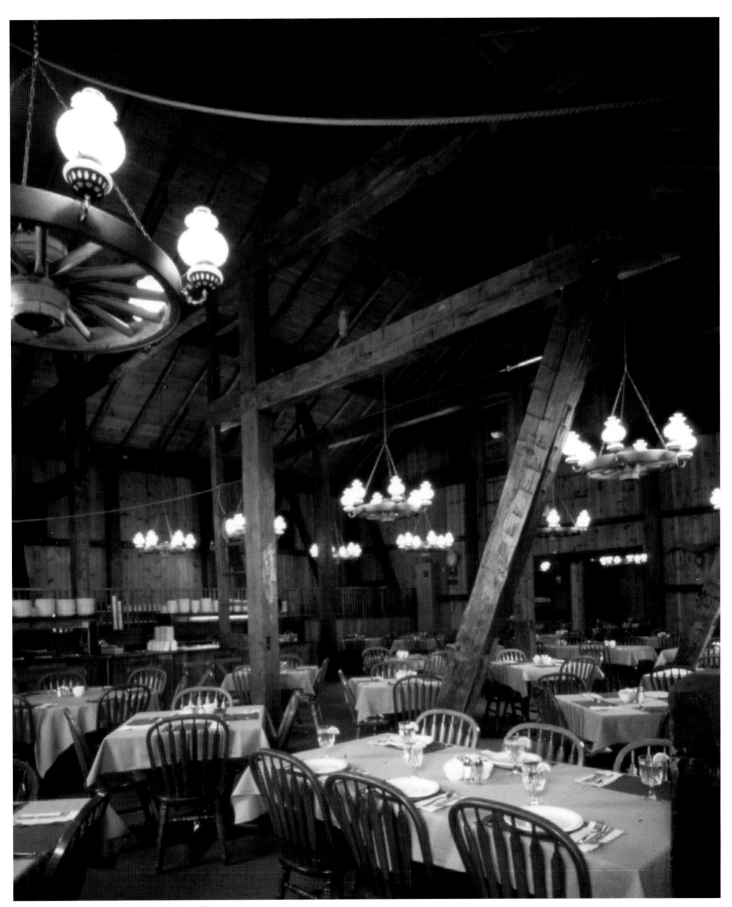

The barn as the Restaurant for Sauder village.

Details

Previous two pages: A Long Island, New York barn newly rebuilt to resemble its predecessor.

Pomfret, Vermont.

South Woodstock, Vermont.

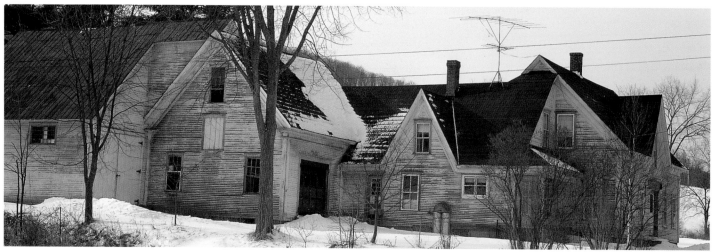

Taftsville, Vermont.

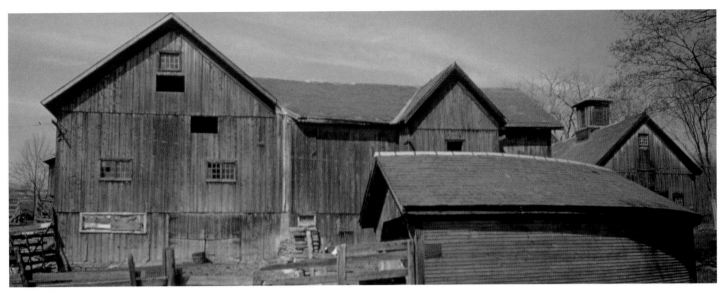

Orwell, Vermont, with a curved, covered livestock ramp.

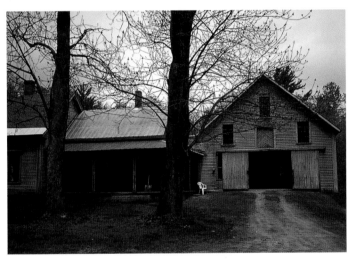

Central Vermont.

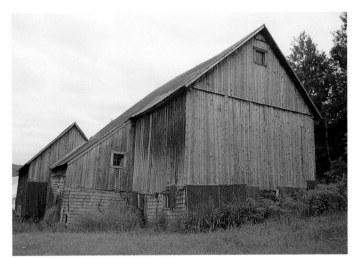

Barnard, Vermont.

Few barns stand alone on the landscape. In much of Europe they are integrated into a self-enclosed courtyard also including the house and a series of other outbuildings. One such protective farm complex figured in the fighting at Waterloo. In the New World barns were initially built as freestanding structures whose distance from the farmhouse was determined by noise, odor, and fire safety. As agricultural practice evolved they were gradually linked by a multi-profiled assemblage of adjacent secondary structures, each with an individual purpose. The true connected farm complex is largely identified with northern New England. Though often incorporating structures dating to the eighteenth century, this convention did not actually come into favor until about 1850. The impetus is clear. Long winters, replete with heavy snow, made the pattern of daily chores among separated buildings arduous. By stringing them together, in roughly the same sequence they inhabited as independent entities, a progression might lead from kitchen to pantry to washroom to milk house to woodshed to privy to tack room to barn. Within a short while the "big house, little house, backhouse, barn" strategy had been promulgated in the construction of new farms within the region encompassing northern Massachusetts, southern Maine, and much of New Hampshire and Vermont. Among those pictured here are examples in Barnard, Barnstead, South Woodstock, and Cavendish, Vermont. So successful was this notion that existing detached farmsteads were frequently amended to assume the new model. This was variously accomplished by interjecting connecting additions, or more ambitious yet, rolling existing structures over frozen ground to abut one another. Today, the same concept is useful in adapting several former farm structures into a single house.

Bethel, Vermont.

Delaware County, New York.

New York / Vermont border.

Strafford, Vermont.

Barre, Vermont.

South Wallingford, Vermont.

Whether restoring an existing barn or designing a successful adaptive conversion, when considering decorative features it is particularly important to acknowledge appropriate proportions and to recognize distinct regional differences. Perhaps no other single feature so clearly identifies the barn for the casual roadside passerby as the cupola. Crowned perhaps by a lightning rod or weathercock, this proud sentinel superstructure might ostensibly serve to further ventilate the haymow, but there can be little doubt that its inherent purpose was to proclaim the prosperity of the farm. In some cases cupolas were apparently built on the ground and only later raised to the peak. At times these weighty embellishments were set atop frames inadequate to their support. In other cases, the force of persistent weather and uninvited occupation by invasive beasts and birds have given rise to insistent deterioration.

While some fine examples have succumbed to these factors, many others, like the one shown on a Sudbury, Vermont, barn reerected in Reddick, Florida, are being restored to their original splendor. The sequence of the removal and restoration is shown on this page. The triple cupolas on the Schaafsma Barn near Pennington, New Jersey, have inspired numerous facsimiles since their dissemination in our earlier title. While most are well executed and appropriately sized, others are absurdly out of scale. As in the case of all such features, the best strategy for their successful introduction is close and careful scrutiny of indigenous local examples with rigid attention to proportion.

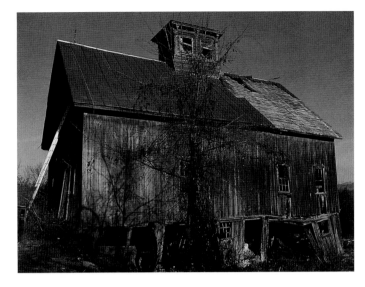

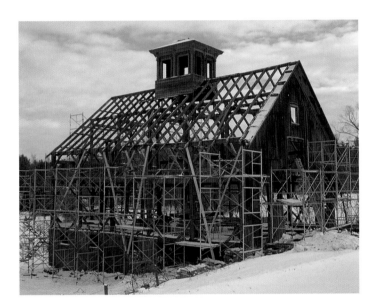

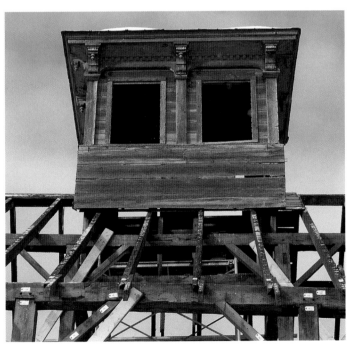

Barnard, Vermont.

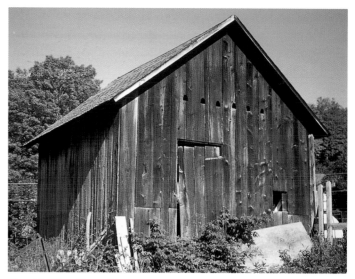

Cornish, New Hampshire.

Bradford, Vermont.

South Pomfret, Vermont.

Perhaps because barns are by nature purely utilitarian buildings, many tend to present a contemporary appearance, starkly geometric and bereft of superficial adornment. In examples built before the Civil War the planes are especially well defined, with tightly clipped eaves and gables. The resulting profiles are bold, particularly when juxtaposed with one another, creating an interplay of slashing shadows moving around the buildings with the advancing path of the sun. Where ornament occurs it is purposeful. *Martin holes* perforating the gables of some early barns follow the widespread European custom of attracting birds to seek out vermin in the haymow. The heart and cross (or swastika) were familiar forms, either alone or in combination. Unlike the free-ranging martins, pigeons were provided with individual nesting boxes, frequently housed in wagonhouse lofts and clearly recognized from the exterior by a rank of *pigeon holes*.

Schecksville, Pennsylvania.

A typical Pennsylvania martinhole.

160

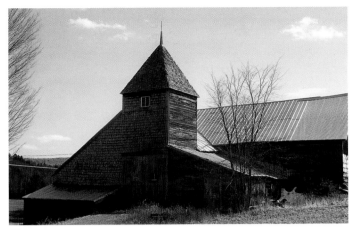

Vermont.

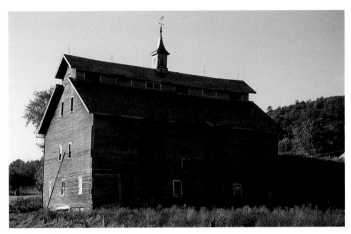

Richmond, Vermont.

Shrewsbury, Vermont.

South Royalton, Vermont.

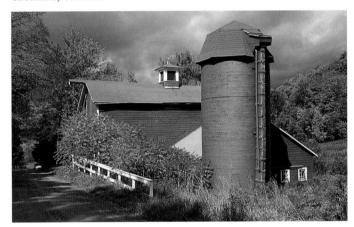

Hillsdale, New York.

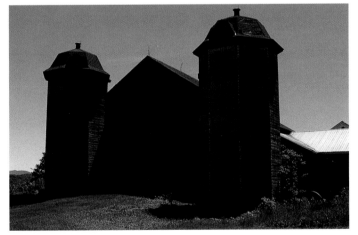

Vermont.

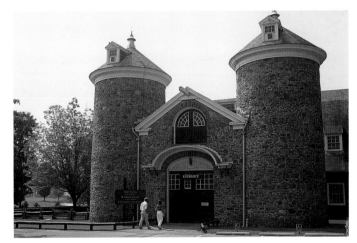

The Farmers' Museum, Cooperstown, New York.

Agricultural innovation was rife in the years following the Civil War. Promulgated by farming journals, canny advancements were adopted into the design of barns across America, consequently revising the vernacular farmscape. Improvements like silos and lightning rods were introduced, the latter being fitted out with the familiar glass globes, which, it is said, would retain an eerie electrical afterglow if struck. The labor-saving hay-fork track necessitated the projecting gable, while attention to ventilation brought decorative louvers, cupolas, and the occasional monitor roof, like the one introduced on a barn in Richmond, Vermont. The square, hip-roofed silo, a rarity, also stands in Vermont. Square silos, while relatively easy to construct, proved to be inefficient and were quickly abandoned for the ubiquitous cylindrical form that still dominates farmsteads across America.

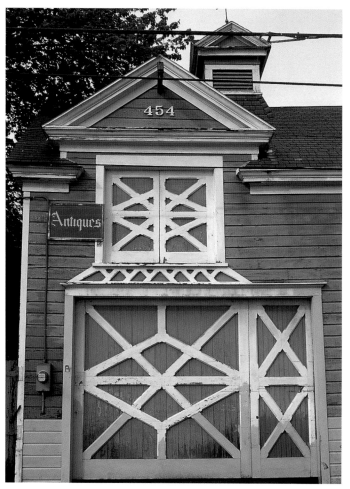

Hudson, New York.

Near Cambridge, New York.

Near Manorkill, New York.

San Antonio, Texas.

Sheffield, Massachusetts.

Watermill, New York.

Without setting foot inside, one can learn quite a lot about a barn by reading its doors. These may include the small doors reserved for humans, the wide doors for livestock, loft doors, and gable doors to the hayfork track. But most significant are the great wagon doors to the threshing bay, the traditional hub of activity on the working farm. Early examples in America occasionally adopt medieval precedent like the chevron pattern on inward opening doors. A protective pent roof is another feature with roots in the Old World. In areas such as upstate New York, Ohio, and Indiana, painted arches, crosses, diamonds, and other patterns embellish these portals, while Victorian examples employ exterior cross-bucks to establish high style. The most successful converted barns acknowledge the importance of this central feature. At times they may embrace traditional conventions like pentices and swinging or sliding doors, but it is actually by respecting the opening itself, infilled glass, that the agrarian origins of the barn are honored.

163

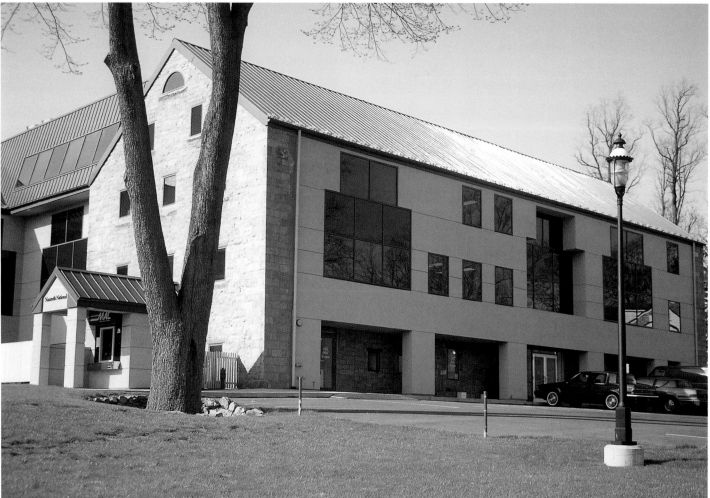

The successful barn house conversion requires uncompromising respect for the integrity of the features that give the original structure intrinsic character. Despite their obvious delight in the "possibilities" of these venerable buildings, architects are too often prone to impose their own clever devices in place of this earlier visual vocabulary. Amateurs are less aggressive in the nature of their adaptations, but the results are too often blandly disappointing. In both cases the most egregious error lies in the appropriation of incompatible fenestration. A series of adapted barns in New Jersey and Pennsylvania illustrate the point. Ganged windows, bay windows,

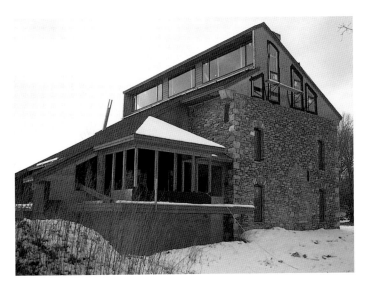

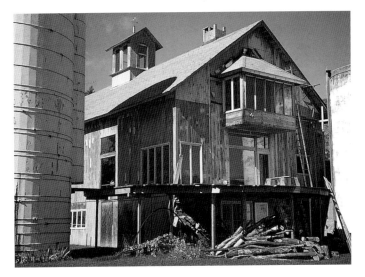

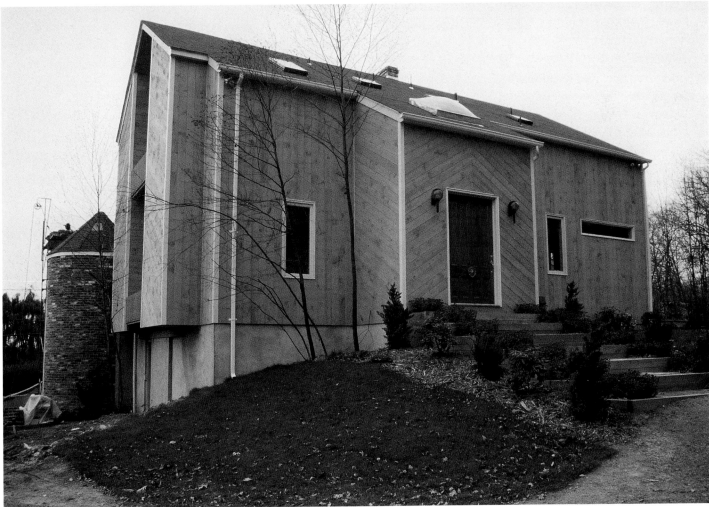

shaped windows, and skylights are all ill-considered impositions, the more unfortunate because they are unnecessary. The original apertures, which were essential to the function of the building and consequently central to its design, are obvious locations for the introduction of glazing. With huge wagon door openings flooding light in the central bay, gable windows, and ranks of sash in the stall areas, many barns are sufficiently well-illuminated — just not in accustomed domestic patterns. Sincerity notwithstanding, would-be designers should check their notions of ingenuity in favor of accepting the barn itself as mentor to any plans for conversion.

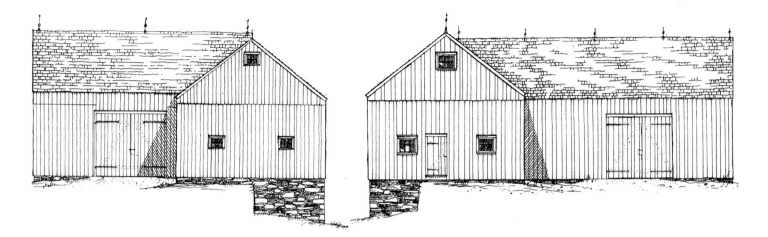

When the old Kurzer Farm in South Kent, Connecticut, was sold some years ago, the barn complex was in a sorry state. Three early nineteenth-century barns, which composed the gangly assemblage, had been drawn together from separate locations, supported on granite fieldstones that enclose an ample cellar dairy. Derelict after years of disuse, the structures presented a pleasing harmony of hardscrabble texture on the exterior, but within many crucial framing members had failed. So extensive was this decline that the barn closest to the road was sacrificed and the other two disassembled. Missing and unsound timbers were replaced in kind or repaired, and the restored frames reerected on reworked stone walls. Not surprisingly, a host of preservation issues was involved. As built each barn presumably stood on relatively level ground with drive-through threshing bays, accessed by strap-hinged wagon doors. Windows were few and likely located only in the gables. The siding was white pine boards, the roof cedar shingles. But over the years, beyond the obvious changes in

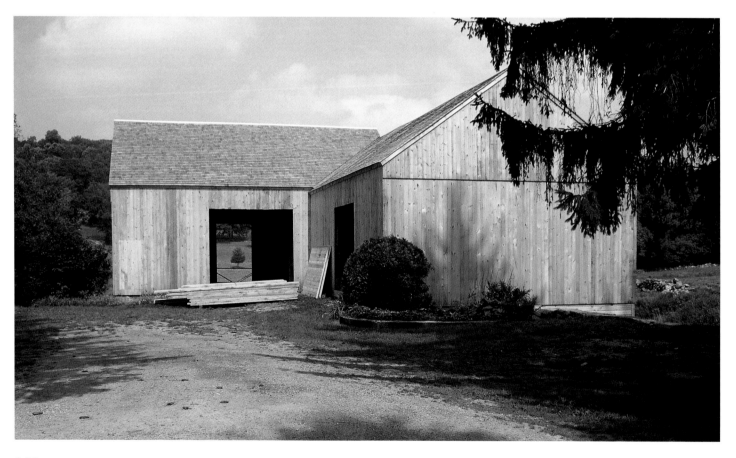

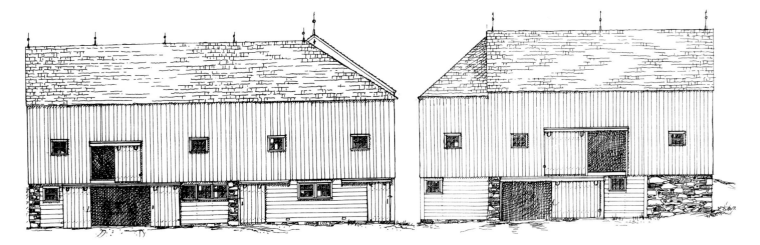

location and elevation, a number of other incremental alterations ensued. Replacement siding, asphalt shingles, and asbestos tiles had superseded the original sheathing. In this case the decision was made to replicate the original materials. On the other hand sliding doors and additional windows, particularly at the dairy level, were practical amendments which that also gave the barns much of their charm. Most of these apertures were retained. In some cases openings were altered to address fresh requirements for reuse of the dairy as storage space. At times it is necessary to weigh the issues of restoration versus preservation, an exercise demanding decisions wrested out of careful and conscientious consideration. The underlying intent of this selective restoration was not to startle the future passerby with the introduction of novel features. Rather, the idea was to rehabilitate the barns so that after a few years of weathering they might retreat quietly into the Connecticut landscape.

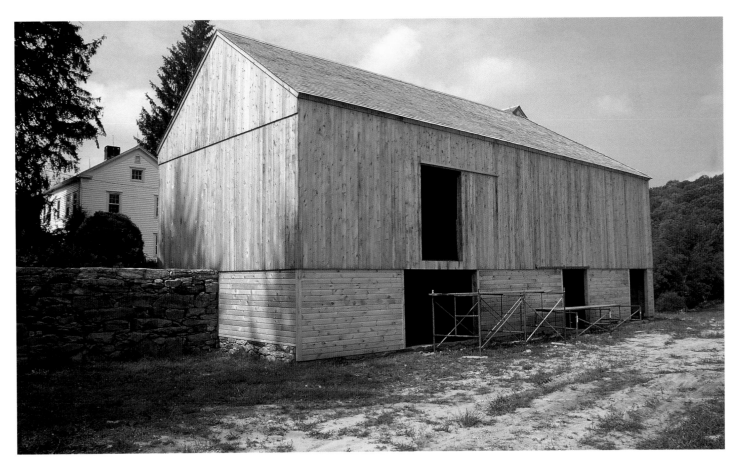

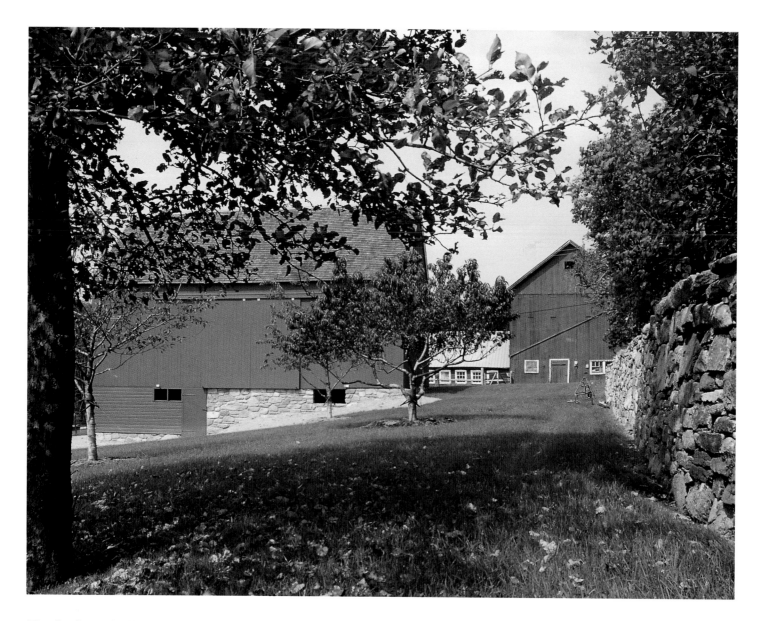

Not far from the Kurzer Farm in South Kent, Connecticut, an even earlier barn required restoration at Peet Hill Farm. Much the same strategy was employed, with the renovated barn rebuilt in its original location on a new fieldstone foundation. Initially, a misguided, multiple-stepped foundation was introduced, creating an awkwardly unnatural division between siding and stonework. By amending this condition to adhere to a more traditional form, the disharmony was eliminated. Wagon doors were introduced at the cellar level to provide access for a two-car garage, while the nearly unbroken twenty-six-by forty-three-foot area above is reserved as a gathering space. Materials are straightforward and openings unobtrusive. The most successful renovations are those where the observer is unaware of the deliberate decisions which allow the original structure to appear comfortable and natural in its surroundings.

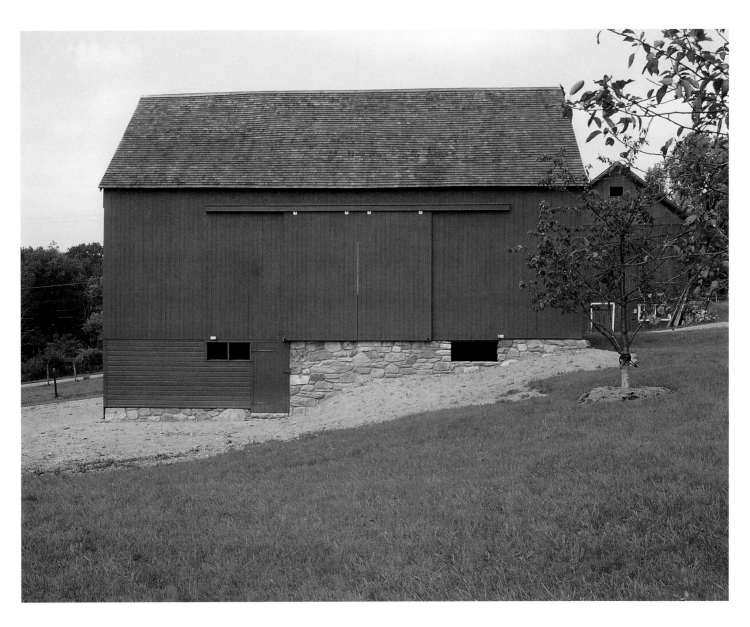

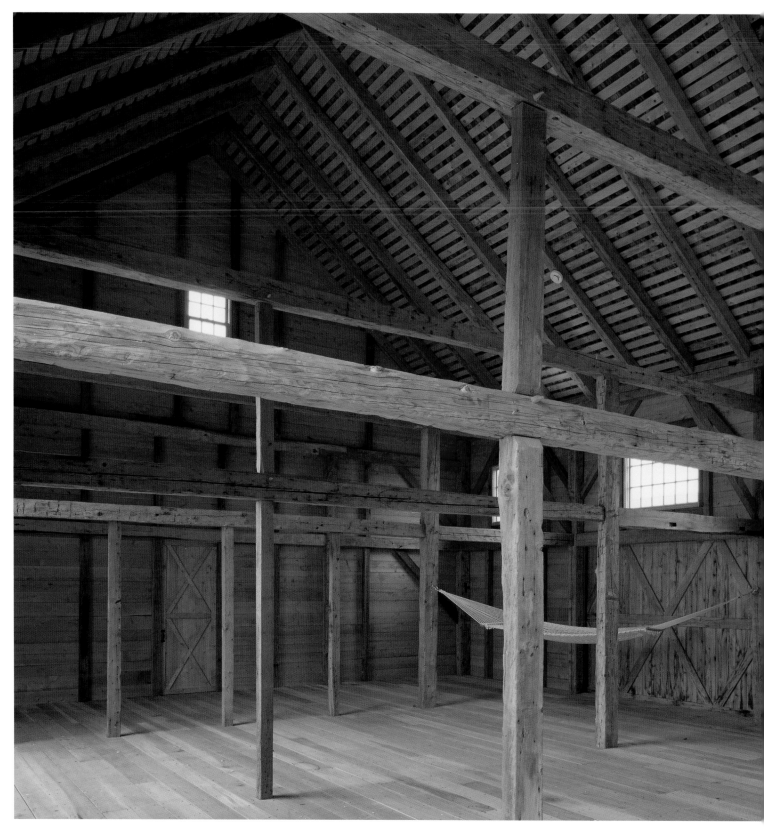

Assaulted over its long history by the tempests of the Atlantic a half-mile away, the large barn near Wainscott, Long Island, had suffered major structural damage by the time it fell into the good fortune of enthusiastic new ownership. So pervasive was the deterioration that it was finally reckoned that the only way to restore the fine old structure was to disassemble it, repair and replace its damaged timbers, and then raise it again — a proud testament to its renewed resiliency.

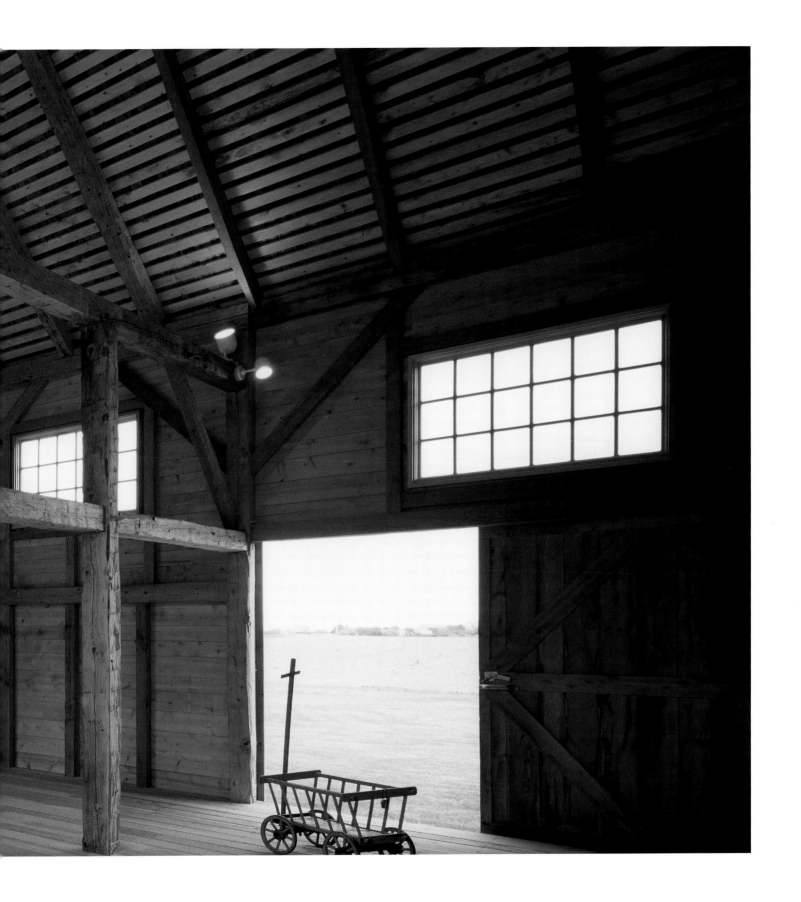

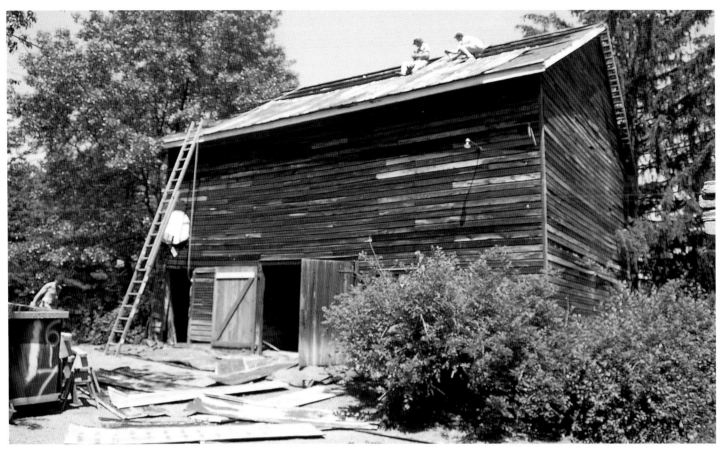

The removal of the old roof covering.

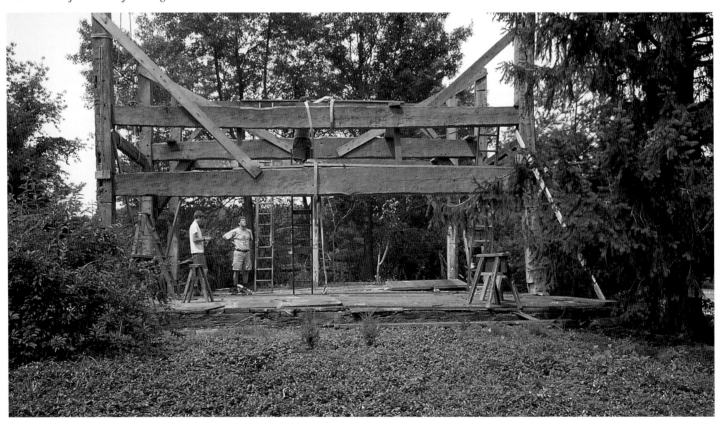

The bents are ready to come down for repair.

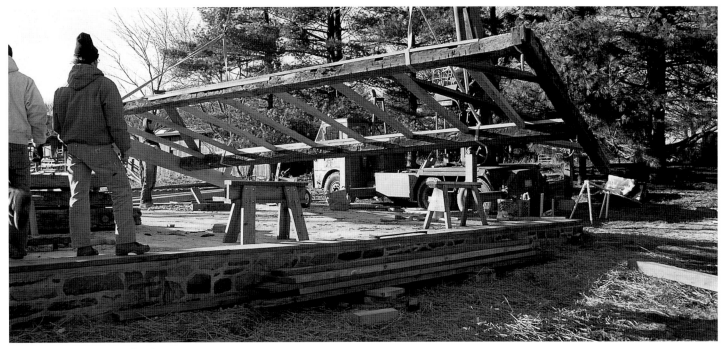

A bent is raised on a new foundation.

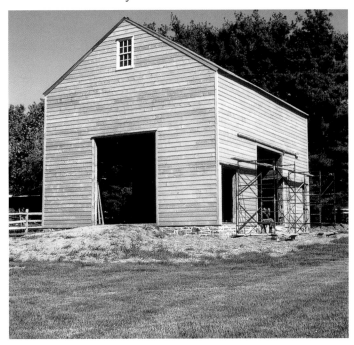

Sometimes, as in the case of the Drake Barn near Stoutsburg, New Jersey, disassembly, repair, and reerection on the same property can result in a far broader understanding of the structure. For this mid-eighteenth-century building, many years of "benign" neglect had resulted in substantial structural problems that would have been difficult to correct in a standing structure. Once the building was stripped to its "bones," long-obscured marriage marks and mortice holes revealed surprising evidence. Previously thought to be a rather

singular English frame, the barn was instead established as a "dropped bent" New World Dutch frame, shorn of its original side aisles and reconfigured with a threshing floor between the central anchorbents. Fully repaired and mounted on a new stone foundation, the once moribund Drake Barn serves many functions, from rainy day playroom to reception space for area organizations. The band at the annual barn dance has proved the efficacy of the acoustics.

In the 1950s, near Philadelphia, a small stone barn on Dove Lake which was also the site of Thomas Eakins' study *Bathers* was domesticated to become a blandly suburban house. It was imbued with a measure of charm, but aside from selected areas of its exterior stone-work and a few glimpses of framing inside, the barn itself was lost in the translation. A new owner planned to remove the building and replace it with a far larger barn from Lancaster County. Instead, he was persuaded to strip only the additions and alterations and retain the earlier structure as an open playroom juxtaposed with the new frame. This was but one of several challenges. Inspection of the stored Lancaster Barn revealed stacks

of beams, many of which required repair or replacement, and an immense pile of stone. As the vendor responsible for disassembly had gone out of business, a knowledgeable timber-framer was retained to decipher the plans and mend the timbers. Successful recreation of the edifice also depended on the considerable abilities of the stone mason. The two barns – one early, small, and native to the site; the other later, larger, and imported – contrast and complement each other. Eschewing temporal novelties of design while embracing classic conventions, it is intended that the new complex may achieve the timeless quality that eluded the earlier conversion.

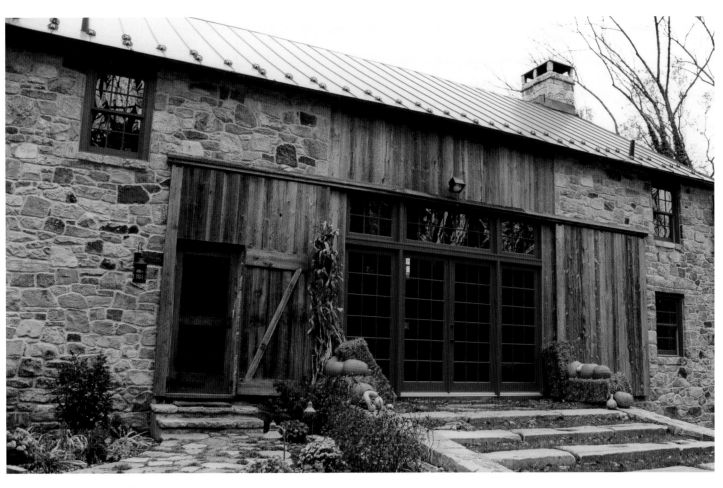

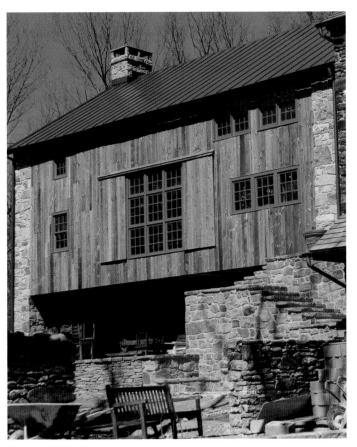

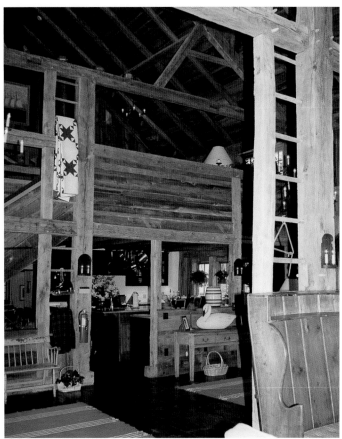

Domesticated Barns

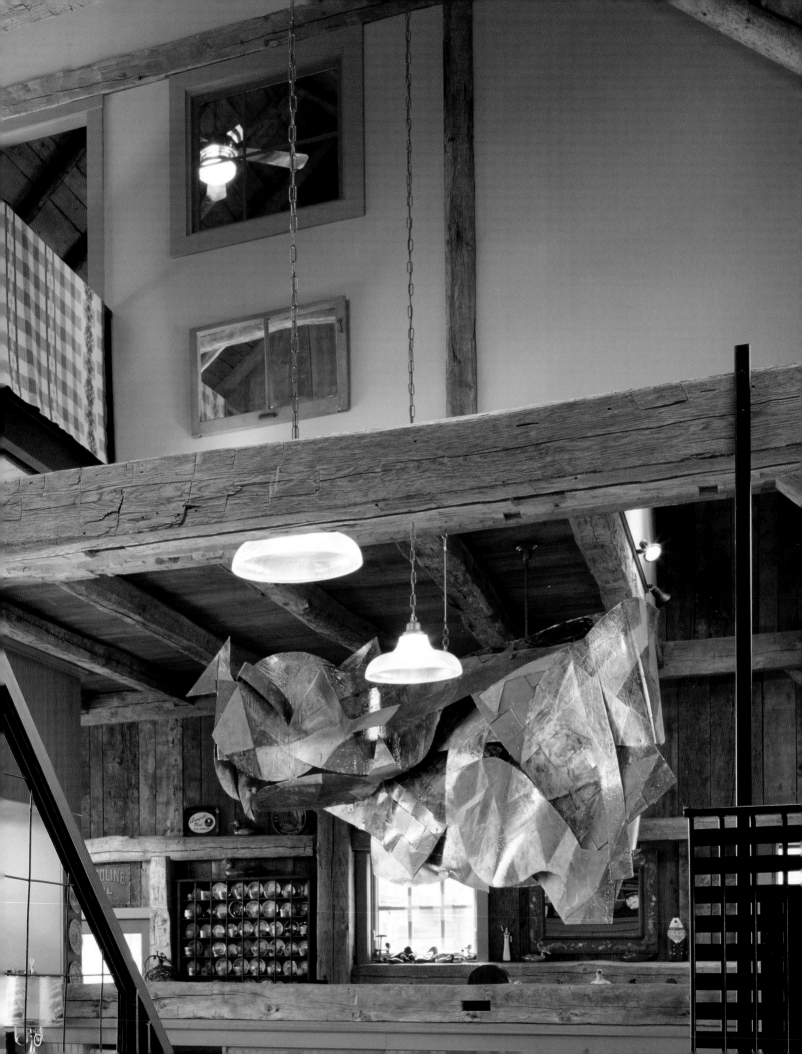

Old surface coverings are revealed during dismantling.

Mr. McCree Cruser's name stenciled on a board covering a dutchman.

When in 1845 his great five-bent barn was raised in what has become Plainsboro, New Jersey, builder J. McCree Cruser had every reason to extol his owner-ship on a *dutchman* prominently positioned on the central tie beam. Measuring thirty-six by fifty feet, the structure was large for its day, raised to shelter the bounty of a successful farm. Good fortune was no doubt linked to its proximity to the Brunswick-Trenton Turnpike, a major route of commerce laid out forty years before. When in the mid-twentieth century the site was trans-formed as the headquarters of a research firm, the barn became an early example of adaptive reuse, serving as a laboratory facility. Years later, when the old "Brunswick Pike" became the burgeoning Route 1, the property was

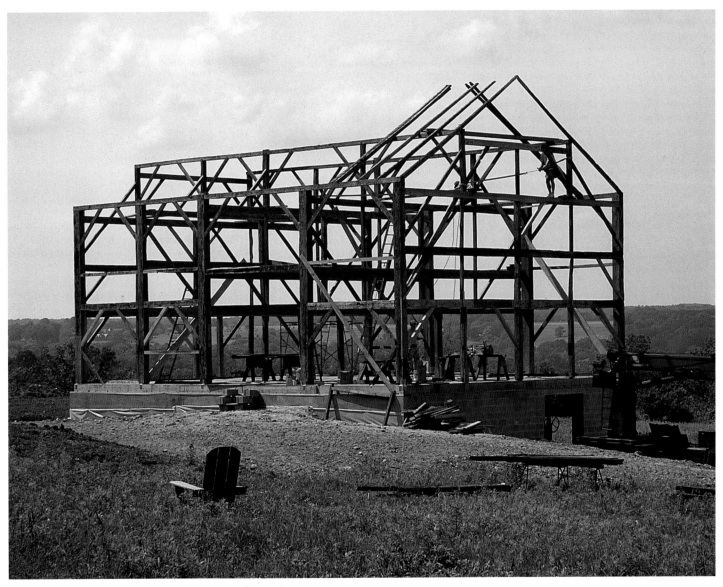

The frame of the Cruser Barn goes up on the slope of a meadow.

rendered even more valuable as corporate office space. In 1996 the Cruser house and barn were scheduled for demolition. At that point a New Jersey timber-framing firm, which had performed repairs to the structure only a few years before, stepped in to save the barn — by removing it. One hundred and fifty years after it was erected, the Cruser Barn was measured, tagged, and disassembled. A year later, the company matched the barn with a new owner and a few acres of pastureland overlooking nearby Hopewell, New Jersey. Reassembly was documented over the summer of 1997.

The conversion of the Cruser Barn into a house was dictated by a strong desire to respect both the integrity of the original structure and the practicalities of a fixed budget. In place of reclaimed original siding to sheath the roof and walls, new rough-sawn shiplap pine was used. The barn was fully sheathed within days after reerection. Lengthy panels of rigid insulation were next applied. Aside from the twelve-foot-square wagon-door opening, fenestration is modestly proportioned on the roadside approach, while larger perforations on the opposite broadside capture the view. After the insulation panels were covered with tar paper and lath, a final outer layer of rough-sawn siding was nailed in place. The completed house, enlarged with a lean-to garage and embellished only with sliding doors, gooseneck lights, and lightning rods, needs no landscaping to fit comfortably into its adopted meadow.

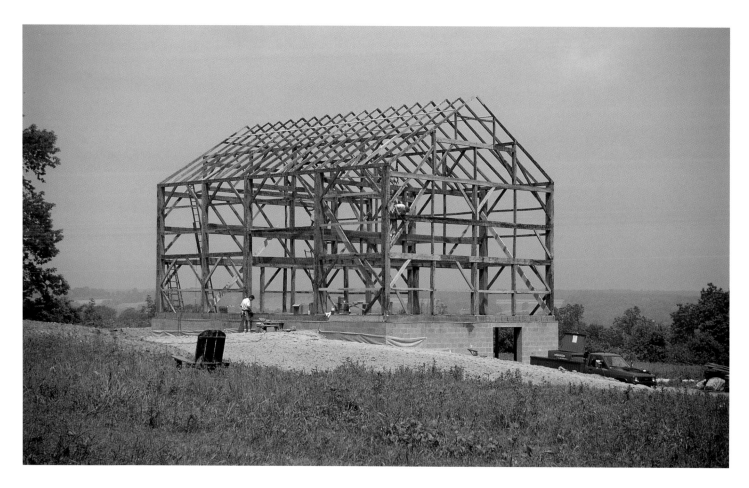

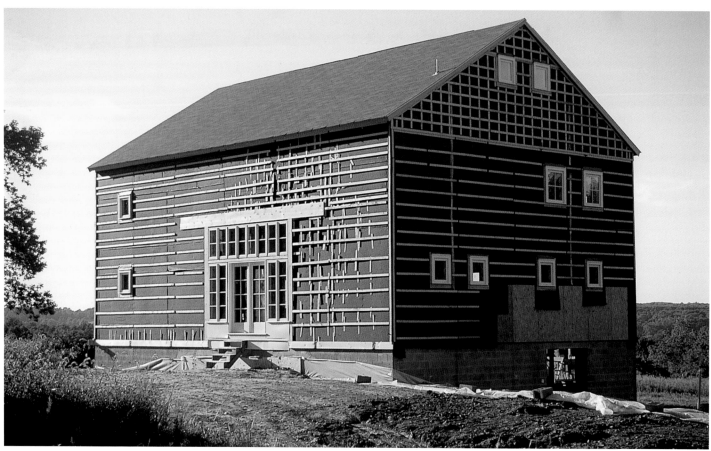

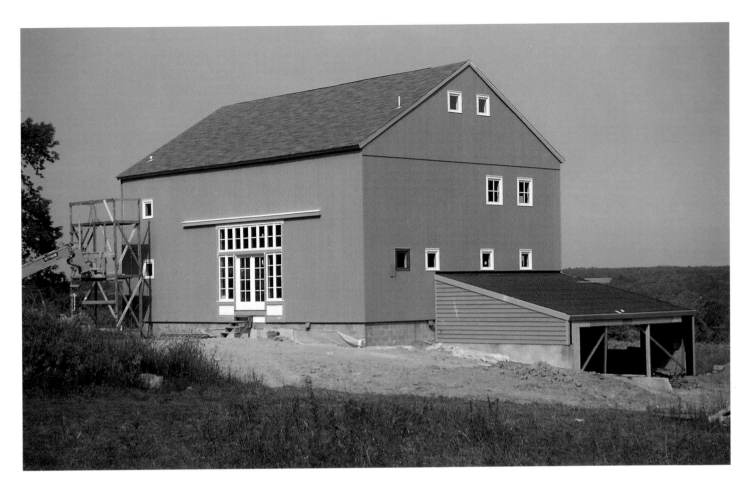

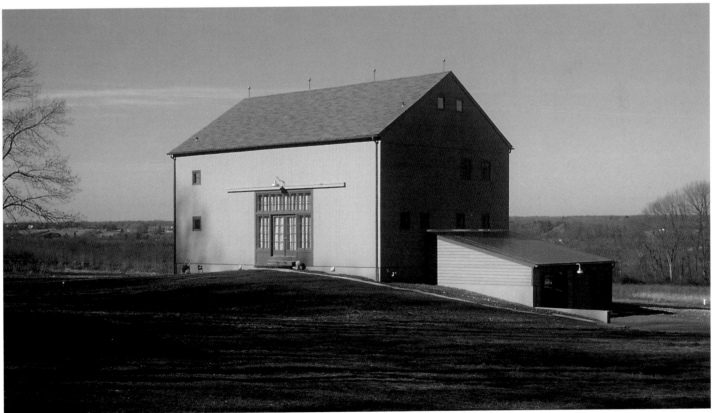

Four stages in the reerection of the Cruser Barn.

The barn is photographed during the inspection.

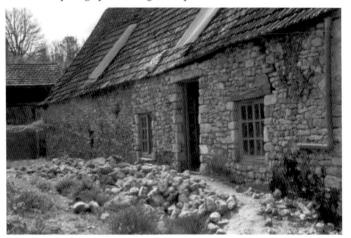

Work starts on the stone walls and foundation.

One side of the barn before the dormers and new tiles are added to the roof.

A gable end before restoration.

Domestic adaptation of agricultural buildings is not confined to the New World. In 1991 two British builders, conscious that they were hardly alone in taking their holidays in France, set out to find an old barn to convert into a summer cottage for themselves and as an income-producing rental. They considered close to fifty properties before settling on a barn in the Dordogne region. When they applied for a building permit, one of the few stipulations was that the resulting structure would conform to other buildings in the community. With families in tow, the first summer they spent six weeks there, followed by two weeks of concentrated endeavor.

The process stretched out over seven years. As each aspect of the project was tackled their knowledge of local building traditions expanded. The outer walls were two feet thick, but there were no true footings or foundations. Apparently, as the walls grew higher and heavier, they consequently compacted the earth below. River mud was used to bed the stones. Not surprisingly, vermin had invaded this soft masonry, and several walls had to be relaid using local stone. As much as possible of the original oak timber-frame interior was retained, with new oak beams from a nearby sawmill substituted as necessary. The old roof of small pantiles was removed and those that could be salvaged were sold to underwrite new dappled brown tiles from the Perigord region. Where windows were added to supplement the few original openings, oak lintels were installed in keeping with vernacular precedent. Dormers, too, were inserted according to prevailing local form. While the completed structure no longer presents a distinctly barnlike appearance, it sits easily in the landscape from which it grew.

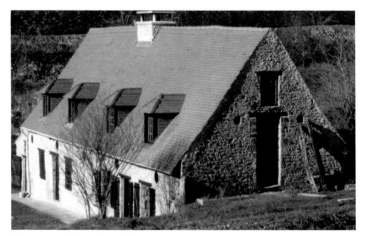

The same gable end ready for occupancy.

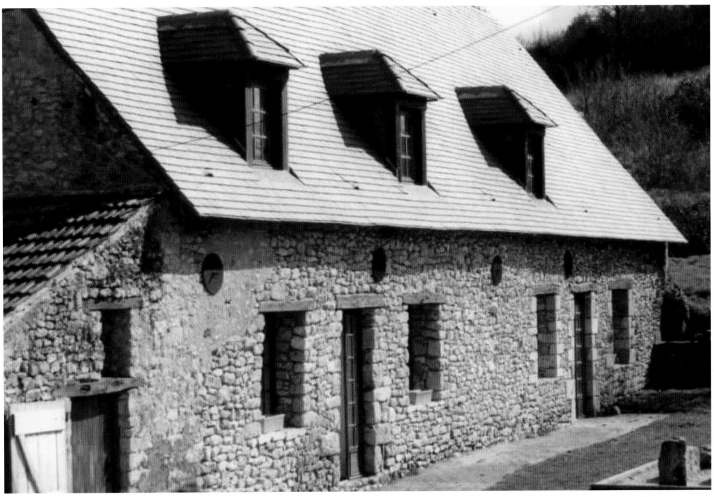

La Grange is divided into two separate holiday homes.

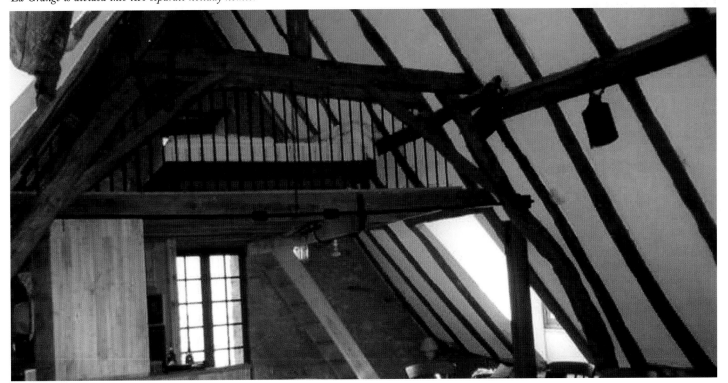

A section of the second floor shortly after completion.

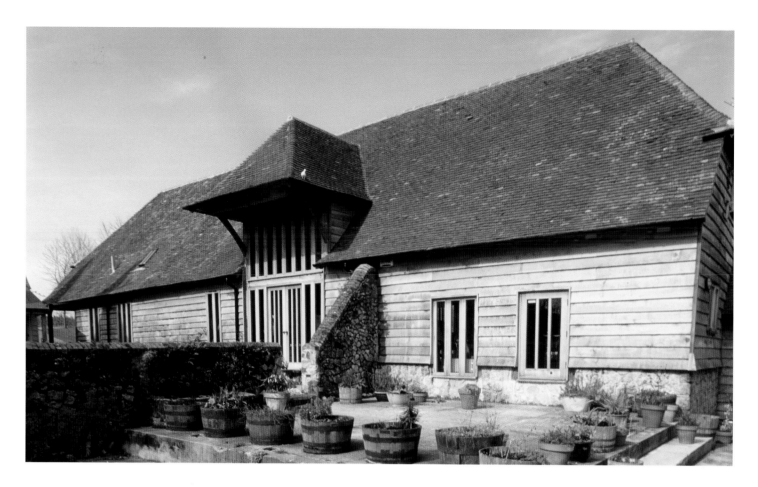

To protect the great doors to the threshing floor, several devices were developed in barns both in Britain and on the Continent. In the Lowlands and much of Germany, doors were often hinged to open inward. Dutch barns at times display a *projecting gable* the full width of the threshing bay. Both the Dutch and English employed the *pentice* or *pent roof* over the principal doorway in order to shield out-swinging doors. And English barns, with their low side walls, often incorporated the cross-gabled porch to accommodate and protect the wagon entry. The converted barn at Egerton, Kent, exhibits a hipped, cross-gable porch entry that also integrates a beautifully detailed pentice. By comparison to the obvious integrity of this framed portal, the fussy fenestration seems somewhat forced and superficial.

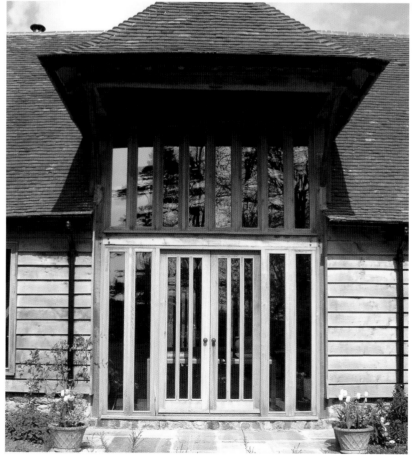

184

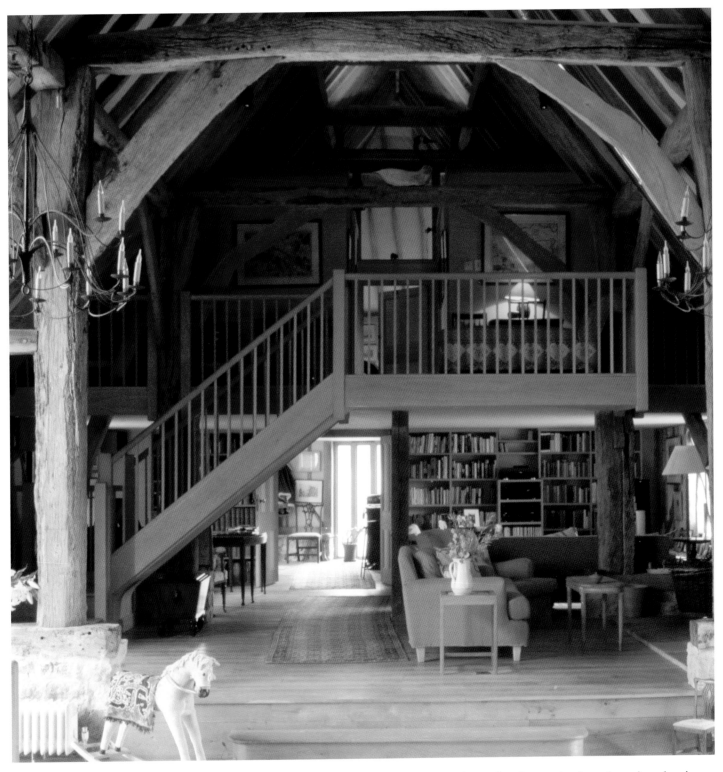

In the Egerton Barn, ancient, timeworn timbers present a proscenium framing the more intimate spaces beyond the drama of the open threshing floor. The well-executed barn house needs to balance a central area, open to the rafters, with more sequestered private retreats, which may take the place of former stalls and granaries. These are the places for overstuffed chairs, table lamps, family photos, and lots of books. In this example, the intrusive factors in the otherwise pleasingly domestic arrangement are the balustrade and stair. The design is fine, but it is poorly placed. Like the fireplace, the introduction of domestic necessities calls for a strategy of subtle placement and sympathetic materials. An eye to similar features in original buildings and to more successful applications in other converted structures is recommended.

Pays Barn before restoration. Below and right, two views of the finished home.

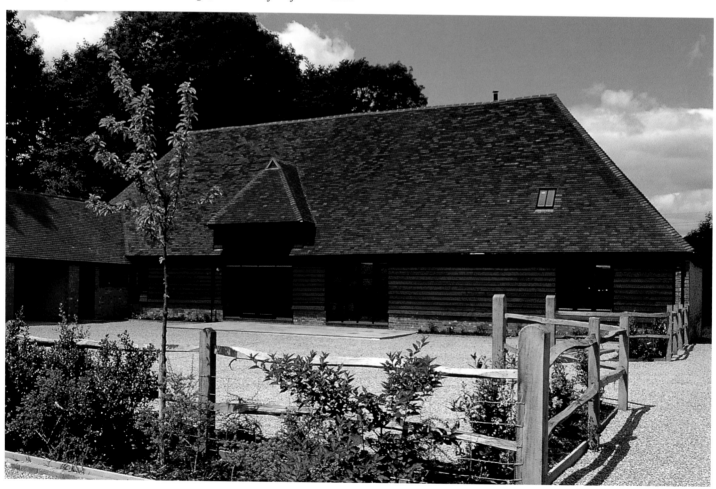

186

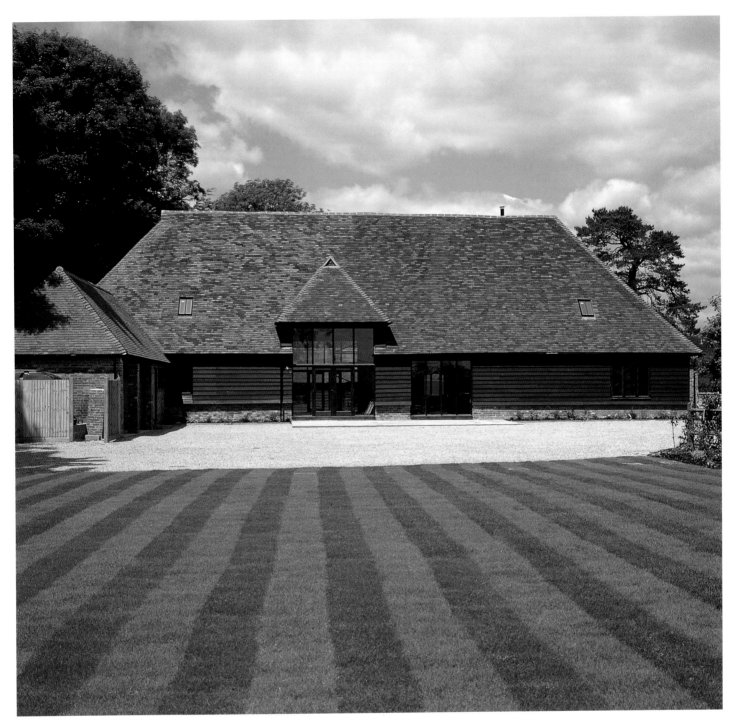

The Pays Barn is a rather more faithful attempt at restoring the original fabric of an antique structure while adapting it to new domestic needs. It is situated in close proximity to several other domesticated farm complexes in South Harting, at the foot of the South Downs in the South Sussex countryside. When it was purchased for conversion, many of its original features were obscured by active farming adaptations. The revitalized barn re-creates the original exterior with clapboard and tile. New features are discreetly introduced. Skylights are so small that they do not distract, and the flue takes the form of a metal pipe, positioned behind the ridgeline. Glazed openings assume the locations of former wagon portals, with large panes divided by dark-painted mullions together calling scant attention to the revision. Landscaping is minor and held at a distance from the structure beyond a recreated barnyard. Such apparently disparate decisions together produce a sensitive and successful project.

A section of the original roof.

The timber frame of the Pays Barn, which remained largely intact throughout its agrarian history, incorporates features such as gunstock posts and canted queen posts. Aside from dropping the floor within a raised foundation, the appearance of the original frame was left unchanged. Nonetheless, its look was vastly altered by substituting plaster for sheathing, lath, and exposed roofing, an unnecessary nod to the quite separate half-timbered tradition. Introduction of modern appurtenances is discreet. A highly effective radiant heat slab disperses warmth through the stone floor, and a fireplace mass mimics a type traditionally used in forges and farmhouse kitchens.

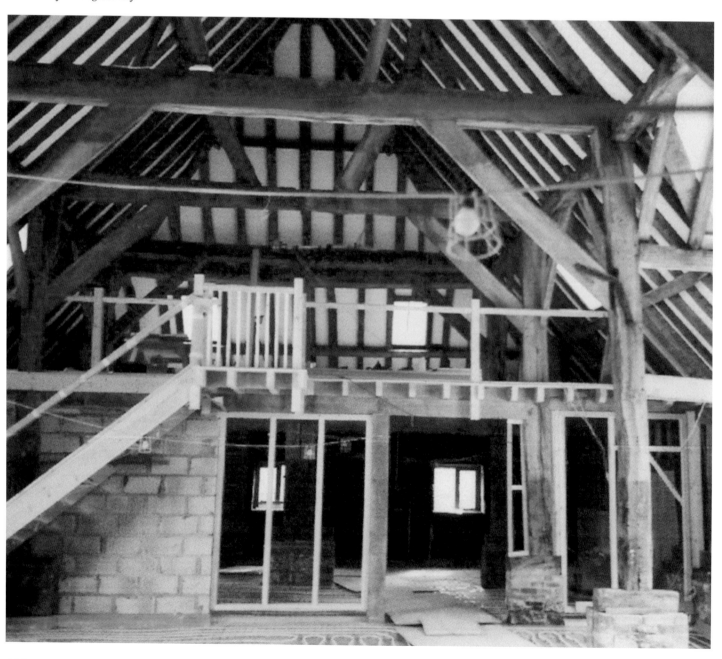

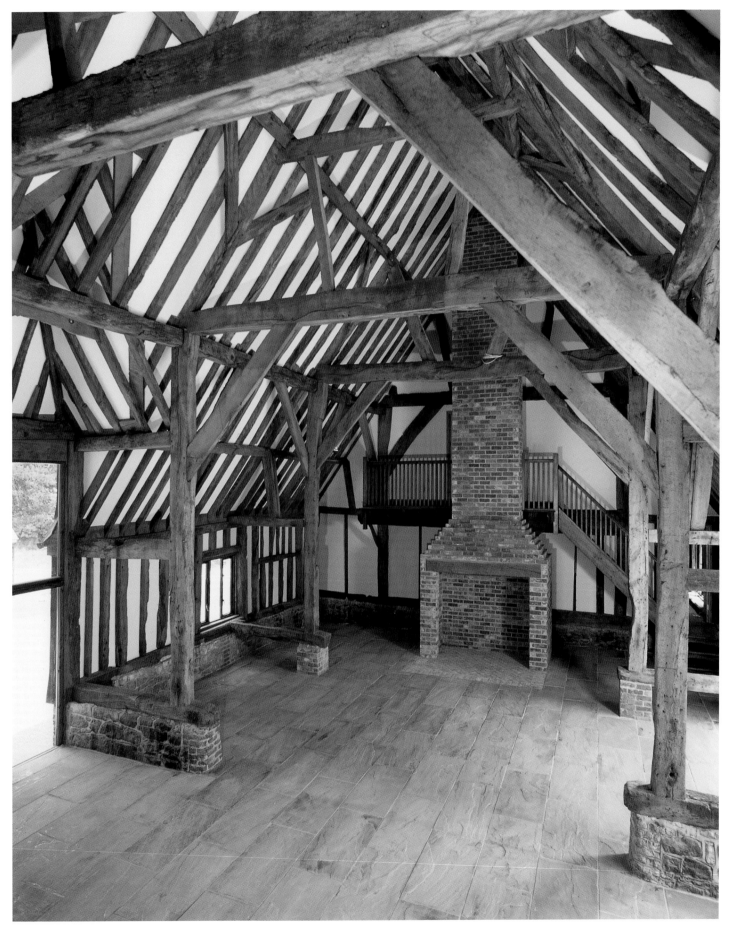

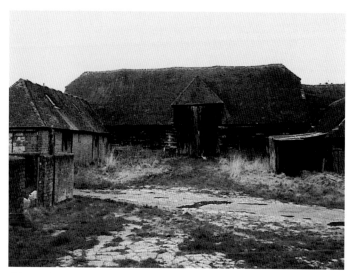

The Nursted barnyard before redevelopment.

Not far from the Pays Barn, in neighboring Hampshire, the Nursted Barns have also been altered for domestic use, but with a broader interpretation and a heavier hand. Local materials like clapboard and red tile are again retained, and new features like skylights and flue are similarly restrained, but fenestration is labored and the addition of exterior corridors obliterates the original relation of the central barn and flanking hovels in the courtyard they define. Interior framing is pleasingly revealed in most of the many independent structures comprising the complex. Again, the plaster infill detracts from the intrinsic character of the buildings.

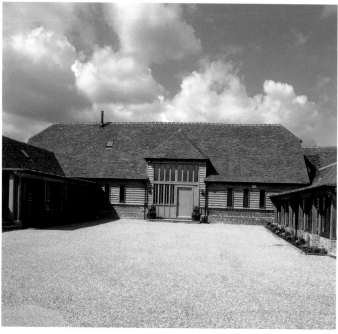

The same area with the completed barn ready for sale.

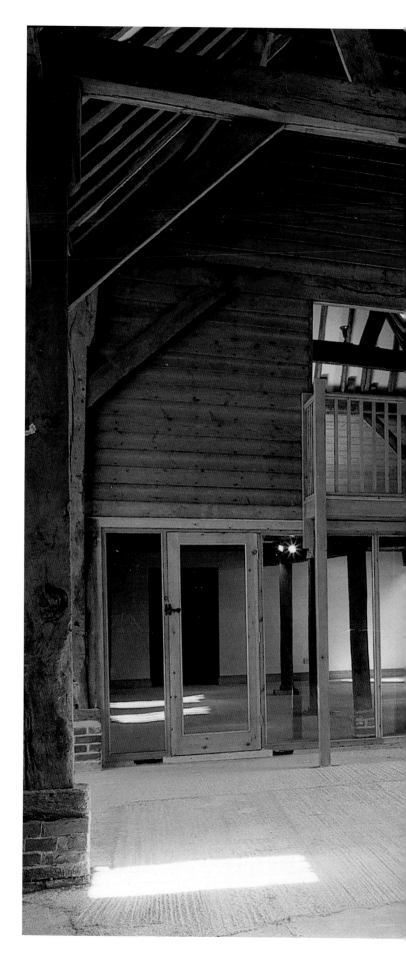

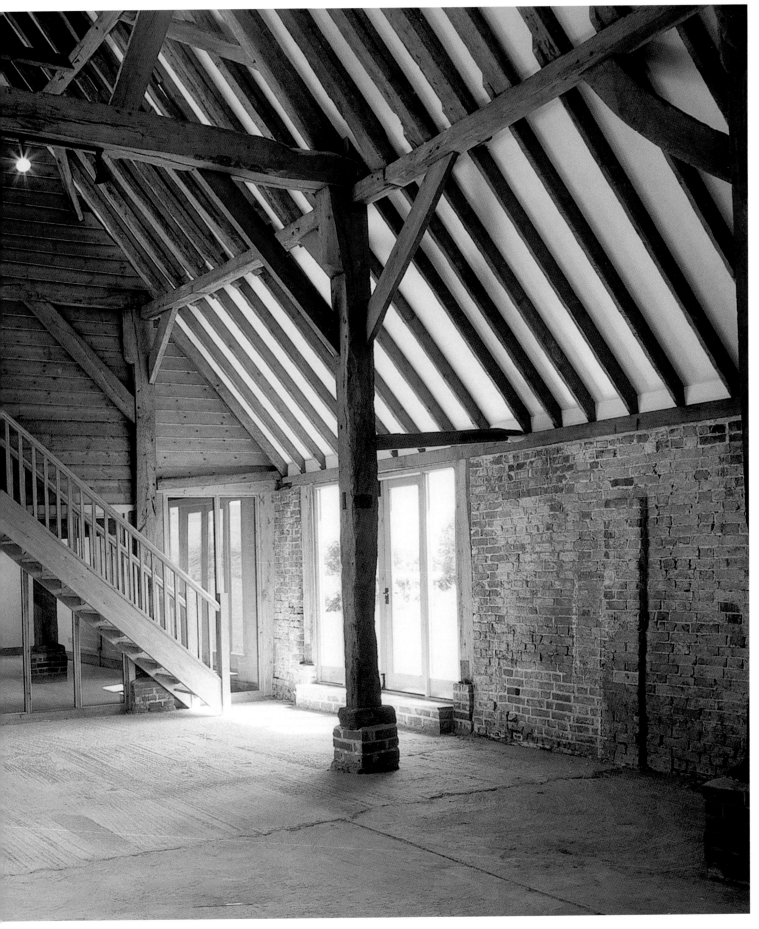

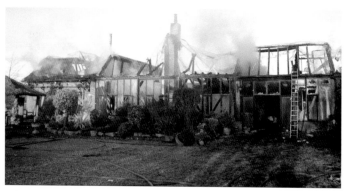

The morning after the fire.

On December 4, 1999, fire destroyed the Little Manor Barn at Britford, Wiltshire. Built in 1689 as a cowshed typical of the countryside in southern Britain, the barn's original oak beams were said to have been recovered from boats on the Beaulieu River in the New Forest. Nearly three centuries later, in 1985, the barn was bought and converted as a house by an ecclesiastical carpenter whose work includes nearby Salisbury Cathedral. In 1996 it was purchased by a couple whose interest in timber frames had been spawned by the

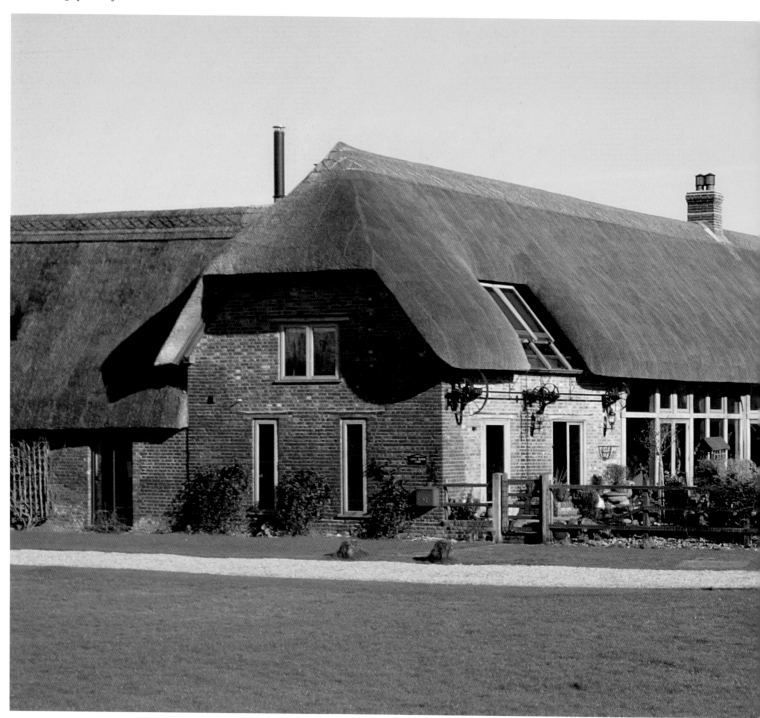

reframing of the Globe Theatre and sharpened by the collection of regional English barns at the Weald and Downland Museum in Singleton, Sussex. This growing familiarity with the vagaries of English joinery led initially to the selection of the Little Manor Barn, and after the devastating fire, to its informed renovation. For this process the new owner took two years off from work and persuaded the restoration carpenter to forestall retirement. To refashion the framing members they determined to use new "green" oak, which has the tendency to "shake" as it dries, splits, and shrinks. Because the historic fabric of the original structure had been lost, building stipulations were less stringent for the recreation of the structure than for its previous restoration. The exterior of the resulting building is not dissimilar to the original, but inside, alterations are rife. As is often the case, the rigidly faithful timber-frame restoration appears far less dated than the more flexible interpretations of the interior.

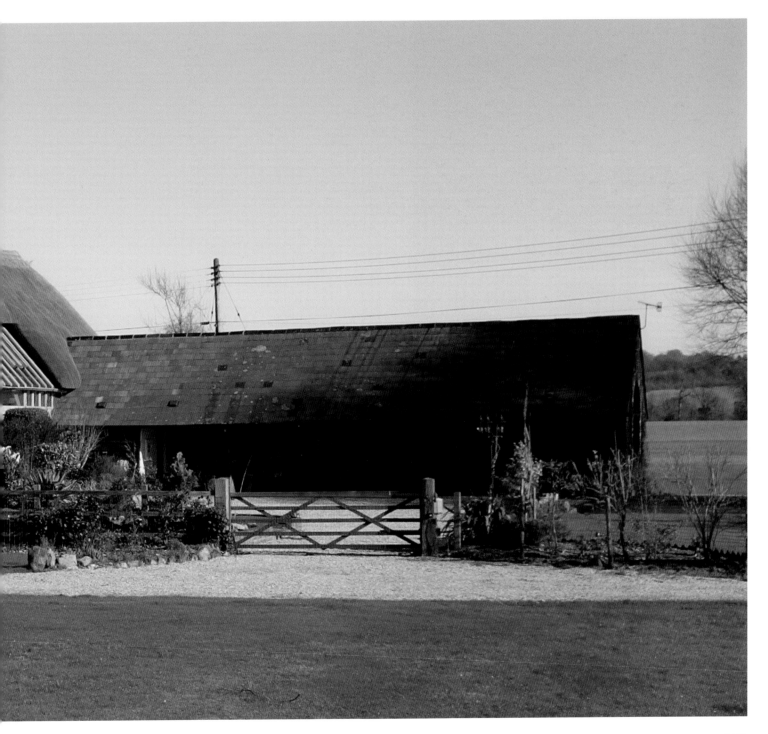

The reconstructed Little Manor Barn is essentially a contemporary house that acts as an homage to the original barn house it replaces. Lighting, landscaping, and the choice of secondary materials make no attempt to acknowledge precedent. Opening the walls and roof to reveal the structure displays to advantage the timeless qualities of early English crooked timber framing, but it is not by any measure restoration. Such distinctions are important to consider before entering into the sensitive effort of conversion.

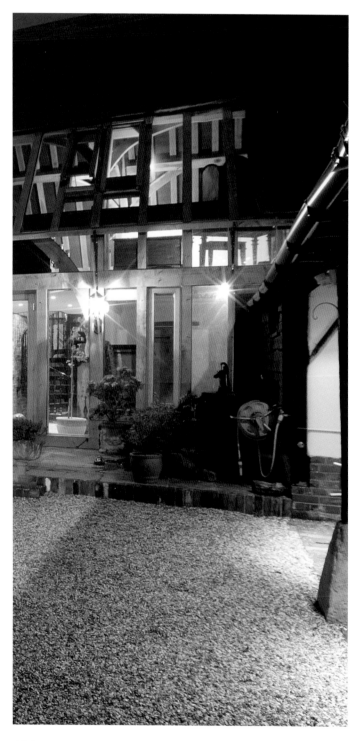

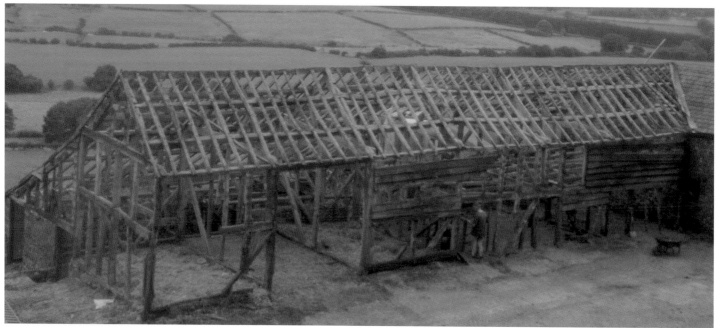

Llandrindrod Wells, Wales.

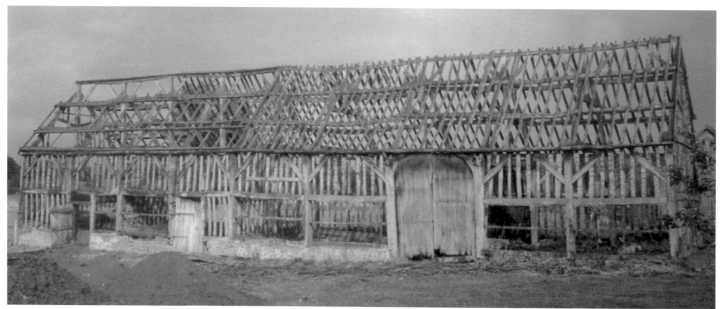

Favrolles, Normandy.

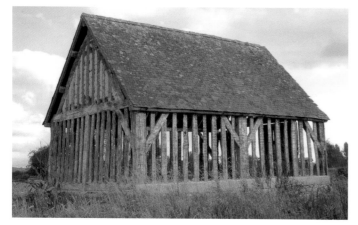

St. Giles, Normandy.

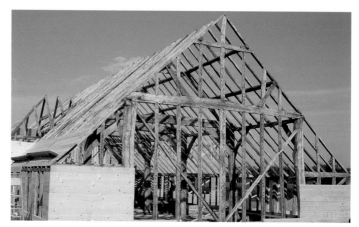

A barn from Britain goes up in Southampton, New York.

The ancient art of timber-framing is never more evident than when a structure is stripped of sheathing during transition. Replete with crucked braces and irregular blades, great barns in Llandrindrod Wells, Wales, and Favrolles and St. Giles in Normandy illustrate the compelling integrity of early heavily timbered frames, as well as their vulnerability to insensitive adaptation. Another early structure imported from Britain laid bare its bones while awaiting its fate as a conversion in Southampton, New York. For many years structures like these, which were deemed less important examples in the Old World architectural litany, were too frequently dismantled, loaded into containers, and shipped away to the States, where many were refitted as quaint cottages. Today, this practice has been effectively thwarted by more comprehensive safeguards for vernacular structures. Nonetheless, some British barns that stay in situ could use some protection from the shortcomings of incompatible conversion. The fascinating patterned stonework displayed in a barn in the Thames Valley is overwhelmed by a roof riddled with skylights, a shaped window, and girdling formal gardens, which, though charming, seem misplaced in the former farmyard.

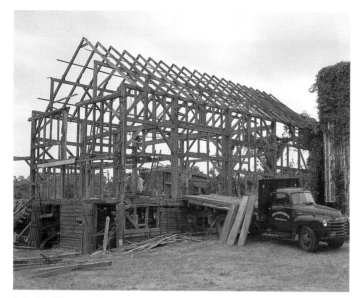

The Middleton-Waln Barn during removal from New Jersey.

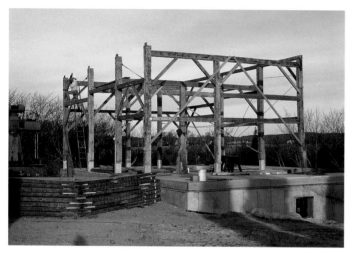

The simple frame with added height to the ground floor goes up on Long Island.

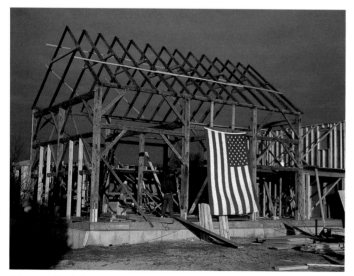

The completed frame with an extra bay being added.

Another barn conversion achieved using simple forms and straightforward materials is the Middleton-Waln Barn, a late-eighteenth-century structure rescued from North Crosswicks, New Jersey, and eventually reerected in Haymarket on Long Island's South Fork. Although the interior is restored to its original form, the exterior has been configured to reflect local Long Island features. Consequently, the old frame is sheathed with vertical pine boards inside, but outside, beyond a layer of rigid insulation, cedar shingles represent the traditional material of the adopted site. Economy dictated the asphalt roof, an inexpensive option. Even on the private side of the barn, windows are modestly scaled, except for the former wagon-door opening. This feature, however, would be far more successful if the French doors and transoms were painted a dark color to infer a sense of a void in that location. The opposite would be true inside, where light-colored mullions would present less contrast with the fieldscapes they frame. Elsewhere within, new sheathing and flooring prevail, a further nod to a firm budget, but the old threshing bay, center today of extensive weekend entertaining, is endowed with well-trod, timeworn, white oak floorboards.

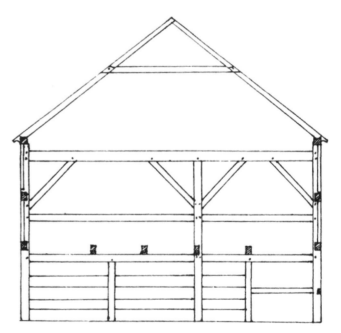

Bent A. An end elevation.

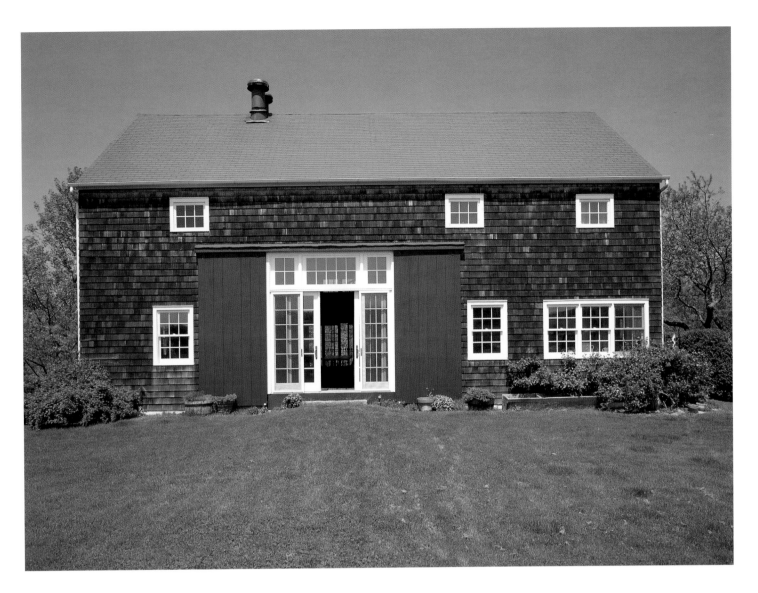

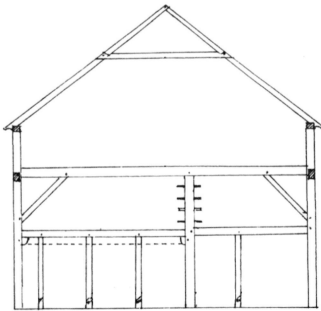

Bent B. *One side of the threshing bay.*

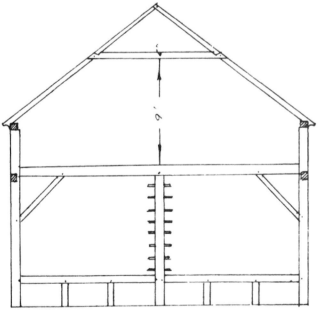

Bent C. *The other side of the threshing bay.*

199

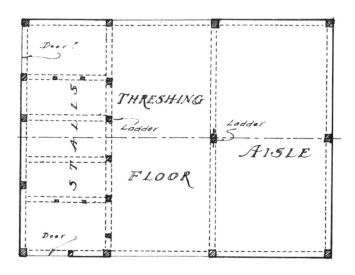

The floor plan.

The Middleton-Waln Barn is a good example of English framing details common in southern New York and New Jersey in the eighteenth century. Measuring twenty-six by thirty-six feet, its proportions reflect requirements appropriate for a modest farm. Although it was raised in central New Jersey, similar examples are common to the area where it was moved. The rhythm of double braces and rare alternate collar ties distinguish the hewn frame. The firebox, shown on the following two pages, and based on the Rumford model first extolled in 1796, was intended to be a few feet lower, reflecting the mass of a blacksmith's forge. In an effort to de-emphasize the chimney, triple-walled flues rise to the rafters.

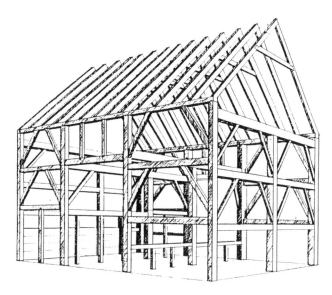

A perspective rendering of the Middleton-Waln frame.

Right:
The threshing floor with its thick, well-worn boards becomes the dining area.

200

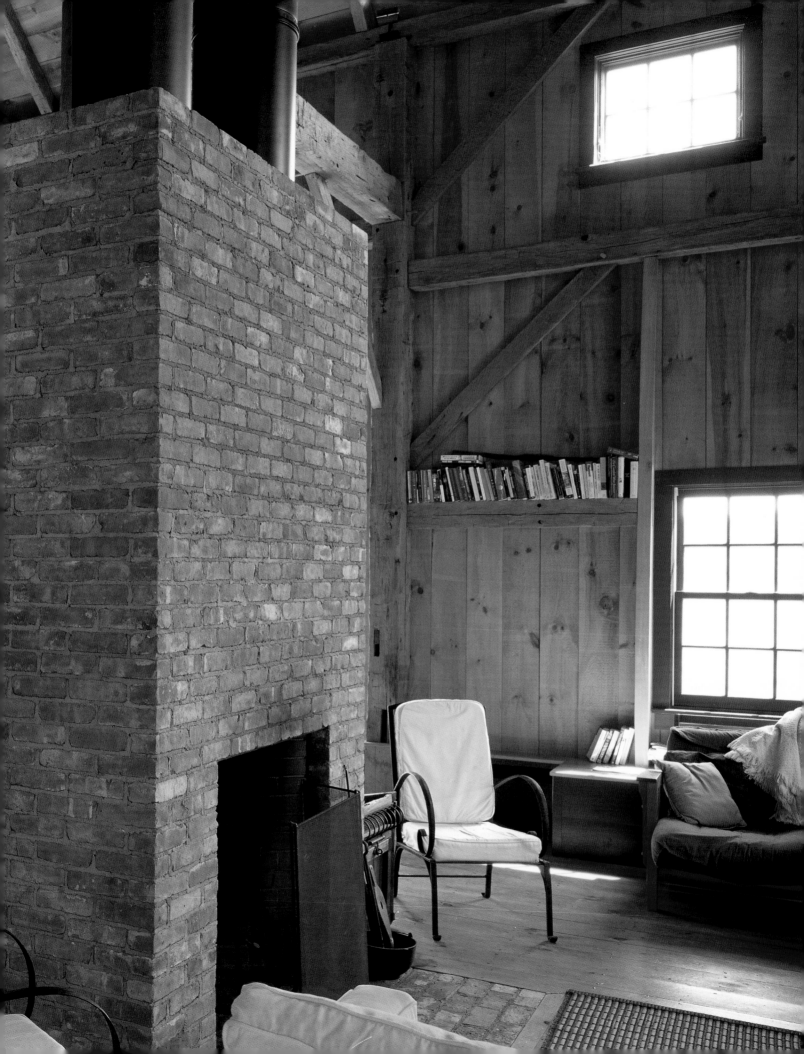

Sliding doors open to the library.

The master bedroom.

A major consideration in the conversion of barns into residential use is the desire to maintain separate, private sleeping quarters without interrupting the great central space of the original structure. The Middleton-Waln Barn includes three different strategies toward that end. Built into a bluff, the main floor of the structure is a story above the approach, consequently providing a lower level containing a garage/storage area and two guest rooms. A library, which doubles as another guest room, is separated from the living space by sliding doors. Above it a bunk room offers a window through which young visitors may observe the entertaining activities of their elders after bedtime. The master suite, included in a one-bay extension of the original three-bay barn, opens off of a loft space from which it is separated by a wide sliding door. When the couple is alone, this door, left open, allows the bedroom to be a part of the greater space of the original structure; with company, it may be closed to afford the desired privacy.

The stairway of the Middleton-Waln Barn.

204

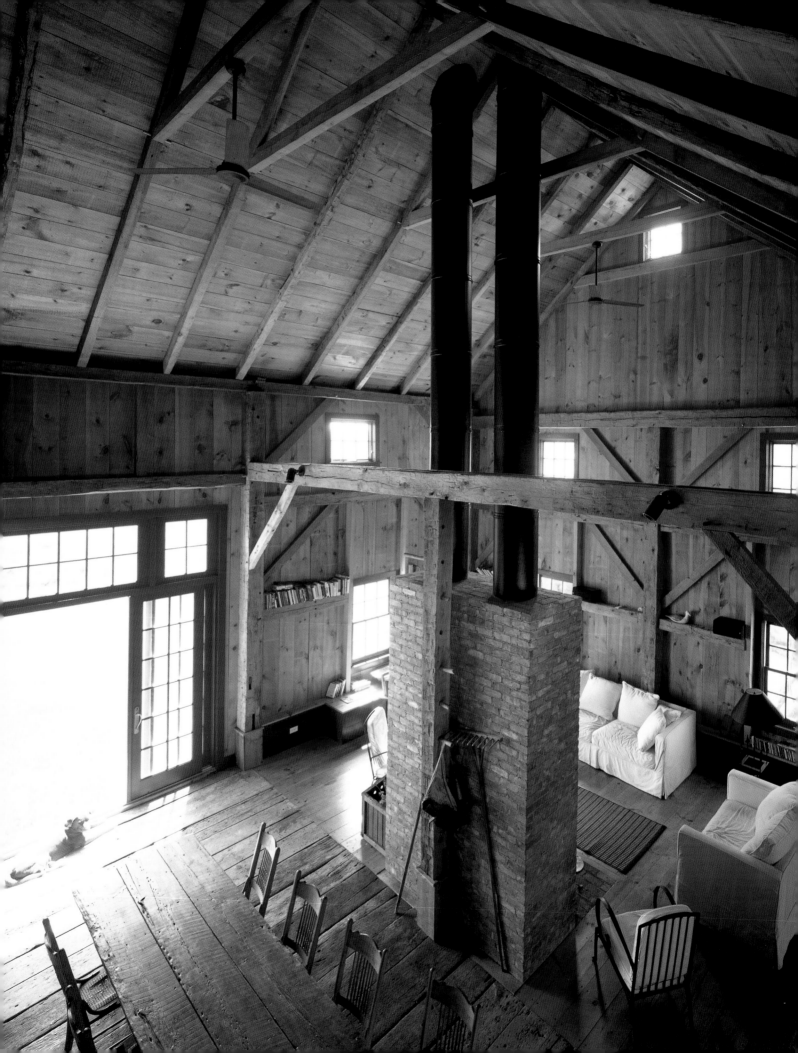

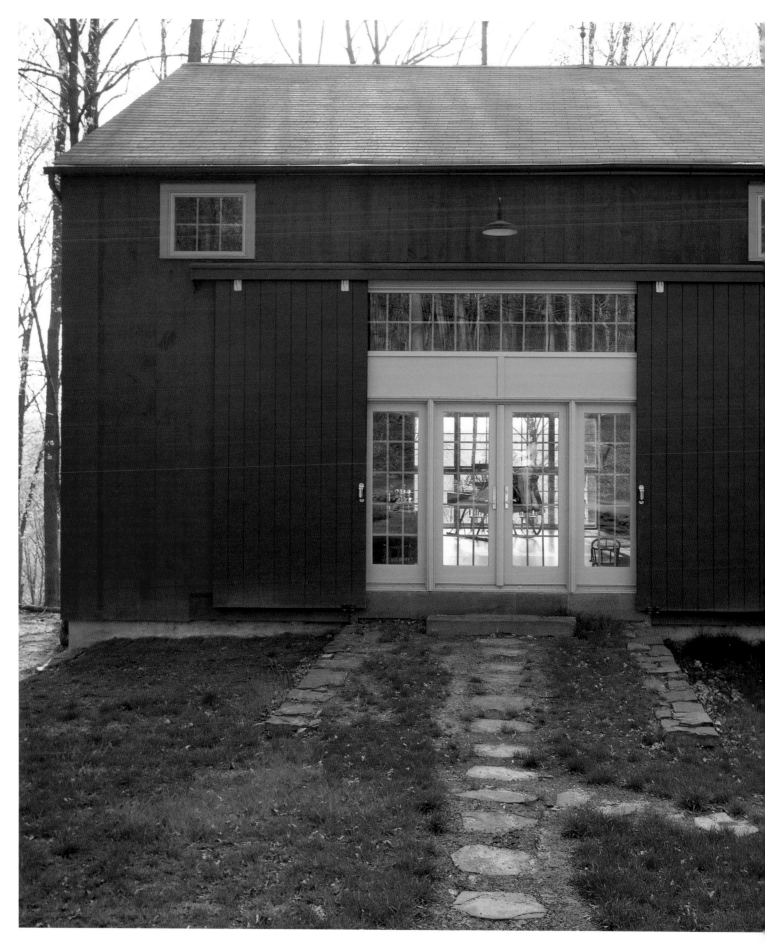

The wrecked barn.

In 1983 a freak cyclone touched down on a hardscrabble farm on the south slope of the Sourland Mountains in Somerset County, New Jersey. In the middle of the meadow a huge tree was felled. Family tradition claimed that when the farm was cleared by ancestral settlers, sapling timbers were leaned up against this tree. Some of that lumber might well have been used to frame the small twenty-six by thirty-two-foot barn that served the small holding. This structure, too, lay in the path of the twister. Though the frame was undamaged, the roof was lifted off, inverted, and dropped nearby, rafters up. No longer required for farming, the barn was disassembled before exposure to the weather could cause further damage. Years later it was appropriated to create a small house on a ridge overlooking the Delaware River near Lambertville. Provided with two swingbeams, a rare feature, the Whitenack-VanZandt Barn offers a floor plan unbroken by posts, which is well-suited to domestic application.

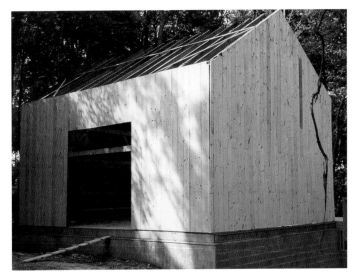

The simple shape of the Whitenack-VanZandt Barn in Lambertville.

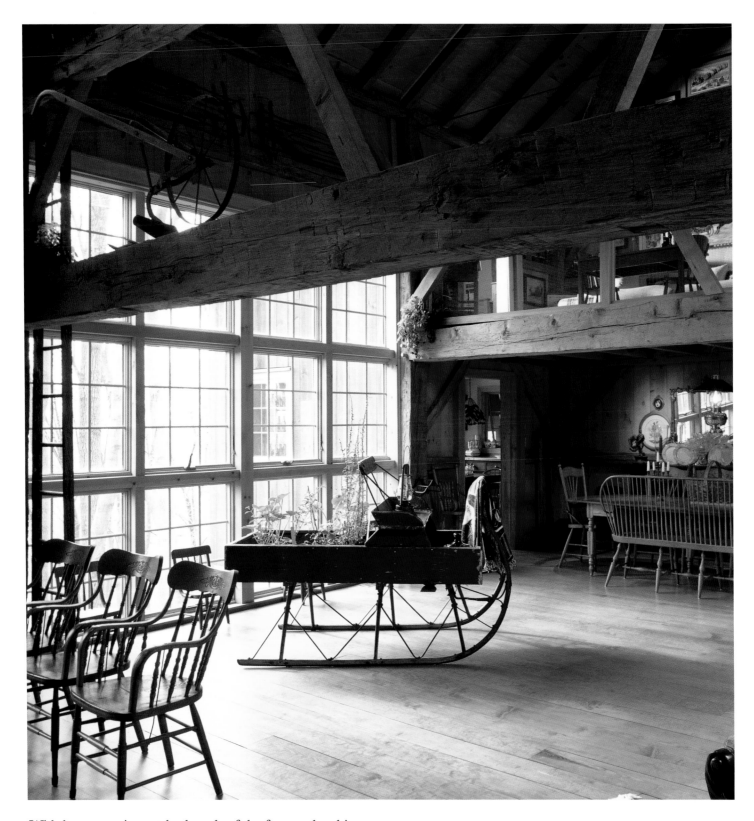

With huge openings at both ends of the former threshing
floor, the central bay of the Whitenack-VanZandt Barn
has been left unfurnished, a fine opportunity to spotlight
or silhouette a singularly dramatic object like a sleigh or
a Christmas tree. Dining is reserved for the relative
intimacy of a side aisle under the loft.

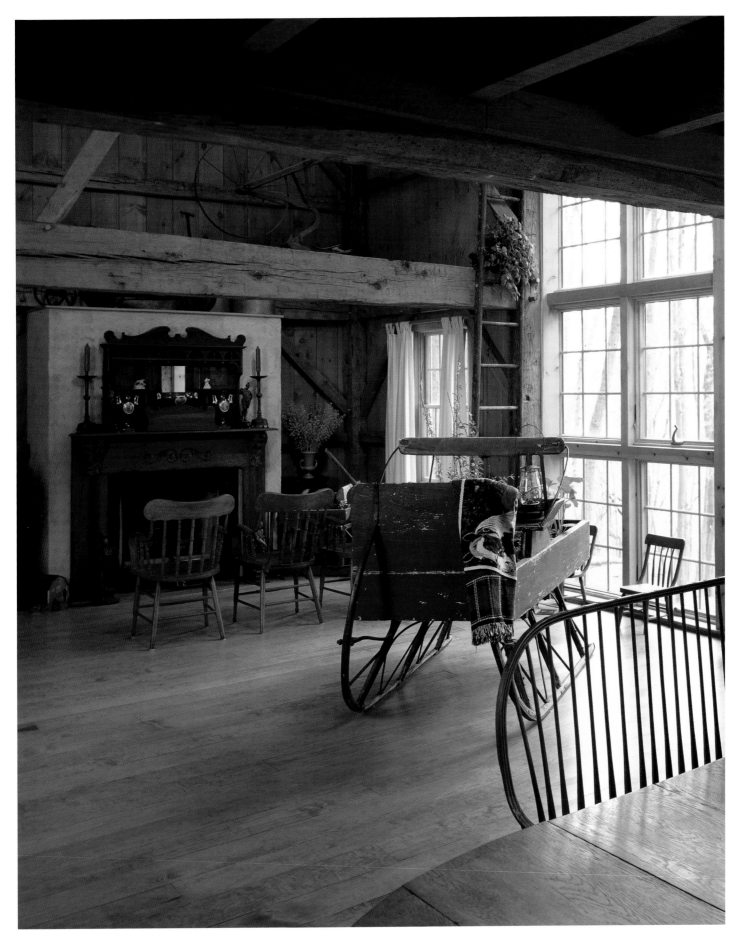

A section shows the trussed swingbeam.

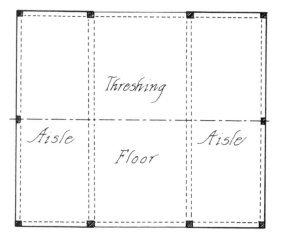

Threshing

Aisle

Floor

Aisle

The simple floor plan.

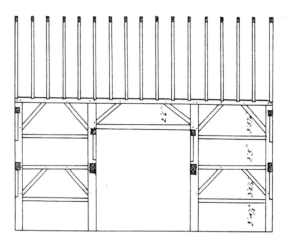

A side elevation.

From the study, which occupies the loft over the dining bay, one of the trussed swingbeams that dominate the Whitenack-VanZandt frame can be fully appreciated. Siding, sheathing, and flooring are all new material. Like the original boards they replace, they will gradually gain a patina through the wear of sustained use and the effects of oxidation.

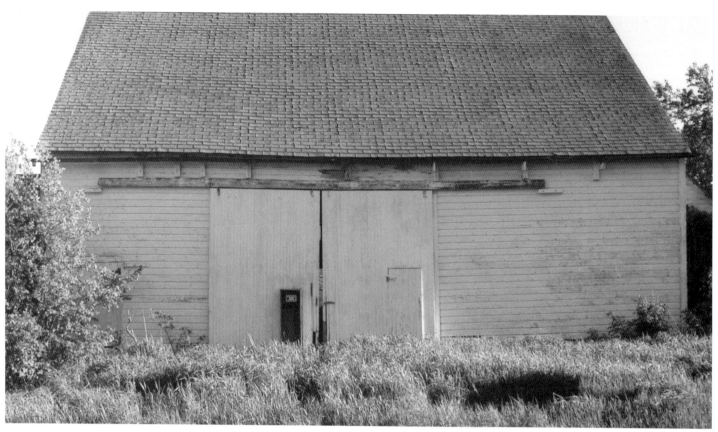

A barn in Williamstown, Massachusetts, facing Mount Greylock, awaits restoration.
Below: The repaired frame. Opposite: The completed barn house with an extension and a separate guest studio.

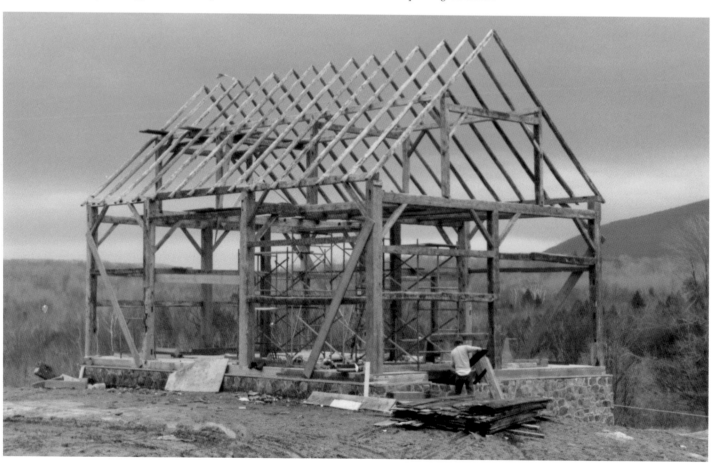

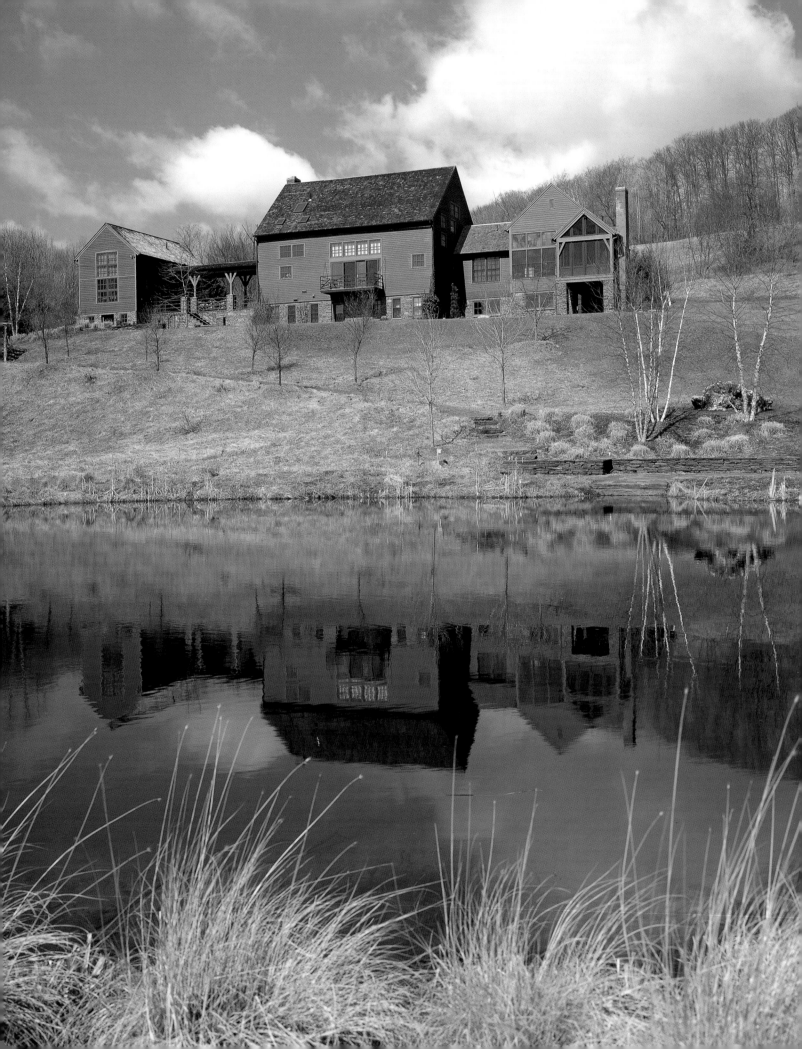

In 1990 a couple with three grown children and many potential grandchildren conceived the notion of converting a barn in Williamstown, Massachusetts, into a family retreat. The first architect entrusted with the task of effecting the plan chose to consider an interior stained white and lit by ranks of windows. When he was unable to continue the project, his successors opted for a less intrusive approach. "The big, dark, mysterious space of the barn was very appealing to us. In order to preserve these qualities, we kept the interior as open as possible. Windows were used sparingly and with considerable planning to keep the interior cool and dark, but not gloomy . . . We used no white or off-white colors because these tended to overpower the rich, muted colors of the old wood. When we introduced new structure into the interior, we used black-painted steel in order to differentiate it from the historic barn structure." The distinction between the original barn structure and added elements must be carefully considered in all successful conversions. The site, with both a pond in the foreground and long views beyond, is ideal for a barn house.

The kitchen area in the barn is lit by three six-light sash, set in the same sort of seeming randomness that often occurs in working barns through the evolution of agricultural practice.

The use of black-painted steel for structural additions to the Williamstown barn is a worthy lesson in contrasting modern insertions with original fabric. The choice to include a period mantel is less well-advised. Still, barns clad in their original dark wood sheathing present a fine backdrop for all manner of collected objects. The colorful period poster is highlighted by the contrast with the siding in the same way circus posters once were when they embellished roadside barns in an earlier day.

In place of balusters, the new steel staircase and gangway introduce the use of wire mesh, a material far more in keeping with traditional utilitarian precedent.

Archibald Mills' deserted barn.

The barn comes down.

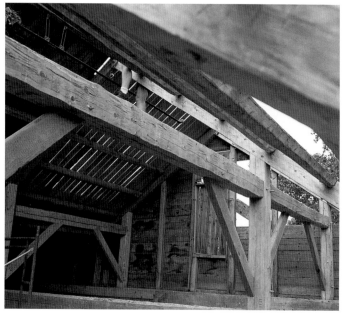

The purlin system.

The builder's inscriptions.

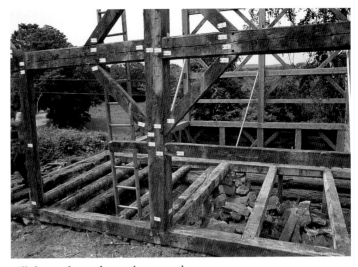

All the members to be saved are tagged.

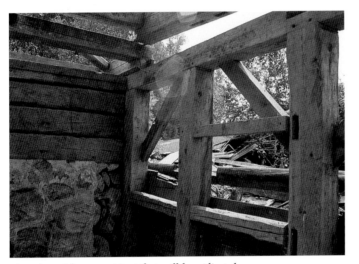

A section with stone support that will be replicated when the barn is rebuilt.

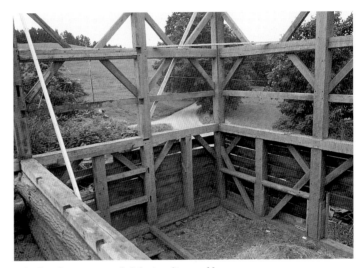

The foundation is revealed during disassembly.

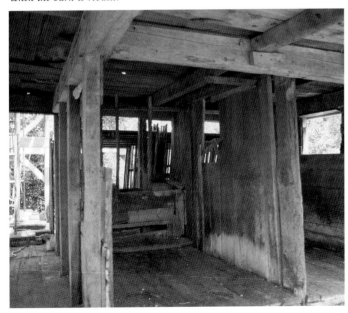

The oxen stalls.

According to the date incised in one of its timbers, the barn that Archibald Mills built in Topsham, Vermont, was raised in 1800. Banked into a hillside, with stalls segregated to the cellar, the structure measured thirty-six by fifty feet. The timber frame followed the English pattern with gunstock posts and principal rafters and purlins supported in part by an elaborate queen post system.

At its inception the barn must have been impressive both for its generous proportions and canny innovations. By 1993, however, the pride of the Mills Farm had fallen into disuse and deterioration was accelerating. Determined to save the structure, a Vermont timber-framing firm documented and disassembled it for eventual reuse in more appreciative circumstances.

219

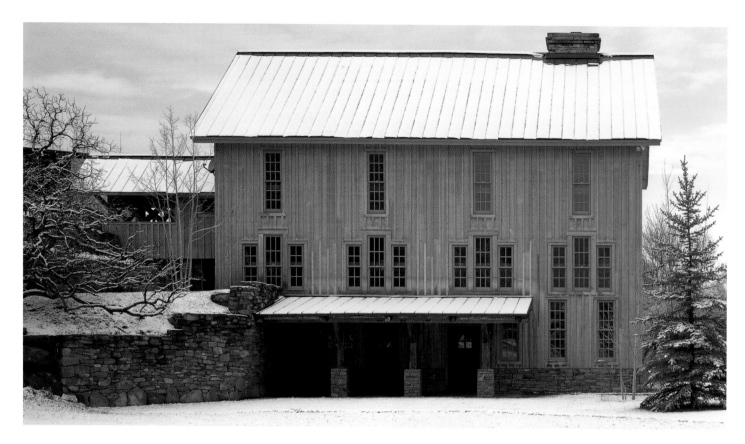

In the end Archibald Mills' barn exchanged a backdrop of mountains in Vermont for mountains in Colorado. A noted photographer, who is also a restoration carpenter, and his wife, with a fondness for vintage materials, conceived the notion of relocating an early Eastern barn to his family's ranch in Basalt. A year after disassembly, the framing members of the Mills Barn were pegged together and raised again. After much thought and planning the barn was fitted with an end into the terrain requiring a massive ramp using local stones rescued from the remains of the old family potato cellar to access the central wagon-door entry. A standing seam roof was chosen as an alternative to the building's original cedar shingles. Another feature which was less true to Vermont precedent of the early 1800s, but in keeping with a New England style of the early 1840s after the advent of the circular saw, was the use of board-and-batten siding. Original clipped eaves and gables have also been reinterpreted with wide overhangs. An effort was made to restrain the size and number of apertures on the approach, and on the opposite broadside a riotous rhythm of windows presents an entirely different effect as light floods in and around the unchanged frame. In this reinterpretation to accommodate the conventions of a new site, Mr. Mills might fail to immediately recognize his own masterwork.

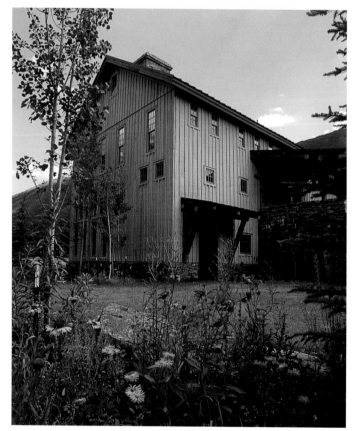

Opposite: The light shining through the windows and its open space from floor to ceiling beautifully recapture Archibald Mills' original craftsmanship and architectural design.

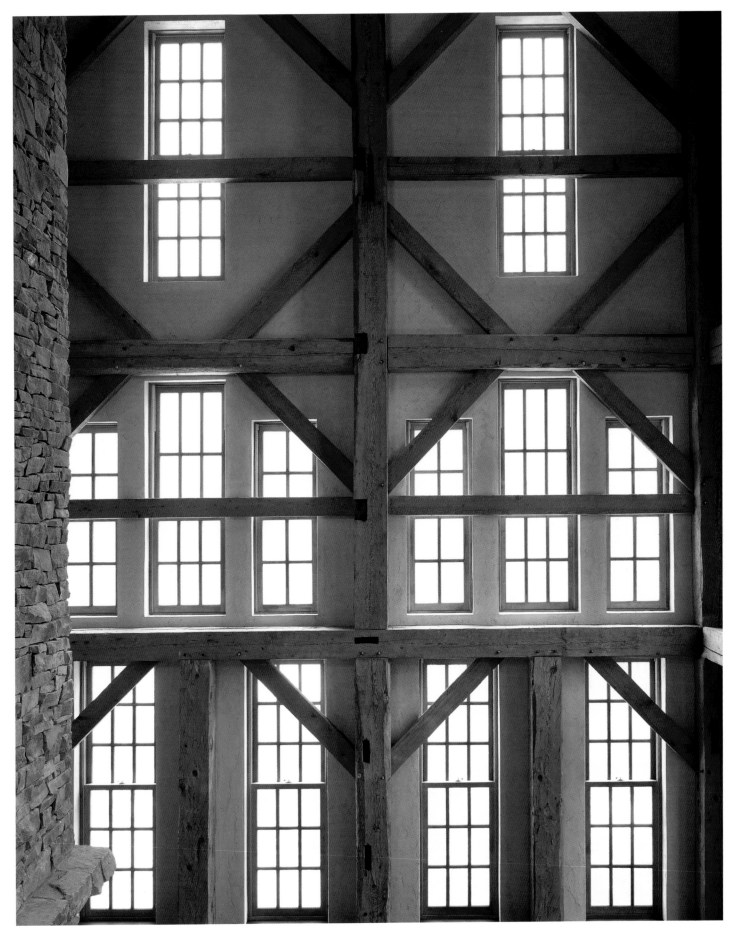

The kitchen cabinets were built by the owner.

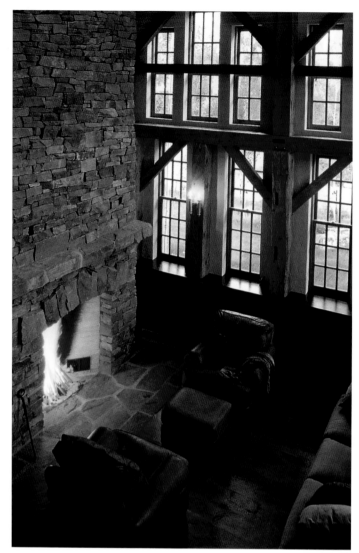

The stone chimney and fireplace.

The Archibald Mills Barn is an impressive and complex structure, which, despite its monumental size, maintains a deceptive delicacy of proportion. The genius of the design is that every member is integral to the inherent capability of the framing scheme. Each component performs a function; no timber is superfluous. Any conversion, by definition, compromises a structure, because the function that created its form has changed. But the successful adaptation will recognize that new design elements and materials must respect the integrity of the original by assuming a secondary role in the new building. The kitchen, for example, is nicely lit and appropriately restrained. The impulse to echo the structural rhythms with new fenestration is also admirable, but the patterns of differently divided sash (superimposed over, not within, the framing members), though exuberant, is extreme.

The most conspicuous example of this reinterpretation is the massive chimney, which rises four stories as an unbroken monolith. The firebox is modeled after a design promoted by another New England native, Benjamin Thompson, better known as Count Rumford. Born in Woburn, Massachusetts, Thompson was a remarkable eighteenth-century man of genius whose contributions ranged from military matters to garden design. The most lastingly renowned is the Rumford fireplace, a shallow firebox with acutely angled cheeks and a smoke shelf, which was capable of throwing heat to all corners of a modestly scaled chamber of his day. Its application in the extravagant space of the converted barn might have amused him.

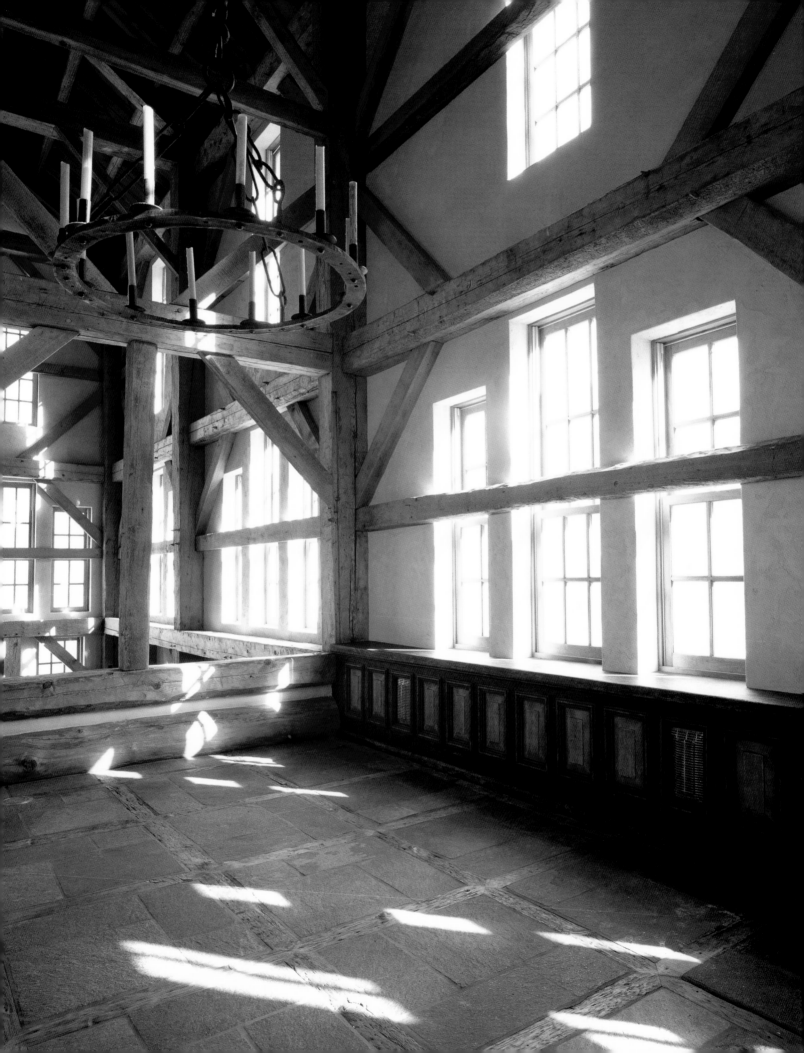

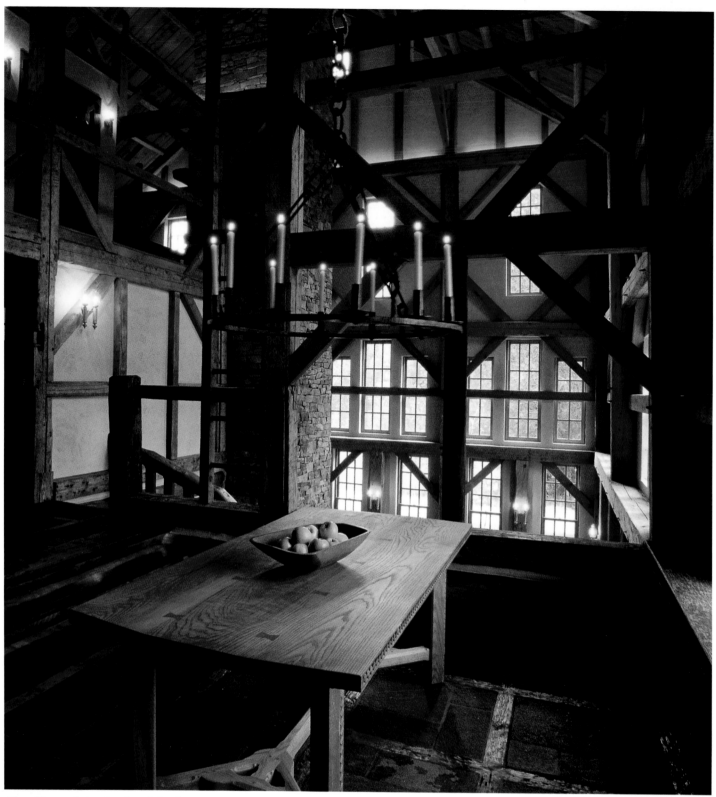

The table was designed and made by the owner.

The timber frame of the Mills Barn is magnificent. At a safe remove from the several interpretations manifested in its conversion, the solid integrity of the original structure still overwhelms the observer. It is rife with the extraordinary capabilities and inherent sense of design possessed by the men whose character shaped the early republic of the United States. The internal ladder, giant hoist, and complex roof structure are only part of the grand scheme that was fully realized in Archibald Mills' wonderful monument to independence.

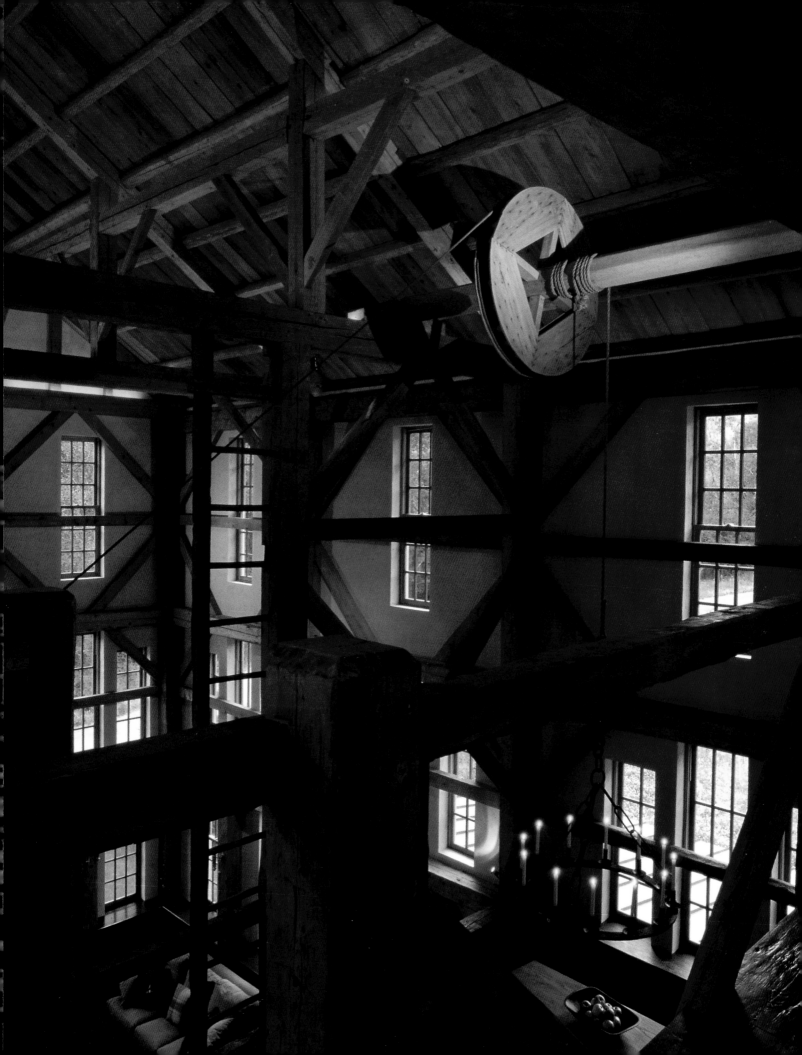

The arrangement of these buildings in Bridport, Vermont, proved to be the inspiration for the complex shown on the following pages.

A Bridport frame in the middle foreground, also shown in the center rear of the picture at the top of this page, joins the others in assembly at Sun Valley, Idaho.

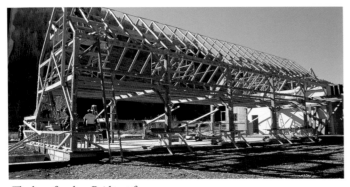

The long five-bay Bridport frame.

As agriculture evolved in America new structures were added to the original barns on most farmsteads. A good example in Vermont was a farm in Bridport, Vermont, which came to incorporate three independent barns arranged to create a U-shaped complex, protecting a central barnyard. Having ceased to perform the purposes for which they were raised, the structures were documented, tagged, and dismantled. Another barn, fifty miles southeast in Grafton, was similarly saved from ruin stemming from sustained neglect. Shorn of its sheathing it reveals the distinctive New England framing type, distinguished by a threshing floor opening from the gable end like a New World Dutch barn, but without internal anchorbents. Removal of vernacular structures from their original locations should be viewed as a last resort, but it should also be recognized that too frequently such radical measures are the only means of survival for buildings abandoned to deterioration or in the path of imminent development.

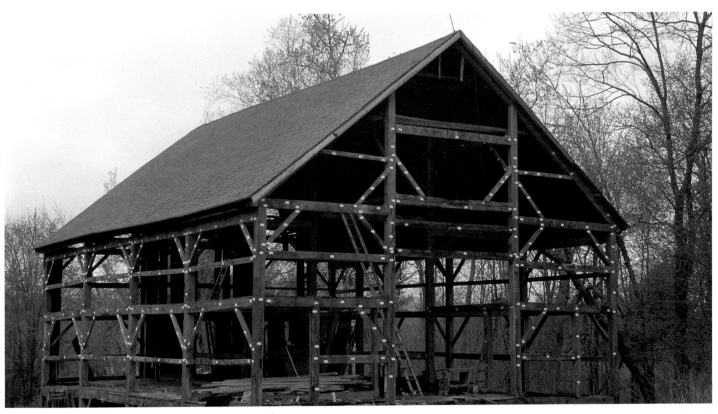

The Grafton, Vermont, barn, tagged and ready for dismantling and transportation.

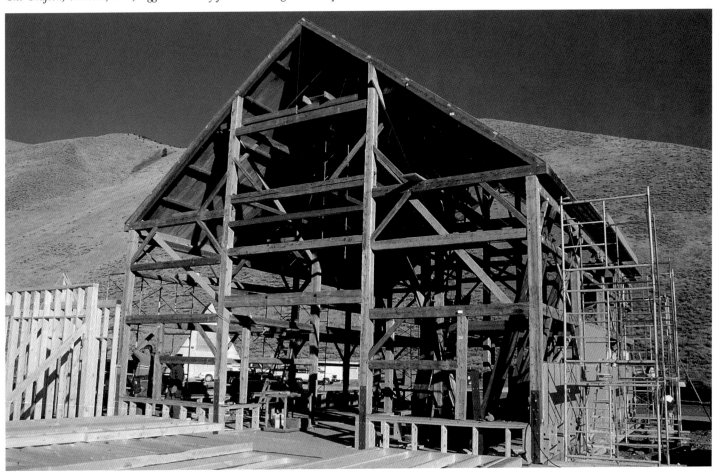

The Grafton barn becomes a domestic structure of the Sun Valley complex.

227

The frame of a Waltham, Vermont, barn is dismantled.

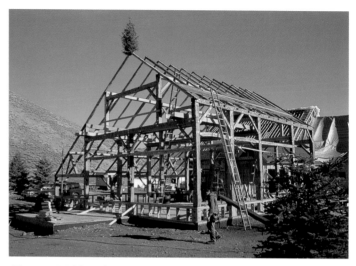
The same Waltham frame is reconstructed in Sun Valley, Idaho.

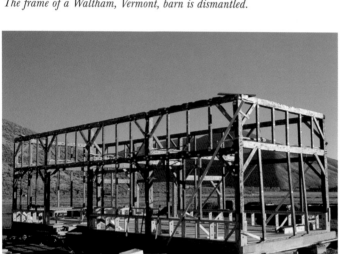
The frame of an Orwell, Vermont, barn is assembled at Sun Valley.

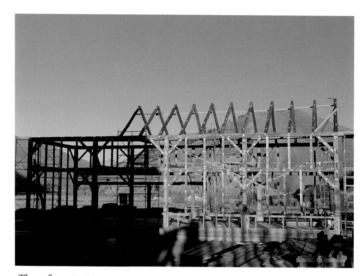
The rafters start to go up.

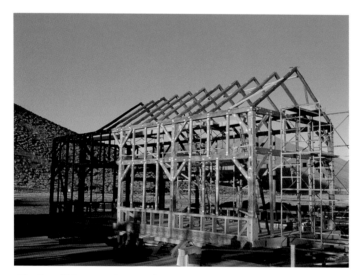
The Orwell frame at the end of a working day.

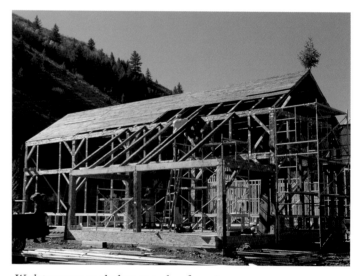
Work progresses on the lean-to and roof covering.

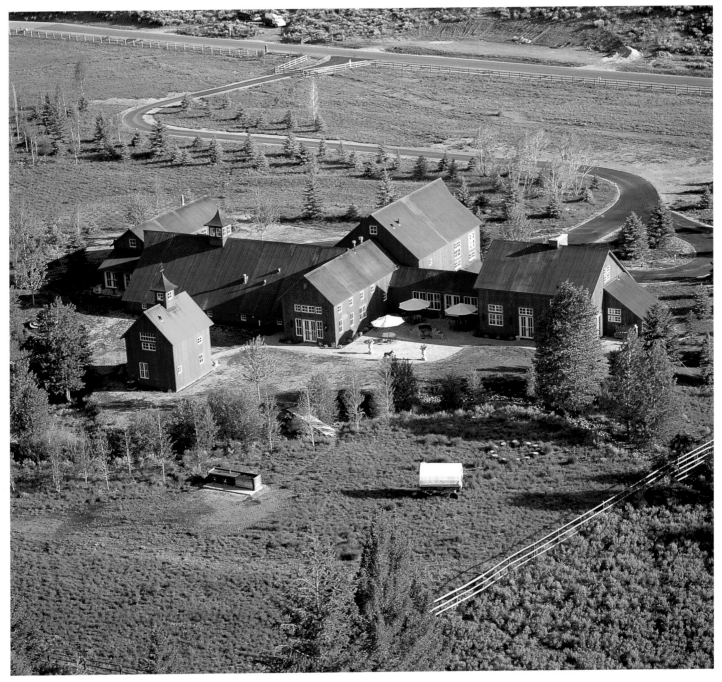

A bird's-eye view of the new "farmstead" in Sun Valley shows some of the New England barn structures.
The barn from Waltham is on the extreme right, the one from Orwell on the far left.

The juxtaposition of several farm buildings offers the pleasing, if unintended, playfulness of contrasting shapes and volumes and an inherent interplay of light and shadow, constantly changing with the advancement of the sun and the seasons. Achieving the same qualities in a reconstructed complex requires skill and understanding borne of studious observation of vernacular survivors in the rural landscape. Today, the restored, relocated, and reassembled barns from Vermont together form a sprawling assembly of domesticated buildings in Sun Valley, Idaho. The conversion may be faulted for its excessive size, but on the whole it successfully reinterprets the notion of gathered structures that informs its design.

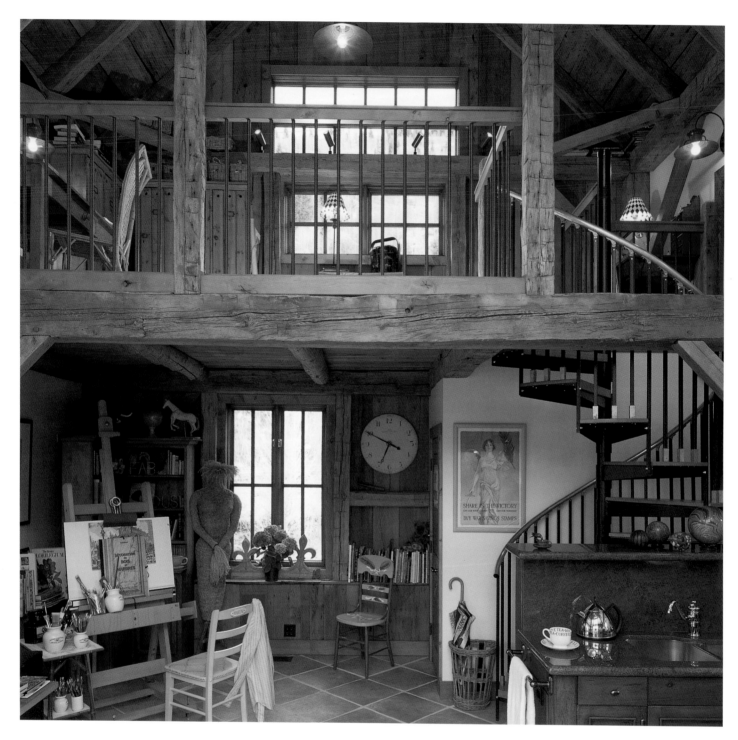

The Sun Valley complex includes a plethora of interior spaces with room for such varied pursuits as painting and piano. Some offer sequestered intimacy; some soar. Original and introduced surfaces are differentiated by the use of alternative materials. The art studio, intimate and well-used, stands apart from the building complex, a separation that discourages interruption.

The dramatic verticality of the nave in the rough-sawn frame from Grafton, Vermont, provides circulation between four bedrooms in the aisles – two up, two down – each the same size with the same appointments. There has been great attention paid to the lighting. Dozens of custom-made sconces, in combination with indirect fixtures that illuminate the reused barn siding, create theatrical effects. The glow of a barn house after dark differs markedly from the play of daylight. Opportunities abound for the skilled lighting designer.

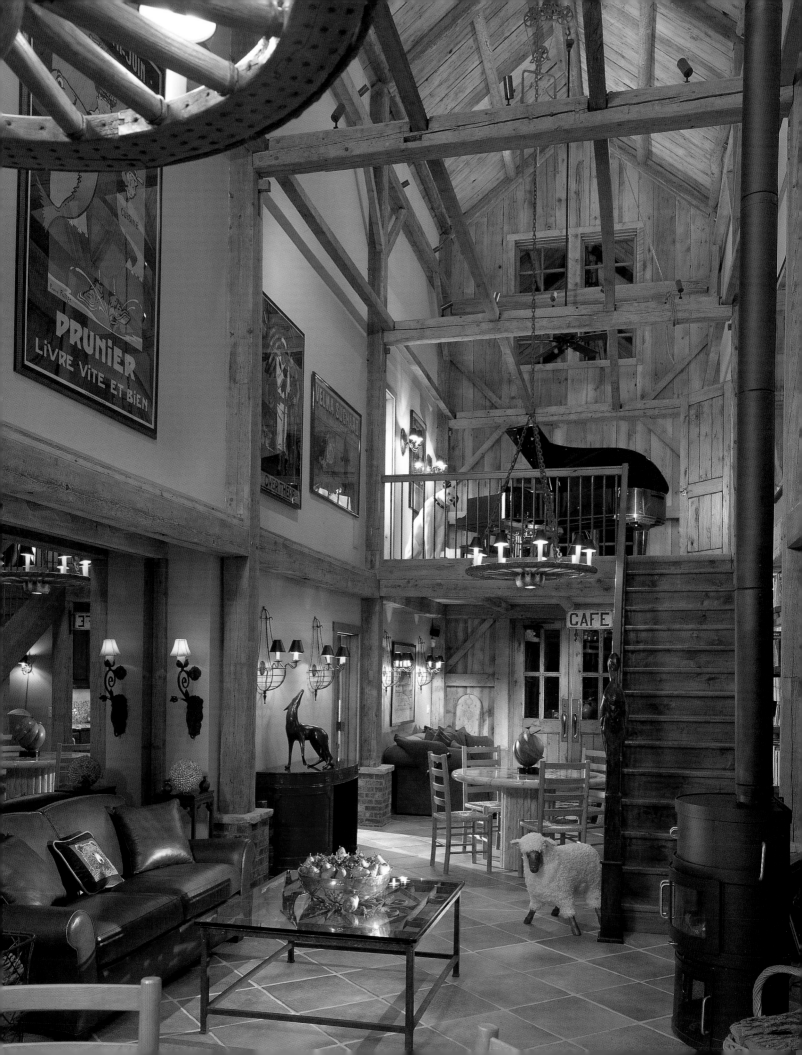

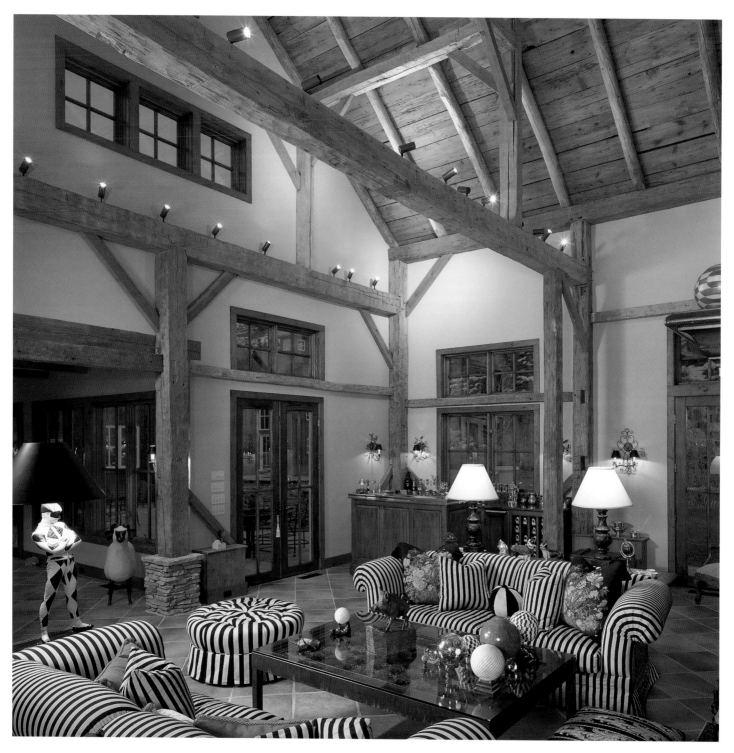

The saltbox barn from Waltham, Vermont, circa 1820, which serves as the great hall of the Sun Valley complex, retains most of the features that distinguish it as a timber frame. The roof is composed of common rafter poles, hewn on the top surface only, and sheathed in antique siding. These, in turn, are supported by an assembly of queen posts, collar ties, and purlins, which when washed in light display a sculptural economy of form matching function. Although the windows largely respect the frame, the substitution of plaster for boards on the wall surfaces has the effect of reducing the impact of the room so that it reads merely as a barn motif rather than as a barn. The decorator's selection of a jarring pattern for the upholstery is a distraction in an otherwise tranquil room. Contemplating a conversion, it is important to assemble a team that shares a full appreciation of the qualities that give character to an original barn structure.

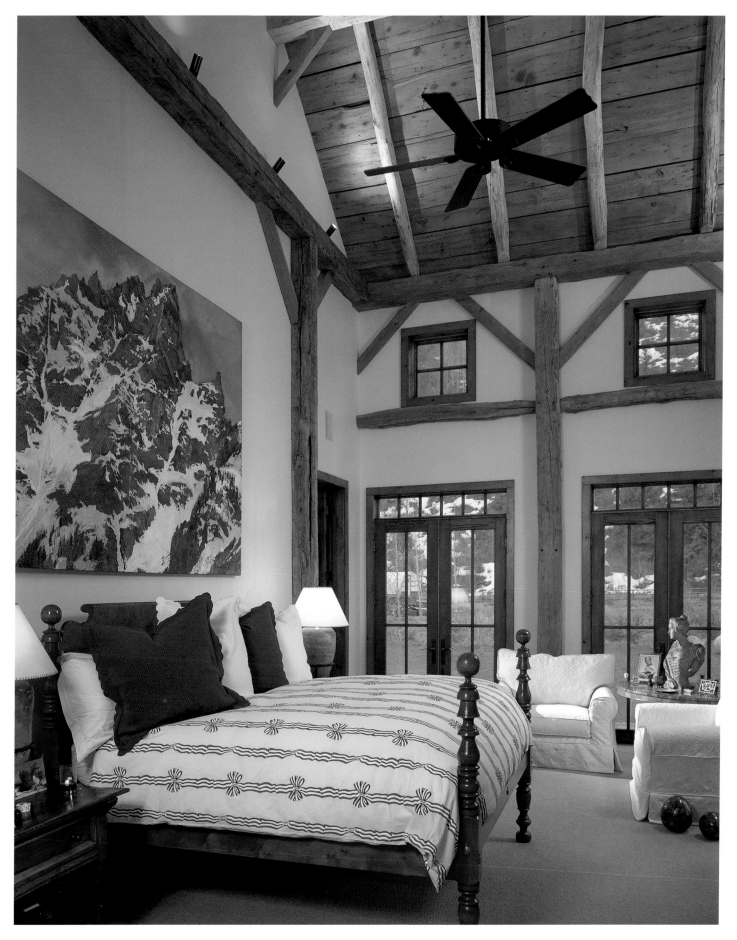

An astonishing barn from Cobbleskill, New York, was selected for the sheer power of its extraordinary frame long before plans had been drawn for the house it was to become near Sheffield, Massachusetts. At forty-five by fifty-five feet, it is immense, and therein lay the challenge. Many successful barn houses establish the barn frame as the core of a complex, serving as a great hall for living, dining, and, sometimes, cooking. Ancillary wings and lean-tos provide private, secondary spaces. In the case of the Cobbleskill Barn, this was not possible. Most of the critical functions were incorporated into the barn, with only a single, modest wing, constructed in a conventional manor, to relieve the otherwise overwhelming mass of the dominating barn. Fenestration follows no traditional pattern, but is scaled appropriately within the espansive gable end. Clapboard with a broad exposure, and clipped trim for the eaves and gables help to de-emphasize the enormity of the building.

234

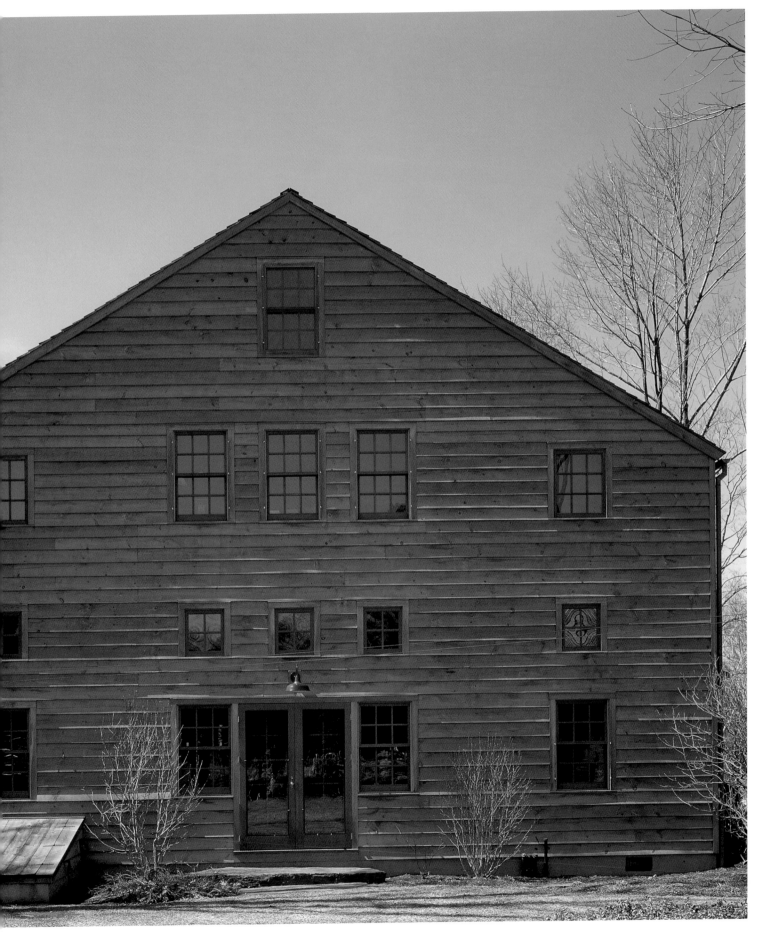

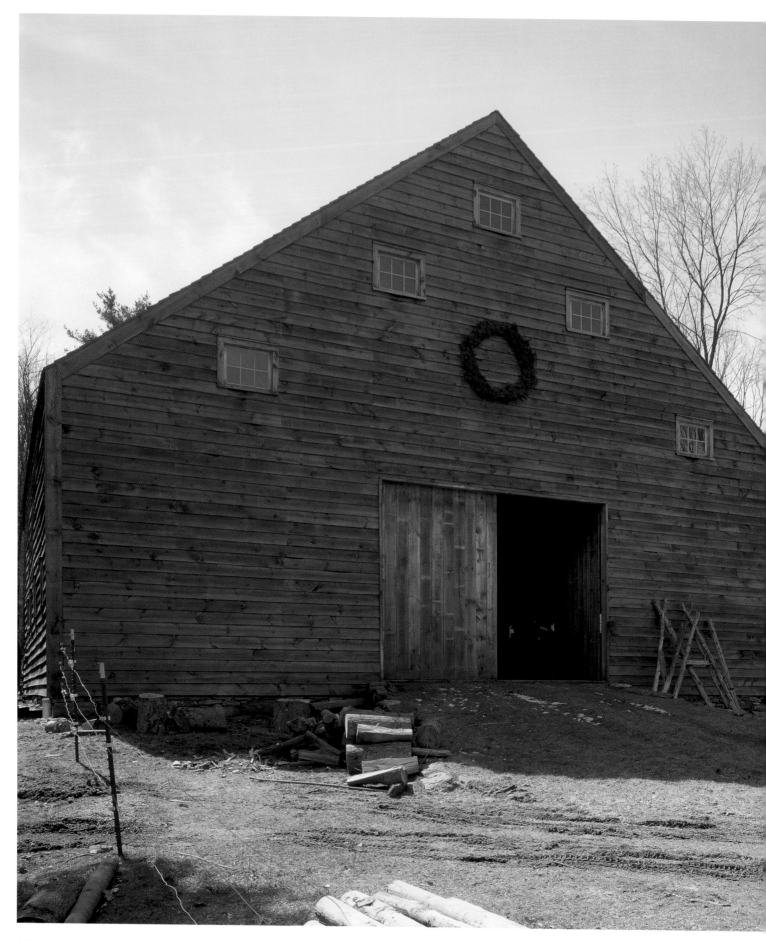

The integration of the Cobbleskill Barn into its lofty hilltop site in the Berkshires is aided by the selective thinning of existing trees and the laying up of stone walls. Fences and walls traditionally root barns into the farmsteads they dominate. Mature trees in immediate proximity are unexpected, but the feeling here is of a former farm, overgrown. Across a greensward a generously proportioned New World Dutch barn, also adopted from Cobbleskill, New York, continues to serve as an outbuilding. A vegetable garden, stables, and a paddock are complementary features. Free-range chickens perpetuate the property's agrarian connections.

Arranged in four bays, with an extraordinary forty-five-foot swingbeam dominating the center bent, the Cobbleskill Barn presents an awesome interior. The challenge of preserving the essential openness of this space while subdividing selected private spaces was accomplished using several devices. Part of the conversion strategy involved segregating one outside bay to serve as kitchen and pantry on the first floor and master suite above. A chimney serving fireplaces in the great hall, the kitchen, and the master bedroom is concealed for most of its great height within the party wall, which is otherwise perforated by doors to the kitchen and windows to the bedroom. In an opposite corner on the first floor a two-bay study has also been walled off to resemble the similarly partitioned granaries often incorporated in working barns. A U-shaped loft offers sequestered corners for weekend visitors without appreciably diminishing the vast unbroken space that defines the remarkable character of the original structure. The adjacent wing contains a laundry, powder room, and workout space on the first floor and children's rooms above.

The hand of a decorator is obvious within the barn, where adoption of an Adirondack style is generally compatible with the original Upstate frame. The dominant feature of this interpretation is a chandelier the size of a Christmas tree created from mule deer antlers. A structure this grand is easily capable of absorbing oversize objects, which resonate to its own astounding proportions. Although the silhouetted braces betray the enlargement of the openings for the former wagon doors, the use of these apertures allows the great interior to be well-lit without the use of unduly large windows elsewhere. Wire mesh, a material often used for partitions in stables, offers protection for the loft without obscuring its openness.

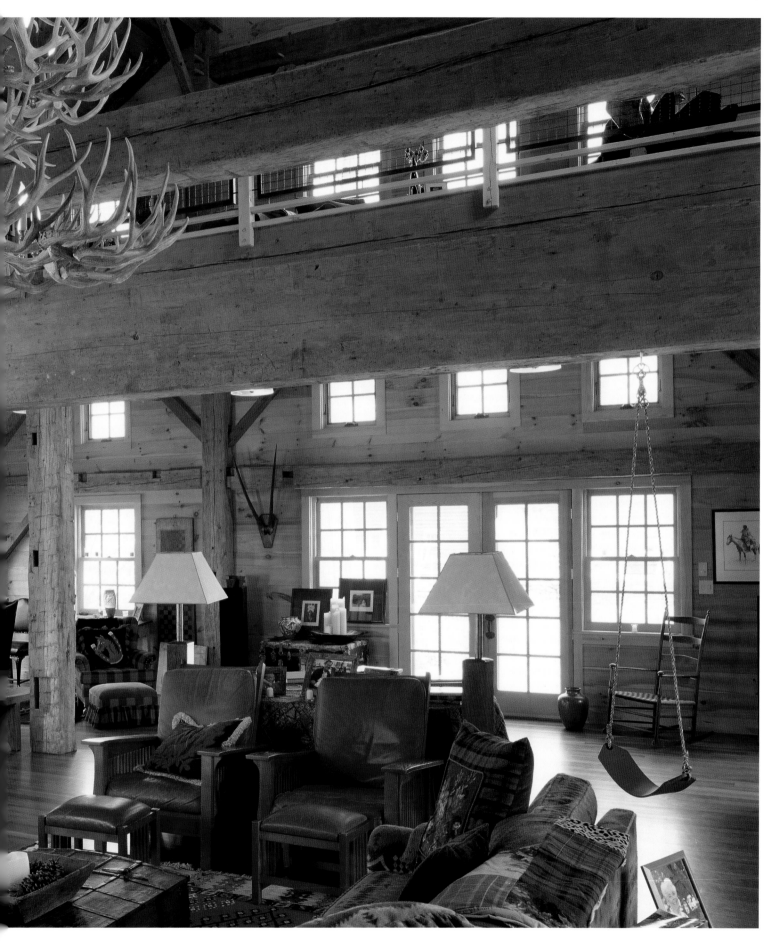

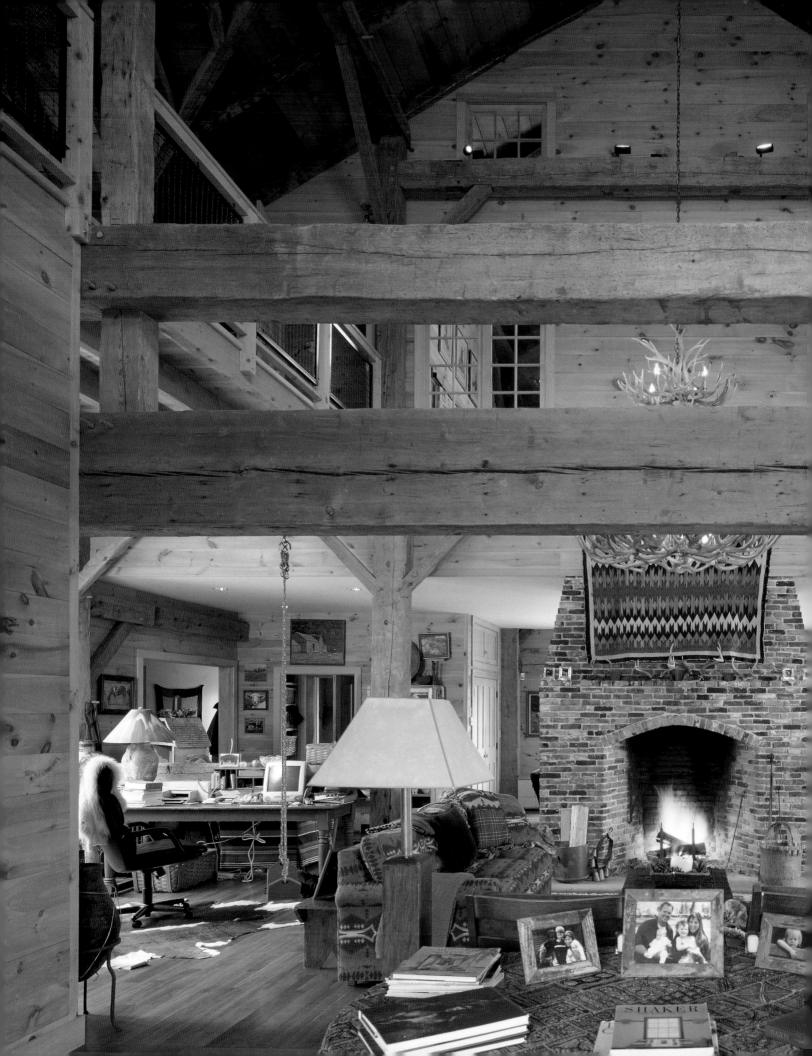

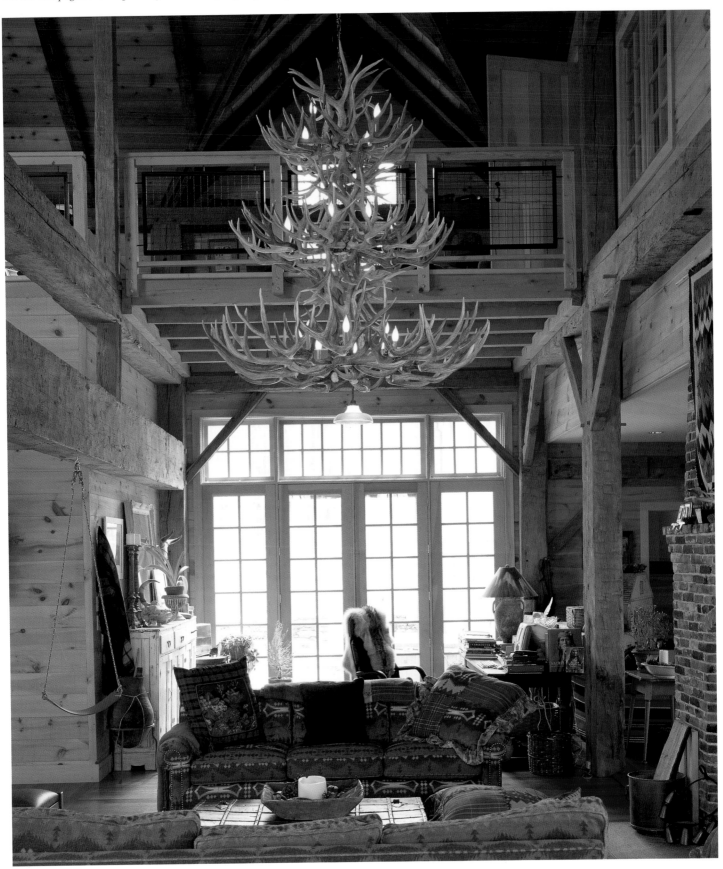

The chandelier, made from mule deer antlers.

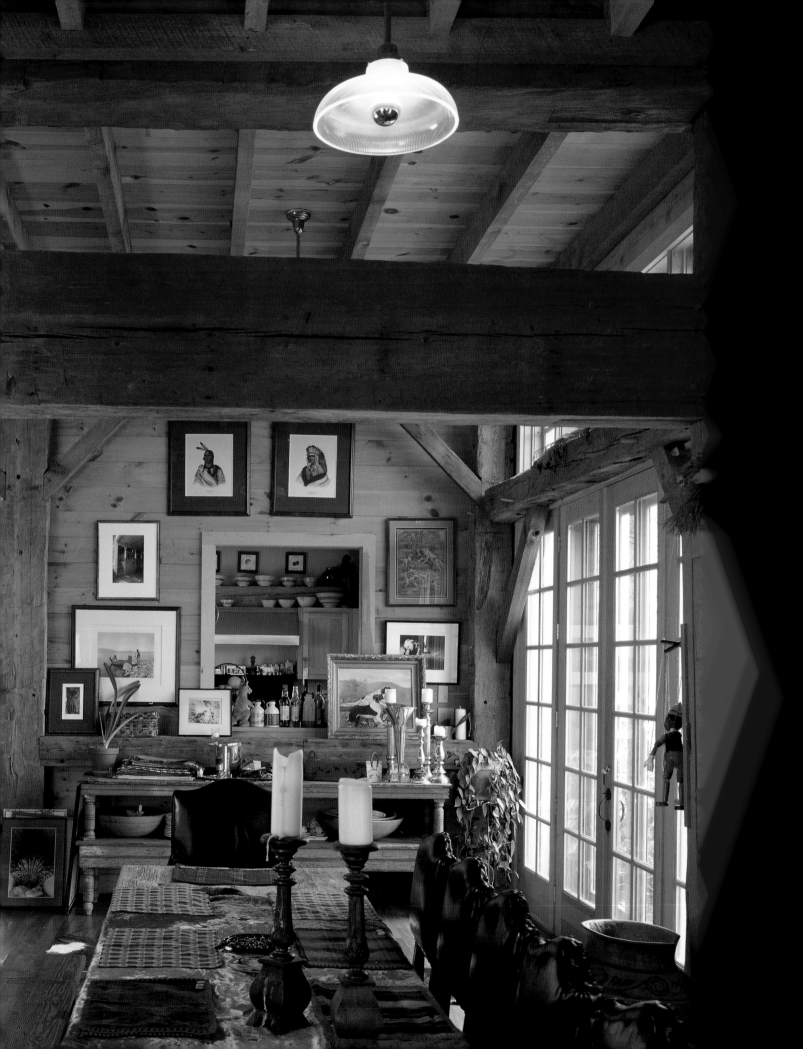

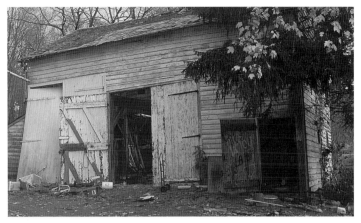

The Potts Barn in New Jersey.

The D. R. Potts Barn was built to serve a small farm in Stanton, New Jersey. An accompanying wagonhouse, built by the same hand, bears Potts' name and the date 1856. Measuring twenty-six by forty-two feet, the frame includes an original lean-to at one end. Large doors accessing one side aisle were an ill-proportioned alteration, improvised during long years of agricultural use. Elsewhere the original doors survived, displaying double diagonal battens, notched to forestall sagging. Relegated to serve as a repository for domestic refuse, by the late 1990s the barn was badly deteriorated. The slate roof had failed in places and portions of the frame had rotted. The structure faced imminent destruction at the hands of a disinterested owner. Consequently, a decision was made to save the barn by removing it from its original site based on the rarity and refinement of the framing design. Ironically, after several years in storage, the Potts Barn found a more hospitable home on forty acres of farmland outside Chapel Hill, North Carolina. While the remarkable frame was painstakingly restored inside, the exterior of the barn and the several other structures which join it are detailed to reflect the vernacular characteristics of this adopted landscape.

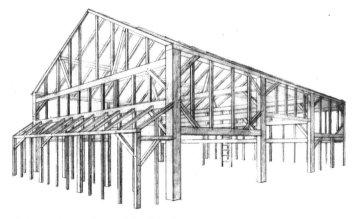

A perspective rendering of the Potts frame.

244

The Potts Barn as the center of the new complex, seen from both sides.

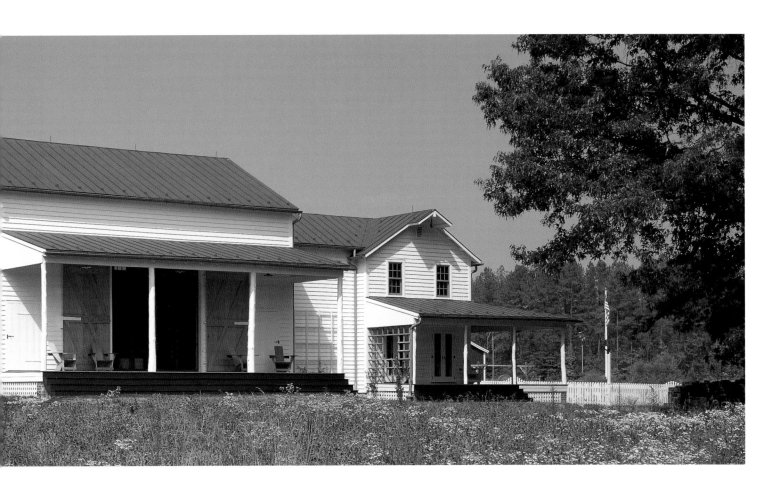

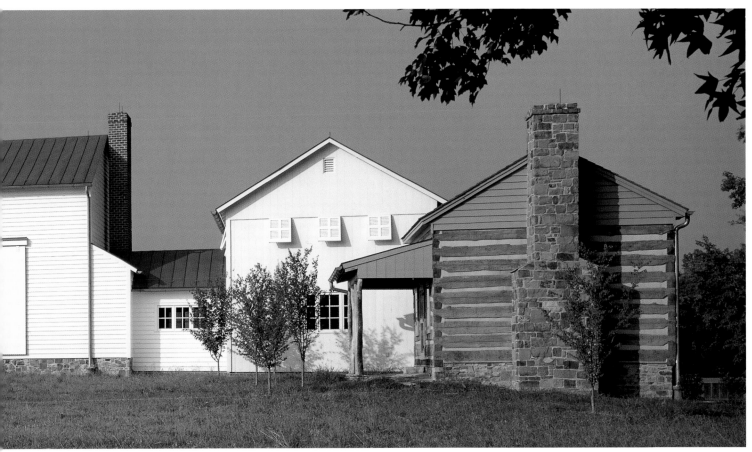

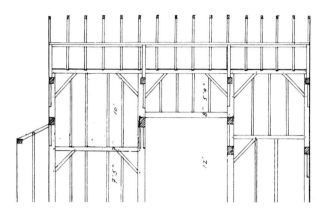

The two side elevations of the Potts Barn.

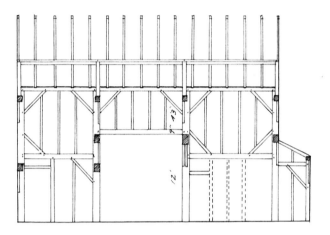

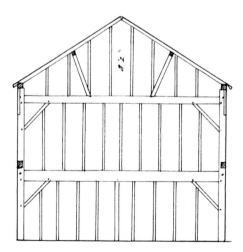

The bent for the lean-to of the Potts Barn.

The first priority in transforming the Potts Barn into a house was to place it naturally in its new surroundings. Siting was critical. Roadside, an existing farmhouse was rejuvenated to serve as a home to the new owners during construction and as a future guest cottage. An existing farm pond separates the old house from the site chosen for the barn house. The driveway starts at the farmhouse and then sweeps around the pond, through an area which has been planted as the remnants of an orchard. The rambling assemblage of structures anchored by the Potts Barn is designed to represent a complex of Carolina farm buildings. The various scales, masses, and materials of these buildings create a playful juxtaposition, which continues to change along the course of the approach. The barn itself is purposefully obscured by other structures until the last curve of the driveway, when it is revealed to be the center of the complex. Local tradition includes log houses, frequently built by settlers and later retained as summer kitchens. A suitable example was eventually located in and removed from West Virginia. It serves today as a private "Sunday room" off the master bedroom wing. This section includes two square structures representing typical local tobacco barns. The Potts Barn retains its original lean-to, which serves as the base to a detached chimney, drawn from the Carolina vernacular. Openings into the barn are minimal, allowing it to remain a relatively dark, cool retreat in the heat of summer. A tall porch, supported by local cypress posts, reinforces this atmosphere on the view side. The wing for the two-story kitchen is sheathed in board and batten siding, representing a possible later addition to the group of buildings. Creating a storyline for a transformed and expanded barn is only effective if, in the end, the observer accepts the deceit without a sense of contrivance.

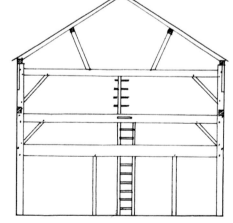
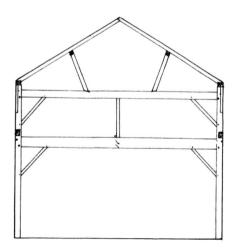

Three sections of the Potts Barn.

The Potts Barn serves as the great hall of the house. The rare double-braced swingbeam provides an expansive unbroken space for a living room area in one bay and an open threshing bay with silhouetted musical instruments. The doors at each end of this bay can be opened to channel cooling breezes through the barn and across the broad porch that shades it. The original loft over the other bay has been recreated, providing an intimate space for dining below and for a study above. The three-part ladder has been retained, while wire mesh forms a natural protective barrier. Bookcases are framed by the original studs. The other walls are covered with antique pine clapboarding and the roof with hemlock sheathing. Through the large-paned window filling the wagon door opening, it is possible to gain a glimpse of a *double-pen dogtrot* structure, which contains two guest rooms separated by a breezeway, which in turn leads to the otherwise concealed swimming pool.

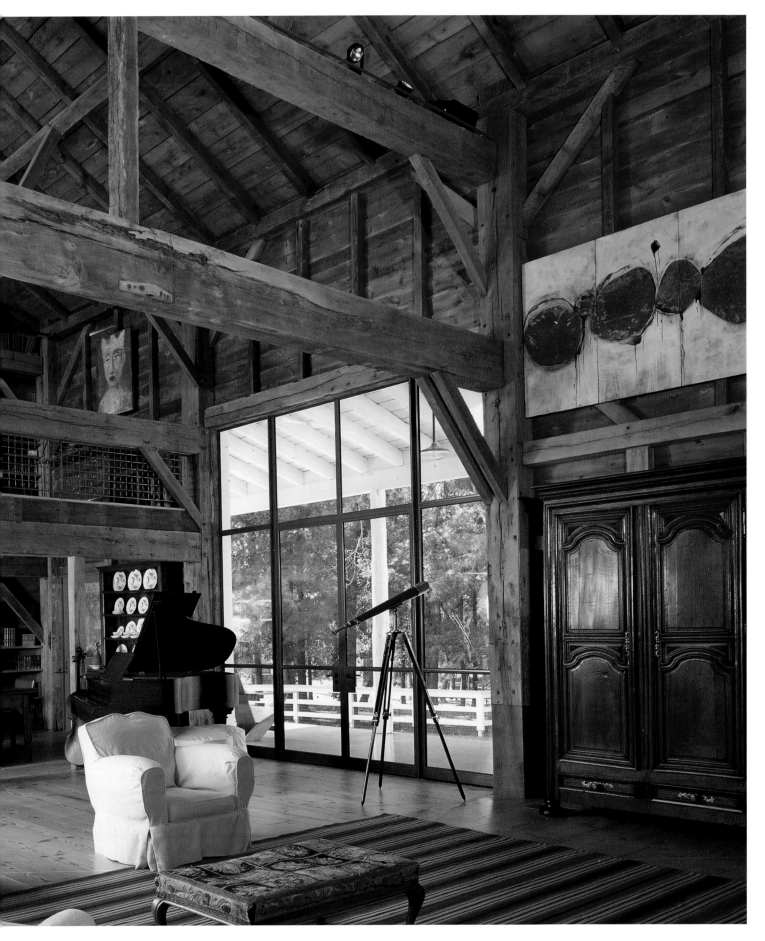

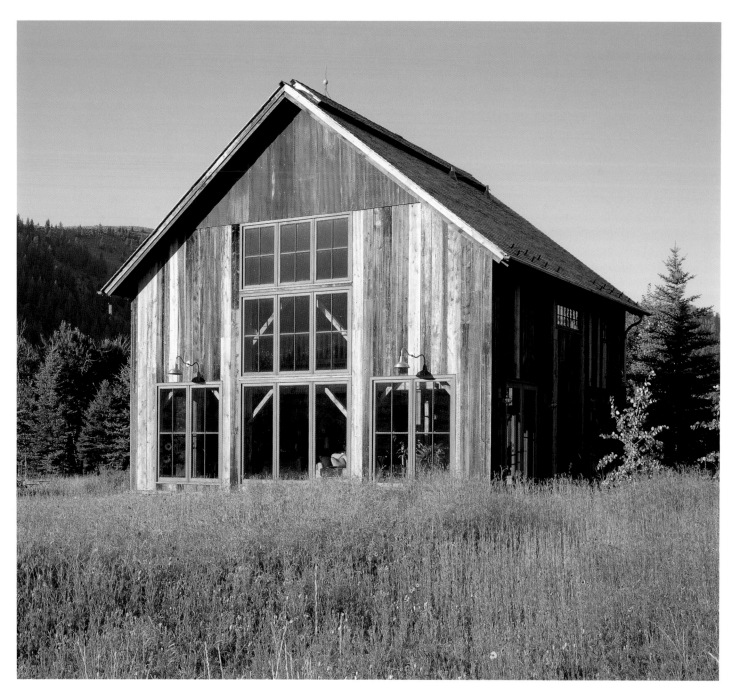

For another Vermont barn transported and reerected in Sun Valley, Idaho, a young architect found herself confronted with the opportunities and limitations of designing a house within the given strictures of an antique timber frame. Her comments are elucidating: "It was my intent to emphasize the building's form as the driver in the design. I'm appreciative of barns, and consider them quite bold in their simplicity of form, massive size, and complexity of joinery. I find it interesting that architects are always trying to be sensitive to massing [as] it relates to human scale. Barns can be absolutely huge and would typically be considered insensitive to that scale, but people gravitate to these structures, and love them as homes. Obviously, there are considerations when designing [a barn house] such as making human-scaled spaces within the confines of the structure and sizing windows and doors to respond appropriately to the scale of the barn." The result of her musings is a barn which shuns special effects for straightforward materials and chaste embellishment. It is further posited that it is important to "incorporate the framing as a feature rather than a hindrance to the windows, allowing braces, posts, and tie beams to be a defining and contributing part of [window design]."

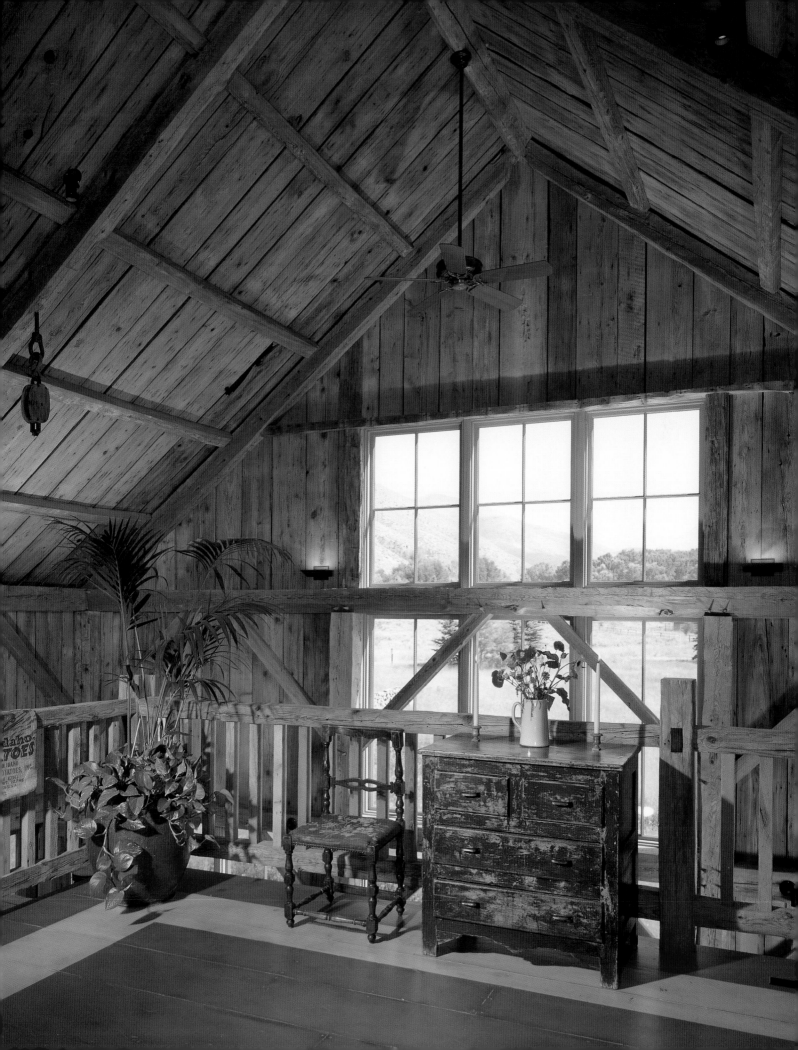

The original Dutch barn.

At first glance, the project – to relocate a rare New World Dutch barn to expand an existing ranch house from the 1960s on a half-acre lot within the city limits of San Antonio – was patently absurd. In fact, the site was located at the end of a private cul-de-sac, immediately adjacent to a seven-acre flood plain and bird sanctuary. Redefinition of the low existing structure was to be included in the conversion plan. The clients were seeking a barn to act as a compatible backdrop for their extensive collection of American folk objects and primitives. Despite long odds, the resulting barn house is especially successful. The proud profile of the Barley Sheaf Barn dominates the site. The old ranch house has been transformed with a rank of small windows and a standing-seam roof crowned with ventilators, so that it assumes the appearance of a dairy wing. Clad in clapboard and a standing seam roof, the old Dutch barn is reendowed with long-lost features like martin holes and a pent roof over the wagon portal. Aside from this opening, windows are kept to a minimum. The chimney is similarly restrained. The sole concession to the extreme Texas heat is a low porch that hugs one side aisle in the guise of a tie-up.

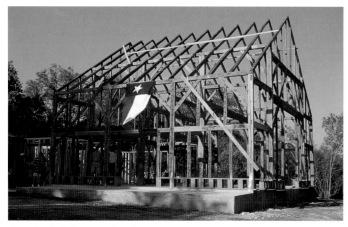

The finished frame in San Antonio.

256

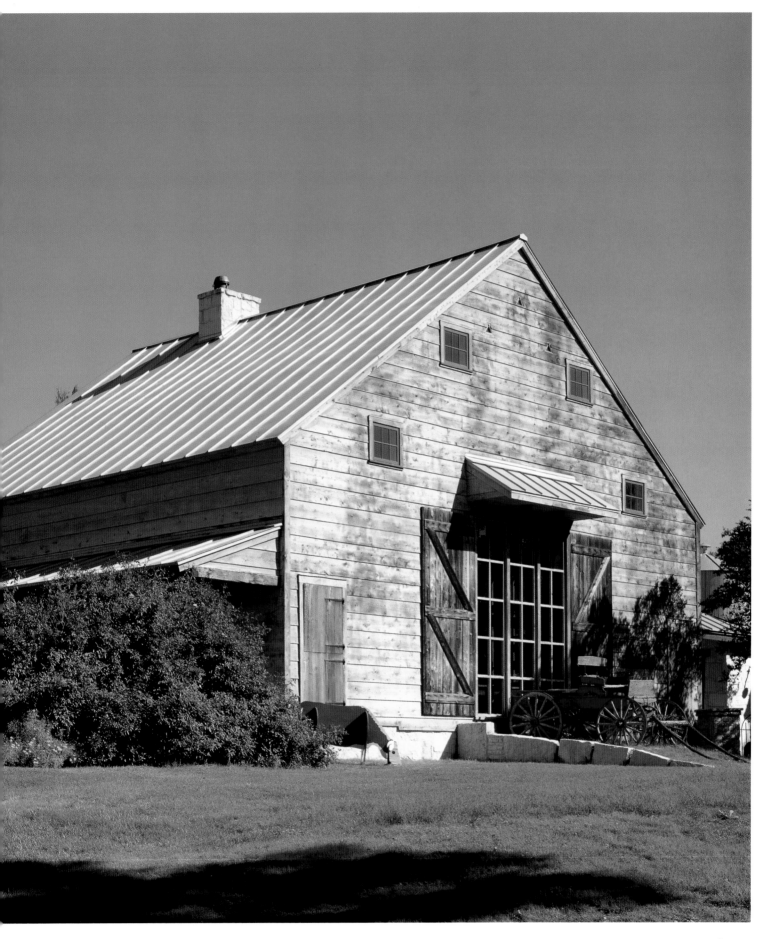

The gable end of the Barley Sheaf Dutch Barn.

The first two bays of the thirty-three by forty-two foot Barley Sheaf Barn, with combined nave and side aisles, form an immense interior space, open to the peak. Light from three wagon door openings is augmented by ascending six-light sash in the gable. An antique oak floor reestablishes the central threshing bay, but where cow stalls once stood in the flanking aisles, the floor is composed of floated, pigmented concrete. Exposed duct-work and ceiling fans are straightforward components in circulating acclimatized air in all seasons. Clad in new rough-sawn pine, the ancient frame provides an armature for the growing folk art collection it complements.

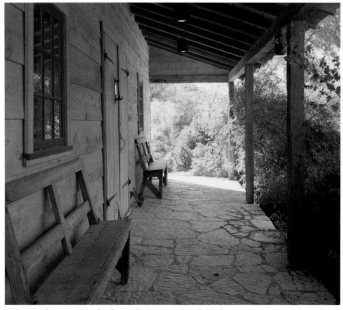

The porch provides shade to the west side of the barn.

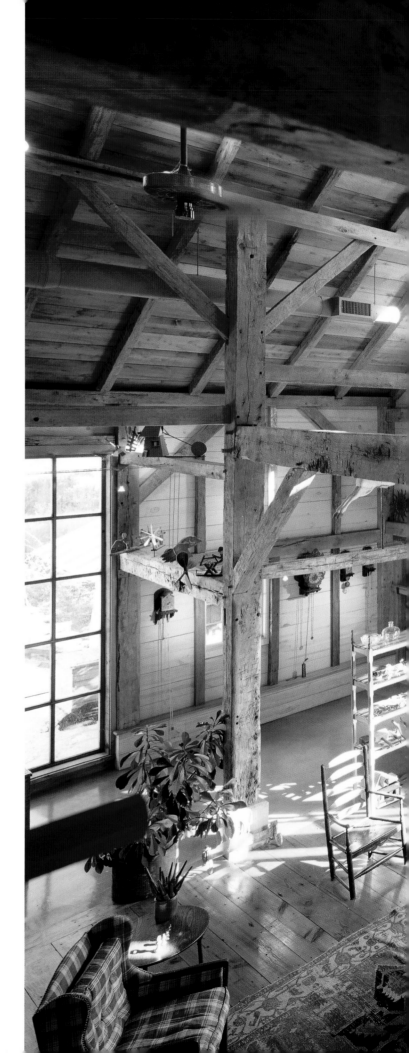

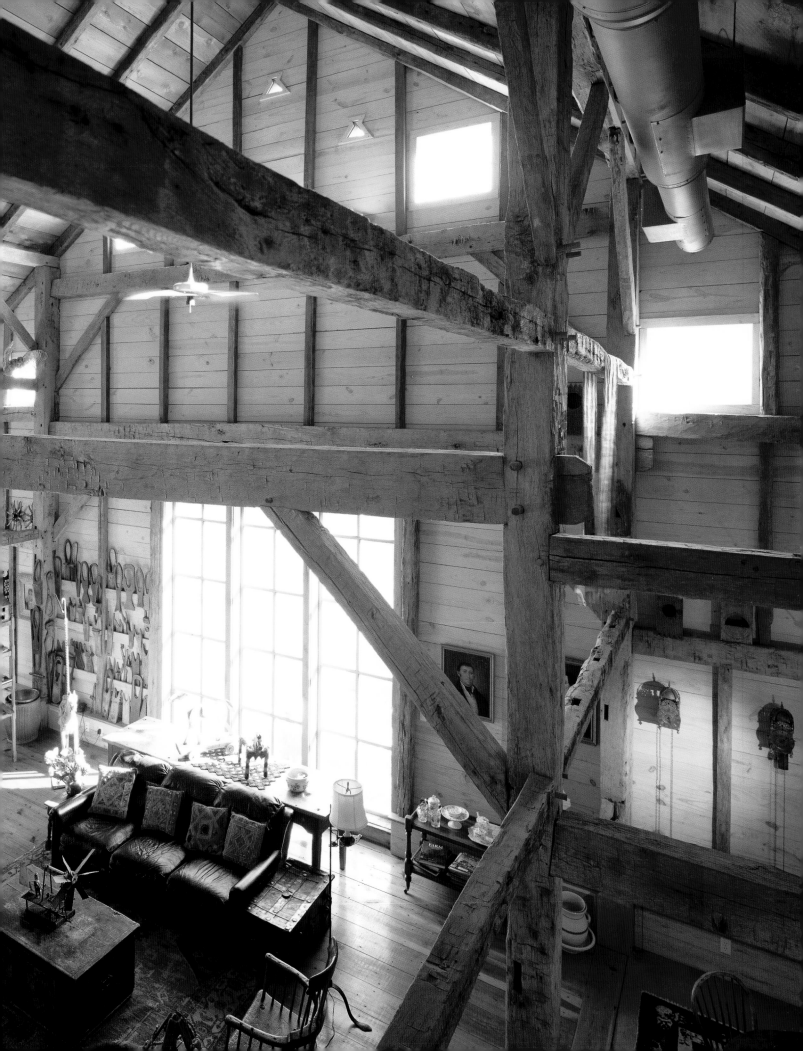

The upstairs hallway.

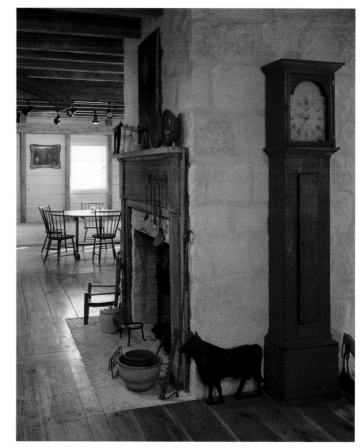

The stone chimney and breakfast area.

The Dutch barn from Barley Sheaf, New Jersey, is a rare example of a local variation with dropped anchor-beams defining the third and floor bents, a condition that creates a lower loft within the third bay. For the conversion, this anomaly allowed the introduction of a chimney of native Texas sandstone positioned behind the bent to service fireplaces opening into the great hall and the breakfast area that occupies the reconditioned space beyond it on the first floor. The loft space above, with provision for a stove, is a private sitting area off the master bedroom. A playroom and bedrooms for four children are located in the former ranch house with direct access to the outdoors.

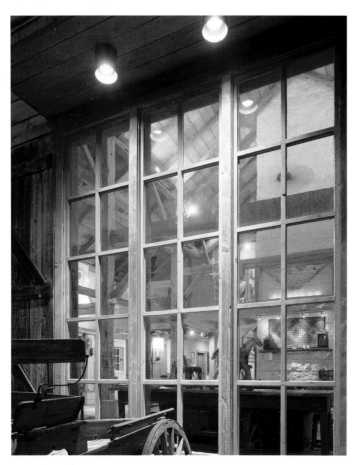

The gable doorway becomes a large window.

260

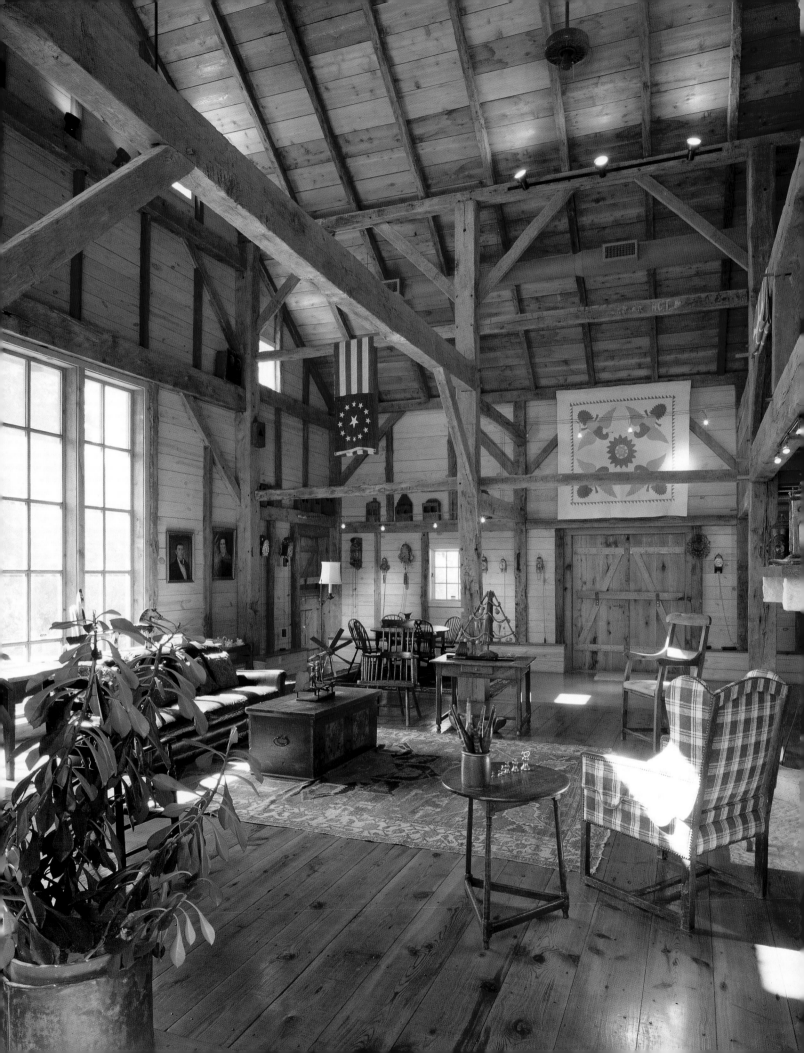

The Colfax Barn before 1940.

Postscript: Save the Barn

George Washington Colfax, godson and namesake of his father's commanding officer, was born soon after the Revolution and built his house and barn early in his maturity on land adjacent to the Dutch-style home of his ancestors in Wayne, New Jersey. Dutch and English cultures flourished side by side, and it is not surprising that for his barn he chose the New World Dutch plan. Hundreds of similar Dutch barns then dotted the landscape. Few survived as the rural character of Passaic County was supplanted by commercial and residential development early in the twentieth century. This was particularly true along principal arteries like the old Paterson-Hamburg Turnpike, site of the Colfax Farm. For more than a century the farm remained in the Colfax family until it was sold to Olaf Haroldson, whose heirs eventually subdivided the property for roadside development. The Colfax house was replaced by a Chevrolet dealership, and the barn would surely have been similarly destroyed but for its early and fortuitous adaptive reuse. In 1940 Mrs. Haroldson and her daughter began selling ice cream from the old dairy barn, which in time came to be known as the Alderney

Milk Bar. Gasoline rationing during the Second World War suspended the enterprise, but new postwar owners re-established the emporium and it flourished. Little League games and prom nights were not complete without a pilgrimage to what became the Old Milk Bar. Thousands of names and initials carved into tables and partitions testified to the persistent popularity that made it a local landmark.

"Save the Barn!" became the rallying cry, when in December 2001 the Old Barn Milk Bar closed its doors. For thousands of patrons, many of whom had left their personal legacy incised in its walls, the event marked the end of an era. Preservationists appreciated this identity as a community icon, but also realized the concurrent historical value of the structure as a vernacular survivor. By the turn of the twenty-first century, it was the sole remaining Dutch barn in Passaic County. By the time the Chevrolet dealership finalized purchase of the property with plans for its reuse as a sales lot, a coalition of constituencies had already mounted a campaign to rescue the barn by removing it to one of Wayne Township's established historic sites. The car dealer donated the building, but funds for its disassembly required a sustained series of offerings and events. T-shirts and coffee mugs were created and sold. A community-wide cookout was held. The former supplier of ice cream contributed five hundred gallons for a "social." Meanwhile, within the darkened shell, documentation proceeded to record the barn's original timber frame, much of which had been obscured during its half-century as a dairy bar. Despite many subsequent alterations and additions, most of the structure remained intact. The frame itself was fascinating. Measuring forty-one by forty-two feet, with an unusually high profile, the structure is distinguished by a particularly narrow nave. What ranks it as unique among recorded New Jersey Dutch barns is the unaccountable presence of side aisles of unequal width, resulting in outside walls of different heights. By the December 2002 deadline for removal, sufficient grassroots funding had been secured for the structure's disassembly. Shorn of subsequent additions, clapboards embellished with advertising were revealed for the first time in forty years. These were carefully extracted, as were wall sections emblazoned with pen-knife graffiti. As the process of unraveling the history of the edifice proceeded, flashbulbs popped as former patrons voiced their testimony. One young man, the third generation

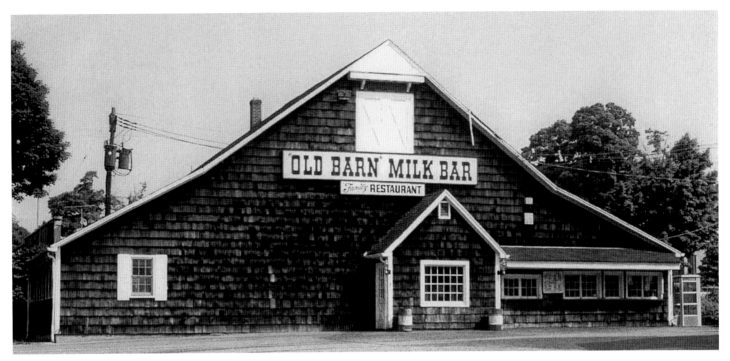

The barn before its uncovering.

in his family to work, there recounted that his grandmother, an original waitress, died the week before the announcement of its closing. Her cortege was routed past the landmark. A police chief with his own memories was observed with tears in his eyes. Today, while further funding is secured for repair and reerection of the Colfax Barn, archaeological investigation has revealed foundations for a similar structure behind the Van Riper-Hopper House, an existing

Township Museum. As plans stand, the barn is to be raised again at that location, where it will serve as a meeting space and interpretive center. Among the principal exhibits will be the story of its own evolution from working barn, to ice cream emporium, to historical museum. Central to this saga is the proposition that only through early, adaptive reuse did the Colfax Barn survive to tell the tale. "Save the Barn!"

The Milk Bar fascia is revealed.

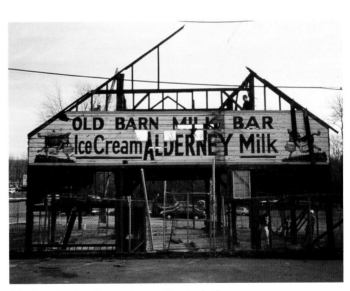

The barn is taken down to be stored and rebuilt.

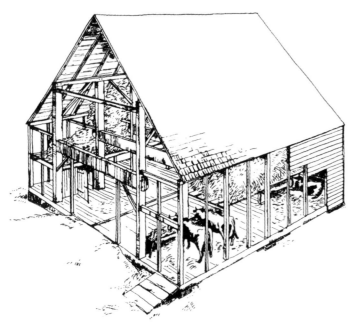

A New World Dutch Barn

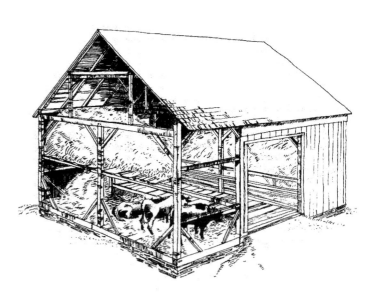

An American version of the English Barn

Glossary

AISLE The side section of a barn, house or church, adjacent and parallel to the central nave (or threshing bay), usually separated from it by an arcade.

ANCHORBEAM In Dutch barns, a large horizontal member that ties together the arcade posts to form a rigid, H-shaped anchorbent, which spans the threshing floor.

ANCHORBENT In Dutch barns, the H-shaped bent formed by a large horizontal anchorbeam connecting two braced arcade posts and stiffened both by pegs and wedged tongues.

ANKERBALKEN The Dutch term for anchorbent.

ARCADE POSTS The columns that form the framing section separating the threshing floor and side aisles in a Dutch barn.

BANK BARN A two level barn with access to the upper level by way of a hillside or ramp.

BASILICA PLAN A building plan in which a dominant nave is flanked by two or more side aisles. Dating back to Roman meeting halls, the form was adopted by early Christian churches. Later it was used in aisled barns in England and Dutch barns in Holland and North America.

BAUERNHAUS In Germany, a structure housing both a farm family and their livestock (and haymow) under one roof.

BENT The basic unit of assembly in a timber frame, in which vertical posts are joined with horizontal timbers and often stiffened with paired braces. A series of bents are connected together to complete the frame.

BOARD AND BATTEN Exterior sheathing, popular in the late-nineteenth century, consisting of wide vertical boards with narrow battens superimposed to cover the seams.

BRACE A subordinant timber that is morticed into two timbers typically set at right angles to each other, to provide strength and rigidity.

BREASTBOARDS Wide horizontal boards that form an interior wall alongside the threshing bay.

BREEZEWAY A covered passageway, as in a double pen barn, open to both sides; a threshing bay.

BRIDGEHOUSE An entry porch to a bank barn that covers and protects a bridge that in some cases separates the ramp and the threshing floor.

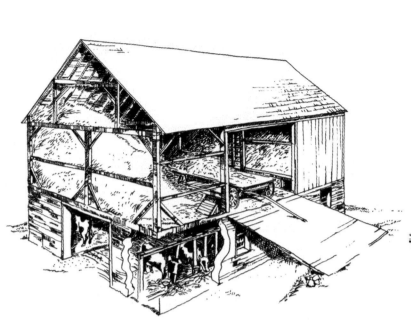

A Bank Barn

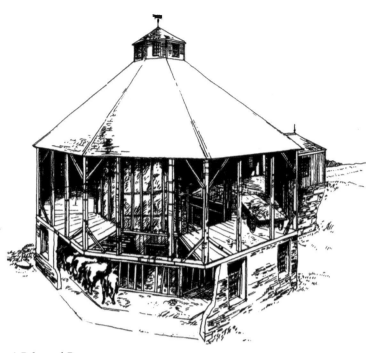

A Polygonal Barn

BROADSIDE The longer side wall of a barn, punctuated by wagon doors to the central threshing bay.

COLLAR TIE A horizontal timber that is framed between paired rafters to stiffen the roof.

COMMON RAFTER A roof timber that slopes up from the side wall to the ridge and is closely and regularly spaced.

CRIB A framework enclosure for ventilated storage of corn or grain. Also the stall of an ox.

DIMINISHED HAUNCH A framing device particularly, though not exclusively, employed in Dutch barns, by which vertical posts are relieved in order to shoulder the weight of horizontal beams, thereby reducing the load on the tenons. The full depth of the shoulder cut is only at the bottom of the joint that trails off diagonally to the top.

DROVER'S BARN A sheltered tie up for the temporary use of animals being driven between farm and market.

DUTCH BARN A broad gable entry barn found in areas of Dutch settlement that employs anchorbent framing according to the basilica plan.

DUTCH DOOR A door generally serving as a portal to a barn or house, with upper and lower halves which can be opened separately.

DUTCHMAN A repair or patch to a piece of wood that retains as much of the original as possible.

ENGLISH BARN A rectangular barn plan generally composed of three bays with a side entrance to a central threshing floor. Common in England and known elsewhere in Europe, this plan was adopted for most early American barns in areas of English settlement.

FACHWERK A Germanic construction system that includes exposed timber framing filled in with pargeted masonry.

FLAILING The threshing of grain, by hand, using a flail, an instrument consisting of a free-swinging stick tied to the end of another stick.

FOREBAY A design originating in Switzerland and southern Germany by which the principal barn structure projects beyond the foundation, forming a cantilever of about six feet over the cellar story on the downhill side. Introduced by central European settlers in Pennsylvania, this feature defined a barn type that subsequently spread south and west.

FORK AND TONGUE JOINT A joint used to connect a pair of rafters at the ridge. The tenon (tongue) at the end of one rafter fits into an open mortice (fork) on the other. This joint is typically pegged.

GIN POLE A vertical pole secured by cables, used with a block and tackle for hoisting and barn raising.

GIRT A horizontal framing timber between two posts.

GRANARY A storehouse for threshed grain.

GUNSTOCK POST A post that flairs near the top to bear both a plate and a tie beam; also known as a jowled post.

HAMMERBEAM In post-Gothic English roof framing a truncated horizontal timber at the top of the side wall, which unlike a tie beam in the same position does not extend all the way across a barn, hall, or other structure.

HAY BARRACK In Germany and the Low Countries, a structure used for the seasonal storage of hay. Supported by horizontal pins set in extended corner posts, the roof can be raised or lowered depending on the size of the mow.

HAYMOW The space in the barn where hay is stored.

HOVEL A humble, open shed for sheltering cattle.

JACK POST A short, vertical timber sometimes employed in interior bents.

JAMB The vertical section of the frame to a doorway or window.

KING POST A post standing on a tie beam or collar beam and rising to the apex of the roof where it supports a pair of rafters or a ridgepole.

LAYOUT FACE The single plane to which major and minor timbers of a bent or side wall are justified.

LOOPHOLE A vertical slot in a stone wall that provides ventilation and light.

MANGER A feeding trough to hold hay or fodder for horses or cattle.

MARRIAGE MARKS Identifying Roman numerals or slashed incised into corresponding timbers of a mortise-and-tenon joint.

MARTIN HOLE Small openings cut into the gable weatherboards of barns, often in decorative patterns, to provide access to martins and other insect-eating birds.

MIDDLETREE / MIDDLEMAN A removable, vertical timber, mortised at the center of the sill and lintel of the doorway to the threshing bay. Wagon doors can be hooked and secured to this timber.

MORTISE AND TENON The timber-framing technique by which the projecting end of one structural member is slotted into a corresponding hole in another and secured with a wooden peg.

MOWPOLES Sapplings laid horizontally to support hay within a barn. Not part of the framed barn structure, mowpoles were sometimes inserted into mortises at one end while the other end was left free so that the poles could be removed.

NAILER A horizontal secondary timber to which vertical siding is nailed in the intermediary spaces between larger timbers.

NAVE In a church or gable-front barn, the central, main section that is positioned between flanking aisles.

NEW WORLD DUTCH BARN A building type based on the basilica plan brought to America by settlers from the Lowlands of Northern Europe. In plan the Dutch barn is defined by a broad central threshing bay, or nave, and lofted side aisles. The frame of the threshing bay is dominated by large, H-shaped anchorbents consisting of a braced horizontal anchorbeam, supported by arcade posts. Dutch barns are usually wider than they are deep with doors to the threshing bay located on the gable ends and long, steeply-pitched rafters extending from the peak down to the low side walls.

OVERSHOOT See Forebay.

PASSING BRACE A diagonal brace that joins three other members. This brace is dovetailed into the outer timbers and lapped at the intersection with the third.

PENT ROOF A shallow roof with a single slope located just above the wagon doors of some Dutch and English barns.

PIKEPOLE A sappling with a metal spike driven into one end. During the raising process, as a bent is raised beyond arm's length, pikepoles are individually stabbed into the frame so that the participants can continue pushing the framing section into a vertical position.

PODSTONE / PADSTONE A large stone that supports a sill plate and rests immediately above a post to bear the building's weight. Podstones were used in place of a full foundation, particularly where stone was scarce.

PRINCIPAL RAFTER A large inclined timber in a roof truss.

PURLIN A horizontal timber running parallel to the rafter plate and ridge, which helps to support and stabilize the rank of common rafters. In British barns and early structures in New England, the purlins are secondary to and spported by widely spaced principal rafters.

PURLIN STRUTS A pair of vertical or canted posts placed symmetrically on a tie beam to support the purlins or principal rafters. Also known as a Queen post.

QUEEN POST See Purlin struts.

RAFTER PLATE A horizontal timber, supported by and connecting the posts of several bents, which in turn supports the rafters.

RAISING BRACE A brace connecting a post to a sill plate and running perpendicular to a bent. These braces were used during a barn raising to secure the first bent in its vertical position until it could be connected to subsequent bents by girts or rafter plate.

RIDGEPOLE The horizontal timber at the apex of the roof into which pairs of rafters are mortised. While ridgepoles are occasionally found in New England barns, most old barns were built without them.

SCRIBE RULE The traditional timber framing technique in which secondary members were individually cut and fitted between major timbers, a process requiring that both bents, side walls and sections be fitted on the ground while the frame was being fashioned. In the nineteenth century this method was gradually supplanted by the less demanding square rule procedure. See also Square rule.

SHOULDER The relieved notch on a post at a timber frame joint that allows the weight of a horizontal timber to be transferred directly to its vertical member rather than loading the tenon alone.

SILL PLATE Long horizontal timbers laid on the foundation to carry the floor joists and support the posts and studs.

SQUARE RULE The timber framing technique in which secondary timbers such as studs, braces, nailers, and rafters are universally cut to length, and major timbers were individually notched to receive them. Using the square rule method, framing sections do not need to be fitted together until the raising. The consequent savings in labor are considerable. See also Scribe rule.

STUD On the outside walls of a barn, a lesser upright framing member functioning as a nailer for horizontal framing.

SWING BEAM In some English barns, a tie beam that is large enough to span the full width of a building without the support of any interior posts.

SWITZER / SWEITZER BARN In early Pennsylvania barns, a form distinguished by an asymmetrical gable and a full cantilevered, unposted forebay.

TENON A projection at the end of a timber that fits into a mortise of another timber to form a secure joint when pegged.

THRESHING The process of beating hay out of the husk, either by flailing with a stick, trodding under hooves, or by means of various mechanical devices.

THRESHING BAY The central bay of a barn, accessed by large wagon doors on one or, more likely, both sides, where grain was processed. With doors open a breezeway was created that blew away the separated chaff, leaving the grain on the floor.

TIE BEAM A horizontal timber that connects the two outside posts of a bent.

TONGUE In Dutch barns, the extended through tenon of an anchorbeam that protrudes a foot or more past the arcade post to which it is secured both by pegs and wedges. The end of the tongue may be square, semi-circular, or pointed according to individual or vernacular preference.

TRIFORIUM The triangular space above the side aisles and under the rafters of a church or Dutch barn, where it served as a lofted hay mow.

WAGON DOORS The large central portal to the threshing bay of a barn, broad and high enough to allow the entry of a fully loaded hay wagon.

WIND BRACE Long, diagonal timbers inset into a number of sequential rafters to forestall the stretching and straining of the roof.

WINNOWING The process of blowing chaff from threshed grain by means of a breeze or mechanical blower.

Bibliography

Andrews, Francis B., *The Medieval Builder and His Methods*, New York, Dorset Press, 1993.

Apps, Jerry, *Barns of Wisconsin*, Madison, Wisconsin, Wisconsin Trails, 1995.

Arthur, Eric, and Dudley Witney, *The Barn, A Vanishing Landmark in North America*, Toronto, M. F. Feheley, 1972.

Auer, Michael, *The Preservation of Historic Barns*, *(Preservation Brief #20)*, Washington, D. C., U. S. Department of the Interior, National Park Service, 1989.

Babcock, Richard W., and Laura R. Stevens, *Old Barns in the New World, Reconstructing History*, Lee, Massachusetts, Berkshire House Publishers, 1996.

Bailey, Rosalie Fellows, *Pre-Revolutionary Dutch Houses and Families in Northern New Jersey and Southern New York*, New York, William Morrow & Company for the Holland Society of New York, 1936.

Blackburn, Roderic H., Geoffrey Gross and Susan Piatt, *Dutch Colonial Homes in America*, New York, Rizzoli, 2002.

Brubaker, Robert and Bert Tucker, *The George Washington Colfax Barn, The Barn with Three Lives*, Wayne, New Jersey, Wayne Historical Commission, 2002 (uncopyrighted).

Brunskill, R. W., *Illustrated Handbook of Vernacular Architecture*, London, Faber and Faber, 1971.

_____, *Traditional Farm Buildings of Britain*, London, Victor Gollancz Ltd., 1982.

_____, *Vernacular Architecture of the Lake Counties, A Field Handbook*, London, Faber and Faber, 1974.

Burnell, Marcia, *Heritage Above, A Tribute to Maine's Tradition of Weathervanes*, Camden, Maine, Down East Books, 1991.

Carl-Mardorf, Die Luneburger Heide, Leipzig, Germany, *Der Eiserne Hammer*, undated (pre Second World War).

Chappell, Edward A., "Germans and Swiss." In Dell Upton, ed., *America's Architectural Roots: Ethnic Groups that Built America*, Washington, D.C., Preservation Press, 1986.

Cliftin-Taylor, Alex, *The Pattern of English Building*, London, Faber and Faber, 1962.

Cohen, David Steven, *The Dutch American Farm*, New York, New York University Press, 1992.

Collier, Rick, *Preservation Area Pre-Mapping Study for Tusculum, Philadelphia*, Wallace Roberts and Todd, and John Milner Associates, Inc. (unpublished), December 1996.

Collins, Varnum Lansing, *Princeton*, New York, Oxford University Press, 1914.

_____, *Princeton Past and Present*, Princeton, Princeton University Press, 1931.

Cramer, Julie, *Turning a Barn into a Business*, Lancaster County, Pennsylvania, April 2002.

De Benaming van Houtverbindingen en Constructieve Houten Elementen bij OudeBoerderijen Een Poging tet Systematisering, Arnheim, Stichting Historisch Boerderijen-Onderzoek, 1982.

Dunn, Shirley W., and Allison B. Bennett, *Dutch Architecture Near Albany, The Polgreen Photographs*, Fleischmanns, New York, Purple Mountain Press, 1995.

Early Architecture in Ulster County, Kingston, New York, Junior League of Kingston, Inc., 1974.

Ebbage, Sheridan, *Barns and Granaries in Norfolk*, Ipswich, The Boydell Press, 1976.

Endersby, Elric, Alex Greenwood and David Larkin, *BARN, The Art of a Working Building*, Boston, Houghton, Mifflin, 1993.

Ensminger, Robert F., "Comparative Study of Pennsylvania and Wisconsin Forebay Barns," *Pennsylvania Folklife*, (Spring 1983).

_____, *The Pennsylvania Barn: Its Origin, Evolution and Distribution in North America*, Baltimore, Johns Hopkins University Press, 1992.

_____, "A Search for the Origin of the Pennsylvania Barn," *Pennsylvania Folklife*, 30, 2 (Winter 1981–82).

Fink, Daniel, *Barns of the Genesee Country, 1790-1915, Including an Account of Settlement and Changes in Architectural Practice*, Geneseo, New York, James Brunner, Publisher, c. 1988.

Fitchen, John, *The New World Dutch Barn, A Study of Its Characteristics, Its Structural System, and Its Probable Erectional Procedures*, Syracuse, New York, 1968.

Fitchen, John, *Building Construction Before Mechanization*, Cambridge, The M.I.T. Press, 1986.

Fowler, Orson S., *The Octagon House, A Home for All*, New York, Dover Publications, Inc., 1973 (originally published 1853).

Glass, Joseph W., "Be Ye Separate, Saith the Lord: Old Order Amish in Lancaster County," In Roman A. Cybriwsky, ed., *The Philadelphia Region: Selected Essays and Field Trip Itineraries*, Washington D. C., Association of American Geographers, 1979.

_____, *The Philadelphia Culture Region: A View from the Barn*, Ann Arbor, Michigan, U. M. I. Research Press, 1971.

Glassie, Henry, *Barn Building in Otsego County*, New York, Cooperstown, New York, New York State Historical Association, 1974.

Goedseels, Vic, and Luc Vanhaute, *Nos Fermes se Racontent*, Bruxelles, Pierre Mardaga, 1983.

Greenberg, Allan, *George Washington Architect*, London, Andreas Papadakis Publisher, 1999, photographs by Tim Buchman.

Greiff, Constance M., Mary W. Gibbons and Elizabeth G. C. Menzies, *Princeton Architecture, A Pictorial History of Town and Campus*, Princeton, New Jersey, Princeton University Press, 1967.

Griswold, James W., *A Guide to Medieval English Tithe Barns*, Portsmouth, New Hampshire, Peter E. Randall, Publisher, c.1999, 85 pp., illus.

Hands That Built New Hampshire, The Story of Granite State Craftsman Past & Present, Brattleboro, Vermont, Stephen Daye Press, c. 1940, 288 pp., illus.

Hanau, John T., A Round Indiana, *Round Barns in the Hoosier State*, West Lafayette, Indiana, Purdue University Press, 1993.

Harvey, Nigel, *A History of Farm Buildings in England and Wales*, London, David and Charles, 1970.

Hawke, David Freeman, *Everyday Life in Early America*, New York, Harper and Row, 1988.

Hewett, Cecil A., *English Historic Carpentry*, Fresno, California, Linden Publishing, 1997.

Hubbard, Charles D., *An Old New England Village*, Portland, Maine, Falmouth Publishing House, 1947.

Huber, Greg, Rare Local Dutch Barns, *The Poest Script*, Poestenkill Historical Society, Volume 6, Number 1, March 1994.

_____, "Seven Bay Wagner Dutch Barn of Rensselaer County, The," New York, *Newsletter*, Dutch Barn Preservation Society, Volume VII, Issue 2, Fall 1994.

Hubka, Thomas C., *Big House, Little House, Back House, Barn, The Connected Farm Buildings of New England*, Hanover, New Hampshire, University Press of New England, 1984.

Hughes, Graham, *Barns of Rural Britain*, London, The Herbert Press, 1985.

Humstone, Mary, *BARN AGAIN! A Guide to Barn Rehabilitation*, Washington, D. C., The National Trust for Historic Preservation, 1988.

Kirk, Malcolm, *Silent Spaces, The Last of the Great Aisled Barns*, Boston, Little Brown and Company, 1994.

Klinkenborg, Verlyn, *Making Hay*, New York, Vintage Books, 1987.

Kulke, Erich, *Wendlanddorfer-Gestern und Heute, Siedlings Structuren in Neidersachsen*, Hanover, Germany, 1986.

Leffingwell, Randy, *The American Barn*, Osceola, Wisconsin, Motorbooks International Publishers, 1997.

Loudon, John, *Encyclopedia of Cottage, Farm and Villa Architecture*, 1833.

Mardaga, Pierre, ed., Loraine Belge, *Architecture Rurale de Wallone*, Bruxelles, 1983.

Marshall, Howard Wight, *Folk Architecture in Little Dixie*, Columbia, Missouri, University of Missouri Press, 1981.

Meeske, Harrison Frederick, *The Hudson Valley Dutch and Their Houses*, Fleischmanns, New York, Purple Mountain Press.

Moffatt, Marian, and Lawrence Wodehouse, *The Cantilever Barn in East Tennessee*, Knoxsville, Tennessee, University of Tennessee School of Architecture, 1984.

Montell, William Lynwood, and Michael Lynn Morse, *Kentucky Folk Architecture*, Lexington, Kentucky, The University Press of Kentucky, 1976.

Morrison, William, *The Main Line, Country Houses of Philadelphia's Storied Suburb, 1870–1930*, New York, Acanthus Press, 2002.

Nash, Randy, *Barns of the Catskills, A Self-Guided Tour Book Through Picturesque Delaware County*, Arkville, New York, 2002.

Noble, Allen G., and Hubert G. Wilhelm, *Barns of the Midwest*, Athens, Ohio, Ohio University Press, 1995.

_____, and Richard K. Cleek, *The Old Barn Book*, New Brunswick, New Jersey, Rutgers University Press, 1995.

_____, *Wood, Brick and Stone, The North American Settlement Landscape, Volume II, Barns and Farm Structures*, Amherst, Massachusetts, University of Massachusetts Press, 1984.

Nicoletta, Julie, *The Architecture of the Shakers*, Woodstock, Vermont, The Countryman Press, 1995.

Peter Johns Family Farmstead, The, ca. 1800, Township of East Lampeter, Lancaster County, Preserved, 2001, Lancaster, Pennsylvania, H. L. Wiker and Sons, Inc., 2001.

Piwonka, Ruth, and Roderic H. Blackburn, *A Visable Heritage, Columbia County, New York, A History in Art and Architecture*, Hensonville, New York, Black Dome Press, c. 1996.

Pogue, Dennis J., *Background Information on the GWPF Barn Complex* (Unpublished Memorandum), 7 January 1997 (revised version).

_____, "Every Thing Trim, Handsome and Thriving, Recreating George Washington's Visionary Farm," *Virginia Cavalcade*, Volume 48, Number 4, Autumn 1999.

Porter, John C., and Francis S. Gilman, *Preserving Old Barns, Preventing the Loss of a Valuable Resource*, University of New Hampshire Cooperative Extension, 2001.

Price, H. Wayne, "The Double Pen Barns of Calhoun County," *Journal of the Illinois State Historical Society*, Springfield, Illinois, Vol. LXXIII, No. 2, Summer 1980.

Pruden, Theodore H. M., "The Dutch Barn in America: Survival of a Medieval Structural Frame," in Upton and Vlach, eds., *Common Places: Readings in American Vernacular Architecture*, Athens, University of Georgia Press, 1986.

Reynolds, Helen Wilkinson, *Dutch Houses in the Hudson Valley Before 1776*, New York, Dover Publications, Inc., 1965.

Rideout, Orlando V, "The Chesapeake Farm Buildings Survey (Work in Progress)," in Camille Wells, ed., *Perspectives in Vernacular Architecture*, Vol. I, Columbia, Missouri, University of Missouri Press, 1982.

Schiffer, Herbert, *Shaker Architecture*, West Chester, Pennsylvania, Schiffer Publishing Ltd., 1959.

Shoemaker, Alfred L., ed., *The Pennsylvania Barn*, Kutztown, Pennsylvania Folklore Society, 1959.

Sloane, Eric, *An Age of Barns*, New York, Funk and Wagnalls, 1966.

Slocombe, Pamela M., *Wiltshire Farm Buildings, 1500 -1900*, Devizes, Wiltshire, Devezes Books Press, 1989.

Soike, Lowell J., "Without Right Angles", *The Round Barns of Iowa*, Des Moines, Iowa, Iowa State Historical Department, Office of Historical Preservation, 1983.

Sprigg, June, and David Larkin, *SHAKER, Life, Work and Art*, New York, Stewart, Tabori and Chang, 1987.

Stephens, Jean, *Springhill, Its History, Occupants and Appearance*, compiled 1958–2001, unpublished manuscript.

Stephens, Tom, *A Brief History of the [Springhill] Barn*, Melrose, Florida, 2001, unpublished manuscript.

Stilgoe, John R., *Common Landscapes of America, 1580 to 1845*, New Haven, Yale University Press, 1982.

Swain, Doug, ed., *Carolina Dwelling, Toward Preservation of Place: In Celebration of the North Carolina Vernacular Landscape*, Raleigh, N. C., North Carolina State University, 1978.

Uldall, K., *Frilandsmuseet, The Open Air Museum*, Copenhagen, Sorgenfri Station, c. 1962.

Upton, Dell, ed., *American Architectural Roots, Ethnic Groups That Built America*, Washington, National Trust for Historic Preservation, 1986.

Vince, John, *Old Farms: An Illustrated Guide*, New York, Bramhall House, 1984.

Visser, Thomas Durant, *Field Guide to New England Barns and Farm Buildings*, Hanover, New Hampshire, University Press of New England, 1997.

Weyns, Dr. Jozef, *Beknopte gids van het Vlaamse Openluchtmuseum in het Limbugse Provinciedomein Bokrijk*, Provincie Limburg - Culturele aagelegenheden, 1984.

Wilstach, Paul, *Mount Vernon, Washington's Home and the Nation's Shrine*, New York, Doubleday, Page & Company, 1925.

Woodforde, John, *Farm Buildings in England and Wales*, London, Routledge and Kegan Paul, 1983.

Wright, Louis B., *The Cultural Life of the American Colonies, 1607–1763*, New York, Harper and Row, 1957.

Yoder, Don, and Thomas C. Graves, *Hex Signs: Pennsylvania Dutch Barn Symbols and Their Meaning*, New York, Dutton, 1989.

Young, Joanne, *Washington's Mount Vernon*, New York, Holt, Rinehart and Winston, c. 1973.

Zielinski, John M., *Amish Barns Across America*, Iowa City, Iowa, Amish Heritage Publications, 1989.

Acknowledgments

Henry Adams, Chichester, Linda Adelmann, Stephen Allen, All God's Creatures Country Retreat for Pets, Antique Buildings Ltd., Baldwin's Book Barn, Peter Barker, Anne Bass, Dick Baxter, Black Creek Pioneer Village, Bookbarn of the Finger Lakes, James Boutwood, Jim Bradshaw and Claire Barraclough, Brazos de Dios, Robert Brubaker, Ben Brungaber, Bucks County Audubon Society, Buffalo Springs Herb Farm, Paul Bukbardis, Andrus Burr, Catskill Center for Conservation and Development, Phil Cannon, Center for Traditional Arts and Agriculture, Rudy and Laura Christian, Children's Defense Fund, Robert Clarke, T. Jeffrey Clarke, Copake Lumber and Supply, Michael Daciek, Gillian Darley, Anne Marie DeFreest, Dan Drackett, Vladimir J. Dragan, Sophie Drakish, Kevin Durkin, Dutch Barn Preservation Society, Ryan Edge, Ken Epworth, The Barn People, Madelyn Ewing, Fair Acres Farm, The Farmers Museum, Cooperstown, Geoffrey France, Furstover Antiques, George Gardner, Jane Ginsberg, Tracy and Jan Hammer, Haley Farm, Kelly Harte, Terry Heffernan, Philetus Holt, Greg Huber, Langston Hughes Library, Independence Construction Materials, Michael Ingrassia, Urs Joder, Jamie Kampf, June and Ira Kapp, David Knight, Knight Frank, Steve Koss, David Kusel, Pam Kusel, Ronald and Jo Carol Lauder, Bob and Judy Laughlin, Julian Lethbridge, Maya Lin, Steve Linvill, Matthew Logan, Russell London, Kevin Lucking, Simon Lush, John MacFarland, Ann and Vincent Mai, Hugo and Lee Lee Mainelli, Bill Mathessius, Frank and Martha McDougall, Middletown Fire Company No. 1, and the Volunteer Fire Services, William D. Miles, Matthew Millan, Candace Miller, Tom and Avril Moore, Mark Myers, Jeremy Nabarro: Pool Design Ltd., Randy Nash, Rich and Laura Novak, New York State Barn Coalition, Jeremy and Margaret Oates, Lorraine O'Byrne, Nicholas Ohly, The Old Inn On the Green & The Gedney Farm, Cheryl Ord, John Parsons, Andrew Perron, Karl Pettit, III, Christopher Pickell, Poestenkill Historical Society, Dennis J. Pogue, John and Claire Pollart, Sarah Powell, Preservation League of New York State, Preservation New Jersey, Race Brook Lodge, C. Rakity, Gretchen Reilly, John Redding, Rennie Reynolds, Cecily Rohrs, Round Barn Bed and Breakfast, Mary Bayes Ryan, Max Ryan, Oliver Ryan, Sauder Village, Napier Simpson, Singleton Barn Museum, Soclair Music Festival, Mark Solomon, Jancis Sommerville, Jack Staub, Jean Stephens, Tom Stephens, Milo V. Stewart, Jon Stone, Museums at Stony Brook, Strutt and Parker, Timber Frame Guild of America, The Tithe Barn: Ditcham, Toronto and Region Conservation Authority, Bert Tucker, Philip Venning, Upper Canada Village, Robert and Louise Wagner, Wayne Historical Commission, Adam Wengryn, Barbara Westergaard, Harold Wiker and Family, Simon Winchester, Alex and Carol Wojciechowicz, Cameron Wu, The Yorkshire Dales National Park Committee.

The photographs are by Paul Rocheleau except for those who supplied the following:

Henry Adams, 186, 187
R. Anderson, 182, 183
Antique Buildings, 96, 196
Mark Bilak. 44, 10-12
Black Creek Pioneer Village, 126, 127
Tim Buchman, 246, 249, 250 - 251, 252 - 253
Brazos de Dios, 102, 103
Andrus Burr, 212
Tommy Candler, 184, 185
Ken Epworth, 98 *bottom*, 117, 138 *middle right*, 156, 157, 158, 159, 160 *top and middle*, 161 *top, middle left, bottom left*, 218, 219, 226, 227, 228, 229, 230, 231, 232, 233
George Gardner, 141, 146, 147
Terry Heffernan, 75
Timothy Hursley, 130, 131
Knight Frank, 190, 191
The Inn at Waitsfield, 138 138, 140
David Kusel, 14
David Larkin, 14 *top left*, 15 *top left, top right, bottom left*, 98 *top*, 120 *top*, 130 *top left*
Steve Linvill, 112 *left*
Middletown Fire Company No. 1, 112 *right*
Mark Myers, 104 - 111
New Jersey Barn Company, 1, 6, 7, 15 *middle right, bottom right*, 18, 19 *top*, 38, 39, 40, 54, 65, 66, 73, 74, 76, 77, 78, 79, 88, 89, 90, 91, 92, 97, 98 *top*, 99 *bottom*, 100, 101, 116 *left*, 132 *top*, 138 *middle right*, 158 *top middle*, 160 *bottom right, middle right, bottom right*, 162, 163, 164, 165, 166, 167, 168, 169, 172, 173, 174, 175, 178, 179, 180, 181, 198, 207 *right*, 237 *bottom right*, 244, 245, 256, 263 *bottom*
David Parmiter, 84, 85
Dennis J. Pogue, 114, 115
John Redding, 132 - 137
Sauder Village, 152, 153
Soclair Brooks Farm, 150, 151
Tom Stephens, 24 - 28
Strutt and Parker, 192 - 195
The Tithe Barn, Ditcham, 148, 149
Upper Canada Village, 128, 129
Roger Wade, 254, 255
Louise Wagner, 39 *bottom right*, 41 *bottom left, bottom right*
Bob Waterman, 220 *bottom right*, 222, 224, 225
Waterview Properties, 197
Wayne Historical Commission, 262, 263 *top*
Wildwood Homes